GOING DUTCH

By the same author

Francis Bacon and the Art of Discourse

From Humanism to the Humanities
(with Anthony Grafton)

Still Harping on Daughters

Erasmus, Man of Letters

Erasmus: The Education of a Christian Prince

Reading Shakespeare Historically

Worldly Goods

Hostage to Fortune
(with Alan Stewart)

Ingenious Pursuits

Global Interests
(with Jerry Brotton)

On a Grander Scale: The Outstanding Career of Sir Christopher Wren

The Curious Life of Robert Hooke: The Man who Measured London

*The Awful End of Prince William the Silent:
The First Assassination of a Head of State with a Handgun*

GOING DUTCH

How England Plundered Holland's Glory

LISA JARDINE

HARPER PERENNIAL

NEW YORK • LONDON • TORONTO • SYDNEY • NEW DELHI • AUCKLAND

HARPER ● PERENNIAL

Published in Great Britain in 2008 by HarperCollins Publishers.

A hardcover edition of this book was published in 2008
by HarperCollins Publishers.

HarperCollins books may be purchased for educational, business, or
sales promotional use. For information please write: Special Markets
Department, HarperCollins Publishers, 10 East 53rd Street,
New York, NY 10022.

FIRST HARPER PERENNIAL EDITION PUBLISHED 2009.

Library of Congress Cataloging-in-Publication Data is available
upon request.

ISBN 978-0-06-077409-7

10 11 12 13 SCP 10 9 8 7 6 5 4 3 2

For Moti

Contents

Illustrations

William of Orange sets out to invade the British Isles. *Style of Abraham Storck.* © *National Maritime Museum, London*

James II at the time of the invasion. *Nicolas de Largilliere, circa 1686.* © *National Maritime Museum, London*

Constantijn Huygens junior, Secretary to William of Orange. Thought to be a self-portrait, dated 1685. © *Rijksmuseum, Amsterdam*

Dutch impression of the departure, and arrival at Torbay, of William's awesome fleet. *Romeyn de Hooghe (Author's collection)*

Prospect of Windsor Castle, by the Dutch artist Hendrick Danckerts. © *Victoria Art Gallery, Bath and North East Somerset Council/The Bridgeman Art Library*

Views of and across St James's Park by Hendrick Danckerts. © *The British Museum*

Idealised picture of William astride his white charger arriving at Torbay. *Ludolf Backhuysen, 1692,* © *Royal Cabinet of Paintings, Mauritshuis, The Hague*

Lurid contemporary print showing the rescue of England by William of Orange. Seventeenth-century English School. © *Private Collection/The Bridgeman Art Library*

Mary Stuart in regal, ostentatiously orange dress, shortly before the invasion. *Caspar Netscher, circa 1677–1684,* © *Rijksmuseum, Amsterdam*

William of Orange's trusted and cultivated adviser Gaspar Fagel. *After Johannes Vollevens,* © *Rijksmuseum, Amsterdam*

William of Orange arriving in sight of Westminster after marching with his army from Torbay. *Romeyn de Hooghe (Author's collection)*

Gardens of the Winter King and Queen at Heidelberg. *From Salomon de Caus, Hortus Palatinus, 1620 (Author's collection)*

Wilton gardens from a popular illustrated book on the subject. *From Isaac de Caus, Wilton Garden, circa 1645–1646*

Orange tree in a blue faïence container, presented by William III to his financial backer Francisco Lopes Suasso. *Collection Amsterdams Historisch Museum, Amsterdam. Photograph* © *Jewish Historical Museum, Amsterdam*

Children of Charles I by van Dyck – apparently promising the continuity of the Stuart line. *Anton van Dyck, 1637,* © *akg-images*

Medal commemorating the birth of Prince James Francis Edward Stuart in 1688. *Seventeenth-century English School* © *Timothy Millett Collection/The Bridgeman Art Library*

Busts of William III and Queen Mary in fashionable blue Delft faïence. *Unknown artists, late seventeenth-century,* © *Rijksmuseum, Amsterdam*

Bust of William III at Petworth House. © *NTPL/Angelo Hornak*

Frederik Hendrik and his wife Amalia van Solms in regal finery. *Gerrit van Honthorst, circa 1637-1638,* © *Royal Cabinet of Paintings, Mauritshuis, The Hague*

Prince William and Princess Mary in their wedding outfits. *Anton van Dyck, 1641, ©*
Rijksmuseum, Amsterdam

Van Dyck portrait of Charles I with horse and groom, c. 1635. *Anton van Dyck, circa*
1635, © akg-images/Erich Lessing

Charles II and his sister Princess Mary Stuart dancing in The Hague, on the eve of
his return to England as king in 1660. *Hieronymus Janssens, circa 1660, The Royal*
Collection © 2007 Her Majesty Queen Elizabeth II

Rubens's *Alexander Crowning Roxane*, acquired by Amalia van Solms. *Pieter Paul Rubens,*
© akg-images

Elizabeth of Bohemia. *Studio of Michiel van Mierevelt, © National Galleries of Scotland*

The Triumph of Frederik Hendrik, by Jacob Jordaens, from the Huis ten Bosch. *Jacob*
Jordaens, 1652, © akg-images

Sir Constantijn Huygens and his family. *Adriaen Hanneman, 1640, © Royal Cabinet of*
Paintings, Mauritshuis, The Hague

Sir Constantijn Huygens and his clerk, painted in the year of his marriage. *Thomas de*
Keyser, 1627, © National Gallery, London/The Bridgeman Art Library

Huygens's artistic neighbour and travelling companion, Jacob de Gheyn junior.
Rembrandt van Rijn, 1632, © Dulwich Picture Gallery

George Gage, artistic agent to Sir Dudley Carleton and others. *Anton van Dyck, circa*
1622-1623, © National Gallery, London

Engraving of the Rubenshuis in Antwerp, imposing home of the artist. *By kind*
permission of Sir Christopher White

Rubens and his family in the garden of his house in Antwerp. *Pieter Paul Rubens, ©*
The Bridgeman Art Library

Self-portrait of Pieter Paul Rubens. *Pieter Paul Rubens, 1638-1640, © Kunsthistorisches*
Museum, Vienna/The Bridgeman Art Library

Titian's *Pardo Venus*, acquired by Colonel John Hutchinson at auction from the royal
collection after the execution of Charles I. *Titian, sixteenth-century, Louvre, Paris, ©*
Giraudon/The Bridgeman Art Library

Mary Stuart, the Princess Royal, painted shortly after the death of her husband
William II. *Bartholomeus van der Helst, 1652, © Rijksmuseum, Amsterdam*

Young Lady Playing the Clavecin by Jan Vermeer. *Jan Vermeer, circa 1670, © National Gallery,*
London/The Bridgeman Art Library

Head of Medusa by Rubens, commended by Huygens for creating 'terror'. *Pieter Paul*
Rubens, circa 1612, © akg-images

Portrait of Huygens by Jan Lievens, painted around 1625. *Jan Lievens, circa 1625, ©*
Rijksmuseum, Amsterdam

Self-portrait by Anton van Dyck. *Private Collection, © Philip Mould Ltd/The Bridgeman Art*
Library

Portrait of William III as a child by Hanneman (1654). *Adriaen Hanneman, 1654, ©*
Rijksmuseum, Amsterdam

Sir Pieter Lely self-portrait. *Sir Pieter Lely, circa 1660,* © *The National Portrait Gallery, London*

Gerrit Dou's *The Young Mother,* part of the 'Dutch Gift' presented to Charles II at his Restoration. *Gerrit Dou, 1658,* © *Royal Cabinet of Paintings, Mauritshuis, The Hague*

Pieter Saenredam's *Large Organ and Nave of the St Bavokerk, Haarlem, from the Choir,* part of the 'Dutch Gift'. *Pieter Saendredam, 1648,* © *National Galleries of Scotland*

Samuel van Hoogstraten's perspective painting *The Slippers. Samuel van Hoogstraten, Louvre, Paris,* © *Giraudon/The Bridgeman Art Library*

A glass rummer engraved with verses to Huygens by Anna Roemers Visscher, responding to a poem of his addressed to 'the diamond-tipped pen of Miss Anna Roemers'. *Anna Roemers Visscher, 1619,* © *Rijksmuseum, Amsterdam*

Double portrait of Sir Constantijn Huygens and his beloved wife Susanna van Baerle. *Jacob van Campen, circa 1635,* © *Royal Cabinet of Paintings, Mauritshuis, The Hague*

Drawing showing the Huygenshuis and Mauritshuis adjacent to one another in the fashionable district of Het Plein in The Hague. *Jan van Gall, circa 1690 (Author's collection)*

Drawing of the six-year-old Constantijn Huygens junior by van Campen. *Jacob van Campen, by kind permission of The Teylers Museum, Haarlem*

Nicholas Lanier, accomplished English musician and courtier. *Anton van Dyck, circa 1630-1632,* © *akg-images*

Thomas Killigrew and his brother-in-law William Crofts, shortly after the death of Thomas's wife Cecilia. *Anton van Dyck, 1638, The Royal Collection* © *2007 Her Majesty Queen Elizabeth II*

Possibly the Duarte family by Antwerp artist Gonzales Coques. *Gonzales Coques, circa 1644, courtesy Szépmüvészeti Müzeum, Budapest*

Hélène Fourment, Rubens's second wife, wearing a magnificent wedding jewel comparable with that acquired by Gaspar Duarte. *Pieter Paul Rubens, circa 1630–1631,* © *Alte Pinakothek, München*

Wedding portrait of Princess Mary Stuart and William II of Orange, showing the jewel given her by William. *Anton van Dyck, 1641,* © *Rijksmuseum, Amsterdam*

Princess Mary in masquing dress as an Amazon. *Adriaen Hanneman, circa 1664,* © *Royal Cabinet of Paintings, Mauritshuis, The Hague*

Portrait of Margaret Cavendish from the studio of Pieter Lely. *Studio of Pieter Lely,* © *Christie's Images, London*

Engraving of Rubens's house in Antwerp, rented by the Cavendishes in 1648. *By kind permission of Sir Christopher White*

Sir William Cavendish. *Studio of Anton van Dyck, by kind permission of The Collection at Althorp*

Engraving of Huygens's fine neoclassical house at The Hague. *Engraving by Pieter Post, 1637 (Author's collection)*

Drawing of Huygens's summer house at Voorburg, outside The Hague, by his son,

Constantijn junior. *Constantijn Huygens junior, by kind permission of the Huygensmuseum, Hofwijk*

Pen and wash drawing by Constantijn Huygens junior of the groves of trees at Hofwijk. *Constantijn Huygens junior, 1669, © Bildarchiv Preussischer Kulturbesitz*

The 4th Earl of Pembroke and his family, owners of Wilton, before the Civil Wars. *Anton van Dyck, © Collection of the Earl of Pembroke, Wilton House, Wiltshire/The Bridgeman Art Library*

Engraving from Mollet's *The Pleasure Garden* of one of his formal parterres. *André Mollet (Author's collection)*

Contemporary engraving of Huygens's paved road lined with trees, linking The Hague to the port of Scheveningen. *(Author's collection)*

Engraved prospect and plans of Huygens's Hofwijk from the published version of his long poem of the same name. *By kind permission of the Huygensmuseum, Hofwijk*

Engraving of Philips Doublet's ambitious gardens at Clingendael. *(Author's collection)*

Seventeenth-century engraving of the royal gardens at Honselaaarsdijk. *(Author's collection)*

Pyramid vase of blue Delft faïence designed to display exotic flowers. *Unknown artist, circa 1690-1720, © Rijksmuseum, Amsterdam*

Frontispiece to a published series of engravings of the gardens at Clingendael, which names as its owners both Philips Doublet and his wife Susanna, Sir Constantijn Huygens's daughter. *© Rijksmuseum, Amsterdam*

Wedding portrait of Susanna Huygens by Gaspar Netscher. *Gaspar Netscher, 1667–1669*

Watercolour by Stephanus Cousyns depicting rarities from Gaspar Fagel's garden. *(Author's collection)*

Rachel Ruysch still-life, showing the rich diversity of the flowers to be found in a grand Dutch garden. *Rachel Ruysch, © Private Collection, courtesy of Thomas Brod and Patrick Pilkington/The Bridgeman Art Library*

A seventeenth-century Dutch painting of the Brazilian landscape. *Frans Post, 1650, © The Metropolitan Museum of Art, New York*

Seventeenth-century still-life of exotic tulips. *Hans Bollongier, 1639, © Rijksmuseum, Amsterdam*

Constantijn Huygens junior's sketch of Lombeek, made during a military campaign with William of Orange. *Constantijn Huygens junior, 1675, © Rijksmuseum, Amsterdam*

The mechanism of Huygens's balance-spring watch, printed in the London Royal Society's *Philosophical Transactions*, thereby establishing Huygens's priority. *© The Royal Society*

The silver dressing-table vanity set belonging to Veronica van Aerssen van Sommelsdijck, Alexander Bruce's wealthy Dutch wife. *By kind permission of the Collection of The Gemeentemuseum, Den Haag*

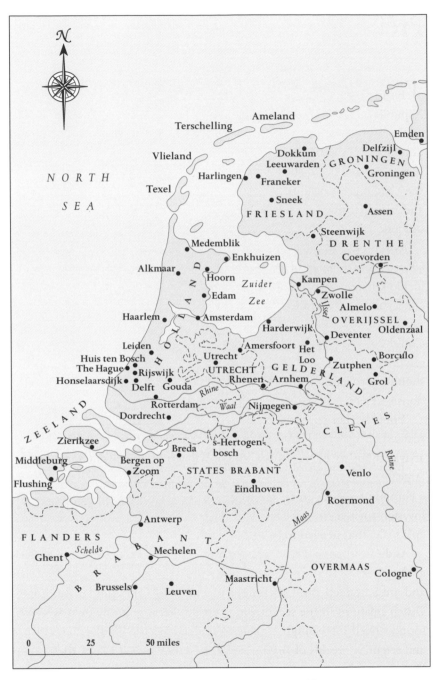

The United Provinces, or the Dutch Republic

Preface

This is a book about cultural exchange between England and the Dutch Republic – an extraordinary process of cross-fertilisation which took place in the seventeenth century, between the life and thought of two rapidly developing countries in northern Europe. The two territories, jostling for power on the world stage, politically and commercially, recognised that they had a great deal in common. Still, each of them represented itself – and has continued to do so ever since – as absolutely independent and unique.

As a historian I was prompted to write *Going Dutch* by recurrent questions I faced from readers of my previous work on the seventeenth century, including my biographies of Robert Hooke and Sir Christopher Wren, concerning the so-called 'Glorious Revolution' (neither glorious, nor a revolution) of 1688. Could I explain what that was, and how it happened? Could I also explain how two countries which regularly declared themselves sworn enemies (to the point of declarations of war) in the period should, apparently seamlessly, have merged administrations and institutions by 1700?

When I tried to provide succinct, straightforward answers I quickly realised that I could not give a halfway comprehensible account of the arrival at Torbay in November 1688 of William III, Prince of Orange, with a large fleet and a considerable army, without providing my questioners with a complicated back story. Indeed, in the end, the story leading up to the invasion turned out to be an involved, far-reaching narrative on an almost epic scale, that needed to be told. So here it is.

Aside from such direct requests for information, as someone with an abiding interest in the way cultural currents and patterns of thought form and are sustained through time, I was drawn to thinking about Anglo–Dutch relations in the seventeenth century because in my own research I found myself increasingly unable to understand the intellectual, cultural and scientific worlds of Britain and the Netherlands if I kept them apart. Documents – letters and manuscripts – relating to the rise of science in the period, for example, regularly involved correspondents or collaborators

across the water. Would British members of the Royal Society in London, including Robert Boyle, Wren and Hooke, have arrived at many of their important original scientific and technological discoveries if they had not been in continuous and mutually advantageous intellectual contact with their Dutch counterparts, among them Christiaan Huygens, Anton van Leeuwenhoek and Jan Swammerdam?

In art and music the cross-fertilisation was even more obvious as soon as one gave the matter any serious attention. Musicians moved between the courts at London and The Hague, exchanging repertoires and techniques. Almost without exception, the great painters of this period, whose works hang prominently at the National Gallery and Tate Britain in London, and include many familiar portraits of the English royal family and prominent members of the court and city circles, were of Netherlandish origin, including, most obviously, Anton van Dyck, Pieter Lely and Pieter Paul Rubens. Of course, there were other players in the cultural exchange game (France in particular), but it seemed to me that the interplay between Britain and the Low Countries deserved more attention than it had traditionally been given.

There also seemed to me to be a seductive similarity between the fortunes of the United Provinces (the seven provinces of the northern Netherlands) at the end of the Dutch Golden Age, and that state Britain finds itself in today. Visibly losing power on the world stage, and with her commercial supremacy increasingly challenged by other enterprising nations, the Dutch Republic nevertheless continued to hold its place culturally in Europe. Its style and taste, in everything from art, architecture and music to faïence, lace and tableware, permeated the European sensibility – and beyond it, the sensibilities of those settling new lands across the ocean (faïence and silverware made to the highest Dutch standards survive from the early Dutch colonies on the east coast of the United States). That Dutch sensibility continued to exert influence long after the Dutch nation had lost its last foothold on world power, and might be considered, I shall argue, still to define what we consider northern European in cultural terms today.

The most powerful stimulus for my undertaking this piece of work, though, was the way the investigations conducted as I carried out the research for it intersected again and again with a set of questions close to my own heart about family and about migration – about the ways in which

communities are permeated, and their cultures altered and shaped by the ideas, skills and attitudes of those they allow in as immigrants.

I am of fairly recent immigrant stock myself. My father's family arrived in London from Poland via Germany in 1920 – economic migrants in search of a new life. My mother's family had arrived a generation earlier, though her father only left eastern Europe on the eve of the First World War. None of my grandparents, so far as I know, ever returned to their country of origin, not even for a family vacation. My father was the only one of his siblings ever to revisit Warsaw, the city of his beloved mother's early life, and then, not until he was well into middle age. Uprooted and cut off from their cultural origins, just as they brought no material possessions, they carried with them only vestiges and memories of their eastern European heritage.

Historians have tended to treat the intellectual and cultural influence of migrants in the seventeenth century as though the movement of groups of Europeans displaced from their country of origin for political, religious or economic reasons in earlier periods was always thus one-directional. They might be settled residents of their adopted country, in which case they were assumed to make the culture of their new home their own, or they might be 'visitors', diplomats or those performing some short-term service as non-residents, in which case their 'foreign' contribution to the culture could be marked out as unassimilated to the growth and development of the field of their endeavour.

Because these early immigrant communities carried so little with them, historians – with good reason – tend to emphasise the identifiable differences between the arriving community and the one it joins. They lovingly uncover pockets of 'resistance', whose occupants live cheek by jowl with settled communities, providing exotic or unusual additions to their way of life.

The story I am about to tell will try to encourage the reader to look beyond such simple assumptions. The seventeenth century was a period of political upheaval and social turmoil in England and the Dutch Republic, resulting in repeated, voluntary and forced, movements of peoples from one to the other. Men and women moved with comparative lack of difficulty (travel by water was generally easier and safer than travel overland) between the northern Netherlands (which for our purposes will include

Antwerp) and the British Isles – the proximity of the one to the other is captured in the Dutch designation of the stretch of the North Sea between Holland and England as the 'Narrow Sea' or 'Narrow Seas'. If we barely register those migrations today, it is because we take for granted, as part of English or Dutch culture, the significant cultural interventions and developments each set of new arrivals contributed.

At the back of my mind while I was writing was a further consequence of the story of interwoven cultural strands. If the creative life of a nation is a whirligig or kaleidoscope of colliding influences brought in by newcomers in their capacious cultural knapsacks, might not the newcomer contribute to the cultural mix on an equal footing with the local, native practitioner? In which case, to whom does the outcome of that bipartisan engagement 'belong'?

So one of the questions I explore in this book is: Who is entitled to lay claim to the culture of a designated nation? Does each country, as was long argued, possess a distinctive, coherent, homogeneous set of tastes, attitudes and beliefs at any given moment in history, closely contained within its national boundaries, to which new arrivals (whether economic migrants, or refugees displaced by conflict elsewhere) are allowed to contribute only within specified limits, while tailoring or reconfiguring their 'native' talents to clearly recognised, local norms? Or is a national culture rather a medley of influences, a rich mix of blended and intersecting tastes and styles, based on a dialogue amongst the many participating individuals who find themselves mingled at any given point on the globe, at any particular time?

The longer I go on writing, the more debts I owe to others, and the greater these are. I am unbelievably fortunate to be surrounded by people who either share my enthusiasm for the pursuit of knowledge, or are prepared to go along with me on that journey (perhaps as the line of least resistance, faced with my insistent enthusiasm).

My immediate family are now so well adjusted to my obsession with pursuing every fresh thought to a conclusion as soon as it arises, that they have all become my collaborators, rushing off to source my latest query so that we can all sit down and finish dinner. Without my husband John Hare's constant, irrepressibly optimistic support, there are times in the past

three years which I could not possibly have got through. No acknowledgement will ever do justice to the difference he has made to my life. My three children and their partners have been there for me whenever I needed encouragement, and have sustained me whenever the going was tough. My granddaughters Freya and Zoë are among my most exacting critics.

My colleagues at the Centre for Editing Lives and Letters at Queen Mary, University of London – Jan Broadway, Robyn Adams, Annie Watkins and Alan Stewart – are also now family. We have been through a lot together over the five years the centre has existed so far, and have come out the other side as a resilient, plucky little band of pioneers, with a burning desire to effect significant change in academic intellectual life. My colleagues at Queen Mary continue to support me in every possible way. Nothing I ever ask is too much for them, which I put down especially to the leadership and imagination of the senior management team – Professors Adrian Smith, Philip Ogden, Morag Shiach, Trevor Dadson and Ursula Martin. I simply could not have achieved all I have done, nor continue to hope to accomplish still more, in any other academic institution, bar none.

There are great scholars of Dutch history whose work has shaped the field in which I have been working for the past four years, and in whose footsteps I tread. The magisterial *oeuvre* of Jonathan Israel, including his extraordinarily detailed work on the Sephardic Jewish community, is the bedrock for what I write here. Peter Geyl's groundbreaking work on Anglo–Dutch relations was also essential. Simon Schama's bold and imaginative work on the Netherlands – the work with which his now stellar career began, and which for many of us defines the way works of impeccable scholarship can be written so as to reach a wider audience – was my inspiration. Gary Schwartz's *Schwartzlist* kept me reminded of how vital and vibrant conversations about all things Anglo–Dutch continue to be (it was he who recommended me to read David Winner's *Brilliant Orange: The Neurotic Genius of Dutch Football*, to get me in the mood). 'If I have seen further,' as Newton wrote, 'it has been by standing on the shoulders of giants.'

I also owe thanks to two distinguished scholars of things Dutch, both domiciled in London, who were generous enough to share the research from forthcoming books with me while I was writing *Going Dutch*. Hal Cook let me study the manuscript of his masterful *Matters of Exchange: Commerce,*

Medicine and Science in the Dutch Golden Age. Anne Goldgar gave me a proof copy of her definitive work on seventeenth-century Dutch life and tulips, *Tulipmania: Money, Honor, and Knowledge in the Dutch Golden Age*. Both books are now published and available, and I recommend them to those who would like to read at a level of detail beyond that which I can offer here.

In the course of my research for *Going Dutch* I have made many new friends in the Netherlands. I have a deep and long-standing affection for the people of the Low Countries – my husband took me there when first we met more than twenty-five years ago, because he had spent happy times there in his childhood, and wanted me to share that pleasure. Jean-Pierre Vander Motten and Marika Keblusek were courteously helpful with bibliography and advice, embracing my project even before we had met. At a sequence of conferences, young Dutch scholars took endless trouble to answer my questions, both during the conference sessions and over late-night drinks afterwards.

This book tries resolutely to resist the idea of national character or national stereotypes of any sort. Nevertheless, the inhabitants of the Low Countries are some of the most generous and tolerant people I have ever met. I single out Nadine Akkerman for special thanks. She and I met at a difficult time in both our lives, and we have formed a friendship which will outlast any work I do specifically on Dutch topics. I hope my thanks to her may be allowed to stand for my indebtedness to so many other scholars who have given me the benefit of their far deeper knowledge of things Dutch and Flemish, and who, without exception, have been happy freely to share the findings of their own research with me. Each of them is, of course, acknowledged in my endnotes.

It also matters to me to acknowledge here that the shocking murder of Dutch film-maker and champion of free speech Theo van Gogh in 2004, gunned down as he cycled in Amsterdam, and the subsequent exile to America of his collaborator on the controversial film *Submission*, Ayaan Hirsi Ali, cast a shadow over the early stages of writing this book. *Going Dutch* shows that the roots of tolerance run historically deep in the Netherlands, as does the Dutch people's capacity to accommodate and be culturally enriched by successive waves of exiles and immigrants, and I am confident that in this generation once again they will, in the end, show the rest of Europe the way.

My agents, Gill Coleridge at Rogers, Coleridge and White in London, and Melanie Jackson of the Melanie Jackson Agency in New York, have been as supportive and encouraging as always. I hope I never seem to take them for granted. My editorial team at HarperCollins have been particularly understanding about my need, following serious illness, to tinker with the timetable for the production of *Going Dutch*. My thanks especially to Arabella Pike and Gail Lynch in London, and Terry Karten in New York. Robert Lacey was a rock as my copy-editor. The indefatigable Mel Haselden has been, as ever, my inspiration and guide in assembling the pictures. Rachel Smyth took up my request for a thoroughly modern design with élan. My Dutch publisher, Peter Claessens of Arbeiderspers, has been full of enthusiasm for the project ever since he first read the proposal. His confidence that *Going Dutch* has an important story to tell for the Dutch has been an enormous encouragement.

And beyond all of these there are my constant companions in learning – my graduate students, friends in the international academic community, artist friends and friends in the professions, too numerous to recognise by name, but all of them vital to the continuing Jardine project which is the urge to know and to change the world through knowledge. My thanks to each and every one of them. They know who they are.

Finally, while I was completing this book I spent a week in the ski resort of Val d'Isère, high in the French Alps, close to the border with Italy. While the rest of my family skied, I put the final touches to my manuscript, sitting in the cosy sitting room of the Hôtel Savoyarde. Inevitably, I found myself explaining the argument of *Going Dutch* to the charming young French waiter who presided there. I felt I owed him an explanation for all the mornings on which he had patiently cleaned and tidied around me.

'Surely you mean, "when the English invaded the Dutch"?' was his first response to my account of the huge military operation which had resulted in William III 'conquering' Britain and claiming the Crown on behalf of himself and his English wife. 'Holland is far too small and insignificant a country to have been capable of such a military manoeuvre. It surely never had the power.' And again: 'But I thought that the English mainland had not been invaded since the Normans in 1066.'

I found his absolute disbelief faced with my account of events leading up to the Dutch invasion of November 1688 both challenging and inspiring –

this must surely be a story worth telling, if it failed to agree in so many of its details with the version of northern European history my educated interlocutor had learned in a good French *lycée*.

Every day he would enquire how my work was doing, and ask another tentative question about how a country like Holland could have taken on, let alone profoundly and lastingly shaped, a country like Britain. It became something of a challenge for me to explain to him the various steps in my argument, and I am sure his responses helped sharpen my own understanding and frame its presentation on the page. So a small extra thank you is due here to that good-natured, patient and obliging waiter at the Hôtel Savoyarde.

Lisa Jardine
London, January 2008

Author's Note: Names, Money and Dates

You only have to try to buy a map of or a guidebook to the Netherlands to realise that the naming of territory in the Low Countries is fraught with difficulty. Strictly speaking, 'Holland' is only one of the seven provinces which have, since the end of the sixteenth century, made up the United Provinces or Dutch Republic. Most ordinary people, however, refer to that territory as 'Holland'. In this book, which is intended for a general rather than a narrowly academic readership, I have used 'Holland', 'Dutch Republic' and 'United Provinces' interchangeably, and I hope that my readers will accept an occasional looseness or even vagueness about the country thus designated. I consistently refer to the people of that territory as 'Dutch'. I have largely avoided calling the diverse and mingled community in Antwerp 'Flemish', because my protagonists there moved regularly between what today we know as Belgium and the northern Netherlands, which is the focus of my story. Academics will, I hope, forgive me for my occasional cartographic imprecision, in the interests of a clearly comprehensible story.

Dutch and English currency conversion in the period:
£9 sterling = one hundred Dutch guilders.
One pond Vlaams = six guilders;
one guilder (fl) = twenty stuivers;
one stuiver = twelve penningen

Two calendars were in use throughout the period this book covers. The Julian calendar was followed in England, and the revised Gregorian calendar was followed everywhere else in western Europe. The difference between them was ten days in the seventeenth century and eleven days in the eighteenth century (because England observed the year 1700 as a leap year, but the Continent of Europe did not). Thus 12 April in the Julian

calendar (in England) would be 22 April in the Gregorian (in the Dutch Republic) before 1700, and 23 April after 1700.

Throughout this book I have given dates in the form appropriate to the location, unless I state otherwise. Sometimes, where correspondence I follow crosses boundaries, the difference in dates becomes significant. In those cases I have specified in brackets following a date whether it is old style (Julian) or new (Gregorian).

During the same period the civil year in England began on 25 March. In ordinary usage, however, the new year started on 1 January, as now. Thus the English civil date 14 February 1675 is 14 February 1676 according to our modern system of dating (some people in the period wrote such a date as 14 February 1675/6 for clarity). I have given all dates as if the new year began on 1 January.

England Invaded by the Dutch: The Conquest that Never Was

The Fame of the Intended Invasion from Holland, was spread all over the Nation, & most Men were preparing for the Generall Insurrection which ensu'd, when I was obliged to go to London to settle my accounts, in October 1688, & had not continu'd there above 3 weeks, before the News came of the Dutch Fleet's being sail'd to the Westward, & seen off the Isle of Wight.[1]

The assault on the supposedly impregnable sovereign territory came out of the blue – the slickest feat of naval planning and execution ever to have been witnessed in Europe.

On 1 November 1688 (new style), Prince William of Orange, elected ruler or Stadholder of the Dutch Republic, and husband of the English King James II's eldest daughter, Mary Stuart, embarked upon a seaborne invasion of the British Isles. His invasion force consisted of an astounding five hundred ships, an army of more than twenty thousand highly trained professional troops, and a further twenty thousand mariners and support staff. As a naval and military undertaking, the sheer scale, temerity and bold ambition of the venture captured the European imagination for years afterwards. The exact numbers of the invading forces were a matter of dispute and deliberate exaggeration (and have remained so ever since), but there was no uncertainty at all about William of Orange's intentions – this was a redoubtable force, and it was headed for the English coast.

Rumours of dramatic action against the increasingly absolutist behaviour of James II had been circulating for months. As early as May, John Evelyn recorded anxiously in his diary:

The Hollanders did now al'arme his Majestie with their fleete, so well prepar'd & out before we were in any readinesse, or had any considerable

OVERLEAF: *William of Orange sets out to invade the British Isles.*

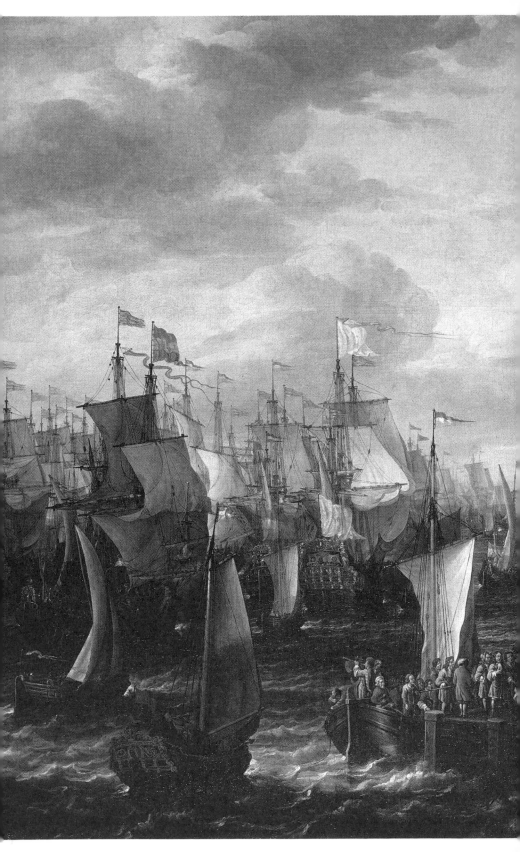

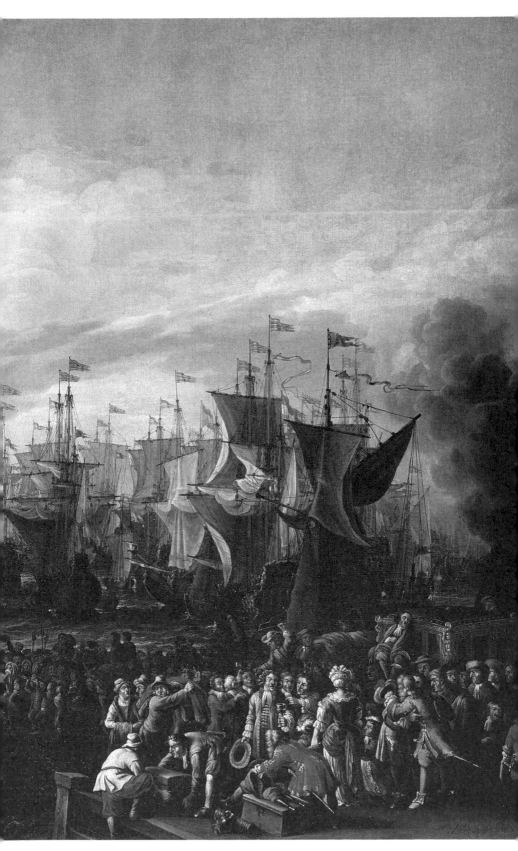

number to have encountered them had there been occasion, to the great reproch of the nation.[2]

Reliable intelligence on Dutch naval and troop movements was unusually hard to come by. Some snippets of information, though, had leaked out. There was talk that troops were on the move on the Dutch borders. There were anxious whispers that France was making preparations to come to the assistance of the Catholic English regime (what Evelyn refers to as 'the Popery of the King' was increasingly an issue). Right up to the moment when William's fleet left the shelter of the Dutch coastline and headed out across open water, northern Europe was awash with unsubstantiated rumour and hearsay, anecdote and false alarm. Once the assault was under way, there was talk of little else.

The joint naval and military operation was on an unprecedented scale. Its meticulous organisation astonished political observers. There had initially been some suggestion that the build-up of troops in the Low Countries was in preparation for a land engagement with the French. It was then rumoured that the Dutch might send these forces to help prevent an imminent French invasion of the Palatinate. But by the time the size of the operation became clear in the middle of October there could be no doubt as to its destination or its purpose. The Dutch, reported the stunned English ambassador at The Hague, intended 'an absolute conquest' of England.[3]

'Never was so great a design executed in so short a time. All things as soon as they were ordered were got to be so quickly ready that we were amazed at the dispatch,' wrote one of those involved in the secret planning,[4] while the English ambassador at The Hague warned that 'such a preparation was never heard of in these parts of the world'.[5] Not only the foreign diplomats at The Hague but all Europe was astounded by the unusual speed and efficiency with which the Dutch state – which historians generally like to describe as one of the less well-organised in seventeenth-century Europe – assembled so enormously complicated an expedition.[6]

William, it slowly emerged, had started to build up his army in the first half of 1688, without consulting the Dutch government – the States General. His closest and most trusted favourites, Hans Willem Bentinck and Everard van Weede van Dijkveld, had shuttled clandestinely around

Europe for months securing backing from those known to be sympathetic to the Protestant cause, and negotiating supporting troops and financial loans. Between June and October they surreptitiously assembled a massive force of well-trained, well-paid and experienced soldiers drawn from right across Protestant Europe. They also made arrangements for troops from neighbouring territories to move into place to fill the gap left on the European mainland, to defend the Dutch borders against possible French attack once William had switched his best troops to the English campaign.[7]

The uncertainty and swirling rumours seem to have paralysed the English administration. By mid-September the diarist John Evelyn, on a visit to James II's court in London, 'found [it] in the uttmost consternation upon report of the Pr: of Oranges landing, which put White-hall into so panic a feare, that I could hardly believe it possible to find such a change'.[8] He also reported 'the whole Nation disaffected, & in apprehensions'. The King himself was suffering from recurrent nosebleeds (a sign of raised blood pressure, perhaps). Strategically, over a period of months, the combination of extreme secrecy, rumour and false alarm sapped English morale.

The Dutch government was not consulted officially until well into September (and the French ambassador got wind of this through his 'intelligencers' – undercover agents – only days later). On 8 October William had let it be known in Holland that his invasion – if it took place – was to be both an intervention on behalf of the Dutch state, to prevent James II from forming an anti-Dutch Catholic alliance with France, and a bid to secure his own and his wife's dynastic interests. The States General were finally asked for, and gave, their approval, on the understanding that 'His said Highness has decided to start the said matter upon His Highnesse's and Her Royal Highnesse's own names, and to make use of the States' power only as auxiliary.'[9]

What the Dutch States General could and did provide was additional financing for the campaign (which they would later require to be repaid from the English exchequer of King William III). In spite of the Prince's personal wealth, there was still a significant shortfall in the ready money needed for so large a naval and military undertaking. The States General placed at William's disposal 4 million guilders, out of taxation income earmarked for defence of their land borders. A further 2 million guilders was raised in loans from sympathetic financiers (chief among them the

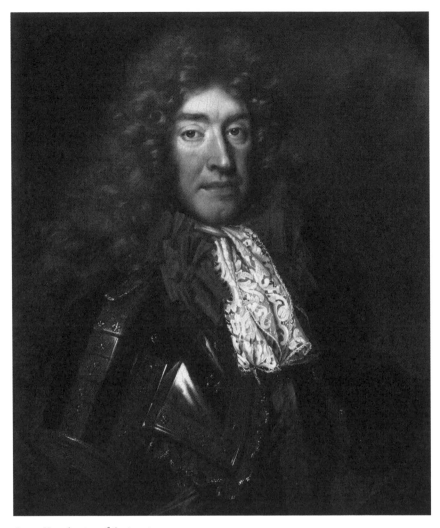

James II at the time of the invasion.

Sephardic Jewish banker Francisco Lopes Suasso).[10]

On 1 November, driven onward at speed by a strong easterly wind, a vast Dutch fleet left its sheltered harbour at Hellevoetsluis and sailed out into open waters. At a signal from William of Orange the great gathering of ships organised itself into a prearranged formation, 'stretching the whole fleet in a line, from Dover to Calais, twenty-five deep'. The Dutch began their mission, 'colours flying', the fleet 'in its greatest splendour', 'a vast

mass of sail stretching as far as the eye could see, the warships on either flank simultaneously thundering their guns in salute as they passed in full view of Dover Castle on one side and the French garrison at Calais on the other'. As the great flotilla proceeded magnificently on its way, the Dutch regiments stood in full parade formation on the deck, with 'trumpets and drums playing various tunes to rejoice [their] hearts ... for above three hours'.

In his diary for the day, Constantijn Huygens junior,* William of Orange's Dutch secretary, recorded how, the morning after they set sail: 'We arrived between Dover and Calais, and at midday, as we passed along the Channel, we could see distinctly the high white cliffs of England, but the coast of France could be seen only faintly.'[11] Constantijn junior, and the other children of the distinguished statesman, connoisseur, poet and musician Sir Constantijn Huygens, together with their father, will be important witnesses and guides as the present book unfolds.

Poised between England and Holland (like other members of his family he was an outstanding linguist, whose English and French were as fluent as his native Dutch), Constantijn junior was equally at home in the élite circles of either country. Like his father and his younger brother, the scientist Christiaan Huygens, he moved easily between countries, his international experience proving invaluable to his princely employer.

From the very start, the Dutch fleet achieved its key strategic aim, creating an unforgettable spectacle, inducing a feeling of shock and awe in onlookers on either shore. The iconic image of its offensive sortie into the English Channel was commemorated in countless contemporary paintings and engravings, still to be found today, on display or in store, in galleries on

* Since the key individuals in three generations of this extraordinary family are all named either Constantijn or Christiaan, the reader is advised to turn to the family tree on page 359 in cases of uncertainty. I shall do my best to use the qualifiers 'junior' and 'senior' for clarification. 'Sir Constantijn' always means Constantijn senior, knighted by King James I of England.

both sides of the Narrow Seas. As the seventeenth-century armada made its way along the Channel, crowds gathered on the clifftops of the south of England to watch it pass. It was reported that the procession of ships had taken six hours to clear the 'straits'.

The departure from Holland and arrival in England of this great fleet had been contrived with exceptional care, down to the very last detail. As the foremost historian of this period of Anglo–Dutch relations puts it, 'The boldest enterprise ever undertaken by the Republic of the United Netherlands was stage-managed with exquisite artistry.'[12] The expedition comprised fifty-three warships, of which thirty-two were 'capital ships' designed for combat – thirteen with between sixty and sixty-eight guns, seven with between fifty and fifty-six, and twelve with between forty and forty-eight – the rest escort ships. There were ten fireships and about four hundred other vessels to transport troops, supplies and horses. The army was made up of 10,692 regular infantry and 3,660 regular cavalry, plus gunners of the artillery train and five thousand gentleman volunteers – expatriate Englishmen, Huguenots and other sympathisers. On top of this there were 9,142 crew members and a further ten thousand men on board the transport vessels.[13] William's plan was that this spectacular floating combination of forces and resources should avoid naval engagement at all costs. Like the D-Day landings, this was a huge feat of transportation, rather than a navy seeking a sea battle.

The munitions, equipment and supplies with which the expeditionary force was provided were formidable, and state-of-the-art. According to one eyewitness (who, as usual, may have slightly exaggerated the numbers), the fleet carried a total of seven thousand horses – mounts for the 3,660 cavalry officers, the Prince, his entourage and the officer and gentleman volunteers, and draught horses for the carts carrying provisions and ammunition. Further draught animals were needed to pull the fifty artillery pieces.

Every possible eventuality had been anticipated. Special equipment for the venture had been manufactured covertly in Amsterdam, The Hague and Utrecht. Intelligencers reported in the months preceding the invasion that the Dutch government had ordered 'at Utrecht the making of severall thousand of pairs of pistols and carabins', while Amsterdam 'has undertaken to furnish 3,000 saddles', and 'they are also night and day employed at The Hague in making bombs, cuirasses and stinkpotts'. There were

'muskets, pikes of all sorts, bandoliers, swords, pistols, saddles, boots, bridles and other necessaries to mount horsemen; pickaxes, wheelbarrows and other instruments to raise ground', and 'boats covered with leather to pass over rivers and lakes'. The fleet carried a mobile smithy for shoeing horses and repairing weapons, ten thousand pairs of spare boots, a printing press, and a large quantity of printing paper. Additional vessels were hired at Amsterdam to transport hay, provisions, etc.[14] The wind, Constantijn Huygens recorded in his diary for the day after the fleet set sail, was steadily easterly, and the weather good.[15]

The one decision that had not been taken by William and his advisers in advance was whether the fleet would aim to make landfall in the north of England, in Yorkshire, or in the south-west (in either case avoiding the English army, which was massed in the south-east). Pragmatically, and to perplex English intelligence, it was decided to leave that choice to the prevailing winds. In the event, the wind, which had blown ferociously from the west for almost three weeks previously, battering the Dutch coast and thwarting William's attempt to launch his attack in mid-October, swung

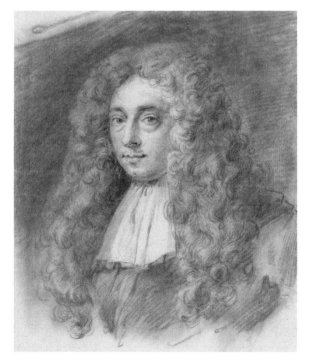

Constantijn Huygens junior, Secretary to William of Orange.

round suddenly (some said providentially) in the final days of October.

Responding to the favourable wind, the invasion fleet proceeded in the direction of the English coast, headed towards Harwich, as if to make landfall in Yorkshire. Having sailed just past Harwich, however, William of Orange, commander-in-chief in person of this mighty flotilla, gave new orders for it to proceed instead south-westwards, to take full advantage of the ever-strengthening easterly wind. The English war fleet, trapped in the Thames estuary by the same wind, watched William's armada go by twice, helpless to follow and engage until it was too late.[16]

The vast Dutch fleet sailed past the Hampshire coast at speed, barely managing to avoid being swept past Torbay, the last port capable of receiving it. It arrived there on 3 November, English style. Since the Northern Provinces, along with the rest of Continental Europe (but not England), used the 'new' Gregorian calendar, this corresponded to 13 November (new style) — the day before William of Orange's birthday. Many in his entourage urged him to take advantage of that propitious day to launch his invasion of England. To the Dutch the choice of date would have had enormous 'good luck' significance.

To the English, whose support had to be won by every propaganda means possible, the coincidence of dates would have been entirely lost. For as far as they were concerned, on what the Dutch considered to be William's birthday, the anniversary was still ten days away. Prince William and his fleet lay to off the English coast for two more days, and then landed. On 5 November 1688 (according to the English calendar) William began disembarking his troops on the coast of Devon.

Thus it was (once again, 'providentially') that the landing took place on the anniversary of another great triumph of English Protestantism over the hostile forces of Catholicism — the Gunpowder Plot of 1605. The convenient match with the familiar date meant that Catholic threats were opportunely on people's minds. Those who had witnessed the Spanish Armada approaching a hundred years earlier, in 1588, had continued to talk about its fearful appearance for the rest of their lives. Now, a century after that failed attempt at conquering Britain from the sea, a Dutch fleet somewhere around four times the size of the Armada successfully made landfall on English soil, bent on conquest. The frigate *Den Briel*, carrying William, flew the colours of the Prince and Princess of Orange. Its banner was embla-

zoned with the motto – announcing the Prince's justification for his offensive action – 'For Liberty and the Protestant Religion'. Beneath these words was the motto of the house of Orange, '*Je maintiendrai*' – 'I will persevere'.

Constantijn Huygens described their arrival in his diary:

> The village where we landed is called Braxton. It is very rundown, with few and poorly constructed houses, built of that inferior stone which this entire coast and the land adjacent to it are made of, and covered in slate. Nearby is a high mountain, and the houses huddle beneath it in short rows, as if stuck to it.

At Braxton he had his first experience of roughing it English-style:

> I ran into Willem Meester in front of an inn which was named the Crowned Rose Tavern. He wanted me to join him for a glass of cider, we entered and discovered the entrance hall crowded with a rabble of soldiers, drinking and raging. Coincidentally, I saw My lord Coote in this place, who had been given a room upstairs, and I entreated him to give me a place to put a mattress on the ground, which he gladly did, and we agreed to have dinner together in the evening. We had an exceptionally leathery fricassée of mutton that evening.[17]

Prince William confided to Huygens that he preferred any kind of lodging, however humble, to spending another night at sea.

Unloading troops and supplies began on the evening of 5 November. Local fishermen proposed a suitable landing point for the horses, where the beach fell away steeply so that they would not have too far to swim ashore, and they were unloaded without incident the following day. The landing was completed late on the seventh. Prince William, his Scottish-born chaplain Gilbert Burnet, his private secretary Constantijn Huygens junior, and his most intimate and influential favourite, Hans Willem Bentinck, 'sitting on very bad horses' (provided by the locals) watched the swift and efficient disembarkation with satisfaction from a high cliff at nearby Brixham.[18]

OVERLEAF: *Dutch impression of the departure, and arrival at Torbay, of William's awesome fleet.*

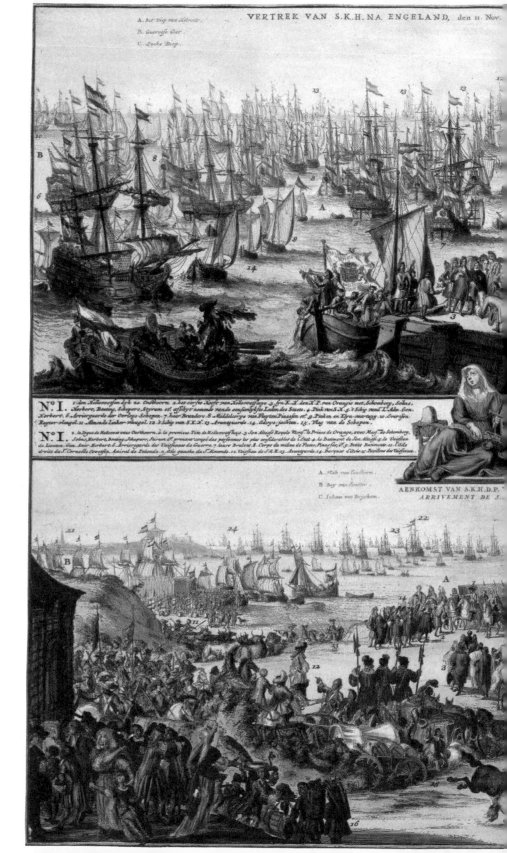

A. het Diep van Helvoet.
B. Goereesse Gat.
C. Loeks Diep.

N° I. 1. den Hellevoetsen dyk na Oosthoorn. 2. het eerste Hooft van Hellevoetsluys. 3. syn K.H. den H.P. van Orangie met Schomberg, Solms,
Herbert, Bentinq, Schepers, Styrum et. al. schynt nemende eensgehlyke Leden des Staets. 4. Pink van S.K. 5. 't Schy van L. Adm. Gen.
Herbert. 6. Arrieregarde der Oorlogs-Schepen. 7. haar Branders 8. Middelcorps van Floten Pinasse et. 9. Pinken en Klyn vaartuyg. 10. 't Oorlof en
Regter-vleugel. 11. Almende Linker-vleugel. 12. 't Schip van S.K.H. 13. Avantguarde. 14. Gloeys-jachten. 15. Vlag van de Schepen.

N° I. 1. la Digue de Hellevoet vers Oosthoorn. 2. la premiere Tête de Hellevoetsluys. 3. Son Altesse Royale Mons. le Prince de Orange, avec Mess. de Schomberg,
Solms, Herbert, Bentinq, Schepers, Sirum &. presant corps des personnes les plus consilerables de l'Etat. 4. le Batiment de Son Altesse. 5. le Vaisseau
de Lieuten. Gen. Amir Herbert. 6. Arrieregarde des Voisseaux de Guerre. 7. leurs Brulots. 8. Corps du milieu de Flotes Pinasse, &. 9. Petits Batiments. 10. l'Aile
droitte du S. Cornelle. Corvesse. Amiral de Zelande. 11. Aile gauche du S. Almonde. 12. Voisseau de S.A.R. 13. Avantguarde. 14. Barquer d'Oris 15. Pavillon des Vaisseaux.

A. Mile van Oosthoorn.
B. Bay van Oosster.
C. Juban ver Boyschem.

AENKOMST VAN S.K.H.D.P.
ARRIVEMENT DE S.

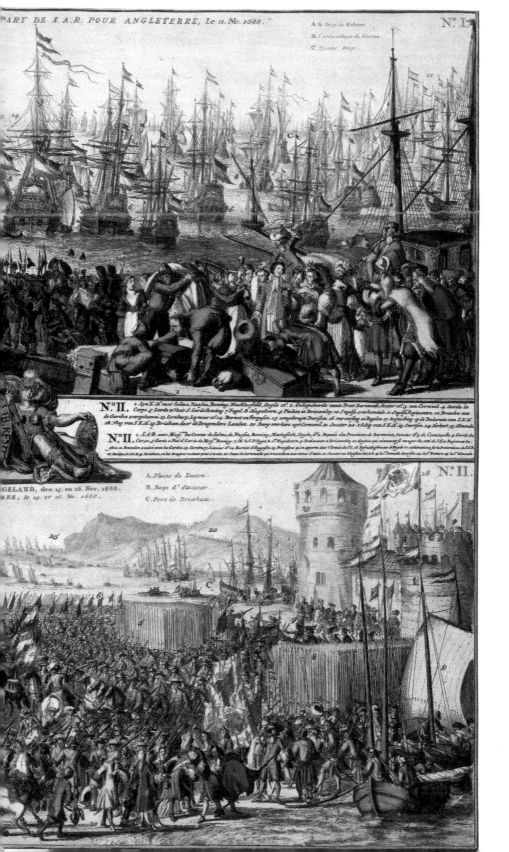

A. le Diep de Helvoet.
B. l'embouchure de Goeree.
C. Goeree Diep.

N.º II. 1. Syn E. H. met Solms, Nassau, Benting, Macklesfield, Argile et. 2. Gedeputeerde vande Prov. Dartmouth, Exeter et. 3. van Cornwall. 4. Garde de Corps. 5. Garde te Voet. 6. Garde Benting. 7. Fagel. 8. Hagelsbore. 9. Pinken in Briceanley. 10. Engelse overkomende 11. Engelse Regimenten. 12. Brandke van de Garden overgekomen 13. Coxbury. Seigneur et. 14. Burnet en Ferguson. 15. aangebragte Provisien. 16. vervoering de Bagagien. 17. beruchting op de Deskroote in S.A.R. 18. Nog van S.K.H. 19. Brixhom daer de Dragonders Landen. 20. Berg-werkers zyn Cornwall. 21. Exeter. 22. t.Schip van S.K.H. 23. Exercitie. 24. Norbert. 25. Almende.

N.º II. 1. S.A.R. avec Mess.rs le Comte de Solms, de Nassau, Benting, Maclesfield, Argile, &c. Depuis des Provinces de Dartmouth, Exeter & de Cornoüaille. 4. Garde du Corps. 5. Garde à Pied. 6. Garde de Mess.r Benting. 7. M. de Fagel. 8. l'Hagelsbore. 9. Bateaux à Briceanley. 10. Anglois qui viennent se ranger du côté de S.A.R. Regiments de &c. Bruden arrivée avec les Gardes. 13. Coxbury. Seigneur &c. 14. Burnet & Ferguson. 15. Provisions qu'on apporte dans l'Armée du &c. 16. Rafraîchissement & Repast & continuation &c. Burlin de S.A.R. 19. Brixhom, où les Dragons mettent pied à terre. 20. Ceux de Cornoüaille qui travaillent aux mines d'étain. 21. Exeter. 22. Navire de S.A.R. 23. l'Exercise. 24. le Norbert. 25. Almende.

A. Plaine de Taxton.
B. Baye d'Exceter.
C. Port de Brixham.

N.º II.

Burnet and the Prince agreed (though not entirely seriously) that the easy arrival was probably proof of predestination, and certainly the work of Providence.

Huygens's first impression of the reception the Dutch were to receive was favourable, in spite of the obvious local poverty (he was clearly relieved):

> Wednesday 17 December: The land between consisted of grand and high mountains and deep valleys, everything separated by many hedges and walls, the roads curiously poor, all of stone and strewed with loose bricks, on top of which layers of sludgy filth.
>
> Alongside the roads the people had gathered, as on the previous day, women, men, and children alike, all shouting: 'God bless you' and waving to us a hundred good wishes. They gave the Prince and his entourage apples, and an old lady was waiting with a bottle of mead and wanted to pour his Highness a glass. In a little square, five women were standing, greeting him, each of whom had a pipe of tobacco in her mouth, like the large crowds we have seen, all smoking without any shame, even the very young, thirteen and fourteen year olds.

This promising start was, however, not to be sustained. Torrential rain hampered the subsequent march to nearby Paignton, and it was freezing cold. En route from Paignton to Exeter, carts and cannon frequently stuck in the mud. William waited for twelve days at Exeter for the weather to improve, and in the hope that the English gentry would begin to flock to support him.

Meanwhile, some two hundred miles away in the capital, news and rumours of the landing were trickling through in dribs and drabs to anxious Londoners: 'confusd news of Dutch Landing near Portsmouth: Forces marchd that way early this morning ... Dutch seen off the Isle of Wight ... Dutch sayd to be landed at Poole ... news of yesterdays and this days riots of Rabble'. Unconfirmed stories of military engagements, casualties, naval assaults and civil disturbance proliferated.

The diarist John Evelyn and the wealthy financier Sir Stephen Fox were

somewhat better informed about William of Orange's movements. Evelyn wrote in his diary on 1 November:

> Dined with Lord Preston, with other company, at Sir Stephen Fox's. Continual alarms of the Prince of Orange, but no certainty. Reports of his great losses of horse in the storm, but without any assurance.

On 2 November (old style) these 'alarms' were made concrete. Some of William's horses had indeed been lost in a first, abortive attempt to launch the fleet in late October, but now the armada was well under way. Eyewitnesses had watched it leave Brill on its way to Hellevoetsluis, seen off publicly by William's wife, James II's eldest daughter, the Princess of Orange. News of the landing at Torbay reached London three days later, and immediately provoked fears of a breakdown in civil order:

> 5th [November]. I went to London; heard the news of the Prince having landed at Torbay, coming with a fleet of near 700 sail, passing through the Channel with so favourable a wind, that our navy could not intercept, or molest them. This put the King and Court into great consternation ... These are the beginnings of sorrow, unless God in His mercy prevent it by some happy reconciliation of all dissensions among us.[19]

By the beginning of December the Prince of Orange was believed to have reached Oxford and to be on his way to London against little opposition, but there were contrary rumours of a French force coming to James's assistance from Dunkirk (this news was contradicted later that day), and of Scottish troops marching south: 'Great confusion of reports, noe certainty. Disturbance at Cambridge, St Edmondsbury and other places.' On 15 December, the Curator of Experiments at the Royal Society in London, Robert Hooke (one of those chronicling events as they unfolded in his private diary), reported 'confusion all' and succumbed to a depression.

Lingering, in Devon, Prince William and his right-hand man Hans Willem Bentinck were privately disappointed at the absence of support from the English gentry and nobility at disembarkation. The Prince's English advisers were quick to reassure him that this was simply a matter

of everyone hanging back, in order not to be seen to be the first to abandon James II. In the absence of troops gathering to William's side, and cheering hordes of English men and women welcoming the Prince who would deliver them from servitude and tyranny, it was decided to choreograph William's arrival with heavy symbolic components, in a bid to proclaim the impeccable moral foundation for the invasion and his good intentions, to be broadcast as widely and as quickly as possible. A hastily written eyewitness account was rushed into print and distributed throughout the area.

The customarily sober and understated William entered Exeter in triumphal procession: 'Armed cap a pee. A plume of white feathers on his head. All in bright armour, and forty two footmen running by him.' Fifty gentlemen and as many pages attended him and supported his banner, which bore the inscription 'God and the Protestant religion'.[20] William rode on a 'milk white palfrey' and was preceded by two hundred gentlemen in armour, English and Scottish for the most part, mounted on heavy Flemish horses. For further dramatic effect, these knights were accompanied by 'two hundred blacks brought from the [sugar] plantations of the Netherlands in America [Surinam]', all dressed in white, turbaned and befeathered. No clearer symbolism could have been used to represent William as God's appointed champion, as described in the Book of Revelation: 'I saw and behold, a white horse: and he that sat on him had a bow, and a crown was given unto him, and he went forth conquering and to conquer.' The white-clad 'blacks' reinforced the millennial theme – William was a global ruler, whose dominion extended to the limits of the known world.

From Exeter, Bentinck wrote to the commander of the Prince's fleet, Admiral Herbert, still expressing concern at their lukewarm reception by the local gentry. The arrival of the Prince's army would, he said, have looked less like an act of military aggression – less like an invasion, indeed – if the local landowners had only ridden out to welcome them:

> I doubt not that the Good God will bless the cause, the people appear everywhere here extremely well disposed, it is only the gentlemen and the clergy who are somewhat more cautious, and do not espouse our cause. I am surprised at the latter, it seems to me that fear of the gibbet has more effect on their minds than zeal for religion.[21]

In fact, the gentry were busy hedging their bets, trying to ascertain whether William's bold adventure would succeed. They were preoccupied, too, with covering their backs – politically and financially. As early as 11 November, Sir Stephen Fox, anticipating his imminent dismissal from his office at the Exchequer, hastily approached the Royal Surveyor, Sir Christopher Wren, for written confirmation that building works he had carried out on his Whitehall lodgings (which belonged to the Crown) ten years earlier had cost him £1,000. Wren obliged with the certification of expenditure, and on 17 November issued a royal warrant guaranteeing Fox the right to remain in his Whitehall property until the money had been refunded to him.[22]

Fox's attempts to put his finances in order were part of a growing recognition at Whitehall Palace that the royal administration there was in the process of collapse. Support began to ebb away from the King's party, and officials started discreetly to leave their posts. King James's own first attempt at flight on 11 December contributed strongly to the confusion, since while attempting to remove himself and his family to safety abroad, he took steps to disrupt affairs of state, allowing him time (he hoped) to get French backing and to return. Before he left, he called for the most recent batch of Parliamentary writs and burned them. As he was being rowed across the Thames from Whitehall Palace to Vauxhall en route for the Kentish coast, he dropped the Great Seal, which he had retrieved from Lord Chancellor Jeffreys two days earlier, into the river. 'He believed – correctly as it turned out – that there could be no lawful parliament held without his writs of summons under the Great Seal. His going thus created a hiatus in government, or interregnum, which was to be exploited by his enemies.'[23]

James was right in thinking that his decision to flee would cause a constitutional crisis. Until he did so, William's mission appeared to be one of 'restauration' – to restore English government to stability by any means necessary. With the throne apparently vacant, and government suspended, the Prince of Orange could for the first time openly express a willingness to fill the political vacuum by taking political control for himself and his wife, 'to prevent the effusion of blood'. 'Affaires being now altered by the King's retirement', William wrote to the Earl of Danby, James's supporters like the Earl should disband their forces, return to their homes and 'stand for to be

chosen parliament men in their counties.'[24] His satisfaction turned out to be premature, however. In London, peers largely loyal to James had already set up a provisional government or Convention, which sat for the first time on 12 December, and continued to govern the country uninterruptedly, and without William's interference, until James II fled for good just before Christmas.

On 12 December, as the Dutch army made its way towards London, reports began to reach them that James II had fled to France. Gilbert Burnet, Prince William's Scottish chaplain, told Huygens 'at table', that a 'Convocation' or 'free Parliament' had been set up at Westminster to govern the country. On 14 December they reached Henley. As they marched from Henley towards Windsor, the weather was fine, and Huygens – an accomplished amateur artist, some of whose exquisite watercolour landscapes survive – marvelled at the beauty of the countryside:

> Because the weather was so beautiful, we marched from Henley to Windsor. My Master was riding along with me, and we went off course, too much to the left, and headed toward the river, to the extent that we made a detour of an entire mile, yet alongside that same river we saw the world's most beautiful views. That of Henley, when one reaches a certain height, is magnificently beautiful.
>
> We rode through a large hamlet, named Maidenhead, where my Master stayed behind because his horse had some pebbles in his horse shoes and consequently had gone lame. I continued on my own, and closer to Windsor came on an empty road. For a long stretch, I had to wade through water, which came up to the horse's belly. I could find no one to ask directions because all the people had gone to the street where his Highness was scheduled to make his procession.

Windsor Castle, when they arrived, provided Huygens with an opportunity to indulge one of his favourite pastimes – appraising the fine art in princely collections:

> At Windsor I saw once in haste the King's apartment, which had many good Italian paintings in it, among them those by Titian of the Marquis del Guasto and his wife, one of a woman leaning on her elbow, lying and

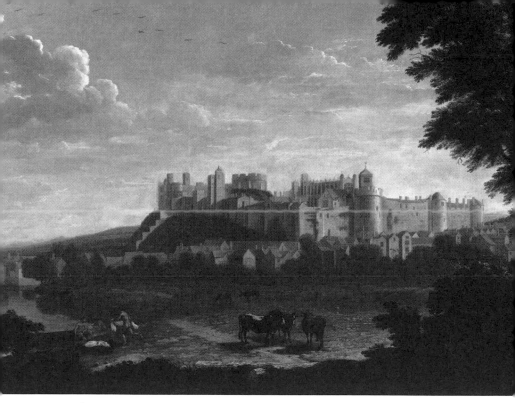

Prospect of Windsor Castle, by the Dutch artist Hendrick Danckerts.

reading, a naked youth of the manner of Michel Angelo da Caravaggio, and many others. There were also some very beautiful tapestries.

On 18 December the Prince of Orange and his army entered London in another carefully organised 'triumph', to be welcomed, this time, by cheering crowds of Londoners. In spite of miserable weather, people in coaches and on horseback, as well as on foot, lined the streets. Huygens reports with evident relief that many of them wore orange ribbons, while others had stuck oranges on sticks and waved them in the air.[25] One of those who has left us his own on-the-spot account of these events records:

> The universall joy and acclamation at his entrance was like that at the Restauration [of 1660] in all things, except in debaucheries, of which there was as little appearance as has been known upon such occasion and such a publick concourse. An orange woman without Ludgate gave diverse baskets full of oranges to the Prince's officers and soldiers as they marched by, to testifie her affection towards them. Divers ordinary

women in Fleet Street shooke his soldiers by the hand, as they came by, and cryed, welcome, welcome. God blesse you, you come to redeeme our religion, lawes, liberties, and lives. God reward you. etc.[26]

William's London entrance was designed to ensure that his arrival would be remembered as a liberation rather than a conquest. Crowds could be fickle – the same people had also lined the streets for King James, who had returned to the capital, after a first attempt at joining his wife and baby son in France had been thwarted, two days earlier. The Prince had therefore taken precautions to ensure that there was no unseemly opposition to his arrival. He had sent a senior troop commander on ahead of the main army, with units of the trusted Dutch Blue Guards, to take up positions protecting Whitehall, St James's Park and St James's Palace, in advance of his coming into residence. One of his key instructions was to replace the guard protecting James II with a contingent of élite Dutch troops, and to move him out of London, ostensibly for his own safety.

Three battalions of Dutch infantry and supporting cavalry entered London at about ten o'clock on the night on 17 December. 'Having secured the posts at St James Palace, they marched on Whitehall in battle formation, their matches lit for action.' As King James was going to bed around eleven o'clock, he was informed of their presence in St James's Park. Thinking there was some mistake ('he could not believe it, because he had heard nothing of it from the Prince'), he sent for the Dutch commander, Lord Solms.

Then Count Solmes pressed the adding of some new [Dutch] Troopes of the Prince's, just then come to town, to the Guards at Whitehall. The King was unwilling of that. But Count Solmes said it was very necessary.

Having vainly 'argued the matter with him for some time', James ordered Lord Craven (long-time devoted servant of James's aunt, Elizabeth of Bohemia, and now in his eighties), commander of the Coldstream Guards protecting the King at Whitehall, to withdraw his men. Craven protested that he would 'be rather cut in pieces, than resign his post to the Prince's [Dutch] guards'. James, however, insisted, 'to prevent the possibility of a disturbance from guards belonging to several masters'. The King retired

to bed, a prisoner in his own palace, only to be woken during the night and escorted out of London to Rochester.

The Coldstream Guards marched reluctantly out of London to St Albans.[28] Solms ordered all English army regiments in and around London to move out to towns and billets scattered throughout Sussex and the home counties, thereby ensuring that the troops were thoroughly dispersed. The Life Guards were packed off to St Albans and Chelmsford. 'The English souldiers sent out of towne to distant quarters,' John Evelyn recorded – they were 'not well pleased'.[29]

So the Prince and his highly disciplined Dutch army marched into London down Knightsbridge, confident that they would meet no resistance, along a two-mile route lined with Dutch Blue Guards.[30] In the absence of any actual military drama to mark this final act in the well-orchestrated invasion, it was an entrance as carefully staged, in a long military tradition of 'glorious entries' into conquered cities, as that first entry into Exeter a few weeks earlier. William again wore white, with a white cloak thrown over his shoulder to protect him from the heavy rain. There was some consternation when the Prince, who disliked crowds, did not actually remain at the head of the cavalcade the full length of the official route to Whitehall, but instead cut across St James's Park and gained access to his new residence at St James's Palace from its ornamental garden.[31]

Some historians have argued that William's route across the park and through the palace gardens was a genuine mistake on his part (leaving his future subjects, thronged several deep along Whitehall to welcome him, disappointed).[32] There is, however, a more plausible explanation. William, in a tradition of Dutch Stadholders going back several generations, was an enthusiastic amateur gardener, taking a keen interest in the latest garden designs and their execution at all of his numerous Dutch royal palaces.[33]

Almost twenty years before the invasion, at the time when William was engaged in consolidating power in the United Provinces for the house of Orange, a former royal gardener to Charles II, André Mollet, had published a book on the design and execution of ambitious formal gardens, *The Garden of Pleasure*. Lavishly illustrated, with plates depicting the formal layout of

shrubberies, kitchen gardens, flowerbeds and parterres, the book was a celebration of the garden designs of various European royal estates for which Mollet had been responsible, including Charles II's London gardens at St James's Palace. Since William of Orange's own ambitious garden for his palace at Honselaarsdijk, outside The Hague, was included, we may be sure it was a 'coffee-table' book with which the Dutch Prince was familiar.[34]

Mollet's description of the garden he had created for the Stuart royal family at St James's particularly emphasised the originality and ambition of its design. Because the site was low-lying, with no elevated viewing point from which 'Embroidered groundworks and Knots of grass' could be admired, the garden designer had instead 'contrived it into several Parallelograms, according to its length'. These lozenges were 'planted with dwarf-fruit-Trees, Rose-trees, and several sorts of Flowers'. The outer perimeter of the garden Mollet had marked 'with Cyprus-Trees and other green Plants, to make Pallissade's of about five foot high, with two per-forated Gates to every Square'. The formal avenues were planted with 'dwarf-fruit-Trees and Vines; the great Walk on the Right-hand is raised Terras-like, and Turff't', and at their intersections Mollet had designed an imposing fountain, and a 'Round of grass whereon to set up a Dial or Statue, as also in several places Cut-Angles, as may be seen upon the Design'. To offset all this formality, there was also a carefully designed wilderness:

> And in regard it falls out, that at one end there happens to be wild Wood, we have contrived another of green trees over against it, of which the great Tree which was found standing there in the middle makes the Head, both of the green Wood and the rest of the Garden; which tree we thought to leave as a remembrance of the Royal Oak [within whose branches Charles II reputedly took refuge from Cromwell's soldiers during the Civil War].[35]

The elegant complexity of the St James's Palace gardens is still to be seen in engravings of the period, and on the many surviving London maps.

When, on his triumphal progress into London, Prince William came to the edge of St James's Park, the sight of a garden project about which he had read, and which was closely related in plan and execution to his own much-

loved pleasure gardens in the Northern Provinces, surely proved irresistible to him. He had already made more than one detour in the course of his military advance on London from Exeter, to indulge in a bit of tourism in the form of excursions to celebrated English stately homes and their formal gardens.[36] Now he simply detached himself from the splendid cavalcade, and commenced his experience as King-to-be and owner of a string of magnificent royal palaces and grounds (including St James's), with a short tour to admire the park, shrubbery and elegant gardens.[37]

Strategically the advance deployment of Dutch troops, and the withdrawal of their English counterparts, ensured that London was secured for William before his arrival, and that King James was at his mercy even before the Prince himself reached London. The King had indeed been 'escorted' out of St James's by Dutch guards on 18 December, 'under pretence of keeping off the rabble', and taken to Rochester, only hours before William took up occupancy. Just over a month had elapsed since the invading forces had landed on English soil. Less than a week later, King James absconded from his Rochester house-arrest, and left England for France. The Dutch Blue Coats guarding him had been carefully instructed to let him get away.

The Blue Coats continued to guard Whitehall, St James's Palace and Somerset House for many months, 'to the general disgust of the whole English army'. The entire London area remained under Dutch military occupation until the spring of 1690. No English regiments were allowed within twenty miles of the city. The English and Scots regiments of the States General's forces, which had led the triumphal entry (in order not to alarm the citizens of London too much) were stationed at the Tower and Lambeth. Dutch and German regiments encamped at Woolwich, Kensington, Chelsea and Paddington, while another crack regiment was positioned at Richmond, and the Huguenots put up in various parts of London. As far as possible, the Prince avoided billeting his troops on private households, and insisted that they behave courteously, and pay for any goods acquired. Nevertheless, in spite of his efforts to avoid the appearance of foreign occupation, the continuing presence of large numbers of heavily armed troops in the city caused growing consternation and unrest.[38]

OVERLEAF: *Views of and across St James's Park by Hendrick Danckerts.*

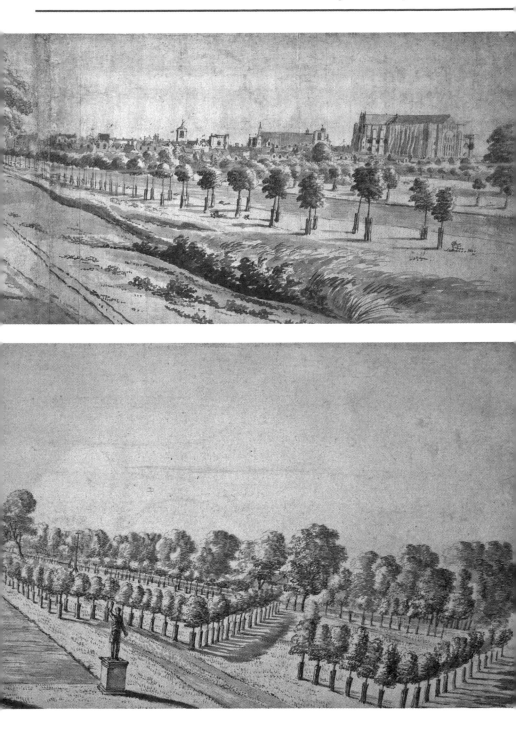

The Dutch invasion of 1688 was a brilliantly stage-managed sequence of events, forever vivid in the memory of those who witnessed them. A number of contemporary diarists record the intensity of their feelings as events unfolded – whether they were for the overthrow of the Catholic James or against. John Evelyn (one of those apparently unsure of his own response to the imminent regime change) had recorded in his diary the sense of dread with which the news was received in late October that William's immense fleet was poised ready to sail. There were 'tumults' in London as 'the rabble' attacked and demolished Catholic places of worship. Evelyn reported a 'universal discontent', which had 'brought people to so desperate a passe as with uttmost expressions even passionately seeme to long for & desire the landing of that Prince, whom they looked on as their deliverer from popish Tyrannie'. For those like Evelyn who had lived through the turmoil of the Civil War years, the upheaval caused by William's intervention in England's national affairs seemed all too likely to herald another period of instability. Figuratively wringing his hands, he recalled in his diary his fearful state of mind as he witnessed the arrival of William's invading army, when 'To such a strange temper & unheard of in any former age, was this poore nation reduc'd, & of which I was an Eye witnesse.'[39]

The complexity of the political response to James's 'abdication' and William's 'peaceful' arrival has been much discussed by historians, particularly since the three hundredth anniversary of the 'Glorious Revolution' was celebrated in 1988. In the end, the decision of the English people to accept William and Mary as joint monarchs had a good deal to do with a general reluctance to return to the bad old days of public disorder and civil unrest. Regime change was preferable to another civil war.

From Invasion to Glorious Revolution: Editing Out the Dutch

So why is there almost no trace of this vast, hostile armada, with its dramatic progress along the English Channel, its fanfares and gun-salutes and parading battalions, in conventional historical accounts of the so-called 'Glorious Revolution'? Why are many of us unaware of the fact that at the time of the English Parliament's 'welcoming' William and his wife Mary Stuart, and subsequently, in early 1689, inviting them jointly to ascend the English throne, the country was in the grip of full-scale military occupation, with Dutch troops posted in front of key buildings throughout London, and growing unrest and resentment throughout the land? Since contemporary accounts clearly report outbreaks of violence up and down the country in support of James II, and Dutch troops being summarily dispatched to restore order, how have we come to believe that William of Orange ascended the English throne in an entirely peaceful, not to say 'glorious', revolution?

Some of the colourful local stories we have heard so far – the providential wind aiding William, James's dropping of the Great Seal in the Thames as he fled – have a familiar ring. But as historian Jonathan Israel has observed: 'Since the early eighteenth century, a thick wall of silence has descended over the Dutch occupation of London 1688–90. The whole business came to seem so improbable to later generations that by common consent, scholarly and popular, it was simply erased from the record.'[1]

One obvious reason for this historical amnesia is the enduring impact and lasting success of the propaganda offensive launched by William of Orange even before he left Dutch shores. Surviving documents tend to exert a strong influence over retrospective historical interpretation – they are the stuff of which narrative history and interpretation are made. It is all too easy for the reader to be drawn into agendas and interpretations intentionally made part of the original telling. In the case of the so-called

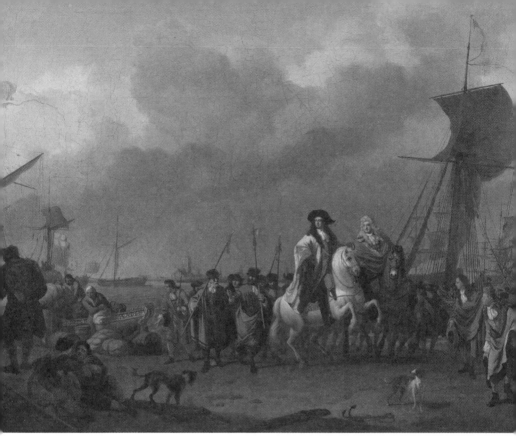

Idealised picture of William astride his white charger arriving at Torbay.

Glorious Revolution that shaping influence is especially misleading. For the story of William's Protestant invasion had been honed and edited with enormous care, fashioned in the telling with great pains, and conscientiously committed to print, before ever the fleet left its Dutch harbour.

While the invasion was still in the early planning stages, English aristocrats sympathetic to William's cause, and corresponding regularly with his closest Dutch advisers, Willem Bentinck, Everard Weede, Heer van Dijkvelt and Frederick van Nassau, Count Zuylestein, argued that a widely distributed manifesto was vital for the success of any bid for the English throne: if he wanted to keep England 'in humour', William must 'entertain it by papers'. They also provided advice and information on the content and distribution of pamphlets, and established connections with local printers and publishers. Jacobite pamphleteers attributed the ready acceptance of regime change to the Prince of Orange's 'debauching' of the English people with his well-judged propaganda publications. The carefully reasoned case

made in the Prince of Orange's *Declaration* 'of the reasons inducing him to appear in armes in the Kingdome of England' – composed in the greatest secrecy, and then blanket-distributed to all those likely to be affected by the invasion – has shaped the telling of the story of the Glorious Revolution ever since.

As a piece of writing, William of Orange's *Declaration* was a masterly effort in collaborative drafting on the part of the Prince, his English and Dutch advisers at The Hague, and selected members of the English expatriate community there. It originated in a series of discussions discreetly held in England in 1687, between Dijkvelt, who had been sent by William to sound out opinion concerning James II's policies for the English succession, and a group of English aristocrats.[2] The final text was produced months ahead of the campaign, during the early autumn of 1688, by Gaspar Fagel – a leading political figure in the States of Holland, and William's chief spokesman in the Dutch government.[3] It was further edited and translated into English by Gilbert Burnet, an expatriate Scottish cleric who had become close confidant and adviser to William and Mary, and who was to play a leading part in orchestrating the acceptance of the new English royal couple.

Specially commissioned printers worked simultaneously at The Hague, Amsterdam and Rotterdam to print the manifesto at speed, in an unprecedented run of sixty thousand copies.[4] To ensure that the invasion and its aftermath went according to plan, enormous care was taken to conceal the contents of the pamphlet even from those sympathetic to William's cause until immediately before the invasion, with Bentinck keeping all copies under lock and key in his personal lodgings. He subsequently arranged, through his agents, for stocks of copies to be carried to (and concealed in) key locations across England and Scotland, and then authorised their release simultaneously at all these places as the fleet left the Low Countries.

Enormous care was taken to avoid leaking the contents of the manifesto prior to the Prince's landing. As soon as he heard of its existence, James II's ambassador at The Hague tried to obtain a copy, entirely without success. On 28 September (new style), James's Secretary of State pressed him: 'It would be of the greatest importance imaginable to his Majestie to see the Declaration they intend to sett out, as soon as possible, and this I am well assured, that you have us'd your best endeavours to gett it, yet the

better to enable you, you are to spare no money, nor stick at any summe, that may procure it.' It was to no avail. 'You may imagine I have taken all possible care to come by the Declaration which I hear is on the press,' the Ambassador responded, 'but the States printer is not to be corrupted; I have employ'd some to see if any of his servants can be; they are all sworn, and their places so lucrative they will not endanger them.' Three days later he reported that 'the manifesto or Declaration can not yet be had at any rate for I have offer'd considerably for it, and you will, I believe, see it there [in England] sooner than we here.'⁵ In fact, William signed and sealed the final, agreed text of the *Declaration* on 10 October. On 15 October, the English consul at Amsterdam reported that 'order is come hither from The Hague for the printing of 20,000 copies of the Prince's manifest', and that 'a proportionable number is printing at Rotterdam and at The Hague', but that he too was unable to obtain a copy. 'They are to be distributed at the same time that the Fleet putts to sea.'

Copies were finally obtained on 20 October. But in spite of the fact that the ambassador dispatched them for England 'by an express', his messengers were held at the Dutch coast, 'nobody being suffer'd to pass that way or by any other till the Prince set sayle'. So although by now packages of the *Declaration* had been distributed to locations right across Britain to be released as soon as the Dutch were known to have set out, the government in London had still not seen it. On 2 November (old style), when William had already set out, James told the Archbishop of Canterbury he had finally been shown copies, by 'several persons, to whom they had been sent in penny-post letters, which he had thrown into the fire; but that he had still one copy'. On 3 November, two days before William landed at Torbay, Princess Anne showed Lord Clarendon 'the Prince of Orange's Declaration, saying the King had lent it to her, and she must restore it to him tomorrow'.

Bentinck's distribution machine launched fully into action on 5 November, and his agents began distributing copies everywhere. Not only was London inundated with copies, but the *Declaration* was now being spread all over England, and a separate *Declaration* of the Prince for Scotland was circulating north of the border. Simultaneously, the *Declaration* in Dutch, French and German was released in the Dutch Republic, the English ambassador reporting that 'the manifesto is now sold publickly and in all languages'.

The pamphlet's coordinated propaganda, and the build-up of expectation before it was finally released, ensured that the *Declaration* had a major impact, not only in England and the United Provinces but throughout Europe. It was printed in Amsterdam, Edinburgh, The Hague, Hamburg, London, Magdeburg, Rotterdam and York. Copies printed at The Hague bore the official imprimatur of the Prince: 'Printed at The Hague by Arnold Leers by special order of His Highness'. Altogether, twenty-one editions in the four languages appeared in 1688, eight of them in English. Intended, clearly, for an international as well as an English audience, the *Declaration* was widely dispersed on the Continent. 'Many thousand copies' were sent across the Channel to be 'consigned to some trusty person in London'. Copies were handed directly to all ambassadors and ministers at The Hague except the English and French representatives. Through copies in the Dutch language, William justified his undertaking to his Dutch subjects on the same grounds he had employed in asking the States General for support. In the German version he used the same general terms he had used in soliciting help from the German Princes. The French translation of the manifesto appealed to Huguenots on the Continent as well as to those who had emigrated to England after the revocation of the Edict of Nantes in 1685.

Bundles of free copies were sent to booksellers to be sold at a price set by themselves. Copies were posted through the penny post and sent anonymously to private citizens. Extra copies were produced after the landing by John White of Yorkshire. The first, and for a time the only, English printer of the *Declaration*, White was rewarded by William after he became King with a monopoly in the city of York and the five northern counties for printing all notices concerning revenue and justice which the government might issue.[6]

Outside London, the distribution and reading of the Prince of Orange's *Declaration* was the radical intervention which effectively substituted for real hostilities in bringing about the 'Glorious Revolution' itself. At Exeter – the first official stop for William and his army en route for London – the Prince's chaplain, Gilbert Burnet, took over the cathedral and 'commanded' the local clergy to sing a celebratory Anglican Te Deum, and then obliged them to listen while he, from the pulpit, 'read aloud the Prince's Declaration and reasons for this his expedition'. When Durham was seized

Lurid contemporary print showing the rescue of England by William of Orange.

by local gentry sympathetic to William's cause on 6 December, Lord Lumley read out the Prince's *Declaration* at Durham Castle in front of most of the gentry of the county. When the Earl of Bath, governor of Plymouth, after holding the town on behalf of King James for five weeks, finally capitulated, he signalled his defection to William's camp by having the *Declaration* read to the town's residents. Chester was seized by the county militia, who supported Prince William, on 14 December. They disarmed James's military governor, the regular regiment stationed there and two troops of Irish dragoons, 'then they read the Prince's Declaration and declared for him'. At Oxford a trumpet was blown at Carfax, and the *Declaration* was 'read openly to the multitude by Lord Lovelace'. The students and residents of the city then proceeded to demolish Magdalen College Bridge to stop James's dragoons getting into the city. So great was the impact of the Prince's *Declaration* that it became central to both Jacobite and French propaganda to argue that the people of England had been loyal to their King until their minds were corrupted by reading the Dutch Stadholder's pernicious manifesto.[7]

What, then, was so persuasive about the *Declaration*? Fundamentally, its achievement was to have succeeded in giving Prince William his own distinctive, measured and rational voice, with which he appeared to engage each individual reader as a reasonable subject or participant. Tone and content are extraordinarily seductive, even today – it is a fine piece of what would now be called 'public relations' or 'spin'.

Such a direct appeal by the Prince as an individual to the general public as reasonable interlocutors had succeeded magnificently for William's great-grandfather, Prince William the Silent, when he took on the might of Spain to champion the right to independence of the Protestant Netherlands in the 1570s.[8] A century later, this first *Declaration* of William III's (it was to be followed by a succession of widely distributed follow-up documents in a similar vein, tailored closely to unfolding events) won the hearts and minds of the English public at large. It has won the hearts and minds of historians ever since.

'It is most certain and evident to all men,' the *Declaration* begins, 'that the publick peace and happiness of any state or kingdom cannot be preserved where the law, liberties, and customs, established by the lawful authority in it, are openly transgressed and annulled; especially where the alteration of religion is endeavoured.'

The direct address and matter-of-fact tone of this opening are sustained throughout the lengthy document. The Prince of Orange's justification for intervention in the affairs of a neighbour state is set against the unreasonable practices of James II's 'evil counsellors', who 'in an open and undisguised manner' have subjected the nation to 'arbitrary government' – that is, to government which has suspended, ignored and ridden roughshod over the laws of the land and the established Church.

Under such circumstances, William explained, he could not sit idly by and watch England's destruction. He had a duty towards the people of the country from which both his mother and his wife had originated, to come to its assistance in its hour of need.

> Both we ourselves, and our dearest and most entirely beloved Consort, the Princess [Mary Stuart], have endeavoured to signify, in terms full of respect to the King, the deep and just regret which all these proceedings have given us ... But those evil counsellors have put such ill construc-

Mary Stuart in regal, ostentatiously orange dress, shortly before the invasion.

tions on those our good intentions, that they have endeavoured to alien-
ate the King more and more from us, as if we had designed to disturb the
quiet and happiness of this Kingdome.[9]

It was, then, with the greatest reluctance and humility that the Prince
felt he had no alternative but to come to the assistance of a country he felt
so closely bound to by bonds of lineage and obligation:

Since [we] have so great an interest in this matter, and such a right, as all the world knows, to the succession of the Crown; since also the English did in the year 1672, when the States General of the United Provinces were invaded in a most unjust war, use their utmost endeavours to put an end to that war…; and since the English nation has ever testified a most particular affection and esteem, both to our dearest Consort, the Princess, and to ourself, we cannot excuse ourself from espousing their interest in a matter of so high consequence, and from contributing all that lies in us for the maintaining both of the Protestant religion and the laws and liberties of these Kingdoms.

No wonder this version of the intellectual underpinning of the Glorious Revolution has been embraced by all except specialist historians of the period ever since. Here is a worthy political manifesto for the dawn of the Age of Reason – the English Enlightenment. William's assault on English sovereignty is represented as an entirely reasonable intervention by one well-intentioned party in support of the fundamental rights of the English people. It has seemed convenient to overlook the fact that within only weeks of his arrival in Britain, William had abandoned all pretence that he was intervening altruistically and claimed the throne for himself and his wife. Even before their coronation, the invasion had begun to look more like simple opportunism, with the outcome directly contrary to the expressed aims of the *Declaration*.

There is something seductive and reassuringly familiar about the comfortable commitment to reasonableness, order and integrity the manifesto voiced. The *Declaration* is closely compatible with John Locke's *Two Treatises on Government* – one of the intellectual cornerstones of late seventeenth-century political thought, first published in England in 1690. Hence, perhaps, the strong temptation for us retrospectively to line up William's declared intention of restoring consensual rule to England, and political 'modernity' of a kind we still recognise. And indeed, Locke is quick to associate his treatise, arguing that the population of any nation was entitled to consent rationally to be ruled by a sovereign power which agreed to serve their interests, with the political upheavals in England of two years earlier. His preface announces:

Thou hast here the Beginning and End of a Discourse concerning Government ... These [papers] I hope are sufficient to establish the Throne of our Great Restorer, Our present King William, to make good his Title, in the Consent of the People, which being the only one of all lawful Governments, he has more fully and clearly than any Prince in Christendom: And to justifie to the World, the People of England, whose love of their Just and Natural Rights, with their Resolution to preserve them, saved the Nation when it was on the very brink of Slavery and Ruine.[10]

Locke's *Two Treatises* were written during his own exile in the United Provinces. Indeed, all his political writings date from the period between his flight from England to the Low Countries in 1683 and his return home in 1689. Prior to that his professional reputation was that of a distinguished medical man with republican leanings. Men like Burnet and Locke were moulded by the Dutch Republic and its mores into political thinkers who harnessed the eloquence and lucidity of the English language to the level-headed pragmatism of the Dutch.

Moreover, it is not just the *Declaration* of reasons – so heavily influenced by the temperament and literary style of Gilbert Burnet – that has permanently shaped the telling of the story of the invasion which led to the Glorious Revolution. Burnet's monumental, six-volume *History of his own Times*, written towards the end of his long and eventful life, has also seen to it that a version of the Dutch intervention as driven exclusively by religious and ethical ideals has persisted down to the present day. The motto for the invasion proclaimed its purpose ('*pro religione et liberate*'), and that Burnet-style justification has remained the legitimising slogan for the Dutch intervention ever since.

In fact, however plausibly contemporaries pointed to Princess Mary's claim on the English crown and her husband's entitlement to try to secure a reliably Protestant succession, there were strong, entirely Dutch political reasons for William of Orange's invasion. The strategic planning which culminated in the great fleet leaving harbour on 1 November 1688 appears in a different light when looked at squarely from the point of view of its

Dutch participants. In the eyes of the Dutch States General, as well as those of key players like Prince William himself and his close advisers, it was driven by the urgent need to get the English King, in spite of his Catholicism, to commit to a 'defensive alliance' with the Dutch Republic, against the increasingly alarming expansionist moves of forces of the French King on the Republic's borders.

James II's accession to the throne in 1685 had raised immediate anxieties with the Dutch States General. The Dutch were deeply concerned, not only that James was strengthening the position of practising Catholics inside his own country, but also that he was reinforcing the English army. 'The King makes large-scale preparations, equips, fills his storehouses, ambassador Skelton is sent to Paris, has ambitions in the East Indies – everything highly suspect,' a Dutch agent reported. The fear was that a Catholic, expansionist Anglo–French coalition was about to form again, recalling the nightmare of 1672, when Louis XIV had been stopped from overrunning the Low Countries with English backing. Then, the French King's aggression and expansionist ambitions had brought down the republican regime of the brothers De Witt, as William of Orange emerged as the only leader capable of marshalling and focusing the support of politicians and the military. Now, once again, it was to be William, as the nominated Orange ruler or Stadholder, who proved capable of leading a robust Dutch response against renewed French military aggression.

William sent Dijkvelt to London as ambassador, charged with winning over James to form an alliance with the Dutch, rather than with France. When this initiative failed (largely because James was too preoccupied with internal English politics), William introduced a number of special envoys, acting on his behalf, charged with forging closer relations with the English King who was both his uncle and his father-in-law. This too met with little support, so Bentinck, who oversaw this network of contacts on the Stadholder's behalf, developed it as an efficient machine for collecting detailed intelligence on the English political situation.

It was through this network of informants that Bentinck laid the groundwork for the eventual invasion. When it became known that James II's second wife – none of whose pregnancies had resulted in the birth of a healthy child who survived beyond babyhood – was well-advanced with a pregnancy which promised to be without complications (an event about

which we will hear more in the next chapter), it was this intelligence service which provided vital information about the growing opposition to James's regime.

There were a number of factors which contributed, in the end, to the Dutch taking the extraordinary risk of a military assault on the British Isles. In the first place, strategic reasons directly related to Louis XIV's continuing aggression on the European mainland pushed the Dutch Republic towards an intervention which would prevent England lending military support to French aggression against them. In 1678, the Dutch Republic had extricated itself from war against France by agreeing to sign the Treaty of Nijmegen, under the terms of which the Dutch gained trading concessions, while the French gained territory. In the period running up to the invasion the policy of the States General (somewhat to the annoyance of the more belligerent Prince William) tried to distance the Republic from the European territorial conflict wherever possible, to protect Dutch commercial interests – the northern Netherlands were, after all, 'a Republic of Commerce', which could not afford to be drawn into a defensive war with France.

This policy of non-involvement in any kind of anti-French action became increasingly difficult to sustain, as events conspired further to disturb the uneasy balance of power in mainland Europe. In May 1688 the Elector of Brandenburg, a long-standing heroic defender of the Protestant cause in Europe, who had been married to William's aunt (his father's sister) Louise Henriette, died leaving no direct heir. William immediately sent Bentinck to Berlin to negotiate a continuing alliance with the new Elector, who was considered less reliable than the 'Great Elector' as a supporter of any kind of Protestant alliance against France. He managed to secure a commitment on the part of the Elector to give troop support to the Dutch venture, which Bentinck and William were by now clear would be a full-scale invasion of the British Isles. After several months of shuttle diplomacy, made more complicated by the fact that his wife was seriously ill at The Hague, Bentinck was able to tell William that he had secured a sizeable army of German troops to defend the Rhine and Dutch borders against French aggression while the Dutch forces were otherwise occupied – a decisive step in the decision-making leading up to the invasion.[11]

But what eventually made up the minds of the Dutch States General and Stadholder William of Orange that an invasion of England was

inevitable was an escalating trade war with France which struck at the heart of the Dutch economy. In August 1687 Louis XIV banned the importing of Dutch herring into France, unless it could be shown to have been salted with French salt. In September he doubled the import duties on fine Dutch cloth and a whole list of other Dutch products. By December, Dutch factors (trade officials) at Paris, Lyons and Lille were reporting that it had become impossible to sell Dutch textiles because of their high price. Similarly, with France the biggest market for herring and whale products, Dutch herring exports dropped by a third in the year following the ban. The French ambassador to The Hague reported that Louis's punitive tariffs 'have managed to sour the spirits of the people and officials here and have raised them to a peak of fury, such that burgomasters and the rabble alike talk of nothing else but fighting to the death rather than remain in the present state'.[12]

By June 1688 tension was running sufficiently high for William confidently to urge the States General that there was no alternative but to prepare for war with France. He also began secret negotiations with members of the Amsterdam administration, hitherto opposed to war, to discuss a pre-emptive strike against England. These complex negotiations were almost entirely concerned with the logistics of anticipating an attack by the French. Louis's absolute refusal to back down over the punitive tariffs eventually produced an unusual measure of agreement among the various Dutch political factions. As the French ambassador reported despairingly, 'there can be no negotiating, even with the most sympathetic of them, unless they are given some satisfaction concerning the commercial matters'.

Some members of the Dutch administration continued to waver. Then, in September, as Bordeaux, Nantes and other west coast French ports began to fill up with Dutch ships, there to take on board the year's output of wine earmarked for export, the French King suddenly announced that all Dutch ships in French waters were to be impounded – a total of some three hundred vessels. 'The Dutch believe a war with France is unavoidable,' the English consul at Amsterdam wrote, unaware that the first strike was actually to be directed against his own country.

The reasons, laid before the States General by William's trusted representative Gaspar Fagel, were plain: France had badly damaged Dutch

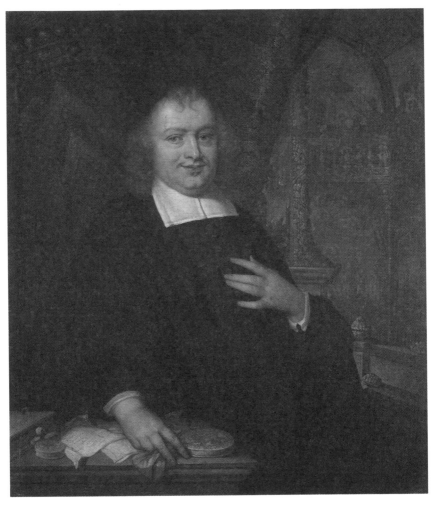

William of Orange's trusted and cultivated adviser Gaspar Fagel.

trade, shipping and fisheries; a French declaration of war on some pretext was now inevitable; if France was allowed to enter into an alliance with England, their combined forces would be bound to overwhelm the Republic. The only way, in these circumstances, that the Republic could be made secure was to bring about the downfall of the Catholic, pro-French regime of James II, and to turn around England against France. 'There can be no doubt whatever that the Dutch State invaded Britain ... to crush late Stuart absolutism thoroughly, turn England into a parliamentary

monarchy and, by so doing, transform Britain into an effective counter-weight to the then overmighty power of France.'[13]

As a clear indication of public assessment of the scale of the risk: on the eve of the invasion, the Amsterdam stock exchange crashed, wiping millions of guilders off government stocks and stocks in the East and West India Company.[14]

Religious considerations did play their part. The revocation by France of the Edict de Nantes (which entitled Protestants to worship freely) in 1685 produced a mass exodus of Huguenots, thousands of whom flooded as refugees into the Dutch Republic. There they spread alarm at the severity of Louis XIV's measures against Protestants. But the sceptical pamphleteer who wrote, on the eve of the Dutch invasion, that 'none that know the religion of an Hollander would judge the Prince or States [General] would be at the charge of a dozen fly-boats or herring-busses to propagate it, or especially the Church of England' was expressing a widely held view of the lack of doctrinal harmony between Dutch Calvinism and Anglicanism:

> The [Dutch] committed the cream of their forces to a full-scale invasion of Britain, incurring vast expenditure of money, effort, and resources, and did so, furthermore, on the eve of an almost certain outbreak of war with France. In doing so, the Dutch leadership, utterly uncharacteristically in the view of diplomatic onlookers, took a stupendous gamble.

On 9 September (new style), the French ambassador at The Hague, the comte d'Avaux, delivered a clear threat from Louis XIV to the States General: the French King knew what the Dutch preparations were for, he warned. If the Dutch attacked England, he would be obliged 'not only to come to James's assistance, but to regard the first hostile act committed by your troops, or your ships, against His Britannic Majesty as an open infraction of the peace and act of war against his own crown'.[15]

As Jonathan Israel emphasises: 'Outside intervention played a main role in setting the Glorious Revolution in motion. The course of the Glorious Revolution was to a great extent shaped by Dutch calculation and interests.'[16] With hindsight that intervention looks decisive and extraordinarily daring. In fact, the conditions needed for the Dutch Stadholder to take such a politically risky step with the full backing of the States General

resulted from a combination of circumstances, which included errors of political judgement (like the French King's reintroduction of punitive trade tariffs) and unexpected good fortune (like that providential wind).

Whether it was England or the Dutch Republic that was driving the political agenda, the Glorious Revolution was not a metaphorical 'pamphlet war', but a pivotal sequence of defining events for English and Dutch history. It was a large-scale naval and military engagement in which the 'enemy' (the legitimate English monarch and his government) more or less declined to participate, and in which victory went surprisingly easily to the aggressor. William and Mary's decisive victory over Mary's father was not achieved because of a persuasive printed justification for Dutch military intervention, or because their Protestant cause was self-evidently a just one.

Let us, then, pursue a little further the characteristics of William and Mary's 1688 campaign which gave it a certain colour of uncontentious obviousness – a kind of union of shared beliefs, recognisable like-mindedness and common outlook – which eased the transition from Stadholder to Stadholder-King, and from adjacent, independent territories (one a monarchy, the other a republic) into an anti-Catholic collaboration of forces and finances.

We might note the extraordinarily shrewd way in which the *Declaration* brought together a characteristically Dutch, and also distinctively English, language of moral probity and individual conscience to create an emotionally compelling hybrid set of arguments justifying Dutch intervention in an English cause for a common, righteous Protestant purpose. The man behind this consummate and effective fusion of two national cultures was Gilbert Burnet. He deserves to be introduced here as our first example of what will turn out to be a recognisable genus of able and determined Britons who found themselves in the Dutch Republic at a particularly crucial stage in their lives, married Dutch wives from wealthy and powerful families, and returned later to shape the politics and culture of their homeland.

Gilbert Burnet was an Anglican cleric, born in Scotland in 1643, who entered English politics in the early 1670s through his association with the Earl of Lauderdale. In the early 1660s he studied Hebrew in Amsterdam

with a Jewish rabbi, and developed a lifelong affinity for the plain doctrines and ceremonial simplicity of Dutch Protestantism. On his return he met and was befriended by Robert Boyle (youngest son of the Earl of Cork, and a prominent practitioner of the new natural philosophy), and came to the attention of Sir Robert Moray, a fellow Scot close to Charles II, and destined to play an important role in Charles's policies in Scotland. Moray introduced Burnet to the new scientific Royal Society (of which Moray was a founder member), and he was elected as a Fellow.

Burnet began his clerical career in the Scottish kirk, but in 1675 accepted the post of chaplain to the Rolls Chapel in England. During the Exclusion Crisis he was seen as a sort of 'honest broker', able to talk reasonably to both sides. The Rye House Plot of 1683, however, led to the execution of two of his closest friends, Lord Essex and Lord Russell. After attending Russell throughout his trial and up to his execution, Burnet resigned his post.

At the accession of James II, Burnet's outspoken anti-Catholic views placed him in serious danger, and he left England for the Continent. After travelling in France and Switzerland, in May 1686 he arrived in Utrecht, where he was presented with letters from Prince William and Princess Mary, inviting him to enter their personal service.

Burnet 'found the Prince was resolved to make use of me', and was introduced to the office of Gaspar Fagel, where from 1686 to 1688 he worked alongside Fagel 'benefiting from the Pensionary's network of political informants and the unrivalled power of the Dutch printing industry, to produce a number of works in support of the Orange position'.[17] Before the invasion he was responsible for several pamphlets against James II, developing a recognisable direct, persuasive voice which carries over into the *Declaration*. As a literary stylist, a native English-speaker and a person with first-hand knowledge of English politics Burnet was invaluable to William's propaganda machine. Fagel's death in December 1688, before William reached London, saw to it that from the beginning of the operation proper it was Burnet's commanding voice which shaped the public face of the invasion.

OVERLEAF: *William of Orange arriving in sight of Westminster after marching with his army from Torbay.*

Receptie van S.K.H. den H. Prince van
Orange, op zyn intrede tot Londen.

The Reception of His Royal Highness
Prince of Orange at his entring London

Once the invasion began, Burnet became an even more key figure in Dutch strategy. As William's chaplain he accompanied him closely from Torbay to London, using the resulting intimacy to advise his master on how to present himself to gain the support of James's subjects. He was closely involved in the physical production of the second and third *Declarations*, issued *in situ* (and run off on the expedition's own portable printing press) in response to the developing political situation. He spoke in William's defence from the pulpit at vital moments, set up public occasions on which William's message could be conveyed to the people — religious services to pray for the Prince's success, ceremonial readings of the *Declaration* — and engineered occasions for the formal expression of support by the Prince's English allies.

It was Burnet who preached to the troops immediately before the Dutch armada set out, emphasising the providential nature of the enterprise, and characterising the invasion as a moral crusade. It was he who devised William's memorable entrance into Exeter on his white horse, and the service of celebration that followed. And the prayer said communally throughout the journey for the success of the undertaking was a carefully calculated continuation of the virtuous Protestant theme:

> Grant O Gracious God that all of us, may be turning to thee with our whole hearts; Repenting us truly of all our past sins, and solemnly vowing to thee, as wee now doe, that wee will in all time coming amend our lives, and endeavour to carry our selves as becomes Reformed Christians. And that wee will show our Zeal for our holy Religion by living in all things suteably to it.[18]

Burnet was equally at home in London and The Hague, and his interventions were carefully judged and coloured so as to resonate with the attitudes and beliefs of the inhabitants of both.

William's *Declaration*, like almost all the other documents issued and circulated during and after the invasion, was countersigned and authenticated by his secretary, Constantijn Huygens junior.

Huygens junior, we recall, was one of the group who stood with the

Prince on the clifftop at Brixham, watching the Dutch forces disembark, and who accompanied him every step of the way to his triumphal reception in London, drafting his letters of instruction in English, Dutch and French as they went along. After the Glorious Revolution he remained in England in the service of the new King and Queen.

His presence as part of that defining scene for our historical exploration allows us to make our first acquaintance with the Huygens family a dynasty of advisers and administrators to the house of Orange, whose cultivation and aesthetic sensitivity, combined with their political acumen and dedicated service, helped transform the fortunes of the Dutch Stadholders. In the story that follows, several members of this prominent and respected family will be among our most reliable guides to understanding the unfolding, curious relationship between the seventeenth-century British Isles and the seventeenth-century Low Countries.

The Prince of Orange arrived in England in November 1688 with a formidable army. But he also came prepared for his encounter with the English, with a fully-formed outlook and set of attitudes. A robust set of common interests and commitments had developed over at least the preceding half-century between a certain sort of Englishman and his Dutch counterpart. While there was always an edge of suspicion (there had, after all, been three Anglo–Dutch wars since the 1650s), there was also a great deal of recognisably shared experience, particularly in the realm of arts and letters.

A small episode on the road leading from Torbay to London and the English throne underlines the importance of this shared 'mentality'. Constantijn Huygens junior records in his diary that in the course of the often arduous and demanding forced march from Torbay to London, Prince William of Orange took some time off from military affairs to do a bit of tourism, and encouraged his secretary to do likewise.

On 4 December, as the Prince travelled towards London at the head of his massive Dutch army, he insisted on making a detour to admire Wilton House near Salisbury, the country seat of the Earl of Pembroke. Wilton was renowned for its architecture, its art, but most of all for its magnificent gardens, designed in the 1640s by Isaac de Caus.

Engravings of the Wilton gardens had appeared in a lavishly illustrated book entitled *Hortus Pembrochianus* (Garden of the Earl of Pembroke), first

Gardens of the Winter King and Queen at Heidelberg.

published in 1645–46, and reprinted several times thereafter – in one case, without any of the accompanying text, but simply as a set of engravings.[19] The book is closely modelled on a famous volume brought out twenty-five years earlier by Isaac de Caus's brother Salomon, depicting the fabulous gardens he had designed at Heidelberg for the 'Winter King and Queen' – the Elector Palatine Frederick and his wife, Charles I's sister, Elizabeth of Bohemia. Both books are likely to have been familiar to a keen enthusiast for gardens like Prince William. Heidelberg's gardens had been destroyed during the Thirty Years War, along with the city's great university and its library.

In the midst of a military campaign, on foreign soil, William took the earliest possible opportunity to inspect the Pembroke gardens in all their glory, and at some length. Constantijn Huygens junior records the detour made for this purpose:

> We marched from Hendon to Salisbury, 13 miles, a good way through Salisbury plain, but for a long time we had a cold, sharp wind blowing directly in our faces.
>
> A mile from Salisbury we passed an undistinguished village (which nevertheless sends two representatives to Parliament), called Wilton,

where the Earl of Pembroke has a rather beautiful house which is moderately beautiful, because there are some very notable paintings by van Dyck. His Highness went to see it, but I did not – I was in a hurry to get to the town to get warm.[20]

William may have been anxious to see the van Dycks, at least one of which showed his mother as a child, with her siblings, but the gardens were far more impressive than the house. Laid out and planted before the house itself was built, as was customary for the period, the Wilton gardens had been designed to complement a classical villa on a grand scale, as de Caus's original drawings clearly show. By the time the house was constructed, the 4th Earl's fortunes had faded, and a more modest house eventually presided over the parterres and wildernesses, statues and elaborate fountains.

Wilton House's architecture, interior decoration, artworks and gardens were entirely to the monarch-to-be's Dutch taste. The weather was abominable, but that in no way dampened the Stadholder's enthusiasm. Rejoining Huygens the following day, William told Constantijn that the house and garden were as outstanding as he had been led to believe: 'In the

Wilton gardens from a popular illustrated book on the subject.

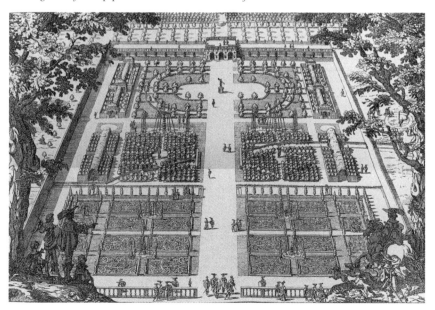

evening the Prince was in his room coughing violently, having caught cold. He told me I absolutely must go and see the house at Wilton.'[21] Huygens 'did want to go to Wilton, but my horses were not available'.[22] He went on foot to see Salisbury Cathedral instead:

> The Cathedral at Salisbury is huge, with many ancient tombs. There is a place where the members of the clergy meet, a round chapel, very neatly built in a gothic style, more than 40 feet in diameter, the ceiling vaulting of which is supported in the middle on a pillar, which is like all other pillars of a greyish polished stone, apparently natural.[23]

But if Huygens did not choose to admire Wilton's gardens, it is entirely likely that Hans Willem Bentinck did, and that he, in contrast to Huygens, chose to accompany Prince William on that cold afternoon tour. It may even have been he who proposed the sightseeing detour. Bentinck was himself a lifelong gardening enthusiast, whose own country estate at Sorgvliet – purchased from the heirs of the cultivated Dutch statesman Jacob Cats in 1675 – was considered in Dutch court circles to be an outstanding example of garden design, in which architecture and statuary perfectly complemented formal landscaping and topiary.[24] His passion for horticulture and expertise in garden design were recognised when, immediately after William and Mary ascended the English throne, the royal favourite was appointed to the official post of Superintendent of the Royal Gardens.

It was Bentinck who designed key features of the gardens at Hampton Court and Kensington Palace, and he too who was responsible for the realisation of the magnificent gardens at William and Mary's favourite palace at Het Loo, near Apeldoorn – both monarchs' favourite retreat. From his correspondence we know that he often combined business with horticultural pleasure – requesting rare plant specimens and seeds from fellow enthusiasts, and exchanging advice and expertise.

During the period when Bentinck was gathering intelligence in the first half of 1688, he observed to one of his key pro-William informants, Charles Mordaunt, that their letters were undoubtedly being read by James's agents, who would be likely to read sedition into anything that passed between them, however innocent: 'If, enthusiastic gardeners that we

are, we were to talk only of plants and flowers, the eavesdropper would want to find some sinister meaning in it.'[25]

I bring this early chapter in our exploration of the world of seventeenth-century Anglo–Dutch relations to a close with a last, suggestive example of the complex and subtle ways in which 'talk of plants and flowers' did indeed, in the circle of William of Orange, acquire cultural significance beyond the simple act of exchange of desirable material objects. Freighted with symbolic meaning, such shared cultural pursuits bridge any notional divide between the United Provinces and the British Isles.

Orange tree in a blue faïence container, presented by William III to his financial backer Francisco Lopes Suasso.

The elaborate, clandestine preparations for the 1688 invasion would not have been possible without loans of almost unimaginable size from wealthy supporters of the Orangists in The Hague. Foremost amongst these was the Portuguese Jewish banker Francisco Lopes Suasso, who provided the massive sum of two million guilders, lent without any collateral security. Effectively, William's entire expedition was underwritten by Suasso.[26] Following the successful invasion, now installed as the English King, William III presented Suasso — a man of considerable cultivation, at whose house the élite of The Hague regularly congregated for concerts and recitals — with a fine contemporary painting, as a thanks offering. The painting is of an orange tree, in an exquisite blue faïence container, with orange blossom and vibrantly coloured fruits appearing together amid the vividly green foliage.[27]

It needs little imagination, even today, to recognise the thriving little orange tree as a symbol of the success of the house of Orange, supported financially in its ambitions by men of business like Suasso. I shall return later to the way in which the meticulously depicted porcelain container also refers directly to the global ambitions – territorial and commercial – of the Dutch under William's leadership. Collecting porcelain became a passion of Queen Mary, whose example created an Anglo–Dutch rage for acquiring exquisite blue-and-white Chinese-style porcelain ware which lasted well beyond her death in 1697. So the grateful King, newly settled in his English kingdom, rewards his financial backer with a small, tasteful token of his gratitude, an enduring sign of the mutual respect that underpinned the financial commitment, in the form of a Dutch painting of an exotic potted plant. This shared passion for the art of gardens, and garden-related fine art, reminds us that the cultural landscape into which William of Orange stepped when he landed on English soil was one in which he already felt comfortably at home. In what follows we shall pursue some of the paths of cultural, artistic and intellectual interest which crisscrossed the Low Countries and the British Isles during the preceding century, and which prepared the way for the arrival of an English-speaking Dutch Stadholder, accompanied by his resolutely English wife, to take their places jointly upon the throne of England.

Royal and Almost-Royal Families: 'How England Came to be Ruled by an Orange'

There was an event I barely mentioned in my opening account of the Dutch invasion which, to anyone familiar with traditional accounts of the unfolding of England's 'Glorious Revolution', might have been expected to have figured more centrally. In summer 1688, Maria of Modena, Catholic wife of the Catholic English King, James II, gave birth to a healthy male heir. The arrival of Prince James Francis Edward Stuart upset long-established Europe-wide expectations for the English succession, and contributed its own momentum to the unfolding events which culminated in the arrival of William III of Orange in London.

Until summer 1688, James's eldest daughter by his first wife Anne Hyde, Princess Mary Stuart, was heir to the English throne. In 1677 Mary married the Dutch Stadholder William of Orange, and went to reside at The Hague. So in the second half of the 1680s it was confidently expected across Europe that the English monarchy would pass after James's death to a Protestant Englishwoman, married to a Protestant Dutchman. The Protestant succession seemed to have been secured, and after the brief, unfortunate interlude of James II's Catholic monarchy, England appeared once again about to be safely in Protestant hands. And although the Princesses in the Protestant line were proving remarkably unsuccessful at producing healthy heirs, it was devoutly hoped that competing Catholic claimants – notably the Italian house of Savoy – could be consigned to the margins of English history.[1]

James's second wife, Maria of Modena, had been pregnant a number of times since their marriage in 1673, and several of these had been brought to term. All her living children, however, had died in infancy. Rumours of another pregnancy began to circulate in January 1688, but they occasioned only a little serious speculation that the English dynastic situation might be altered – another miscarriage or stillbirth was confidently predicted. As the

pregnancy advanced, however, and the Queen remained in good health, the possibility of a Catholic Stuart heir once more became a real possibility, and on 10 June (old style) Maria was delivered of a healthy boy, James Francis Edward Stuart.

It was this event that forced the hands of the Dutch Stadholder and his wife, eventually compelling them to lay claim to the English throne by force. So, before we go any further, we need to interrupt this exploration of the patterns of influence and exchange between England and the Dutch Republic to look more closely at royalty, dynasties and the accidents of succession, as these are woven into the social and political fabric of seventeenth-century Anglo–Dutch affairs. Close family connections between the English royal family and their faction, and the Dutch Orange Stadholders and theirs, meant that an unexpectedly close eye was kept by both parties on political developments in the territory presided over by their cousins. As we shall discover, Anglo–Dutch marriages provide many of the clues in this period to the often unexpectedly intimate liaisons between things British and things Dutch.

With the arrival of the Stuart line at the beginning of the seventeenth century, after the death of the husbandless and childless 'Virgin Queen', Elizabeth I, the English succession once again looked secure. To the relief of the English public and Parliament, the Protestant King James I, son of Mary Queen of Scots, was married with children, and the Anglo-Scottish house of Stuart looked set to provide a lasting dynastic line for the English throne. Yet by the 1680s the direct Stuart line had already effectively petered out. Charles II, though married for over twenty years to Catherine of Braganza, and with a palace full of illegitimate sons and daughters by his many mistresses, had no legitimate heirs. His brother James had two adult daughters by his first marriage to Anne Hyde (commoner daughter of Edward Hyde, later created Earl of Clarendon), both of whom were married but childless, and he had no surviving children by his second wife.

The sense of dynastic disarray is probably best captured by a phenomenon which tends to be ignored by traditional historians – the extraordinarily high number of known miscarriages, stillbirths and infant deaths among the increasingly desperate Stuart royals. Dynastic succession is both the boon and the bane of monarchy. All the royal wives and Princesses in the direct line of succession to the English throne were in some state of

Children of Charles I by van Dyck — apparently promising the continuity of the Stuart line.

pregnancy for most of their adult lives, yet none succeeded in producing a healthy heir, whether male or female, who lived to adulthood.

With no direct line of Stuart inheritance, the country once again held its breath in anticipation of a likely descent into disorder and political chaos, of the kind that had been widely feared towards the end of the reign of Elizabeth I. The future political direction of the nation depended on the outcome of the next dynastic roll of the dice. Since Charles II's brother James had declared himself a practising Catholic, the whole of Europe waited expectantly, too. If James's line should successfully take control of the English throne long-term, the alliance of European Protestant nations against the might of Spanish and French Catholicism would be dangerously weakened.

Across the water, the Dutch Stadholder was equally concerned at the prospect of a line of Catholic monarchs on the English throne. The

proximity of the two nations, and their apparently closely compatible social structure and religious convictions, had led to attempts at close political union on several occasions in the course of the seventeenth century. Catholic rule in England would leave the United Provinces acutely vulnerable to being engulfed and overrun, as a result of the French King Louis XIV's expansionist ambitions. Dutch and English dynastic ambitions were thus separately concentrated on the immediate future of the English crown, the Stuarts and the Oranges both directly implicated because of their dynastic history.

Scandalous rumours began circulating in England even before the official announcement in January 1688 that after a gap of six years, James II's wife was once again pregnant.[2] They reached King James's eldest daughter Mary in The Hague in December 1687.[3] On 15 January Henry Hyde, Earl of Clarendon, wrote that 'the Queen's great belly is everywhere ridiculed, as if scarce anybody believed it to be true'. To those associated with James II's first Protestant wife, Anne Hyde, and her family (Henry Hyde was her brother), it simply seemed too politically convenient that the Catholic King and his Catholic Queen Consort should at this moment produce a Catholic heir (already anticipated to be a boy), just as it seemed settled that the succession was bound to pass eventually to one of James's adult, Protestant daughters.

Following the announcement, those closest to the Protestant line of succession naturally reacted most readily to the suggestion that the Queen's condition might be feigned – a ruse to secure an enduring Catholic succession. On 13 March, William Cavendish, Earl of Devonshire, writing to Prince William of Orange, husband of Princess Mary Stuart, at their court in the Low Countries, reported that 'the Roman Catholics incline absolutely that it should be a son'. The next day, Mary's sister, Princess Anne, wrote to her with even greater candour:

> I can't help thinking [the King's] wife's great belly is a little suspicious. It
> is true indeed she is very big, but she looks better than ever she did, which
> is not usual: for people when they are so far gone, for the most part look
> very ill. Besides, it is very odd that [her visit to] Bath, that all the best

doctors thought would do her a great deal of harm, should have had so very good effect so soon, as that she should prove with child from the first minute she and [the King] met, after her coming from thence. Her being so positive it will be a son, and the principles of that religion being such that they will stick at nothing, be it never so wicked, if it will promote their interest, give some cause to fear there may be foul play intended.[4]

A week later Anne returned to the subject. There was 'much reason to believe it is a false belly':

For, methinks, if it were not, there having been so many stories and jests made about it, she should, to convince the world, make either me or some of my friends feel her belly; but quite contrary, whenever one talks of her being with child, she looks as if she were afraid one should touch her. And whenever I happen to be in the room as she has been undressing, she has always gone into the next room to put on her smock.[5]

Anne's suspicions were echoed by Thomas Osborne, Earl of Danby. He reported to the Prince of Orange that 'many of our ladies say that the Queen's great belly seems to grow faster than they had observed their own to do'.[6]

On 10 June, the Queen gave birth to a son, James Francis Edward Stuart, Prince of Wales, who was immediately declared first in line to the throne, ahead of his grown-up half-sisters. Officially, the joyous event was greeted with delight and enthusiasm nationwide. After nearly thirty years of dynastic uncertainty, ever since Charles II's Restoration in 1660, at last the country had a healthy male heir. Bonfires were lit, gazettes and newsletters were 'stuffed with nothing but rejoicings from Towns for the birth of the Prince', and the government spent £12,000 on fireworks with which to celebrate.

At The Hague, however, the news was greeted less enthusiastically. Prince William banned all public celebrations of the Prince's birth. Firm statements were issued, insisting on the irrelevance of the new Prince of Wales to the English succession.

The tide of speculation continued unabated. 'People give themselves a

Medal commemorating the birth of Prince James Francis Edward Stuart in 1688.

great liberty in discoursing about the young Prince, with strange reflections on him, not fit to insert here,' one contemporary commentator wrote. Matters were not helped by the fact that the deeply sceptical Princess Anne had been away at Bath Spa taking the waters at the moment when the Queen went into labour, and was thus unable to testify to the authenticity or otherwise of the birth itself. Writing to her sister on 18 June, Anne expressed her 'concern and vexation' that 'I should be so unfortunate to be out of town when the Queen was brought to bed, for I shall never now be satisfied whether the child be true or false'. Reiterating her suspicions to her absent sister, Anne expressed surprise that the Queen had so miscalculated the date at which the baby was due, and had thereby 'chosen' to

give birth during her sister-in-law's absence. Had Anne perhaps, as more than one contemporary pamphlet proposed, been persuaded to leave London for fear that she would be a too 'vigilant observer' at the lying in?

If the timing of the pregnancy had been judged suspicious, the arrival of a hale and hearty male heir now prompted a flurry of publications voicing the opinion that somehow or other a surrogate baby had been substituted for Mary's sickly or stillborn one – perhaps smuggled into the delivery room in a warming pan by a midwife. Talk of a 'warming-pan plot' became so loud and persistent that four months after the birth, on 22 October 1688, the King called a special meeting of the Privy Council, at which forty-two men and women who had attended the delivery, or had access to the Queen immediately prior to it, presented their testimony, giving the reasons and evidence for their sincere belief that the Prince of Wales was the King's *bona fide* son. These depositions were lodged in the official records of the Court of Chancery (thereby giving them quasi-legal status), printed and widely circulated – ostensibly the conclusive rebuttal of the malicious rumours.[7]

By the autumn, however, reactions to events in England had moved from the domestic setting to an international one, and a fresh wave of rumours from abroad seemed destined to drown out those at home concerning the legitimacy or otherwise of the newborn Prince. Prince William of Orange was reported to be engaged in large-scale preparations for an invasion of England, to defend his wife's claim to the English throne. It had been suspected for several years that the Dutch Stadholder might eventually use military might to strengthen the dynastic bond between his wife's country and his own. Whether or not Prince James Francis Edward could be proved beyond a shadow of doubt to be the King's flesh and blood (and before DNA testing, what mother could ever provide such conclusive proof?), official recognition of the baby as his by James II had put paid to William's expectations that his marriage to James's daughter would bring royal status for the house of Orange.

On 18 September, two months before the actual invasion, John Evelyn went to Whitehall Palace in London from his home in Deptford and 'found the Court in the utmost consternation on report of the Prince of Orange's landing; which put Whitehall into so panic a fear, that I could hardly believe it possible to find such a change'.[8]

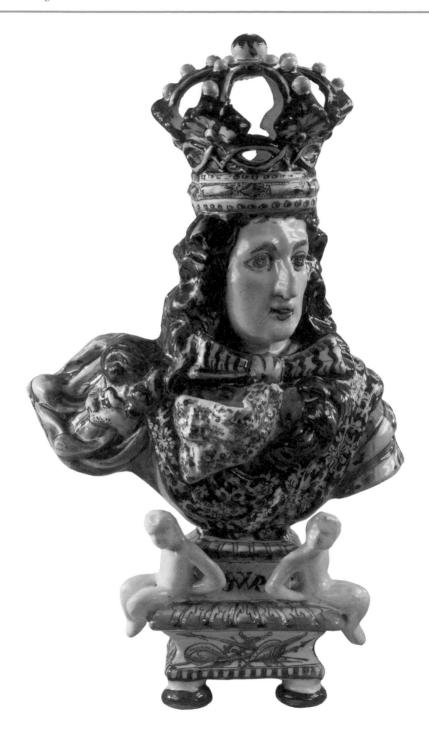

Busts of William III and Queen Mary in fashionable blue Delft faïence.

Since his marriage to James I's eldest daughter Mary in 1677, Prince William of Orange had more or less confidently assumed that his wife would one day sit on the throne of England, and that the country would become, to all intents and purposes, his to govern. William's own mother, Mary Stuart, was Charles II's eldest sister (she had died of smallpox when William was only ten). Thus William was his wife Princess Mary's first cousin, and the reigning English King's nephew as well as his son-in-law. William and Mary's joint claim had seemed irrefutable, and the fact that both were staunch and committed Protestants was a major point in their favour in the eyes of the English. By 1686 Mary herself was expressing the hope that William would one day become King of England.[9] The marriage in 1677 between the Dutch Stadholder and Princess Mary had been understood at the time by the people of the Dutch Republic as intended primarily to serve a political rather than a dynastic purpose. After the traumatic events of 1672 – when the French had almost overrun the United Provinces, and the Dutch had abandoned the republican rule of the De Witt brothers for the reassuringly militaristic régime of the young Stadholder William of Orange – the northern Netherlands had believed themselves to be under permanent threat of invasion by the French forces of Louis XIV. It had indeed been the actual arrival of French troops on Dutch soil that had driven the States General to reinstate William as Stadholder, as well as head of the Dutch military forces, after twenty years during which the house of Orange had been expressly barred from holding the position. Acclaimed by the Dutch Republic then, after he had successfully driven back the French, Prince William was determined to avoid any future expansionist moves northwards on the part of the French King by creating a counter-balancing alliance with the English and the Spanish. Having tried unsuccessfully to persuade Charles II and his government to become involved in defending the Low Countries from the French predator by diplomacy, the United Provinces (which had definitively won independence from Spanish rule in 1648, after eighty years of bitter struggle) hoped that as Charles's son-in-law William would have better success in turning English foreign policy in their favour.[10]

In this, William and the Dutch were largely mistaken. Charles II remained cautiously neutral as an expansionist France continued to encroach on its anxious European neighbours. In 1678, the Treaty of Aachen extended the French border northwards to include Tournai and

Charleroi. In 1681, Louis XIV attacked from his eastern border and took the strategic town of Strasbourg. In 1682, in a move designed specifically to antagonise the Dutch Stadholder, Louis seized Orange in southern France – an independent principality of which William was titular head, and whence the family claim to royal status derived. In 1684, France annexed Luxembourg. Faced with Charles's continued reluctance to be drawn into the conflict, William was driven practically to despair by England's strategic isolationism. 'The insufferable behaviour of England,' he expostulated in 1681, 'is the principal cause of our present dangers because of which the situation at the end of this year will perhaps be even worse than in 1672.'[11]

The accession to the English throne of the Catholic James II in 1685 removed any further hopes of strengthening the Anglo–Dutch accord by family-based strategic alliance between England and the Protestant Low Countries. Instead, there were now real fears in the Dutch Republic that James would enter into a formal treaty with Louis XIV, significantly strengthening the French King's power base, thereby allowing France to pursue its dream of universal rule in Europe by taking control of the Netherlands.

So when news of Maria of Modena's pregnancy reached William of Orange, it gave concrete form to his growing alarm over England's intentions regarding, and influence over, the wider political scene. It strengthened his resolve to put into action his 'Grand Design' – to invade England, settle the uncertainties over the succession, and assert his and his wife's joint claim in person. Long before the English Queen's condition was public knowledge, William's agents and intelligence-gatherers in England had let him know that his and Mary's position in the English inheritance stakes might be at risk. Whether plausible or not, the clamour of accusation and counter-accusation concerning the 'warming-pan plot' provided William with an excellent excuse for launching his invasion. Indeed, in the 'invitation' extended to William by a group of influential Englishmen on the eve of his fleet's sailing for England, the 'immortal seven' who put their names to it reproached the Dutch Stadholder for having sent official congratulations to James following the birth:

> We must presume to inform your highness that your compliment upon
> the birth of the child (which not one in an thousand believes to be the

Queen's) hath done you some injury. The false imposing of that upon the Princess and the nation, being not only an infinite exasperation of the people's minds here, but being certainly one of the chief causes upon which the declaration of your entering the kingdom in a hostile manner must be founded on your part. Although many other reasons are to be given on ours.[12]

William's *Declaration of Reasons*, published on the eve of the Dutch invasion to justify his unprecedented intervention by force in the affairs of a neighbouring nation state, did indeed cite as one of the grounds for what looked, on the face of it, like a piece of unwarranted international aggression, 'the just and visible grounds of suspicion' that 'the Pretended Prince of Wales was not born by the Queen'. Should the invasion succeed, he promised to refer to Parliament 'the enquiry into the birth of the pretended Prince of Wales, and of all things relating to it and the right of succession'. In the minds of the Dutch Stadholder and the Protestant faction in England, dynastic and political strategic planning thus became closely enmeshed. The claim that the birth of James II's son was 'suppositious', however far-fetched, symbolised the acute concern on both sides of the Narrow Sea at this unexpected disruption of the anticipated train of events.

By 1688, the Dutch house of Orange had been actively manoeuvring to increase its control in the Low Countries and its wider European influence for three generations (since the turbulent times of William III's great-grandfather, William the Silent).[13] In the climate of uncertainty that surrounded the birth of James II's son, one thing is beyond a shadow of doubt: William of Orange acted with characteristic personal decisiveness in seizing the opportunity to intervene in English dynastic affairs while the country was internally in considerable political disarray. William had always taken a keen interest in English dynastic affairs. Third in line to the English throne after James II's daughters, he himself was known to consider that his claim was technically stronger than theirs. Orphaned at the age of ten, he had been brought up carefully to understand the importance of his English heritage. His mother (James II's older sister) had been quite clear that her royal line was superior to that of James's children, since James's first wife Anne Hyde had been a mere commoner (married hastily, and against his family's wishes, indeed when pregnant with their first child, who was stillborn).

Constantijn Huygens junior records in his diary that on a wet and windy day in October 1673, when he and the future King William III were in the field, engaged in military action against the French, the Stadholder talked, at table during the midday meal, about 'the death of his grandfather the King [Charles I] and affairs in England'. His own line, he insisted, surely took priority over

Bust of William III at Petworth House.

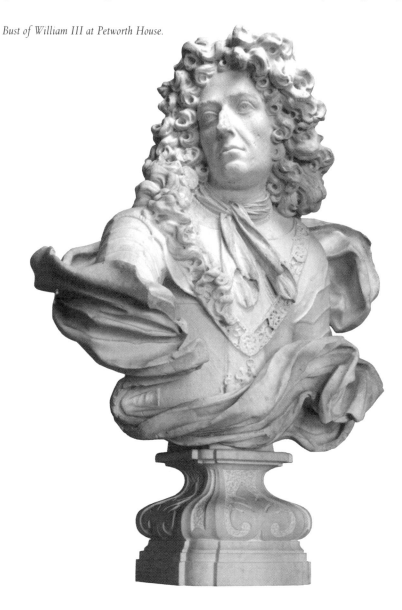

that of James: 'He said that if the Duke of York [James] died before the King [Charles II], the right of [James's] daughters to take precedence over himself with regard to the Crown would be disputed.'[14]

The opportunity for William to marry James II's elder daughter in 1677 significantly strengthened his claim to the English throne, since in the dynastic chess-game it united the second and third in line. The claim became a real prospect at another moment when the inheritance rankings of the various possible claimants on the English throne were apparently in the process of reorganisation. Four years into James's marriage to his second wife (his first, Anne, died in 1671), Maria of Modena had given birth to one daughter who had lived only months, while a second daughter, Isabel, was a year old. Now, in spring 1677, the Queen was again pregnant, and the clear expectation was that she would finally give birth to a boy, who would take precedence over James's daughters by his first marriage as claimant to the English throne.

The possibility of Charles II's brother producing a male heir by his second wife meant that at that moment Princess Mary looked temporarily a less attractive figure dynastically, less of a 'catch' on the international royal marriage market, and hence suitable as a bride to a member of the comparatively minor house of Orange. Maria of Modena did indeed give birth to a son, Charles, Duke of Cambridge, just three days after William and Mary's wedding on 4 November 1677. Princess Mary's new husband was one of the little Prince's godfathers. Baby Charles died, however, just a month later, on 12 December.[15]

William's dynastic interests were not merely aspirational in European royal terms. They were inseparably entwined with his political and military aspirations, in particular with a strategy of pressuring England into an anti-French coalition. The ambitious dual purpose of the match with Princess Mary Stuart was simultaneously to advance his chances of inheriting the English crown, and to exploit the favour of the English government, whose expressed desire in 1677 was to assist the Dutch in their struggle to retain their independence in the face of a ruthlessly expansionist France.[16]

William of Orange's marriage was the second occasion within forty years on which the minor royal house of Orange successfully exploited a situation in

which a Stuart bride's currency on the international dynastic market was temporarily reduced by circumstances, in order to move themselves strategically up the European royal rankings, increasing their power inside and outside the United Provinces. The first of these occasions had been William's own English mother Princess Mary Stuart's marriage to his Dutch father, the future William II of Orange, in May 1641.

In the 1630s, a dynastic alliance with the ruling line of the neighbouring Protestant power was an obvious, if ambitious, aim for William III's grandfather, Frederik Hendrik, and his wife Amalia van Solms. In addition to the obvious strategic advantages of consolidating Protestant influence in the region, an Orange–Stuart marriage was particularly attractive to the Stadholder's ambitious wife, who had met and married her husband while serving as lady-in-waiting to Charles I's sister Elizabeth of Bohemia, resident in The Hague with her court since the early 1620s. By marrying her son to the former Queen of Bohemia's niece, Amalia could reasonably consider herself to have risen to comparable royal status with her former royal mistress.

The immediate incentive for an Anglo–Dutch match, however, was a pressing political one. In 1639, Charles I, who during the period of his 'personal rule' (rule without recourse to Parliament) had drawn increasingly close to Catholic Spain, allowed the Hapsburg Spanish ruler Philip IV to send a large fleet towards Flanders via English waters and harbours, and there was talk of a marriage between Charles's eldest daughter and the Spanish Crown Prince.[17]

In late 1639, the senior Dutch ambassador François van Aerssen, Heer van Sommelsdijck, was sent to England to negotiate closer relations with the United Provinces, including the re-ratification of an existing peace treaty between the two countries. Charles proved reluctant to jeopardise his relations with Spain by throwing in his lot with the Dutch, but in the course of their discussions, van Aerssen learned that the King was interested in a marriage between the Stadholder's son William and one of his daughters. At the end of 1640, after protracted negotiations between representatives of the Stadholder and the English King, it was agreed that Frederik Hendrik and Amalia's only son, the future William II of Orange, would marry Charles I's five-year-old second daughter, Elizabeth.

The Stadholder and his wife would naturally have preferred their son

Frederik Hendrik and his wife Amalia van Solms in regal finery.

to marry Charles's eldest daughter, but this was perhaps too much to expect. Indeed, Frederik Hendrik's ambassadors — first Jan van der Kerckhoven, Lord of Heenvliet, and then van Aerssen — had been trying unsuccessfully to pursue this even more attractive marriage proposition since the previous year. As van Aerssen pointed out to the English King, a marriage between his eldest daughter and the Dutch Stadholder's son would bring family benefits beyond those of mere strategic political alliance with Spain:

By this marriage you will gain for yourself a first claim on the affections and interests of His Highness and the United Provinces, while if you seek kinship with a house of greater power than your own [like Spain], you can expect nothing from their ambitions, but will only lose your daughter, whom you will force into wedding interests opposed to your own.[18]

When van Aerssen advanced this argument in late 1639, he was roundly rebuffed. The match, he was told, was out of the question. Princess Mary was to become the bride of a member of the ruling house of Spain, thereby securing the 'Spanish Match' Charles had failed to secure for himself a decade and a half earlier. The eldest daughter of so elevated a royal line as the Stuarts could, in any case, hardly become the bride of a mere minor princely house like that of Orange.

In England, however, the political situation was steadily worsening for Charles I, and it looked increasingly unlikely that Parliamentary consent would be forthcoming for a Spanish, Catholic match for his daughter, or indeed that the Spanish Hapsburgs would any longer be interested, as Charles's political power waned. A significant Protestant match, on the other hand, might go some way to allaying the fears of an increasingly nervous and suspicious Parliament.

In spite of the growing sense of foreboding at the English court, the political situation there probably looked less discouraging to Frederik Hendrik in the Low Countries than it did to the Spanish. Unlike most other European headships of state, the position of Dutch Stadholder was technically not a dynastic one, and the power of successive Princes of Orange who had occupied the position depended on the agreement and support of the States General – the elected administration of the northern Netherlands.[19] The growing power of the English Parliament may therefore have been perceived by the Orange negotiators as merely a shift in the balance of power between ruler and state.

Frederik Hendrik's pursuit of an advantageous Anglo–Dutch marriage for his son was in due course rewarded. By 1641 the personal circumstances of the English royal family had deteriorated dramatically, the prospect of a Spanish match had collapsed, and it was agreed that Princess Mary would after all become William's bride, in exchange for Low Countries support for the King's party in England, when such became necessary. Frederik

Hendrik's negotiators assured the English King that the Dutch Stadholder would 'acknowledge [the bond of family alliance] by his services whenever it might please His Majesty to let him know his commands'. They omitted to point out to Charles that the Stadholder actually had no authority to dictate to the States-General – the administrative arm of the Dutch Republic, and the Dutch equivalent of the English Parliament – in matters of foreign policy. The marriage contract was signed in London on 12 February 1641.[20]

The fourteen-year-old Prince William of Orange arrived in England for his marriage to nine-year-old Mary in early May 1641.[21] At the court in Whitehall it was made absolutely clear that the Stuart King and Queen were on this occasion consenting to a dynastically inappropriate marriage for their eldest daughter solely through force of circumstances. The Orange delegation were repeatedly reminded of their inferior position in relation to the family of the bride. William was ostentatiously taken in hand by his bride's family: his wardrobe was considered insufficiently gorgeous, and he was taken off to be decked out in a more suitable outfit. This is the orange silk suit in which he is shown in van Dyck's glorious wedding portrait – it probably cost several times more than the painting that commemorates the event. By rights the double portrait should have been paid for by the bride's family, but Frederik Hendrik probably footed the bill, as he did that for the wedding suit, and for all other expenses relating to the union.[22]

The wedding ceremony was conducted by the King's former personal chaplain and favourite Anglican prelate, Matthew Wren, Bishop of Ely, in the chapel of the Palace of Whitehall.[23] Charles and Henrietta Maria, father and mother of the bride, were seated together prominently on a raised dais, to distinguish them in rank from the Orange party.

So uncharacteristically low-key were the ceremonies to celebrate the marriage that there was some suspicion on the Dutch side that the Stuarts might default on the contract should their political circumstances improve and a more prestigious royal bridegroom become available. Charles refused point blank to allow his daughter to travel back to The Hague with her new husband, while at the obligatory 'bedding of the bride' which took place

Prince William and Princess Mary in their wedding outfits.

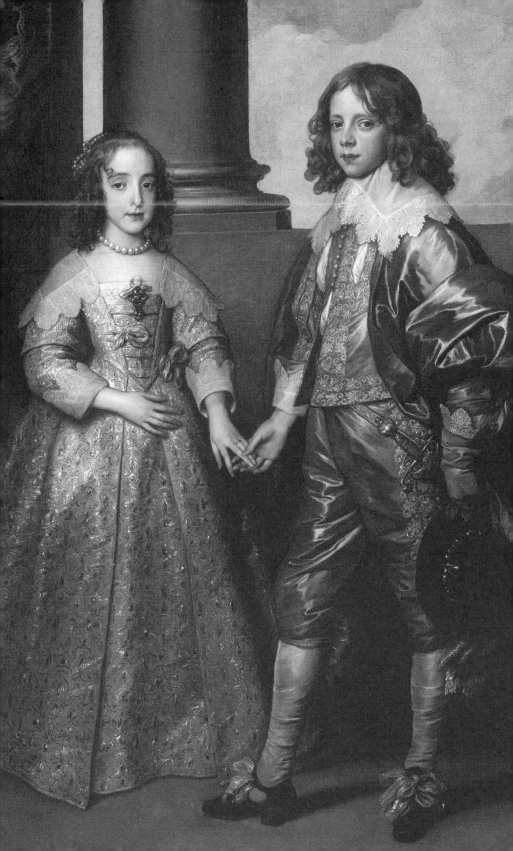

before the bridegroom's departure for home, elaborate precautions were taken to make it clear that the marriage had not been consummated. It was not a good sign, one member of William's entourage wrote, that such care had been taken to demonstrate to the world that the bride's virginity had been left intact: 'In the presence of the King, Queen, ambassadors and some bishops, the Princess being put to bed in a double shirt, sewn fast below and above, between two sheets, over which two more were spread in which the Prince was lying.'[24]

Matters were, however, soon taken out of the English King's hands. In early 1642, Charles's flight from London and his subsequent declaration of war against his Parliament at York marked the beginning of civil war in England – an internal conflict which lasted seven years, devastated the country, and culminated in the execution of the King on 30 January 1649. On 7 February 1642, Charles escorted his wife and eldest daughter from Windsor Castle to Dover, from where it had been decided that Princess Mary and Queen Henrietta Maria should embark for the safety of the Netherlands, and the protection of the royal couple's new son-in-law. Two weeks later, after lingering farewells, the Queen and the Princess sailed out of Dover on a modest ship, the *Lion*, with an escorting flotilla. King Charles galloped along the white cliffs, waving to his wife and daughter until they were long out of sight. Queen Henrietta Maria had prudently taken with her most of the Crown Jewels, with the intention of pawning them in The Hague to raise much-needed funds for an army to support her husband's cause.

The Queen and her daughter were received at The Hague with enormous pomp and ceremony, as befitted their elevated royal status. Frederik Hendrik resigned himself to bearing most of the costs of this extravagant display of prestige and status – particularly since it had the desired effect of greatly impressing the Dutch people.

In the months that followed, Frederik Hendrik and Amalia toured the northern Netherlands with their new daughter-in-law, dazzling the Dutch citizens with the scale and splendour of their entourage. In May there was a lavish reception in Amsterdam, at which allegorical scenes depicted historical marriages made between Counts of Holland and English Princesses, thereby implying that the house of Orange too had now achieved sovereign status. The massive costs of such entertainments fell to the

Stadholder and the States General. Frederik Hendrik, for whom the expenditure formed part of a conscious strategy of dynastic aggrandisement, absorbed his share without demur. Only occasionally did the Dutch administration complain, protesting that the English Queen 'for her amusement' travelled with great ostentation 'at the country's expense, with a retinue of 600 persons' (the number of followers given here probably included the Stadholder's retinue as well as those of Henrietta Maria and Princess Mary).[25]

Queen Henrietta Maria's purpose in remaining in the Low Countries, though, was primarily to raise a substantial cash sum to purchase men and munitions for her husband's Royalist cause, secured against the jewels she had carried out of England. These were valued at 1,265,300 Dutch guilders; bankers in Amsterdam, however, were reluctant to deal with them. The stones were too large, and besides, the English Parliament had lodged a formal complaint with the ambassador for the Low Countries in London, protesting that the Crown Jewels were state property and that the Queen had no authority to dispose of them. It became clear that unless Frederik Hendrik was willing to add his own personal security, no bank would be prepared to lend against the pieces of jewellery. This is precisely what the Prince proceeded to do, thereby effectively providing concrete support for the Royalists at the outbreak of the English Civil War in August 1642, in spite of the clearly expressed resolve of the States General to remain neutral.

Royal mother and daughter together exerted considerable emotional pressure on their new relations for financial assistance, men and ships to assist Charles I, thereby driving a wedge between the Stadholder and his government. Charles I was quick to take advantage of his daughter's new access to the material and military resources of the house of Orange, and pressed her to seek assistance from them. 'Dearest daughter', he wrote to her, 'I desire you to assist me to procure from your Father in Law the loane of a good ship to be sent hither to attend my commands. It is that I may safely send and receive Expresses to and from your Mother.'[26]

In February 1643 Queen Henrietta Maria left the Dutch Republic for France, taking with her large quantities of munitions for her husband's cause. Frederik Hendrik persuaded the Dutch government to turn a blind eye to these, 'because without [the armaments] there is no appearance at all

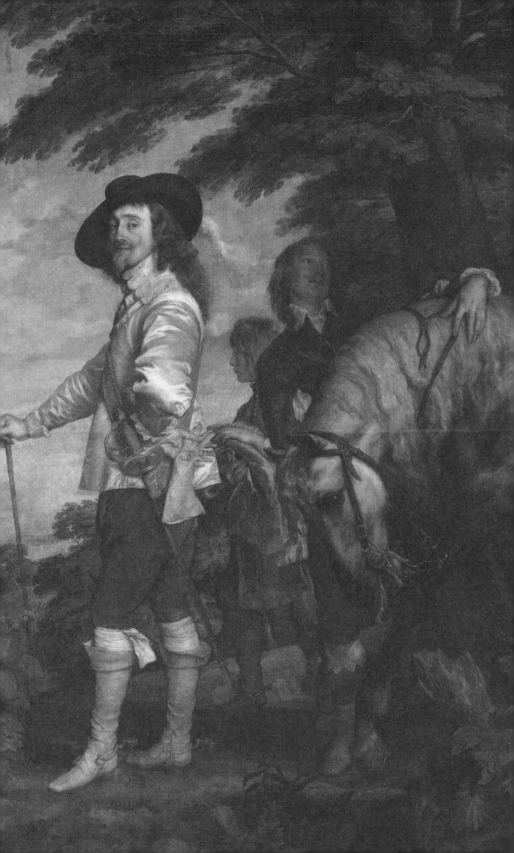

Van Dyck portrait of Charles I with horse and groom, c.1635.

that the Queen will depart, but only that she continues to stay with us to the great detriment of the country'.[27] Left alone with her new family, Princess Mary celebrated her twelfth birthday at The Hague in November, on which occasion it was considered that she had formally consented to the marriage as binding, as required under English law.

In June 1644, Henrietta Maria dispatched an emissary from her residence in Paris to The Hague, proposing a marriage between her eldest son, the Prince of Wales – the future Charles II – and Frederik Hendrik and Amalia van Solms's eldest daughter, Louise Henriette. These first negotiations failed, but the English Queen sent her representative back in early 1645. She did not want a large dowry, but rather intensive assistance from the Dutch Republic at sea, against the English Parliamentary forces. Frederik Hendrik rejected any such combination of political and dynastic arrangements, though he declared himself entirely ready to countenance the marriage, and offered a generous dowry. Negotiations continued until April 1645, when Henrietta Maria learned that Frederik Hendrik had secured a more reliable (and ultimately more advantageous) match for his daughter with the Elector of Brandenburg. Their marriage took place in December 1646.[28]

Shortly after negotiations had been broken off concerning a second Orange–Stuart marriage, in October 1645, the complete correspondence between Henrietta Maria's envoy and Frederik Hendrik was captured by Parliamentary forces in a skirmish near Sherborn in Yorkshire. It was published for propaganda purposes, to reveal to the English public the extent of the royal family's negotiations with foreign powers in its attempt to secure victory on behalf of the Crown over the people. The following spring the contents of the 'King's cabinet' relating to the proposed Orange–Stuart match were translated into Dutch and circulated in the United Provinces, in an attempt to arouse republican indignation at the Stadholder's high-handed use of the Dutch Republic as a marital bargaining counter in the international power play for territory between ruling royal dynasties. Among the Dutch, however, the exchanges were read rather as confirmation that Frederik Hendrik had eventually fended off any such politically dangerous English suggestions.[29]

Charles II and his sister Princess Mary Stuart dancing in The Hague, on the eve of his return to England as king in 1660.

In 1658 one final attempt was made by the house of Orange to contract a marriage between Prince Charles – now the exiled Charles II – and Louise Henriette's younger sister. Negotiations continued for a year before they eventually broke down. Once again this was due to the elderly Dowager, widow of Stadholder Frederik Hendrik and mother of William II, Amalia van Solms, who decided that, after eight years of the English Common-

wealth, there was no serious prospect of Charles regaining the English throne. Or perhaps she was put off the match by Charles's indiscreet and sexually predatory conduct, philandering with the ladies-in-waiting at her court in The Hague: in 1649 his mistress Lucy Walter had given birth to the future Duke of Monmouth in Rotterdam. Charles subsequently fathered illegitimate children by Elizabeth Killigrew, Viscountess Shannon, and Catherine Pegge.

Hardly more than a year later, and very much against the odds, in 1660 King Charles I's wayward son was reinstated as the reigning English

monarch. In May 1662 a highly advantageous marriage was contracted between Charles II and the Portuguese Catholic Princess Catherine of Braganza. She brought with her an exceptionally large dowry in both goods and territory (which included the ports of Tangier and Bombay). There must have been many in the Protestant Low Countries – not least Amalia herself – who now regretted the failure of the attempt to ally him by marriage with the reliably Protestant house of Orange. Nor did marriage put an end to Charles's wandering eye. In stark contrast to his official childlessness, he acknowledged nine illegitimate children before his death in 1685, six of them boys.

The on-off negotiations between the princely house of Orange and the royal house of Stuart throughout the middle years of the seventeenth century are a strong reminder of the deep dynastic ties that bound together the English and the Dutch. In the protracted diplomatic relations between France and England during the seventeenth century, historians have been quick to point out how the interventions of Queen Henrietta Maria (daughter of Henri IV of France) and, a generation later, Charles II's younger sister Henriette (married to Philippe, Duke of Orléans), influenced events within the British Isles.

The double bond, in the period 1641–88, between the ruling houses of England and the Dutch Republic has received far less attention. Yet throughout these years, first Princess Mary (wife of William II) and then her niece, also Princess Mary (wife of William III), exercised significant influence over decision-making on both sides of the Narrow Sea.

We shall never know whether Mary of Modena's son had been substituted in the lying-in chamber in a warming pan, or was actually of Stuart royal blood. But like many potent myths, the story of the 'warming-pan plot', circulating right across Europe, was as powerful as an instrument of history as if it were established fact. Though the story of plots and substitutions is largely discounted by historians today, it was equally widely believed in England and abroad during the fraught summer of 1688, and persisted for a generation afterwards. Since the Queen went on to bear James a daughter in exile in France, the claim that she was incapable of bearing healthy children was plainly false. At the same time, by spiriting away the pretend-

ed heir to the throne, James and his wife removed the possibility of any kind of 'trial' of whether the supposed Prince of Wales was indeed genuine. An inquiry was started early in 1689, but was dropped on the grounds that it was by now impossible to establish the truth. As a sympathiser with James's cause wrote in early February 1689:

> There is no room for the examination of the little gents title which perhaps will be hearafter the best proof he has of his title that after 'twas in their power to examine his birth they durst not refer it to a free parliament as was pretended.[30]

As late as 1712 Queen Anne remained convinced that the baby who had almost ousted her from succession to the throne had been substituted in the delivery room. When her physician David Hamilton told her that he believed 'that the Pretender was not the real son of King James, with my arguments against it', the Queen 'received this with chearfulness, and by asking me several questions about the thing'.[31] But by the time of William and Mary's coronation on 11 April 1689, the legitimacy or otherwise of the baby was immaterial to the arguments mustered to affirm the legal legitimacy of their claim to the throne.

Neither will we ever know whether William of Orange had intended to seize the English throne when he launched his invasion in November 1688. In a later *Mémoire*, Mary implied that William invaded England with the intention of dethroning James. This may, however, have been her retrospective view of events, since for some years before the invasion she had hoped that William would one day be King. King James himself said on 27 November 1688 that he thought William had come to England to seize the Crown. This remark clearly tells us about the King's state of mind at the time, but it does not help us decide what were William's actual intentions. Whatever the case, the public actions of English officials underlined the finality of what William had done. By 18 December, when they knew James was in William's custody, they began greeting the Prince symbolically and ceremonially as if he were King.[32]

We do know that as early as 1670, when William paid his visit to England to reclaim the large sums owed to him by the English royal family, he was delighted by the evident enthusiasm of the Protestant party, and

their clear approval of the fact that he stood close to the throne in the line of inheritance. On that occasion, the seventy-two-year-old Sir Constantijn Huygens (Constantijn junior's father) certainly encouraged him to believe that his ultimate royal destiny (he was not yet Stadholder) might lie in England.

Devoted lifelong servant of the house of Orange (both in and out of power), and unashamed anglophile, Sir Constantijn could think of no more glorious future for his young Orange protégé, on the threshold of regaining his royal standing in the Low Countries, than to consolidate still further the bonds between his family and the similarly restored Stuarts. In spite of his age and infirmity, Huygens senior worked unstintingly during his London visit to develop a strong and durable relationship between Charles II and the young nephew who would, though neither of them could know it, one day ascend the English throne as King William III.

Designing Dutch Princely Rule: The Cultural Diplomacy of 'Mr Huggins'

In 1667, Thomas Sprat, the first official biographer of the Royal Society in London, praised the ingenuity and inventiveness of the Dutch, and stressed the importance for the development of their science and technology of the many intellectual migrants drawn to the Republic by its reputation for toleration. The hub of this activity, he reported, was at The Hague – equal to Sir Francis Bacon's 'New Atlantis' as a catalyst for intellectual endeavour:

> They have all things imaginable to stirr them up: they have the Examples of the greatest Wits of other Countreys, who have left their own homes, to retire thither, for the freedom of their Philosophical Studies: they have one place (I mean the Hague) which may be soon made the very Copy of a Town in the New Atlantis; which for its pleasantness, and for the concourse of men of all conditions to it, may be counted above all others (except London) the most advantagiously seated for this service.[1]

In the mid-seventeenth century, the elegant small town of The Hague on the north-west coast of Holland, a comparatively easy journey across the water from London (embarking from Gravesend), had indeed been for many years a destination for Englishmen fleeing persecution or simply civil unrest at home.

Furthermore, in the first half of the seventeenth century, at the end of Holland's Golden Age (the high point of its financial power), it housed no fewer than three princely courts. Two of these were, as far as visitors from England were concerned, reassuringly English in culture and ambience. These were the court of Prince William II of Orange and his wife, Princess Mary Stuart (the Princess Royal), and the court of Mary's aunt (Charles I's sister), Elizabeth of Bohemia, Electress Palatine, the ill-fated 'Winter Queen'.

The official focus of courtly activity at The Hague after 1625, however, was the residence in The Hague of the Orange Stadholder Frederik Hendrik himself. His wife Amalia van Solms, whose acute sensitivity to the shades and nuances of European courtly conventions had — like those of the Princesses Mary and Elizabeth Stuart — been strongly influenced by English tastes and court practice during her pre-marriage period as lady-in-waiting to Elizabeth of Bohemia, presided over a court designed in emulation of that of her former royal Stuart mistress. The Orange Stadholder's court was thus as congenial for élite English visitors as the less politically powerful courts that flanked it (in all three, English and French were the languages of everyday use, alongside Dutch).[2]

Almost as soon as Frederik Hendrik assumed the Stadholdership in 1625, after the death of his half-brother Maurits, he and Amalia embarked on a programme of ostentatious expenditure on luxury objects and works of art, to create a cultural and artistic context which would put the house of Orange in the United Provinces on the European 'royal' map. Although the Orange court was small by the standards of the French, by the 1640s it was comparable with the courts of the German Princes, or that of the Elector Palatine at Heidelberg. The programme of expensive purchases and newly established courtly rituals and occasions was designed and put in place with the close guidance of the Stadholder's trusted secretary, Sir Constantijn Huygens, in his capacity as art adviser (the cultivated and anglophile Sir Constantijn was particularly close to Amalia). The process of designing a princely milieu for the house of Orange paid homage to the Stuart court in London, whose tastes and social habits were self-consciously adopted. What made this strategy for glorifying the Orange house by ostentatious expenditure and design unusual was that the family in question were Stadholders (nominated officers) rather than a significant, dynastic royal line — in theory at least, the state could (and for a short time in mid-century did) overrule the appointment of the next in line to the position of head of state.

Descriptions of the grand sweep of aspirational purchasing and display by the Stadholder and his wife, however, do not do justice to the way Frederik Hendrik and Amalia were intimately involved in the process of building up the collection, with Amalia taking a particularly close interest in acquisition. Like collectors throughout the ages, she may have paid

exorbitant sums for individual items, and accumulated art objects at a phenomenal speed, but she was nevertheless passionate about what she bought, and took lasting pleasure in paintings and decorations which it had taken time and effort for her adviser, Sir Constantijn, to acquire on her behalf.

Somewhere between 1625 and 1626, for example, shortly after her marriage, and at the very beginning of her activities as prominent patron and connoisseur, Amalia took a close interest in the purchasing of a painting by Rubens, depicting the marriage of Alexander the Great and Roxane – a nice compliment, perhaps, to her new husband, who like Alexander had raised a wife from among his imperial conquests to princely rank, while she had obediently complied with his royal command. The negotiator acting on Amalia's behalf for the purchase was Sir Constantijn Huygens, the agent and intermediary was Michel le Blon, who was also responsible for commissioning and purchasing Rubens paintings for James I's favourite the Duke of Buckingham. A memorandum in Rubens's handwriting, found among Huygens's papers, formed part of the negotiations leading to the purchase by Amalia, and reminds us how many decisions had to be taken, by her advisers, to ensure that she as patron was satisfied (financially and aesthetically) with the outcome.[3]

In 1632 Rubens's *Alexander Crowning Roxane* hung in pride of place over the chimneypiece in Amalia van Solms's private cabinet, or withdrawing room, in the Stadholder's quarters in the Binnenhof (the seat of government) at The Hague. A surviving inventory of effects in the royal palaces at the time allows us to visualise the painting in its original, intimate setting – not just a great painting by a great Flemish artist, but a beloved possession of a Princess, memorialising an emotional crux in her own life. The cabinet was entirely hung with rich green velvet, braided with gold. The same braided green velvet covered the table in the centre of the room, and the three chairs and large couch. The swagged curtains were of matching green silk. The wooden over-mantel on which *Alexander Crowning Roxane* hung was gilt on a green ground.

As well as *Alexander Crowning Roxane*, the cabinet also contained an oblong painting by Rubens, placed 'before' the chimney, depicting 'the courage of Cloelia' – a young Roman woman taken captive by the Etruscans, who led other young girls to safety in a daring escape – along

Rubens's Alexander Crowning Roxane, *acquired by Amalia van Solms.*

with portraits of Henry IV on horseback, the Winter Queen and the Count of Hanau. There was also a profile of the Princess herself, painted by the young Rembrandt.[4]

Frederik Hendrik and Amalia's efforts to match the lavishness and grandeur of long-established royal households benefited, in its early stages, from a piece of sheer good fortune, in the form of a financial 'windfall' from the buoyant Dutch commercial sector. In September 1628, a Dutch West India Company fleet under the command of Admiral Piet Hein captured a

Spanish convoy off the coast of present-day Cuba, in the Bay of Matanzas. To the amazement of the Dutch, the convoy turned out to be carrying a cargo of silver worth approximately twelve million guilders. This was a stroke of luck not only for the nineteen directors of the Dutch West India Company, but also for Frederik Hendrik and Amalia van Solms. Under Dutch plunder law, the Stadholder, in his position as both admiral and commander-in-chief of the fleet, could claim 10 per cent of the value of the cargo of captured enemy ships. In the account books recording disbursement of sums for the construction and embellishment of the Stadholder's residences over the next ten years, the expenditure is often ordered to be taken from the seized cargo money. For instance: 'to be paid from the Sea Prince's monies to Gerard van Honthorst the sum of 6,800 carolus guilders for painting the large room at Huis ter Nieuburg in Rijswijk [...] 16 May 1639'.[5]

The programme of deliberately extravagant expenditure was carried out with speed and efficiency. In the course of the 1630s, the house and garden of the Orange country estate at Honselaarsdijk were extended and the house lavishly refurnished. A new palace was built at Rijswijk, while the official residence of the Stadholder in the Binnenhof in The Hague was substantially added to and renovated. The castle of Buren was provided with handsome gardens in the 1630s and its interior modernised and refurbished. The Noordeinde palace in The Hague was almost entirely rebuilt during the same period. All these 'royal' houses were filled with paintings, tapestries, sculptures, hangings and other objets d'art in unprecedented quantities. Sir Constantijn Huygens saw to it that all of these were items of quality, guaranteed to provoke the admiration and envy of the more established crowned heads of Europe.[6]

The arrival of King Charles I's daughter from London, as the child-bride of Frederik Hendrik and Amalia's only son, was the occasion for a further round of expenditure, particularly since the match significantly enhanced the family's 'royal' standing. From 1642, the court of Princess Mary Stuart and her husband Prince William II of Orange at The Hague rivalled that of William's parents for its lavishness and conspicuous consumption of all and every available luxury. The adolescent Prince and Princess of Orange, having turned down their traditional quarters at the Binnenhof as insufficiently luxurious, settled into the newly renovated and

refurbished Noordeinde palace, which Frederik Hendrik and Amalia decorated and equipped for them in a manner befitting a royal couple.[7] Prince William and Princess Mary introduced a lifestyle and level of princely display at The Hague that deliberately emulated and sought to compete with established royal courts like those in London and Paris – developing her mother-in-law's strategy for enhancing the standing of the house of Orange. The pampered pair rapidly acquired an international reputation for their extravagant lifestyle and the luxury and spectacle of their courtly entertainments.

The third court at The Hague was that of the 'Winter Queen', Elizabeth of Bohemia, and her husband, Frederick of Bohemia. The marriage of Charles I's sister to Frederick, Count Palatine of the Rhine and Elector of the Holy Roman Empire, on 14 February 1613, had been celebrated enthusiastically across Protestant Europe. On the way to her new home in Heidelberg, the new Electress had been fêted in The Hague, with a series of banquets, ceremonial progresses and theatrical performances. To the Dutch the match symbolised the realisation of their hopes for a securely Protestant European royal dynasty. Elizabeth herself – elegant, expensively dressed and altogether glamorous – was their 'Queen of hearts', and retained their affection throughout her turbulent life.

Once they reached Heidelberg, the new Electress Palatine, whose large entourage of servants and retainers had accompanied her from England, insisted on living in Stuart style, filling the palace with her luxury possessions, including her small dogs and tame monkeys. Under her and Frederick's influence, Heidelberg came to be clearly distinguished from other minor European princely courts by an altogether grander way of life, which while ostentatiously extravagant and frivolous, claimed nevertheless to be infused with the ideals of chivalry, humanism and committed Protestantism. From its fabulous gardens designed by Salomon de Caus, to the sumptuous decoration of its interiors, it set the tone for seventeenth-century court fashion across Europe.

In 1619 Frederick accepted the crown of Bohemia, on behalf of Protestant Europe, and in direct opposition to the wishes of Hapsburg Spain. He and Elizabeth were crowned in Prague in December 1619, but their glittering reign as King and Queen was abruptly brought to a halt early the following year, after only one winter in power, when Spain issued

Elizabeth of Bohemia.

a declaration of war (hence their lasting title of 'Winter King and Queen'). By October 1620 Catholic forces had advanced on Prague, and on 8 November Frederick's army suffered a devastating defeat at the battle of the White Mountain. The royal couple fled via Breslau, Berlin and Wolfenbüttel to the United Provinces. They arrived in The Hague in April 1621, and the States General granted Frederick, Elizabeth and their five children asylum and generous financial support, providing them with a residence in keeping with their (by Dutch standards) elevated royal status. Although Frederick continued to try to regain possession of his Palatinate territories – seized by the Spanish after his loss of the crown of Bohemia – these were only

eventually partially returned to his son Karl Ludwig (Charles Lewis or Louis to the English) under the Treaty of Westphalia of 1648.

The continuing indulgence of the States General of the United Provinces towards the Winter King and Queen's lifestyle and its excessive costs depended to no small extent on the fact that until the birth of Prince Charles (later Charles II) in 1630, Elizabeth and her determinedly Protestant family were next in line to the English throne. Hers was also a family which included — unusually for the Stuarts — four healthy sons (though the eldest died in a boating accident in 1629). Throughout the 1620s, Elizabeth and Frederick continued to live in The Hague 'with all the trappings of royalty and little regard to the costs this entailed'.[8] Hunting, dances and spectacles dominated life at the Palatine court in exile. Elizabeth was an enthusiastic supporter of Netherlandish artists, and had herself and her family painted by some of the leading Dutch portrait painters of the period, in particular Gerrit van Honthorst and Michiel van Mierevelt. Many of the portraits were sent as gifts to her supporters in the Netherlands and abroad, spreading the fashion for Dutch portraiture across Europe.

After Frederick's death in 1632, the dowager Winter Queen remained in the United Provinces, dividing her time between her home in The Hague and the castle she and Frederick had built together at Rhenen in the province of Utrecht. In both places Elizabeth continued to hold court in her accustomed style, and during and after the Civil Wars, her court became a refuge for English exiles, including the exiled Charles II and close members of his entourage.

She had received a substantial pension from Charles I before the outbreak of civil war in England, which (somewhat surprisingly) the Commonwealth administration had continued to pay right up to the King's execution — after which the horrified Elizabeth refused to accept financial support from her brother's murderers. Thereafter she was dependent on the generosity of the States General and the Stadholder. Nevertheless, those who returned to England from her court reported admiringly the continuing sophistication of life in the milieu of the Winter Queen. Accounts survive of court masques and musical performances in the 1650s which in their dramatic and musical conception and execution match those to which she was accustomed in her childhood at the court of her father James I — the court which had formed the social aspirations

The Triumph of Frederik Hendrik, *by Jacob Jordaens, from the Huis ten Bosch.*

of the Stadholder's secretary, Sir Constantijn Huygens.[9]

There was no shortage of available funds at the Stadholder's own court, across town from that of Elizabeth of Bohemia. The last project undertaken by Frederik Hendrik and Amalia as part of their carefully-contrived cultural enhancement programme was to design and build one last lavish princely retreat for themselves on the outskirts of The Hague. The Huis ten Bosch was begun in 1647, the year of Frederik Hendrik's death. Designed by Pieter Post, it was adapted by Amalia van Solms, following the Stadholder's demise, to become a grand memorial to her husband's achievements. The entire undertaking was carefully supervised by Huygens and carried out over a period of five years with his customary commitment and dedication – a fabulous integration of architecture and painting, which was finally completed in 1652.

The Huis ten Bosch, uniquely among the seventeenth-century Orange royal palaces, has survived with the interior decoration of its imposing central room virtually intact, and can still be visited today. In close consultation with Huygens and van Campen, Amalia selected a set of themes and designs that showcased the work of an array of Dutch and Flemish painters into an iconographically organised, connected cycle of thirty wall paintings. Van Campen himself contributed several of the painted elements; others were executed by Gerard van Honthorst, Caesar van Everdingen, Jan Lievens, Pieter Soutman, Salomon de Bray, Christiaan van Couwenbergh, Pieter de Grebber, Jacob Jordaens, Gonzales Coques and Theodoor van Thulden. The decoration of the room effects the apotheosis of Frederik Hendrik, who is heroicised throughout – first as a warrior, then a bringer of peace, and finally as the founder of a Golden Age. The largest, most complex and most 'Baroque' of the series, *The Triumph of Frederik Hendrik*, was entrusted to the Antwerp Catholic artist Jacob Jordaens – remarkably, in the politically and doctrinally tolerant atmosphere of Flemish Antwerp, a Catholic artist could undertake a large-scale work celebrating the achievements of a Dutch Protestant Prince.[10]

This extraordinary compilation of celebratory memorial artworks by a wide range of Dutch and Flemish artists marks an important watershed in the fortunes of fine art and artists in the United Provinces in the course of the seventeenth century. Monumental in scale, the project was at once the apotheosis of Frederik Hendrik, and of the simply remarkable talent which could be assembled to mark his passing. The painters involved were drawn from all over the United Provinces, and from Antwerp (where freedom of expression allowed artists of all political and religious persuasions to congregate). But as Sir Constantijn Huygens, the originator and orchestrator of the entire piece, explained to Amalia van Solms in a letter, painters from Brussels had necessarily to be excluded, because, in spite of the artistic enlightenedness of the Archduke Leopold Wilhelm (himself a major collector of Italianate art), the climate of Catholic religious conformity would not allow artists to produce work celebrating the Protestant and Huguenot-sympathising house of Orange. Caspar de Crayer, whom otherwise Huygens would have wished to commission, was obliged to turn down his invitation:

Crayer, the great painter from Brussels, has declined by letter to make his contribution, using a number of pretexts. I think the true reason is that the subject is too Huguenot and Orangist, to be executed in Brussels. It was supposed to have been the expedition of Frederik Hendrik with Prince Maurits to the battle of Flanders. Someone else will have to take it in hand.[11]

Meanwhile, the two 'English' courts at The Hague received an unexpected injection of vitality, and gained significantly in international importance, as a result of the civil unrest and turbulent times in England. By the late 1640s there were plenty of refugees from the continuing civil wars semi-permanently installed at The Hague, who were prepared to accord Princess Mary Stuart all the respect and royal status she required. Throughout the 1650s, too, English Royalist visitors sought refuge in the United Provinces in increasing numbers, transforming it, in spite of its republican government, into one of the great courtly centres of Europe.

On several occasions already we have encountered the figure of the Dutch diplomat and poet Sir Constantijn Huygens (1596–1687), who died eighteen months before the 1688 invasion, in his ninety-first year, having been the foremost, loyal adviser to the House of Orange for almost fifty years. It is no exaggeration to suggest that over the course of his exceptionally long career, Sir Constantijn Huygens carefully shaped every aspect of the affairs of the house of Orange, from diplomacy and dynastic liaisons to interior décor. He was a man of erudition, taste, discernment and diplomatic skill, a poet, musician, art connoisseur and courtier. From his youth he was a passionate lover of England and all things English (not least its monarchy), and the intimate understanding he acquired of the attitudes and mores of the English élite made him an invaluable adviser to three generations of Stadholders.

Sir Constantijn was born at The Hague in 1596. His family on his father's side came from Brabant, while his mother was one of the Hoefnagels – distinguished artists, displaced from the important mercantile community at Antwerp by political events at the end of the sixteenth century. Constantijn Huygens senior was thoroughly educated in

languages, law and social forms and practices, as part of an intensive grooming to equip him to follow a career in public life. He fulfilled this role assiduously, remaining a loyal servant of the house of Orange throughout the long period when it was excluded from political power, between 1650 and 1672.

The extraordinarily pervasive influence of Sir Constantijn across Europe throughout the seventeenth century extended beyond himself, to

Sir Constantijn Huygens and his family.

include the prominent roles played in fields as diverse as politics, garden design and natural science by his children. In my opening chapter we encountered Sir Constantijn's eldest son, Constantijn Huygens junior, secretary to William of Orange, the future King William III of England, who was a prominent Dutch witness to the events of November–December 1688. His place at the side of Prince William III had been assured over ten years earlier, when he succeeded his father (who had previously succeeded his) in taking up that sensitive and key role. Constantijn junior, though less talented than his father, discharged his duties as secretary to the Stadholder-King impeccably, and, via his prolific diary in French and Dutch, is one of the most important sources of information about William's private thoughts and state of mind at all stages in the unfolding of the story of the Glorious Revolution.

Probably the most renowned (at least in the eyes of posterity) of Sir Constantijn's sons who lived to maturity was the distinguished scientist Christiaan Huygens, who spent much of his working life in Paris, in the service of Louis XIV, and of whom we shall hear more.[12] Sir Constantijn's only daughter Susanna married well, and with her husband Philips Doublet became an influential figure in seventeenth-century Dutch garden design. Son Lodewijk also became a government administrator, though he appears to have been somewhat less reliable in office than his elder brother.

Sir Constantijn Huygens is a pivotal figure in the history of seventeenth-century Anglo–Dutch relations. For three-quarters of a century he was the *éminence grise* behind vital decision-making in political and diplomatic circles, polite society, art connoisseurship and music appreciation on both sides of the Narrow Sea. What history treats as an unexpected agreement in aesthetic matters in the fields of art and music between two supposedly separate nations turns out to be the result of his assiduous taste-formation and opinion-forming within the two cultural communities. Since he plays such a vital part in the story I am telling here, it is worthwhile to look more closely at Sir Constantijn Huygens's form-ative early career.[13]

On 10 June 1618 (new style), in the early hours of the morning, the twenty-two-year-old Constantijn Huygens senior, son of Christiaan Huygens

senior, the trusted First Secretary to the Dutch Raad (its governing council), arrived in England for the first time in the entourage of the English Resident Ambassador to The Hague, Sir Dudley Carleton.[14] The visitors disembarked, then waited at Gravesend until seven, when coaches were found to take them to King James I's palace at Greenwich. Arriving there shortly before noon, they discovered that the King had left at short notice, on a whim, to go hunting – they had missed his departure by just a few hours. The ambassador (whose first duty upon arrival was to present his credentials to his royal master) set off again in pursuit with his entourage.

As fast as the ambassadorial party travelled, the King was ahead of them, restlessly looking for entertainment at each of his royal palaces in turn. Thus it was that the party spent their first week in England on the road, lodging each night at a different stately home and engaging in some enjoyable high-class tourism, before they eventually caught up with the King and his court at one of James's favourite royal residences, Theobalds ('Tibbalts') in Hertfordshire.[15] Here, on Saturday, 16 June, Carleton formally kissed the King's hand, delivered his credentials and received his royal instructions. Afterwards the party retraced its steps, arriving finally at the ambassador's London residence.[16]

For the rest of his extraordinarily long and active life, Constantijn Huygens would recall fondly, with pride and nostalgic delight, this first encounter with England, its topography and culture, and the elaborate, baroque lifestyle of the English court. The magnificence of the parks and houses he visited, the displays of wealth in the form of works of art, statuary and collections of exotica, the ostentation of the dress and entertainment, were in striking contrast to the way of life he had grown up with in the Low Countries – both because of the far greater formality and flamboyance of English aristocratic life in the early decades of the seventeenth century, and because the fifty years since the beginning of the Dutch Revolt had scarred the landscape, and damaged homes and countryside across the flat, featureless landscape of the United Provinces.

A few days after his first fleeting encounter with King James, Constantijn left Carleton's household and took up more settled residence in London. As had been carefully arranged by his father before he left home, he went to lodge with the elderly Noel de Caron, Lord of

Schoonewalle, Dutch Resident Ambassador in London and long-term servant of the house of Orange. Caron occupied an elegant mansion, Caron House, on the south bank of the Thames, built for him by the English Crown.[17] From this palatial residence the young Huygens proceeded to experience London life to the full, taking full advantage of Caron's excellent connections to further frequent the court circle, though in his letters home he complained to his parents about the distance from Caron House to central London, and the exorbitant cost of transport.

The Huygens name (pronounced 'Huggins' by the English) opened doors: his father was considered to wield considerable political power. Constantijn did some enthusiastic sightseeing, commenting expertly on elegant locations and new buildings in and around London, visited friends of his father and of his host across the city, dined and partied. He also made great strides with his English – the main purpose of the trip as far as his father was concerned, aimed as it was at grooming him for an international diplomatic career. Huygens's absolute fluency in English, together with his fond memories of the glamour and glitter of his first encounter with the country, contributed to his lifelong commitment – even in times of war – to fostering strong bonds of friendship between England and the United Provinces.

In Huygens's later reminiscing – some of it in elegant, celebratory Latin verses – one of the high points of his stay at Caron House was a private visit there by the King himself, accompanied only by his son Charles, Prince of Wales (the future Charles I), and his closest favourites, the Earls of Arundel and Montgomery, and the Marquesses of Buckingham and Hamilton. The King was apparently anxious to spend some time in Caron's garden, picking and tasting recently ripened Dutch cherries (which James harvested himself by means of 'a ladder, specially carpeted for the purpose'). Afterwards the visitors stayed on for a light meal and a tour of Caron's picture gallery, 'to give serious attention to the paintings' ('*à spéculer aux peintures*').[18]

During the meal Huygens was presented to the King by his host, who drew particular attention to the young man's virtuosity on the lute (Constantijn may have been invited to provide the background music while the royal party ate). According to Constantijn, writing proudly to his parents to keep them informed of his linguistic progress and social successes overseas, James was so delighted by his playing that he insisted

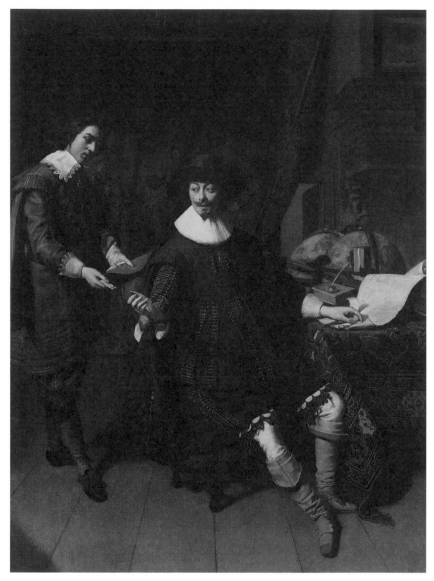

Sir Constantijn Huygens and his clerk, painted in the year of his marriage.

that Caron must have Constantijn entertain him on the lute at length on a future occasion, at Bagshot, the grace-and-favour hunting lodge given by James to Caron for his use during his residence in England.[19]

That later occasion (towards the end of September 1618) made such an

impression on the young and impressionable Constantijn that he com-
mitted it to verse in a poem entitled 'Being about to sing to the lute in the
presence of the King of Britain':

Thrice the greatest among Kings lends a majestic ear;
Grant, O skilful Thalia, more than my usual strains…
Kingly glory, I admit, dazzles the eye.
In the Divine presence the tongue stiffens and is numb.[20]

'But shall he who speaks the Batavian [Dutch] language despair of
pleasing the English Gods?' Huygens concludes, with youthful enthusiasm.
The question was a rhetorical one.

On that second occasion also, James engaged the charming young
Dutchman in private, informal conversation. Although at the very
moment they were talking together, the Dutch Stadholder Maurits of
Nassau was in the process of effecting a very public coup in the United
Provinces to take control of the States General (a power play in which
Constantijn's father, as secretary to the governing council of the States
General, was necessarily heavily involved), the exchange consisted entirely
of *politesse* and social banter. Still, Huygens was well pleased to have made a
good impression on the English monarch. When, heady with excitement at
his proximity to the monarch, he was dismissed from the royal presence, he
felt 'delighted with the excellent success of my humble affairs'.[21]

Constantijn's father, Christiaan Huygens senior (to whom Constantijn
was dutifully writing almost daily), must have been particularly gratified
that it was Constantijn's musical talents which had brought him to the
attention of the English King. His son had begun lessons on the 'English
viol', with an English music teacher, when he was barely six years old, the
beginning of a systematic training in elegance to equip him for a career
in the service of one of Holland's great dynastic families (the career of
a 'courtier'). Unaccompanied solo performance on the viol – known
as playing 'lyraway' – was a peculiarly English speciality in the early
seventeenth century. In fact, it was as a solo instrument as much as in
consorts that the viol became established as the performance instrument of
the English (the lute was similarly regarded as particularly 'French').
Huygens had met and been greatly impressed by one of the pioneers of the

English style of viol-playing at The Hague in 1613.[22]

Constantijn, who had shown early musical promise (his mother discovered that he could hold a tune when he sang a psalm melody back to her faultlessly at the age of two), had later been encouraged to perfect his skills in the company of members of the household of the English Ambassador at The Hague. Sir Henry Wotton, during his brief period as English Resident Ambassador at The Hague in 1614–15, was a neighbour, living just across the street from the Huygenses. As Constantijn's proficiency increased on the viol, harpsichord, lute and theorbo, and he added a pleasing voice, his virtuosity gained him admission to the most select circles at The Hague – on a number of occasions he played for Frederik Hendrik's mother, widow of William the Silent, Louise de Coligny. Thus by the time he was invited to play for James he was accustomed to performing in public, with élan, in front of discerning audiences.[23]

By the time he performed for King James, too, his was a specifically international, Anglo-Dutch musical expertise. He had absorbed the notational practices, playing techniques and even choices of accompanying instruments from his English and Anglo-Dutch teachers and fellow musicians. His playing was flexible and adaptable, and made him much in demand as a participant in any music occasion, whether in London or The Hague. We might indeed wonder whether the 'lute' on which he is supposed to have played, acquitting himself well enough to attract the admiration of the King of England himself, might actually have been a theorbo (close cousin to the lute), his preferred accompaniment for his singing.[24]

Apart from Constantijn Huygens's personal delight at being allowed to demonstrate his musical prowess to the King, what most impressed him on this first English trip were the guided tours of several private art galleries, including that of his host. The Huygens family were notable art-lovers and connoisseurs. The artistic skills of all members of this talented family were not confined to music. Parents and children were also accomplished practitioners of pen-and-ink sketching and watercolours. Constantijn's mother came from the distinguished family of artists the Hoefnagels, and Constantijn (who had been trained by his uncle, Jacob Hoefnagel), and later his own children, sketched and painted with exceptional skill.

Huygens's artistic neighbour and travelling companion, Jacob de Gheyn junior.

Furthermore, Huygens had the good fortune to have as travelling companion on this visit a young contemporary, Jacob de Gheyn junior, the son of more neighbours of the Huygenses in the élite residential district of The Hague. Jacob de Gheyn senior (Jacob de Gheyn II) was a renowned Dutch painter of portraits and still-lifes, and the younger Jacob would later become an artist of international standing himself. He was certainly in a position to inform young Constantijn of the importance of the works of art they had the good fortune to be able to view in the collections of prominent figures in the English court circle.

The official reason for Sir Dudley Carleton, the English Resident at The Hague's visit to England in 1618 was to take instruction on how to handle the sensitive situation in the United Provinces, where the Dutch Stadholder was attempting to seize additional powers from the Raad of the United Provinces by force. Less officially, though, the trip was undertaken in order to sort out Carleton's personal financial affairs.

To start with, there were his ambassadorial financial difficulties –

significant sums were owing to him as arrears in his stipend (ambassadors invariably found the monarch slow in reimbursing them). To this end his wife had arrived at their London residence in Westminster two months before him, to begin lobbying for the release of monies owing to them. There were also Carleton's continuing efforts to secure a senior position back in the English court, with more significant financial rewards.

(Eventually, in 1628, his persistent efforts to secure preferment, and to end his expensive peripatetic life as an English Resident Ambassador around Europe, were rewarded when he was appointed Secretary of State to Charles I – three years after his young protégé Constantijn Huygens senior became First Secretary to Stadholder Frederik Hendrik, across the water in the northern Netherlands.)

But there was an even more pressing personal reason for Carleton's presence at the English court, one which explains why priceless works of art should have been at the very forefront of the Ambassador's mind, and therefore prominent in the day-to-day activities of his accompanying Dutch party. In early February 1615, just before Carleton had been recalled from his post as Resident English Ambassador to Venice to take up the English Residency at The Hague, he had borrowed an embarrassingly large sum of money from the Protestant merchant banker of Italian extraction Philip Burlamachi (whose banking activities were largely based in London and Antwerp) to allow him to purchase a magnificent private collection of Italian paintings and antiquities. Carleton had stood personal guarantor for the safe arrival of the precious consignment – should anything happen to it before delivery, he would be responsible for repaying the bankers.

Carleton referred to the affair of the Venetian art purchase as a 'mischance', and such it became shortly after it was made. The collection he had acquired was indeed a fine one, consisting of Italian paintings by known 'masters', among them Tintoretto, Titian, Veronese and Bassano, and over ninety fine antique statues of various types and sizes, acquired via the agency of the Flemish dealer and fixer Daniel Nys (or Nice). It was Carleton's intention to offer this pre-eminent collection to James I's leading favourite, the Earl of Somerset – a significant art collector, who might be expected to jump at the chance of such an acquisition, and reward Carleton handsomely, over and above the purchase price.

Building up a notable private collection of Italian art, and displaying it

in a purpose-built gallery, was much in vogue at the English court in the early decades of the seventeenth century.[25] Carleton's hope was that by making this important art acquisition (purchased as a complete collection from the estate of a deceased or financially embarrassed collector), he would attract Somerset's attention and gratitude, and thereby secure the lucrative promotion he desired for himself at the English court. The paintings were shipped from Venice to London on 25 April 1615. The antiquities followed shortly afterwards, by separate shipment.

By the time the paintings and the twenty-nine cases of sculpture arrived in London, however, the Earl of Somerset had been disgraced, and was no longer in any position to concern himself with art acquisitions. In fact, even as Carleton was undertaking the purchase in Venice, at home, Somerset was already under suspicion, with his wife Frances, of conspiring to murder Sir Thomas Overbury. The couple were arrested on 17 October 1615, tried, imprisoned and permanently barred from royal favour.

Somerset's personal possessions were immediately confiscated by the Crown, and there was some danger that Carleton's newly arrived artworks, just unpacked, and sitting in Somerset's quarters at Whitehall, would be seized by the King and added to his own collection, even though technically they still belonged to Carleton. Carleton — by now in post at The Hague — hurriedly arranged for the paintings to be identified as technically his, and offered for sale in London. Entering the 'Bowling ally' in Somerset's apartments, Carleton's agents marked his pictures with a cross, excluding them from the inventory of possessions seized by the King. While Carleton looked for another buyer, the pictures were moved to the home of a merchant who handled Daniel Nys' accounts in London. Disposing of the paintings turned out to be a comparatively straightforward matter. Not only was the Earl of Arundel a leading collector, but he had been personally involved in advising Carleton over the original Venetian purchase — these were works of art entirely to his own taste. Arundel agreed to take possession of almost all the paintings. On 9 April 1616, two years before the visit on which Constantijn Huygens senior accompanied him, Carleton's agent informed Carleton:

> The L. Arundel is nowe returned & this day I gave my attendance on him,
> who I perceaved is passing desirous to deale for the halfe of them [the

paintings], telling me that my L. Danvers undertooke to take the other halfe.

On 25 May 1616, Carleton was notified by his agent in London that 'My L: of Arundell is content to take all the pictures (I would he were of the same mind for the Statues) to himself.'

Carleton's agent was right to be anxious: it proved much more difficult to dispose of the sculptures. In spite of the full inventory which accompanied them, the individual pieces were less obviously 'collectible' than the high-quality paintings by recognised Italian masters. Many of the figures and reliefs were bulky and unwieldy to deal with, particularly from a distance, as Carleton was obliged to do. There was also the vexed issue of authentication. In the case of the paintings, Arundel had relied on his trusted expert Inigo Jones to scrutinise each one and give an opinion of its value (artistic and financial). And although, in spite of all this, Arundel might have been expected to take an interest in the sculptures as well as the paintings, this prospect had been scotched part-way through the long-distance negotiations, when Arundel was presented with another outstanding collection of antique statuary as a gift at precisely that moment – the superb collection which later came to be known as the 'Arundel marbles'.

Eventually Carleton gave up trying to offload the antiquities in London, and had them all packed up again and sent back to him at The Hague, where he and his agents began casting around for another interested party to purchase them.

The idea of offering the sculpture collection to the great Flemish artist Pieter Paul Rubens may have come from Arundel or from Constantijn Huygens's father, Christiaan senior, or both.[26] In August 1617, Carleton's agent George Gage wrote to him from Antwerp concerning the statues:[27]

[He] understands he has received divers antique heads and statues out of Italy, wishes to know if they were bot [bought] of Daniel Nice, shd much like to see them, especially if any Statues as large as life.[28]

Gage was aware that Carleton had successfully effected a transaction with Rubens earlier that year, exchanging a Rubens hunting scene for a

George Gage, artistic agent to Sir Dudley Carleton and others.

chain of diamonds.[29] Now he believed that Rubens might be interested in exchanging Carleton's collection of antiquities for a significant number of the famous artist's own fashionable and highly desirable paintings.[30]

The suggestion was a timely and attractive one to Rubens. He had just finished overseeing substantial modifications to his grand new house on the Wapper canal in Antwerp. A fine collection of antique statuary 'as large as life' would create an imposing classical presence in the grand Italianate wing which Rubens had had added to house his studio, 'museum' of antiquities and receiving rooms. These were the rooms in which prospective buyers would wait for an audience with the great man himself. Their sumptuous decoration with antiques and costly furnishings would publicly

demonstrate his status as an internationally renowned and much sought-after artist. Rubens was also engaged in creating sensational outdoor spaces around his new home (his courtyard was hung with *trompe-l'oeil* paintings of his own of classical statues and friezes), and a large classically-inspired garden, which included architectural features and statuary as well as exotic plants and birds. Here too, genuine antiquities, strategically placed as the focal point in walks and alleyways, would confirm Rubens's taste and discernment.

On 1 November 1617, George Gage wrote to Carleton from Antwerp that he had 'delivered to Sigr Rubens what yr L. wrights to mee concerning yr heades and statuaes'. The proposition, as eventually negotiated, was that in exchange for the complete collection of antiquities, Rubens should supply four thousand florins' worth of his own paintings, plus two thousand florins' worth of fine tapestries. Rubens hoped to come to The Hague with Gage to inspect the collection, but in the event was unable to do so. In March 1618 he wrote (in Italian) to Carleton himself, confirming his enthu-

Engraving of the Rubenshuis in Antwerp, imposing home of the artist.

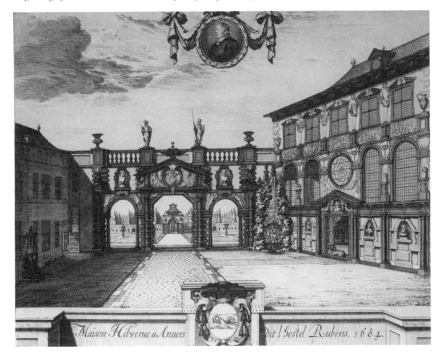

siasm for the proposed exchange: 'Y.E. having expressed to Mr. Gage that you would determine on making some exchange with me of those marbles for pictures by my hand, I, as being fond of antiques, would readily be disposed to accept any reasonable offer, should Y.E. continue in the same mind.' He would, he wrote, send a list of paintings for Carleton to choose from.[31] A month later the list arrived, including the dimensions of each work. They included an oversized crucifixion scene (twelve feet by six feet) of a kind that a collector of Protestant persuasion could not comfortably have hanging on the walls of his gallery, and an even larger Last Judgement. Carleton declined these, and Rubens agreed to substitute more suitable items. After further negotiations, since no tapestries could be found that met Carleton's high standard of design and execution, it was decided by further negotiation that Rubens would pay Carleton the sum of two thousand florins in cash in their place.

In late May, Rubens wrote to Carleton to tell him that he had agreed the final list of paintings and their measurements with 'that Man of Your Excellency's who came to take them', and had come to an agreement to have gilt frames supplied for them at his own expense. He assured Carleton that the pictures would all be his own work, rather than studio productions, and promised that they would be dispatched to him as soon as possible:

> I cannot, however, affirm so precisely as I could wish, the exact day when all these pictures will be dry, and to speak the truth, it appears to me better that they should go away together, because the first are newly retouched; still, with the aid of the sun, if it shines serene and without wind (the which stirring up the dust is injurious to newly painted pictures) will be in a fit state to be rolled up with five or six days of fine weather.[32]

A note among Carleton's papers records that the final list of paintings was brought to him in The Hague, from Antwerp, by 'Mr Hugins' – doubtless the same 'Mr Huygens' (Constantijn senior) who was about to set off with Carleton on his diplomatic voyage to London.[33]

On 1 June 1618 Rubens confirmed in writing that he had taken delivery of his statues.[34] They included allegories of Peace, Justice and Abundance, a

Rubens and his family in the garden of his house in Antwerp.

Diana and a Jupiter, busts of Marcus Aurelius, Cicero, Drusus, Germanicus, Trajan, Nero and Domitian, as well as Augustus and Julius Caesar, and burial urns, tablets and inscriptions, putti and dolphins. Ten days after the deal had been settled, and knowing that he would eventually recoup his outlay of money for them in the desirable form of artworks by the great Dutch painter Pieter Paul Rubens, Carleton and his ambassadorial party (including the young Constantijn Huygens) arrived in London. He could now concentrate on recovering cash, or goods in lieu, for the Italian paintings which the Earl of Arundel had taken off his hands with alacrity two years earlier. (In the end, apparently, Danvers's interest had waned, and Arundel took almost the entire collection.)

The deal struck between Carleton and Rubens to 'unload' the consignment of antique statuary was the beginning of an extremely fruitful relationship between the two men as artist and backer, and led to Rubens acquiring a string of prominent patrons at the English court. Carleton claimed that his successful exporting back to the Continent of the Venetian

antiquities, and their replacement by a collection of outstanding works of art by Rubens, had caused a radical change in fashions for collecting in England, replacing antiquities with modern Netherlandish paintings. Carleton having publicly preferred the paintings to antiquities, the vogue in court collecting had followed suit, to the annoyance of English artists: 'I am blamed by the painters of this country who make ydoles of these heads and statuas, but all others commend the change.'[35]

It is likely that the Earl of Arundel — one of England's most prominent connoisseurs of paintings and statuary — had already played some part in the acquisition of Carleton's consignment of artworks. Having eventually found himself the proud owner, he paid Carleton most of the sum owing, but procrastinated over supplying him with selected artworks in lieu of the remaining indebtedness.

It was this outstanding debt that Carleton spent much of his time pursuing during his 1618 trip to London. When he paid visits to the Earl of Arundel to talk business, he was still trying to sort out the unhappy affair of the Venice artworks. And when he visited to talk art business, Constantijn Huygens senior and Jacob de Gheyn went too. De Gheyn was well-qualified to draw attention to the most remarkable acquisitions in these aristocratic collections, and to explain their felicities in composition and style to his companion. These visits were precious opportunities for Constantijn to be instructed in the finer points of artistic taste, in the presence of some of the most magnificent examples of Italianate art to be encountered anywhere in Europe.

So Huygens reported to his father that he had seen the Earl of Arundel's collection of paintings and classical statues in their elegantly classical, purpose-built gallery at Arundel House on the Thames. He judged the recently acquired 'Arundel marbles' *'choses admirables en vérité'*. He also told him that he had been given a guided tour of Prince Henry's fabulous collection of Italian paintings at St James's Palace, down the road from Whitehall. The charismatic Crown Prince Henry, regarded by many as the golden prospect of the Stuarts, had died tragically young in 1612, and among his cultural legacies was his carefully compiled art collection. The private tour was in all likelihood conducted by Henry's Dutch keeper of his

collection, Abraham Van der Doort, soon to be appointed keeper of the future Charles I's collection (a deathbed promise of Charles to Henry).

The Earl and Countess of Arundel already knew the Huygens family, from Princess Elizabeth's progress through The Hague on her way to Heidelberg in 1613.[36] Arundel (accompanied by Inigo Jones, Toby Matthew and George Gage) had left the royal party at Strasbourg, and travelled on to Italy in search of art treasures for his collection. In autumn 1613 he was entertained in Venice by Carleton, who went along on a series of guided tours of galleries, churches and monuments with the visitors. 'Such activity was clearly unusual for the ambassador since, when he gave formal thanks on the Earl's behalf for the hospitality the Arundels had received, he admitted that "I who have been here three years, may say that until now I had not seen Venice."'[37] When Carleton arrived in The Hague in 1615, Christiaan Huygens senior had already been recommended to him by Arundel as an expert guide to Dutch art, and besides, the two were neighbours on the Voorhout – one of The Hague's smartest streets. On Huygens's recommendation, Carleton visited Rubens's Antwerp studio (or at least his agent George Gage did) during his first year in the United Provinces. By 1617 he was trying to buy a hunting scene by Rubens.[38]

According to Constantijn senior's letters home, he and Jacob de Gheyn spent a considerable amount of time at Arundel House, where de Gheyn drew some of Arundel's antique statues. In fact, the two men's continued presence in the Arundel galleries marked the end of Carleton's attempt to strike a deal with Arundel to give him works of art in place of the money owing. Huygens told his father that he and de Gheyn were particularly impressed by the Dutch artist Daniel Mytens's newly painted companion portraits of the Earl of Arundel and his wife Althea seated in front of their artistic treasures. It seems Carleton had tried unsuccessfully to acquire these two works from Arundel just before he left England. We have the following letter from Mytens himself to Carleton in August 1618, written just after Carleton's departure for The Hague:

> I send you by this bearer that picture or portrait of the Ld. Of Arundel and his Lady, together in a small forme, it is covered up in a small case. I have donne my indeavor to perswaide his Lordship to send your honor those great picteures, butt he is not willing to parte from them, by reason

theye doe leyke his honnor so well, that he will kepe them, and hee
willed me to make these in a smaller forme, wch I trust your Honor will
accept and esteeme as a small presente donne for my Lo. Of Arundel, and
for my paynes and care I have donne therein to the most of my power. I
leave the judgement to your Lordships good discretion.[39]

Two years later, when Carleton's relationship with Rubens had been
cemented by the acquisition of further significant paintings by the Flemish
artist on his own behalf, it was he who arranged that when the Countess
was travelling through Antwerp, she sat for Rubens herself. Rubens por-
trayed Lady Arundel as the important collector she undoubtedly was,
surrounded by all the paraphernalia of the wealthy and culturally influ-
ential English aristocrat: her coat of arms, her fool, her elegantly dressed
dwarf Robin, her falcon and a hunting dog. Behind her chair hovers the
satisfied deal-maker, Sir Dudley Carleton, the man knowledgeable about
art, responsible for bringing Rubens and the Arundels together.

During his stay in London, Carleton had apparently also commis-
sioned a portrait of Charles, Prince of Wales (the future Charles I), by
Mytens. In the letter accompanying the work 'in small forme' of the
Arundels, Mytens writes:

> I have binne at Sharckney [Hackney] to see wether I cold fynde occasion
> to draw the Princes Highnes picture; but the Prince being a hunting and
> suddainly to departe further in progress, I am returned to London, so
> that I must waiyte for a better opportunity at his Retorne back.

And the curious story which began with the 'mischance' of Carleton
acquiring a significant collection of antiquities, and involved the young Sir
Constantijn Huygens on his first visit to London, participating at first hand
in the strenuous art-related dealings between Carleton and the Arundels,
does not end here.

In 1626, Pieter Paul Rubens's wife Isabella Brant died, and (as was
customary) her grieving husband had to return her dowry to her family.
The obvious source of the significant sum required was the fine collection
of antiquities on display throughout his house and garden. Ever the
pragmatist, Rubens made plaster casts of the collection, then sold the

originals, as an intact collection, to the Duke of Buckingham, James I's favourite. The agent who brokered the deal on behalf of Buckingham – who was in the process of establishing himself as a leading power in the land by competing with the King himself for the prestige and ostentation of his art collection – was Michel le Blon. Le Blon probably negotiated (with Huygens) the *Alexander Crowning Roxane* for Amalia van Solms at the same time, while he was at the house on the Wapper canal on a daily basis, seeing to the acquisition of Buckingham's 'marbles' – a collection of antiquities to rival that of the Earl of Arundel himself.

So the collection of antique statuary which Carleton had first acquired in Venice and transported to London, returned to London once more – only to be returned to the United Provinces again following Buckingham's assassination. In 1648, the whole of the Duke of Buckingham's great art collection was sent to Antwerp for auction.[40]

By the time he eventually made his way home to The Hague, Constantijn Huygens senior had been entirely captivated by England's courtly milieu. Fortunately, his now-fluent English made him invaluable as a diplomatic emissary, and he was able to return to soak up more of the art and culture of London in 1621, when he made two trips, one as an official member of a States General delegation, the second an extended visit, lasting almost a year, in the entourage of the powerful Dutch diplomat François van Aerssen.

Three years after that third visit, Sir Constantijn succeeded his father as personal secretary and artistic adviser to the Dutch Stadholder Frederik Hendrik. His early encounters were a fundamental influence on him when he set about the task of acquiring artworks and exotica for Frederik Hendrik for his palaces in and near The Hague, as part of a conscious effort to raise the profile of the Orange Stadholders to something like 'royal' status on the international scene.[41] Among the substantial numbers of Dutch paintings included in the important collection of paintings Huygens assembled were significant works by Rubens.[42]

By the late 1640s, Sir Constantijn Huygens occupied an unrivalled position in cultivated circles in the Dutch Republic, as arbiter of taste in all things cultural, from music and poetry to art and architecture. His position

Self-portrait of Pieter Paul Rubens.

as a privileged intermediary between the élites of England and the Low Countries had been further strengthened in 1641 by Frederik Hendrik's son William's marriage to Charles I's daughter Mary. Upon the death of Frederik Hendrik in 1647, William became Stadholder, and Huygens his secretary. Huygens's absolute fluency in English, as well as his extensive

knowledge of England and its customs and practices, made him invaluable to this Anglo–Dutch court, locked in diplomatic negotiations with the English royal family and its supporters throughout the English Civil Wars (1642–49).[43]

In his early experiences in England, we watch the moulding – socially, politically and culturally – of the young Sir Constantijn Huygens, and the beginnings of the considerable influence he came to wield in the formation of opinion and taste over the course of the seventeenth century, between English and Dutch court circles. By mid-century his approval was vital to young international artists and musicians on the make, his personal recommendation ensuring their enthusiastic reception at court and in salons across Europe.

And, of course, the point of greatest interest to us here is that these formative encounters with fine art and music in the most prestigious of contemporary court settings were strenuously Anglo–Dutch. Agents, pro-curers, patrons and collectors apparently move (and move their expensive purchases) between and among circles of like-minded individuals who operate in London, The Hague and Antwerp. The 'Englishness' of Sir Dudley Carleton's opinions regarding Italian and Dutch paintings, and ancient statuary, is shaped and coloured by Dutch and Italian Protestant facilitators to his purchases, and by the involvement of Pieter Paul Rubens – the most internationally famous of Flemish painters at the time – in determining their value and desirability.

So, as we watch Sir Constantijn Huygens tirelessly intervening to facilitate access of appropriately talented musicians and artists to the courts of the Dowager Princess of Orange, the Prince of Orange and the Winter Queen at The Hague, his shaping over time of 'Dutch' taste cannot in fact be separated from the English influences that shaped him, and which he in turn continued to contribute to shaping himself.

Auction, Exchange, Traffic and Trickle-Down: Dutch Influence on English Art

The execution of Charles I in London on 30 January 1649, and the death from smallpox of Prince William II at The Hague in November 1650, coincidentally brought both Orange and Stuart aspirations in art and culture, as they manifested themselves in the public domain, together with their long- and short-term political ambitions, to an abrupt halt.

The mirrored dynastic disasters for the Orange and Stuart élites are well conveyed by the wording of the legislation passed in May 1651 by the States General in the Dutch Republic, at the request of Oliver Cromwell's 'brotherly' republican administration in England, prohibiting Prince William's young widow, Princess Mary Stuart, from offering sanctuary to, or harbouring in any way, her exiled brothers or their followers:

> We propound, that no rebel or declared enemy of the commonwealth of
> England shall be received into or be suffered to abide in any of the castles,
> towns, ports, creeks, or other places privileged or not privileged, which
> the Prince of Orange, Princess Mary the relict of William late Prince of
> Orange, or any other person, of what degree soever, have or hereafter
> shall have or possess by any title whatsoever within the dominions and
> jurisdictions of the United Provinces, nor suffered by the said Prince,
> Princess, or any other person, to any such rebel or declared enemy, but
> shall openly and expresly prohibit and hinder the same.[1]

Any infringement of this order would result in the 'forfeit and losse' of all lands and titles 'for their respective lives'.

The two calamities did not, however, as we might perhaps have expected, interrupt the activities of Dutch artists, nor slow down the buying and selling of Dutch art in both England and the United Provinces.

Rather, they temporarily displaced them from the realm of dynastic ostentation to the domestic sphere. The collapse of court culture on both sides of the Narrow Sea produced an unexpected flurry of movement within the artistic and musical communities in both countries, as courtiers and court hangers-on attempted to continue to make a livelihood, and to promote their cultural interests in the drastically reorganised social landscapes of Commonwealth London and Stadholderless Holland.

On the English side of the Channel, we get a strong sense of this

Titian's Pardo Venus, *acquired by Colonel John Hutchinson at auction from the royal collection after the execution of Charles I.*

defining period of reorganisation and redistribution of art interests through the well-documented rapid sale and dispersal at the end of the English Civil Wars, as settlement for the King's huge accumulated debts, of the extensive collections built up by Charles I. Shortly after Charles's execution, plans were set in motion by the new republican government for the disposal of his personally much-loved and internationally highly-regarded collection of paintings and sculpture. The sale was based on the meticulous inventory drawn up in 1640 by the royal keeper Abraham van der Doort. In the autumn of 1649 some 1,570 paintings were offered for sale, to buyers from England and abroad.[2]

In terms of its capacity to raise revenue, the sale proved a disappoint-

ment. Not only were prices inevitably depressed by the sheer quantity of quality artworks suddenly released onto the market, but other collections, including those of the Duke of Buckingham and the Earl of Arundel, were put up for sale at almost the same time.

Times were bad and money was in short supply. There were many in England who felt uneasy about profiting from the King's downfall, and foreign buyers, although encouraged to participate, preferred to buy anonymously, and at one remove, from the speculators who moved in to make a quick profit by buying low and selling on at a much higher price. The most prominent Parliamentary purchaser was Colonel John Hutchinson, who had been a member of the tribunal that pronounced the death sentence on the King. He spent £1,349 acquiring a large number of works, including two voluptuous, oversized nudes by Titian, *Pardo Venus* and *Venus with Organ Player*. Colonel William Webb (another prominent figure in the Parliamentary administration) bought a number of van Dyck's portraits of the Stuart royal family.

Knowledgeable art connoisseurs from abroad were shocked at the low prices for which works of art by great named artists could be acquired in the aftermath of the English King's execution. Sir Constantijn Huygens's third son, Lodewijk, was in London in 1651 as part of a delegation from the States General of the United Provinces sent to pursue possible closer links with the new English Commonwealth following the execution of Charles I. On the face of it, the prospects for an alliance between the two Protestant republics looked promising. The delegation, however, was made up of strong supporters of the house of Orange, with an equally strong continuing commitment to the rule of their Stuart cousins in England, and came to nothing. As a dutiful Huygens son, Lodewijk made use of the opportunity for tourism, to visit Somerset House – former home of Queen Henrietta Maria – where the dead Charles I's art collection was on display, with everything up for sale to the highest bidder:

> We went to Somerset House again and saw a number of beautiful things, among them the most costly tapestries I ever saw. One room was valued at £300. In that same room were many antique and modern statues, though nearly all damaged. There was also a unicorn cane as thick as an arm, with a large crystal knob.

Lodewijk's training in connoisseurship under the able tutelage of his father, Sir Constantijn, allowed him confidently to identify some of the paintings ranged in disorderly fashion around an upstairs room as of real artistic importance and high value. He was astonished at the low estimates placed on them, though in such uncertain times most of these items failed to realise even these deflated prices:

> In a gallery above, we saw a very large number of beautiful paintings, but all so badly cared for and so dusty that it was a pitiable sight. There was an admirable portrait by Van Dyck of King Charles sitting on a white horse, which could be obtained for £150. Five or six Titians, however, surpassed everything else there, and yet these also could be purchased at a very reasonable price. All these goods, brought together from several of the King's houses, had been given in payment to some creditors of the late Sovereign, who did their best now to get rid of them.[3]

Long before Lodewijk toured Somerset House, incredulous at the artistic riches lying around in neglect, it became obvious that the sale was not meeting expectations. By May 1650 only 375 pictures, roughly a quarter of the total, had been disposed of, for £7,700 in all. A special committee was convened, empowered to settle the debts of former royal servants and other needy creditors with a combination of cash and goods from the collection. The creditors in their turn endeavoured to sell the valuable pictures on. Bakers and butchers, purveyors of bread and meat for the royal household, whose outstanding bills were settled in the form of works of art were only too keen to unload them back onto the market, thereby deflating prices still further. Foreign buyers (generally acting anonymously through local intermediaries) took advantage of the situation. Important works were discreetly acquired by agents acting for the King of Spain, Philip IV – an enthusiast for paintings and other art objects, with a collection to match that of Charles I. A number of important paintings from the King's collection were bought by Dutch collectors, who felt less inhibited than the English about snapping up bargains by painters admired in the Netherlands. While the works acquired by English collectors were forcibly returned to Charles II at the Restoration in 1660, some of those which had been dispersed farther afield remained in the hands of their purchasers. I

*Mary Stuart, the Princess Royal, painted shortly after
the death of her husband William II.*

shall argue that this has had a curious effect upon our retrospective evaluation of what constituted 'great' art in the eyes of the English and the Dutch in the middle years of the seventeenth century.

In the United Provinces, the Stadholderless period (1650–72) had a less obvious impact on fine art and its distribution. In spite of the fact that William III, as a mere infant, could not immediately lay claim to the Stadholdership, and that three years later, under pressure from Cromwell, the States General passed legislation permanently banning the house of Orange from ever again holding that office, the courts of the widowed Princess Royal, the widowed Amalia van Solms, and the widowed and exiled Elizabeth of Bohemia continued to operate as beacons of cultural and artistic activity throughout the 1650s and '60s. One might, indeed, argue that, for the widowed Princess Royal and her mother-in-law Amalia, it became of even greater importance than previously to affirm their international importance and political status by continuing to enlarge their collections of artistic treasures. Just as in the 1630s the leading courtiers around Charles I had jostled for position by competitively purchasing the best and most exotic of art and luxury objects to grace their cabinets of curiosities and galleries, so now the three royal Princesses in The Hague competed for cultural prominence by commissioning paintings, hosting sumptuous balls and masques, and presiding at elegant musical soirées.

The continuing flow of commissions for portraits and engravings of the Princess Royal and her family, under Huygens's watchful eye, and their circulation as gifts around Continental Europe, was a pragmatic part of this strategy for keeping the house of Orange and Prince William III in the public eye. A thriving community of artists conducted their business from The Hague, and a striking number of young Dutch painters continued to gain their early experience in the studios of portraitists working there.

Furthermore, the Dutch already had a distinctly different attitude towards works of art from their English neighbours. Art-purchasing in the United Provinces was not confined to those in court circles and high society. In the

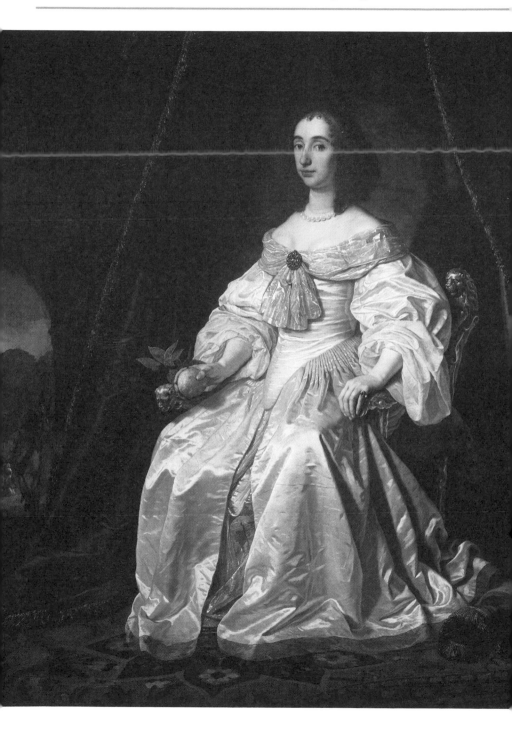

Netherlands fine art already appealed to, and found a market among, town-dwellers and those in commercial circles with large amounts of disposable income. Paintings hung on the walls of the homes of prosperous tradesmen, and the wills of local dignitaries included carefully itemised inventories of paintings and art objects. English travellers comment in their letters and diaries on paintings hanging on the walls of those they would not expect (because of their rank and occupation) to own them. The same English assumption that only the nobility collect art informs the 'world turned upside down' sentiments expressed in London following Charles I's execution when witnesses claimed to be aghast at the sight of van Dyck portraits of the King and his family hanging on the walls of the royal baker.

Dutch purchasers who acquired works from the English royal collection in 1651 were not necessarily of elevated rank, nor – in the 1650s and 1660s – necessarily associated with the house of Orange, prevented by legislation from taking up its traditional ruling position in the Republic. In the United Provinces, men of means, but not of elevated birth, were proud, by the mid-seventeenth century, to own and display works of art.

As a consequence, in Amsterdam, Antwerp and Rotterdam (the main centres for art production and its sale), dealers in cheaper works of art flourished alongside those controlling the commissioning, acquisition and sale of bespoke paintings for wealthy private purchasers. The leading historian of the economics of art at auction in seventeenth-century Holland, John Michael Montias, has distinguished between the activities of high-class dealers acquiring works by well-known artists for relatively knowledgeable and wealthy clients, and those encouraging a demand for less ostentatious art by ordering cheaper originals and copies: 'while some dealers specialised in mediating the demands for art works, others concentrated on increasing the supply of works available in the market'.[4] A figure like Huygens's close friend, the Antwerp diamond merchant and art dealer Gaspar Duarte, for example, himself a very considerable art collector who entertained the great and the good in his luxurious private home, clearly helped shape and develop the tastes of those who purchased from him.[5] We can see the effect of Gaspar Duarte's influence if we look at the inventory of Duarte artworks made on behalf of his son Diego in 1683. This listed more than two hundred paintings including works by Holbein, Raphael, Titian,

Rubens, van Dyck and Vermeer (*Young Lady Playing the Clavecin, with Accessories*, believed to have been given to Duarte by Huygens).[5]

By contrast, the turnover in artworks offered to ordinary individuals on the open market – through general dealers or at auction – was much faster, and included those bought largely for investment purposes. Accessible markets held two or three times a year, at which paintings were freely bought and sold, were a source of some astonishment to English travellers. Visiting such a Dutch art fair in 1641, John Evelyn commented:

Young Lady Playing the Clavecin *by Jan Vermeer.*

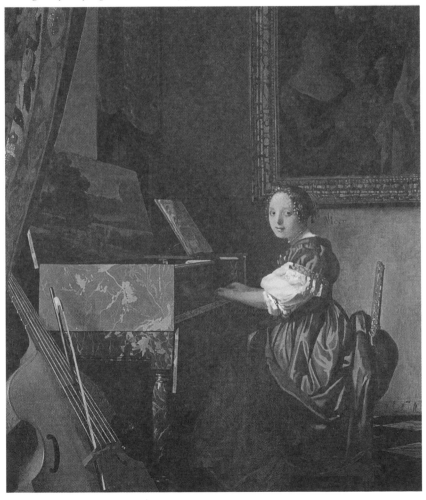

We arrived late at Rotterdam, where was their annual mart or fair, so furnished with pictures (especially landscapes and drolleries, as they call those clownish representations), that I was amazed. Some of these I bought, and sent into England. The reason of this store of pictures, and their cheapness, proceeds from their want of land to employ their stock, so that it is an ordinary thing to find a common farmer lay out two or three thousand pounds in this commodity. Their houses are full of them, and they vend them at their fairs to very great gains.[6]

Art auctioned in Antwerp passed from one owner to another quite rapidly, whereas élite owners considered their acquisitions as part of a sustained process, sometimes extending over an entire lifetime, of building a valuable and distinguished collection. The middle half of the seventeenth century was a period during which plague and other epidemics took their toll. It was also a period of fluctuating financial fortunes, with bankruptcy a frequent occurrence among those trying to make their living in the new markets. Art collections crop up regularly in the 'Orphan Chamber' auctions in Amsterdam, at which the possessions of deceased citizens were sold on behalf of their underage heirs, in order to provide for their subsequent upbringing, and in the so-called 'Desolate Boedelkamer' (bankruptcy chamber). Here, complete collections of systematically accumulated paintings which had hung on the walls of one family home, pass to another. In a number of such cases, relatives of the deceased acquired several items, or entire collections, thereby keeping well-loved works in the family.[7]

Paulus Bisschop, whose art collection was auctioned by his widow in 1620, was born in London to parents from the south Netherlands, and lived there until at least 1601, when he was betrothed to Elizabeth van der Moer. After Elizabeth's death he remarried, and moved back to the Low Countries, where he built up a significant collection of paintings by northern artists. Bisschop's second wife was Petronella van Baerle, the sister of David van Baerle. Another sister of David's, Susanna, married Sir Constantijn Huygens. At the auction of Paulus Bisschop's art collection, David van Baerle bought four Dutch paintings, while another brother, Johan van Baerle II, bought four further paintings and 'an atlas with horn bound in gold'.[8] All but one of the paintings – including several landscapes and a 'painting of a market with fruit' – cost them between nine and fifty-

six guilders; the most expensive of the works acquired was a landscape by Gillis van Coninckloo, for which Jan paid 120 guilders. When David himself died, his 1671 inventory still contained a number of the paintings he had acquired more than fifty years earlier.

Auctions, however, introduced a further element of risk into the acquisition of works of art. Private dealers could be asked to vouch for the authenticity of a work attributed to a particular artist, and buyers could — and did — complain to the supplier of a painting if it failed to comply with the description provided by them. Sir Dudley Carleton, for instance, protested to Rubens that paintings offered to him as by the hand of the artist himself were in fact largely the work of his studio. Rubens was quick to replace them with works he could vouch for as being entirely his own — it would not do to acquire a reputation for passing off inferior work as original. In a market in which legitimate copies of rare works and works by prestigious artists circulated freely, a bidder at auction might find himself with a copy when he had believed himself to be bidding on an original.

Jan Meurs, an Antwerp city councillor, died in January 1652. He left an impressive collection of paintings, largely by artists from the region, and the sale of his effects in May caused a considerable stir. A number of items were carefully identified in the sale catalogue as copies (mostly of rare works which Meurs knew he was unlikely ever to get the chance to purchase as originals). Several further items, however, were listed as originals, but had had questions raised about them by the auctioneer, Hendrik Tessers, who was knowledgeable about paintings. One of these was a *Cattle Market* by Jan I Brueghel, which Tessers was unsure was genuine. At the auction itself, Tessers began the bidding on the Brueghels with a landscape, which was bought by the painter and art dealer Jan Siebrechts for 204 guilders. The next lot was the *Cattle Market*, presented as an authentic original, and after lively bidding this went to Peter van Halen, painter and dean of the Guild of Saint Luke, for 160 guilders.

Once van Halen had got home and taken a close look at it, he decided that the painting he had bought was not an original but a copy. Furious at what he considered a deliberate deception, he rushed off to the Meurs family home, where Siebrechts, delighted with the landscape he had bought, was chatting to one of Meurs's sons. Van Halen stood in the street

and loudly demanded compensation, on the grounds that he had been sold a copy, and not an original ('*gheen principael*'). Finally Meurs's son replied: 'I cannot help you there – my father bought it as an original so we sold it as one.' Van Halen retorted that the family had better get hold of the person who sold it to them to vouch for the painting, because he was going to go to law. After three years of lawsuits, van Halen managed to establish that the painting was indeed a copy: 'his expertise overrode the picture's supposed provenance, and he recovered his money as a buyer and his honour as dean of the painters' guild'.[9]

There is, fortunately, a wealth of surviving documentary evidence, on the basis of which it is possible to take a closer look at some of the ways in which the initially separate trends in taste, stylistic appreciation and acquisition on

the part of art-purchasers, patrons and connoisseurs in England and the United Provinces began to converge during the middle decades of the seventeenth century.

In the half-century before the 1650s dip in the fortunes of the houses of Stuart and Orange, the ground had already been thoroughly prepared for the effortless and easy transmission of art connoisseurship, artists and works of arts in both directions across the Narrow Sea. At the centre of the expanding network created by this developing, shared pool of taste and artistic enthusiasm we find, again and again, the figure of Sir Constantijn Huygens. In the previous chapter I described the process whereby his taste in art was shaped by his three trips to England between 1618 and 1624 – a process which, intriguingly, included close involvement in high-level

Head of Medusa by Rubens, commended by Huygens for creating 'terror'.

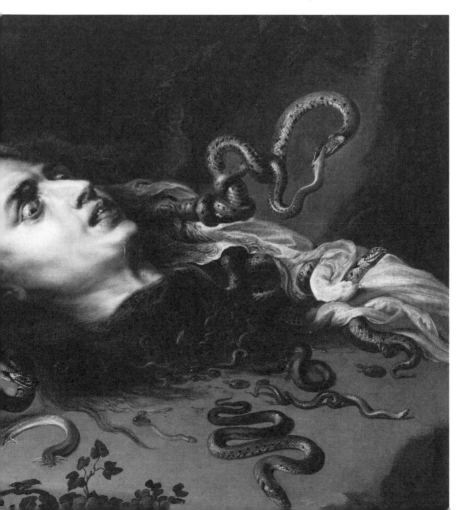

dealing in contemporary art in English court circles. Now we need to look at his experiences of fine art in a Dutch context, between 1625, when he assumed the position of secretary to the new Dutch Stadholder, Frederik Hendrik, and the late 1660s, when the house of Orange resumed its pivotal position in Dutch politics and culture.

We are fortunate in having a detailed account by Constantijn Huygens himself of the artists he considered the leading lights of their generation, including precious critical comments on works of art we can still identify, and to which we can refer.

In an early fragment of autobiography written in the late 1620s and made public around 1630, Huygens, commenting on the state of contemporary Dutch art, selected for particular mention two young artists from Leiden for whom he predicted stellar careers: Jan Lievens and Rembrandt van Rijn. Here were two 'moderns' – contemporary young artists (both were under twenty-five at the time) – from modest backgrounds, whose virtuosity entitled them to consideration as outclassing in artistic terms more long-established names among Dutch painters. Demonstrating his command of the Dutch art world, Huygens conceded that Hendrik Goltzius and Michiel van Mierevelt were artists of distinction, but believed that Cornelis van Haarlem was old-fashioned. Although he criticised Hendrik Hondius for technical shortcomings as a painter of landscapes, he expressed the belief that a whole school of Dutch landscape painters, including Poelenburg, Uytenbroek, van Goyen, Jan Wildens, Paul Bril and Esaias van de Velde, were exceptionally accomplished, to the point of being able to show 'the warmth of the sun and the movement caused by cool breezes', and a match for artists from anywhere else in Europe.[10]

Dutch narrative history painters also meet with Huygens's warm approval. He judges them a match for any of the Italians (hugely in vogue with the royal courts of England, Spain and Italy). Pieter Paul Rubens is, in Huygens's view, undoubtedly the greatest of them, but he also names Honthorst, Terbrugghen, van Dyck and Janssens. He singles out a Medusa by Rubens for special approval – it 'combines charm and horror', especially because it is hidden behind a curtain, which is drawn back to create 'terror'.

But above all, he expresses the view that the future of Dutch fine art lies with the younger generation of painters, from among whom he singles out Lievens and Rembrandt. Rembrandt is, Huygens thinks, superior to

Lievens in judgement and in the representation of lively emotional expression. Lievens, however, depicts 'that which is magnificent and lofty', 'larger than life'. Rembrandt, by contrast, 'loves to devote himself to a small painting and present an effect of concentration', as in his *Judas Returning the Pieces of Silver*. What impresses Huygens about this painting is Rembrandt's ability 'to depict expression, appropriate gestures and movement, particularly in the central figure of Judas, whose face is full of horror, whose hair is in wild disorder and whose clothes are torn, his limbs twisted, his hands clenched bloodlessly tight'. The whole body of the kneeling Judas 'seems ravaged and contorted by his hideous despair'.

From this remarkable fragment we discover those characteristically modern and Dutch features of contemporary painting which drew the eye and the approval of Sir Constantijn: concentration, precision and detail in depiction, and above all, the capacity to convey intensity of personality and feeling by way of the painted image.

We gain further insight into Huygens senior's taste through the surviving portrait Lievens painted of him, some time around 1625, concerning which we also have Huygens's own critical comments.[11] As Huygens describes it, once having met him (and been praised by him), Lievens badly wanted to paint him, and having obtained permission, arrived only a couple of days later, saying that he had been unable to sleep because of his excitement at the prospect.[12]

Huygens later described the sombre Lievens portrait as one of his 'dearest belongings'. In spite of what others have said about the painting, Lievens has, he says, painted him as he was at the time. He goes on:

> Still, some deem it necessary to point out that my pensive stare overshadows the natural cheer of my mind. To them, I'd like to say that I have myself to blame for this, because at the time I was seriously involved in very grave family matters, and, as things are wont to go, the concern that I tried to hide inside was not completely left without its trace in the expression on my face.[13]

Lievens's portrait is broodingly dark and melancholy. As far as critical appreciation goes, we have a number of helpful comments by Huygens himself upon it. Portraitists, he tells us in that early autobiography, strive

Portrait of Huygens by Jan Lievens, painted around 1625.

to represent the inward soul of their sitter, not simply his outward appearance. Nor is this as difficult as it sounds. 'After all,' he writes, 'the expression on our face offers a highly reliable indication of the status of our soul.' 'In case someone would want to argue against this', he goes on, he himself has learned it 'not so much by the lessons given to me by others, but through personal experience and great attention to the matter'.[14]

In his 1629–30 appreciation of Lievens's and Rembrandt's pre-eminence as Dutch artists, Huygens senior urged the two of them (they were sharing a studio at the time) to go to Italy to further improve their technique. In

fact, the career paths of the two men parted at this point, and Lievens took another route to international recognition. Some time in 1631 or early 1632 Sir Constantijn Huygens seems to have introduced him to Anton van Dyck, who was visiting The Hague, and who sketched Huygens for inclusion in his print series known as the *Iconographia* during his stay.[15] Lievens had already formed a plan to travel to England in 1629: in April of that year he petitioned the city guard of Leiden to release him from his obligation to serve on the night watch there for a period of three months, so that he could finish a painting commissioned by the Stadholder. He promised then to fulfil his obligation, unless he carried out his plan to travel to England. Now, a year and a half later, van Dyck seems to have persuaded him to try his luck with him at the English court.

Before he left, however, Lievens painted several fashionable 'story portraits' for the court of Frederik Hendrik and Amalia van Solms at The Hague, thereby smoothing his way into Stuart circles across the water in London. The most ambitious of these — a large *Soothsayer* — hung over the fireplace in the Stadholder's own quarters: '*Een stuck schilderei daer een waerseghster off een heyen in de handt goeder geluck seght*' ('A painting of a soothsayer telling fortunes by reading palms'). 'The painting shows an old woman with a child on her back who has put down a basket and kneels, holding the palm of a richly clad young woman in a chair. Behind is a girl in white and to her right an African woman in silhouette.'[16]

Lievens's reputation preceded him at the court of Charles I — Robert Carr had presented the King with a Lievens painting acquired by the Dutch Stadholder, while Charles I's sister, Elizabeth of Bohemia, had commissioned a portrait of her eldest son by him. We can be sure that Huygens, who was a trusted adviser both to the household of Frederik Hendrik and to that of Elizabeth, and who knew the English Stuart court well from his three visits there, facilitated Lievens's entry into patronage circles at Whitehall.

The transition was a success. Lievens's biographer Orlers tells us that in London he, 'thanks to his artful works immediately became famous, even to His Majesty the King, who he portrayed with his wife the Queen, the Prince of Wales his son and the Princess his daughter, together with many great Lords. He was richly paid by the King of Great-Britain for these.'[17]

Van Dyck's dramatically successful career at the Stuart court in London is well documented. He had gone to England for the first time in

Self-portrait by Anton van Dyck.

1620–21 at the invitation of the Earl of Arundel, who had made enquiries concerning his availability while he was still working for Rubens in Antwerp in 1620. Van Dyck travelled in Italy and France between 1621 and 1627, returning to Antwerp, and then visiting The Hague in 1631, at exactly the time that Lievens was at work there. Van Dyck moved to London via Brussels in 1632, arriving there by the beginning of April, and was named court painter to Charles I shortly after his arrival. The last evidence of Lievens's presence in Holland is his signature on a document dated 6 February 1632, and his most recent biographer maintains that he and van Dyck must have arrived in London almost simultaneously.[18]

By the time Lievens arrived with van Dyck, Dutch and Flemish artists

were already well established at the English court. Rubens, van Dyck and Gerrit van Honthorst had all had major commissions.

The Utrecht artist Honthorst had already travelled extensively in Italy before he was brought to the attention of Charles I by the English Resident Sir Dudley Carleton, who sent a sample of his work in 1621. It was in fact Balthasar Gerbier, acting as agent for the Duke of Buckingham, who in 1628 brought Honthorst to England, where he stayed for eight months, until the assassination of his patron sent him hurrying back to Holland, though not without substantial signs of recognition from Charles I: English citizenship, a £100-per-annum pension, a silver service and a horse. Honthorst settled at The Hague, where he became enormously successful as a portrait painter. His work for Elizabeth of Bohemia included a family portrait commissioned as a gift for the English King, Charles I.

Many major court commissions by van Dyck survive today in the Royal Collection in London, and further examples are distributed across Europe. By contrast, deceptively few works by Lievens from this period are to be found, in spite of the fact that according to Huygens he was known for his 'indefatigable application to diligent labour'. In part, this is simply an accident of history (and his most recent biographer has suggested that works attributed to other artists are in fact Lievens's). In part also, it may be a direct result of the way that Charles I's collection was dispersed after his execution (by way of the auction, the viewing for which, as we saw, was attended by interested Dutch art connoisseurs, including Lodewijk Huygens), and also the way it was reassembled at the Restoration. While some works bought by overseas buyers were returned in 1660, many more remained in mainland Europe.

Lievens returned from England to the Netherlands in 1635 and settled in the second centre of art activity after The Hague, the Flemish trading city of Antwerp, shortly after van Dyck's arrival there (though van Dyck, unlike Lievens, was to return for a further period to work in London). After a brief return to Leiden, he settled in Antwerp for the next nine years.

We have no comments by Sir Constantijn Huygens himself on the execution or critical success of a second immediately recognisable and frequently reproduced portrait, which hangs today in the Mauritshuis at The Hague. Constantijn Huygens senior was painted around 1640 by another artist who shuttled between patrons, clients and milieux in England and

Portrait of William III as a child by Hanneman (1654).

the United Provinces, Adriaen Hanneman. This is a family portrait, showing Huygens and his five children, their portraits placed symmetrically in roundels around the central portrait of their father, with the roundel at the bottom replaced by a cartouche, which contains an inscription. The work is probably a silent tribute to his wife Susanna (a portrait of whom might have sat in a sixth, completing roundel), who had died in 1637.

Adriaen Hanneman had trained in The Hague with the portraitist Anton van Ravestijn, with whom Lievens had also worked during his period there.[19] In 1626 Hanneman moved to London, where he may have worked as assistant to Daniël Mitjens (another Dutch artist who had worked first for the Earl of Arundel, and then for Charles I). In 1630 he married an English wife, Elizabeth Wilson, having first unsuccessfully courted the daughter of goldsmith Nicasius Russell. Although she may have died by 1635, it is clear that Hanneman was well integrated into London life, and a competent English-speaker.

Some time between 1638 and 1640 Hanneman returned to the United Provinces, settling in The Hague, where he married for a second time, the niece of his old master, Maria van Ravestijn. Thereafter he built a thriving portrait-painting business in The Hague, benefiting particularly from the arrival of a steady flow of privileged exiles from England, fleeing the Civil Wars. By 1645 he had gained the patronage of Frederik Hendrik and Amalia van Solms, and also that of Princess Mary Stuart (the 'Princess Royal'). There can be no doubt that this patronage was secured through the efforts of Sir Constantijn Huygens, whose efforts to develop a sophisticated artistic style and iconography on behalf of both courts at The Hague were at their most successful and energetic at this time. In 1646, Hanneman painted the portrait of the fourteen-year-old Princess Mary, in a 'jauntily feathered cap with a sheaf of arrows slung upon her back, a costume which imitates the "huntress" fashion employed several years before by her exiled Palatine cousins at the Hague'. In January 1650, we have a record of a payment made to Hanneman for 'several likenesses executed by him in the service of the Princess Royal'.[20]

Hanneman also painted portraits of Charles II himself (1648), Charles's sister, Henriette, Duchess of Orléans, his cousin Louise Hollandine

(daughter of Elizabeth of Bohemia), as well as prominent officials of the English court in exile, like Sir Edward Nicholas (1652 or 1653). The Princess Royal was an important and influential patron of Hanneman. 'The close family ties between Dutch and English royal families continued to produce commissions for Hanneman even after the Royalists had all returned home. In 1664 he executed two copies of a portrait of William of Orange (both Royal Collection), for which he was paid 500 guilders. He also found patrons among wealthy residents of The Hague, including Cornelia van Wouw, whose portrait he painted in 1662 (van Wouw almshouse, The Hague). For these sitters he combined the glamorous style of van Dyck with the more sober Dutch tradition of portrait painting.'[21]

So when Hanneman painted the portraits of Sir Constantijn Huygens and his children in 1640, we may consider this picture as a monument to more than a family which had recently lost a mother. It is also a memorial to a fascinating moment in Anglo–Dutch art history, when the English Channel was no obstacle at all between artists and clients who confidently shared the same taste in the styles and execution of expensive portraiture. In The Hague, Princess Mary Stuart liked to sit for Adriaen Hanneman because he could converse with her in English during their sittings. Perhaps Sir Constantijn Huygens indulged his personal love of the English language by doing likewise.

While Hanneman took advantage of the turbulent times to build a flourishing business in portraits of Orange and Stuart princely sitters and English exiles associated with them at the courts in The Hague, another Dutch painter was doing the same for those in and around the milieu of Oliver Cromwell and the Parliamentarians in England. Pieter Lely's family came from The Hague, and he received his training in Haarlem as a pupil of the artist Frans Pieter de Grebber. By 1643 he was in London, where the Civil Wars interrupted his career as a promising portrait-painter, perhaps hoping to take the place of Anton van Dyck (who had died in 1641). During the Commonwealth years Lely seems to have continued to work for important former court patrons in London, while maintaining links with The Hague (he was there in 1656 on family property business), at the same time building up a clientele among influential Parliamentary and Commonwealth figures.

In 1653, three established Dutch portraitists resident in London – Pieter

Lely, George Geldorp and Sir Balthasar Gerbier – petitioned Parliament for a commission to decorate Whitehall Palace with a series of paintings celebrating Parliament's victories in the Civil Wars, including individual portraits of its most important generals and commanders. They proposed a large group portrait commemorating 'the whole Assemblie' of Parliament to decorate one wall of 'the great Room, formerly called the Banqueting House'. On the opposite wall there was to be a group portrait of members of the Council of State.[22] Although the proposal was not acted upon, the following year Lely painted the portrait of Oliver Cromwell. By 1658 Lely was described by the seventeenth-century historian William Sanderson as one of the seven notable 'Modern Masters' of English portrait painting.

At the Restoration in 1660, Lely had sufficiently hedged his bets, established a high enough reputation as a portraitist, and gained enough influential supporters in the King's party, to be sworn in to the post of Charles II's principal painter (George Geldorp also managed to survive the change of regime, and was appointed picture-mender and cleaner to Charles II). The first instalment of his annual pension of £200 'during pleasure as formerly to Sr A. Vandyke' was made in October 1661, and he was granted naturalisation by Parliament on 16 May 1662 and exempted from paying local taxes.

Lely's career continued to flourish, as the returning Royalists celebrated their return with family paintings proclaiming the new English royal order. His most important royal patrons were James, Duke of York (later James II), and his first wife, Anne Hyde. His first portraits of them were the pair of pendant paintings commemorating their wedding in 1660. These were commissioned by Anne's father, Edward Hyde, 1st Earl of Clarendon. Lely seems to have met the Hyde family in exile in The Hague, in that other cultivated courtly circle, with its shared Anglo–Dutch tastes and artistic preferences. Over a four-to-five-year period beginning in the early 1660s, the Duchess of York commissioned him to paint a group of three-quarter-length portraits, known as the 'Windsor Beauties', of the most good-looking women at her own and Queen Catherine of Braganza's courts. Samuel Pepys records that he saw a full-length portrait of Anne, in a white satin dress, seated on a chair of state, in Lely's studio on 18 June 1662, and a few years later Lely painted a seated full-length portrait in which Anne holds a tress of hair in her right hand.[23]

Sir Pieter Lely self-portrait.

When Lely died in 1680 he was an extremely wealthy man, with a fashionable house on the piazza in Covent Garden, another house at Kew and further properties at Greetwell and Willingham in Lincolnshire and in The Hague. He was also the proud possessor of an impressive art collection of his own, containing no fewer than 575 paintings, although over half (about 320) were works either by himself or his studio. Of the rest the

largest proportion were by Dutch and Flemish artists. Lely was an unusual and early example of a painter who also collected, and his interest in acquiring other artists' work was probably triggered by that very sale of 'the Late King's Good's' in the early 1650s whose low prices and lack of orderliness had so shocked the young Lodewijk Huygens. Lely purchased eight paintings there, all of which were returned in 1661 to the 'Committee for the Restoration of the Royal Collection'. The Dutch artist turned art dealer Gerrit van Uylenburgh, who worked briefly in Lely's studio, valued the collection at approximately £10,000.

In 1631, Rembrandt and Lievens both painted different versions of the Crucifixion, perhaps as an official competition staged by Huygens. Immediately afterwards, Rembrandt was awarded the commission for a series illustrating Christ's Passion for the Stadholder. In 1639, with the series still incomplete, Rembrandt wrote to Huygens to tell him that two paintings, 'being the one where the dead body of Christ is laid in the grave and the other one where Christ rises up from the dead to the great shock of the guards', were now complete:

> I therefore would request if my lord could please tell his Highness of this and if my lord could please have the two pieces first delivered to your house as happened before. I will wait first for a short note to this effect.
>
> And since my lord will be bothered with this business for the second time in recognition a piece 10 feet long and 8 feet high will be included as well which will do honor to my lord in his house.[24]

Like those dealing in art for the top end of the market today, Sir Constantijn Huygens became the possessor of a large work by Rembrandt of his own, as recompense for the time and trouble he had taken in securing the deal and seeing it through to completion.

Huygens retained his commitment to the talents of Lievens and van Dyck throughout his life. In 1633 he penned a commendatory distich on a sketch by Rembrandt of his old friend Jacob de Gheyn III (Huygens's companion on that memorable first tour of the major private art collections of England):

Rembrandtis est manus ista, Gheinij vultus:
Mirare, lectore, es ista Gheinius non est.
[Rembrandt's is the hand here, the face is de Gheyn's:
Marvel, dear onlooker, that this is not de Gheyn in person.]

In the end, though, he (unlike us) preferred a more intense, painterly representation of human feeling, and greater attention to detail than that developed by Rembrandt in his maturity. Rembrandt's name was not among those selected by Huygens senior to decorate the memorial room at the Huis ten Bosch following Frederik Hendrik's death in 1647.

Sir Constantijn Huygens's influence as an artistic facilitator, adding lustre to the reputations of the princely courts at The Hague by astute encouragement of talent and acquisition, was by no means limited to painting. An enthusiast for classical architecture, he also encouraged a generation of classical sculptors, whose work adorned houses like his own in The Hague. One of these was François Dieussart, with whom Huygens was closely involved for the ten years during which he lived and worked in The Hague (Dieussart arrived in 1641 bearing a letter of recommendation for Huygens from Gerrit van Honthorst). Through Huygens, Dieussart received a number of important commissions. The year of his arrival he executed an Italian marble bust of Elizabeth of Bohemia, followed by marble busts for the large reception room in Johan Maurits van Nassau-Siegen's newly completed Mauritshuis, and a bust of the Elector of Brandenburg for an overdoor niche in the bedchamber. In 1646, Dieussart produced a dynastic series of full-length figures of the Princes of Orange for the Huis ten Bosch. For this last commission, Huygens was responsible for negotiating the conditions of delivery and the cost, as well as keeping an eye on the sculptor's progress. In April 1646, Huygens wrote to Frederik Hendrik assuring him that he expected to get the price of the four statues reduced:

> On Wednesday evening, the sculptor Dieussart will give me four little clay models for Madame's [Amalia van Solms's] statues. He is quoting 1000 francs each, not including the marble, which adds about another 200 francs, but I think I can make him see reason.[25]

Like other artists who had depended heavily on expensive commissions from within the court circle, Dieussart left The Hague in 1650, shortly after the death of William II.

By the Restoration, then, artistic taste and artistic practice on either side of the Narrow Sea were strenuously entwined. And throughout the period 1630–60, Sir Constantijn Huygens advised, facilitated and pressured in England and the United Provinces, establishing a vigorous dialogue between the growing number of connoisseurs both within and beyond court- or pseudo-court-related circles in both places. If developing tastes began to elide during this thirty-year period, it is not an exaggeration to suggest that he was in large part responsible.

So it is no surprise to find him involved in another watershed art 'moment' – the hasty assembling of a gift of suitably distinguished paintings by the States of Holland to present to the English King, Charles II, as he returned to his artistically-depleted kingdom in 1660.

In spring 1660, as Charles II gathered his supporters and future ministers around him in the northern Netherlands prior to his return to England to lay claim to the throne, the States of Holland and West Friesland resolved to secure the favour of the new King by making him a fine and memorable diplomatic gift. Its expensive centrepiece was a magnificent, highly decorated carved bed, with bed-furnishings, and there was also the promise of a handsome ship, to be called the *Mary*. But the 'Dutch Gift' also included a carefully selected group of paintings by major, recognised artists, and a number of classically inspired sculptures.

By the late 1660s, Sir Constantijn Huygens was in his seventies, with a career's worth of experience brokering art and culture for the house of Orange. He occupied an unrivalled position in cultivated circles in the Dutch Republic, as arbiter of taste in all things cultural, from music and poetry to art and architecture. When it came to the delicate task of selecting a few Dutch pieces to include in the 'Dutch Gift', he was the obvious expert to consult.

Discreet enquiries had been made, and it had been determined that Charles's taste, like his father's, was for Italian art and antique statuary.

Accordingly, most of the works presented were by Italian masters, beginning the process of reassembling a major collection for the English monarch to replace that sold off and dispersed by the Commonwealth in 1650. Art connoisseurship at The Hague now tended towards modern, Dutch works — visiting the palace of Rijswijk some years earlier, John Evelyn had commented that there was 'nothing more remarkable than the delicious walks planted with lime trees, and the modern paintings within'.

So the Italian paintings and sculptures for Charles's 'Dutch Gift' were acquired, conveniently, from the collection of the art-collecting brothers Gerrit and Jan Reynst, which had recently come on the market, following the death of Gerrit in 1658 (Jan had died in 1646).[26] This was one of the most celebrated collections of Italian paintings of its time — though later the authenticity of a number of prominent works in it would become a very public matter of dispute.[27] The States of Holland approached Gerrit Reynst's widow, Anna, with the proposal that they should select from among her late husband's paintings and sculptures a group of the most outstanding. In September 1660 the sculptor Erasmus Quellinus and the dealer Gerrit van Uylenburgh chose twenty-four pictures and twelve statues, which arrived in London at the beginning of November, and were exhibited in the Banqueting House at Whitehall. Charles II ceremoniously paid a visit to inspect the paintings, and his evident delight caused a considerable stir.[28]

In addition to the Italian artworks, with their acknowledgement of the Stuart taste of Charles II's father, the Dutch Gift included four contemporary Dutch paintings. One of these was a classic near-contemporary work: Pieter Saenredam's *The Large Organ and Nave of the St Bavokerk, Haarlem, from the Choir* (1648), which was purchased from the Amsterdam Burgomaster Andries de Graeff. The other three were bought directly from the much-admired 'modern' artist Gerrit Dou. One of these was a characteristic Dutch domestic interior (exquisitely detailed): Dou's *The Young Mother* (1658), now in the Mauritshuis at The Hague.

In the case of Saenredam's *Large Organ and Nave of the St Bavokerk, Haarlem, from the Choir*, the connection to Huygens's patronage can be documented,

Gerrit Dou's The Young Mother, *part of the 'Dutch Gift'*
presented to Charles II at his Restoration.

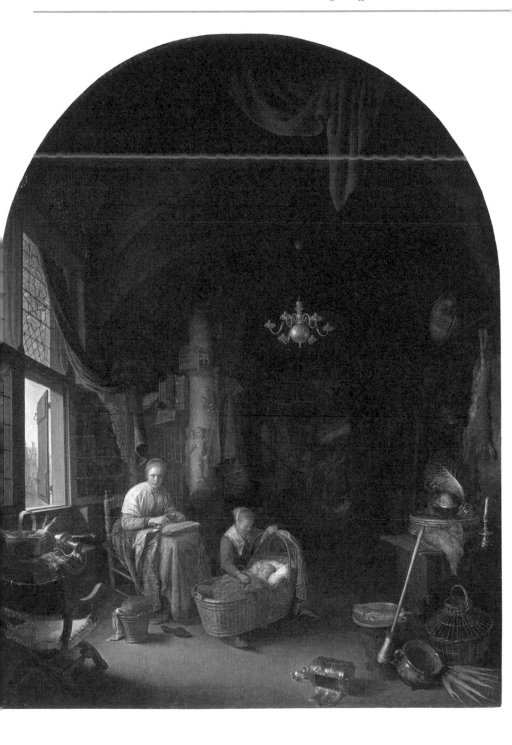

since we can identify this very painting, acquired from de Graeff, as one that Huygens had seen some years earlier, and considered purchasing himself. On 21 May 1648, Pieter Saenredam wrote a letter to Huygens, following up an approach by Huygens on behalf of Stadholder Willem II concerning some newly completed works:

> My Lord van Zuylichem, It pleases me very much to hear that His Highness has begun to take pleasure in paintings, that he indeed desired to see my recently completed great church, and that he wanted to have it shipped now, in which I foresee, on the basis of continuous experience, difficulties of such magnitude, too long to relate, that I do not dare ship it or take that risk.
>
> Nonetheless I cordially wished that His Highness saw the same with his own eyes, as has happened with you, My Lord. I have had this piece along with five more of the largest brought to Monsr Vroons.
>
> As for the price of the church, I trust that Your Excellency still recalls our oral discussion.[29]

Huygens had clearly been with Saenredam, seen the paintings, and discussed purchase prices. Nothing, however, came of the Stadholder's interest in the St Bavokerk painting – Saenredam was never represented in the collections of the house of Orange. But it is possible that the six paintings were indeed sent via Vroom to The Hague, and five of them were purchased instead by Huygens himself, and thence entered the collections of members of his family. *The Large Organ and Nave of the St Bavokerk, Haarlem, from the Choir*, was sold to Andries de Graeff, from whose collection it was acquired by the States of Holland to give to Charles II.[30] It is a particularly appropriate piece for the Protestant monarch, in a strongly symbolic moderate Protestant Dutch tradition.[31]

Recent work on the art market in the northern Netherlands has stressed the fact that in the mid-seventeenth century, 'access to the latest artistic knowledge depended on personal introductions, from patrons to painters and painters to patrons. Even in the Dutch Republic, where painters sold their works through myriad channels, from auctions and dealers' shops to fairs and lotteries, some of the most innovative and expensive art remained primarily accessible through private élite

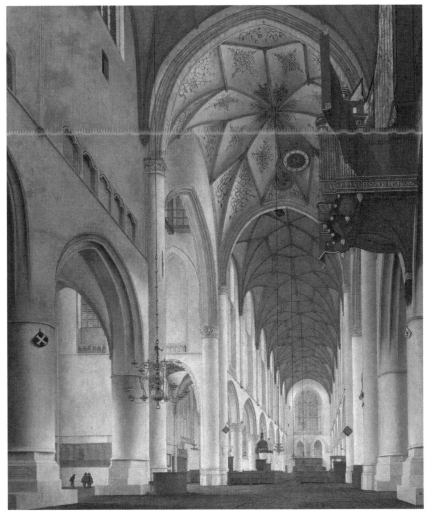

Pieter Saenredam's Large Organ and Nave of the St Bavokerk, Haarlem, from the Choir, *part of the 'Dutch Gift'.*

channels.'[32] As well as his brokering of art acquisition for the house of Orange, Huygens also acted as just such a trusted facilitator, helping would-be collectors gain access to the already highly-esteemed northern Netherlandish painters in the 1660s.

Gerrit Dou received his training as an artist alongside Jan Lievens, in Rembrandt's studio at Leiden. He entered Rembrandt's studio in February

1628, at the age of fourteen, and remained there for three years, until he became 'an excellent master'. Since Lievens painted Huygens's portrait at just around this time, we may assume that Huygens also made the acquaintance of Gerrit Dou (though Dou was too young to be included in his autobiographical fragment from this period, which included a celebration of the Rembrandt studio).

In 1669, Pieter Teding van Berckhout, a patrician of The Hague with family connections to both the Huygens and Paets families, visited Delft in the company of Huygens. He noted in his diary that he paid a call on 'an excellent painter named Vermeer'. On a second visit to the 'celebrated painter named Vermeer' van Berckhout saw several 'curious perspectives'. In assessing the value of Vermeer paintings currently on the market, he and Huygens compared these with prices for comparable works by Gerrit Dou.[33] Here is somewhat more circumstantial evidence that Huygens probably played a part in selecting Dou's work to be included in Charles II's 'Dutch Gift'.

The arrival of the Dutch paintings in the Royal Collection made a tremendous impression on the English art-appreciating public, particularly after their public display at Whitehall, and may be credited with helping to consolidate a taste and a flourishing market for contemporary northern Netherlandish art in Britain. Evelyn saw the Dou (and another 'rustic' painting) at court, on 6 December 1660, and wrote with approval:

> I waited on my Bro: & sister Evelyn to Court: Now were presented to his Majestie those two rare pieces of Drolerie, or rather a Dutch Kitchin, painted by Douce [Dou], so finely as hardly to be at all distinguished from Enamail.[34]

The King himself is supposed to have been so charmed by the exquisitely detailed painting that he offered Dou the post of court painter (Dou declined).[35]

And the story of Anglo–Dutch cultural circulation and percolation does not, in fact, end here. When William III came to the throne in 1689, he quickly identified major works by artists Huygens had encouraged his

family in the Low Countries to acquire in the English Royal Collection, and selected them to be shipped back to Holland, to be hung in his royal palaces, like Het Loo. There they joined the extensive house of Orange art collections, some of them – like the Dou *Young Mother* – being given pride of place for their exceptional quality.

The exquisite little Dou painting which had been included in the Dutch Gift to Charles II in 1660 was removed from London by William and Mary and taken to Het Loo, where it hung in pride of place over the fireplace in Queen Mary's private apartments. An English visitor who had known her toured Queen Mary's apartments at Het Loo around 1700, and reported on the splendour of the royal closet, or private sitting room, closely hung with exceptionally fine paintings:

> In the first closet were several good paintings in bright colours. Through that we passed into a second which was hung with extraordinary fine paintings. There was a small piece of a woman rocking a cradle [the Dou], which was valued at 16,000 guilders.[36]

After William's death, the English Crown had to apply to the Dutch government for the return of these paintings – with limited success. In the early-eighteenth-century inventory of paintings which ought to be returned to the Royal Collection in England, drawn up by the English Resident Ambassador Alexander Stanhope, the Dou was prominently listed as needing to be recovered. Today, it still hangs in the Mauritshuis – too beautiful a painting for the Dutch ever to have relinquished to the less appreciative English.[37]

Here, perhaps, lies the answer to the vexed question of what happened to the Jan Lievens works produced for the court of Charles I during the 1630s. A growing taste in England for Dutch painters of both portraits and landscapes developed from the 1660s, as exiles returning home absorbed tastes they had acquired abroad, which merged seamlessly with tastes established by Dutch artists working in England before the Commonwealth period. Samuel Pepys (to take just a single example) records his admiration for perspective paintings by Samuel van Hoogstraten that he had seen at wealthy city entrepreneur Thomas Povey's house, and in 1669 himself commissioned his own Dutch 'landskips' in 'distemper' by

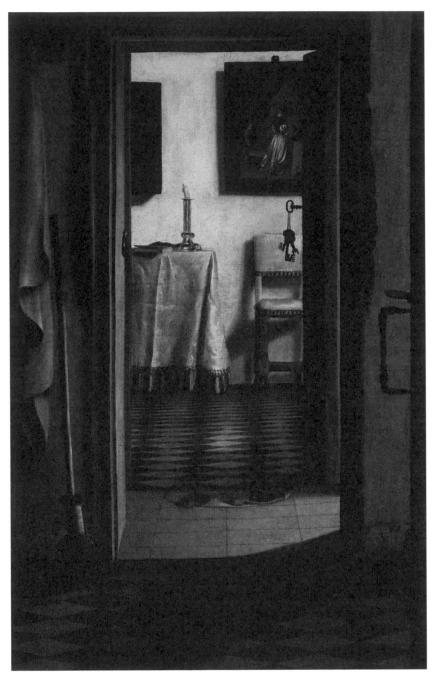

Samuel van Hoogstraten's perspective painting The Slippers.

Hendrick Danckerts made to measure for his living room: 'Mr Dancre ... took measure of my panels in my dining room where ... I intend to have the four houses of the King, White Hall, Hampton Court, Greenwich and Windsor.' Once these works were complete, Pepys pronounced them to be 'mighty pretty'. Sir Pieter Lely owned at least three Danckerts landscapes at his death in 1680.

Dutch artists like these, even if they did not reside in England, made it their business to visit regularly during these years – van Hoogstraten was in London at the time of the Great Fire in 1666 (in his treatise on painting he describes the effect of the dense smoke on the sunset).

Yet the English Royal Collection remains today depleted of many of its former Dutch holdings. Some failed to return at the Restoration, when forcible and conscience-based restitution of artworks dispersed in 1651 was most effective inside England, and with aristocratic owners in Italy and France, who had, on the whole, acquired Italianate paintings. Paintings sold under the Commonwealth to overseas buyers – particularly those that did not represent members of the Stuart royal family – remained with the purchaser, and over time passed into galleries and collections worldwide.

The importance of Dutch works of art for the great collections of the Stuart royals and the Orange Stadholders is also lost on us today for a further reason. When Amalia van Solms died in 1675, under the terms of her will the magnificent collection of paintings she and Frederik Hendrik had assembled over their married life together were divided up between her three daughters and her Hohenzollern grandsons (the children of Louise Henriette, Electress of Brandenburg, who had predeceased her). The most distinguished works in the collection, including paintings by Rembrandt, Rubens, Lievens and Honthorst, were dispersed between electoral household in Berlin and other court cities in the Empire.[38]

After the 1688 invasion, when William and Mary took advantage of their newfound access to the riches of the English Royal Collection to enhance their own, the trusted member of William's household charged with selecting and transporting these works of art was none other than Sir Constantijn Huygens's son Constantijn junior, William III's personal secretary.

On the very day on which William was proclaimed King of England – 23 February 1689 – William and Constantijn Huygens junior appraised the

art in a number of rooms at Whitehall Palace (which Mary had decided the couple could not live in, because the central London air exacerbated William's asthma). These, according to Constantijn, 'also contained fine and admirable works; one of them contained many miniatures by [Isaac] Oliver, some of them after Italian originals'. William arranged for van Dyck's great equestrian portrait of Charles I to be removed from the gallery at Hampton Court so that it could be hung where he could admire it. Over the next nine months, Huygens records numerous occasions on which the new King had him draw up lists of paintings in one or other of the royal palaces (Whitehall, Hampton Court, Windsor and Kensington), and have some or all of them moved from one to another. After the death of Queen Mary in 1695, William had Huygens move the best paintings from her apartments at Windsor and Hampton Court, to be hung in the refurbished rooms at Kensington Palace. The King instructed Huygens 'that I should sort the small paintings from the large ones to some extent'. They were to be hung on strings 'so that they can be arranged and rearranged'.[39]

It was inevitably paintings appealing to developed Dutch courtly taste that William and Mary moved to their palaces in The Hague and elsewhere in the northern Netherlands — particularly large numbers of works of art from the English Royal Collection found their way to the walls of their favourite palace at Het Loo. These were the paintings that remained in the Netherlands when the English Crown passed back to the Stuarts (in the reign of Queen Anne) and then to the house of Hanover.

At The Hague, by contrast, the mingled and interwoven fortunes of Anglo–Dutch art continue to be represented today in the Mauritshuis collection and the Rijksmuseum, which retain the traces of the shared tastes of the houses of Stuart and Orange, from 1660 down to the invasion of 1688 and beyond.

Double Portraits: Mixed and Companionate Marriages

Throughout his long life, Sir Constantijn Huygens showed a weakness for attractive, talented, intelligent women. He cultivated intellectual friendships (seriously, and sometimes flirtatiously) with well-educated ladies across northern Europe who were renowned for their strong character and scholarly, musical and poetic aptitudes. He left rhetorically highly-wrought tributes to them scattered throughout his poems and correspondence.

These included outpourings of emotion and admiration for the artist and linguistic prodigy Anna Maria van Schurman (daughter of a Dutch father and a German mother),[1] the poet Maria Tesselschade Visscher (with whom he exchanged particularly passionate poems when she converted to Catholicism), her sister Anna Roemers Visscher (who engraved verses on glass for Huygens) and the English poet and philosopher Margaret Cavendish, who lived in exile in Antwerp during the English Commonwealth period.[2] He was master of the well-turned piece of flattery. In a characteristic letter written in middle age, complimenting the musician and singer Utricia Ogle and her friend, his erudite neighbour Dorothea van Dorp, together in a single missive, Huygens writes:

> Yesterday I received from Mademoiselle Dorp the two beautiful tunes which it has pleased you [Utricia Ogle] to have copied for me. Never has so beautiful a package in so beautiful a hand been delivered to me by [another] so beautiful a hand. I leave you to imagine whether I am able fully to grasp the glory let alone to put the extent of the favour into words.[3]

Comparatively little, though, is known about the woman Huygens chose to spend his life with – his beloved wife, Susanna van Baerle. The glimpses we get of her, mostly through his letters and poems, are tantalising and shadowy, but do suggest that theirs was indeed an equal, companionate partnership.

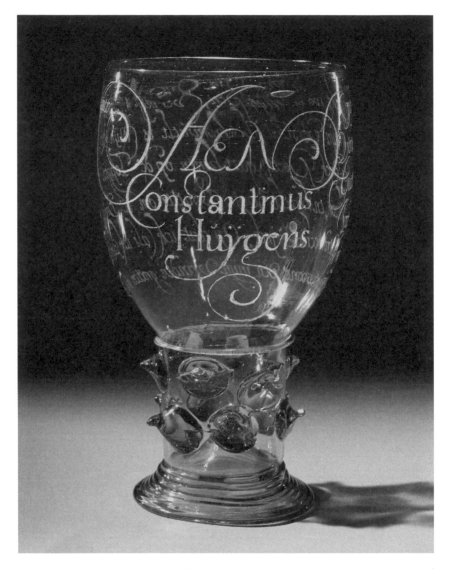

A glass rummer engraved with verses to Huygens by Anna Roemers Visscher, responding to a poem of his addressed to 'the diamond-tipped pen of Miss Anna Roemers'.

Susanna was the eldest of six children born to an affluent and influential Amsterdam family. Her father, Gaspar van Baerle, was a wealthy businessman and the cousin of Huygens's mother. Like many with extensive commercial interests, he and his family had migrated north from

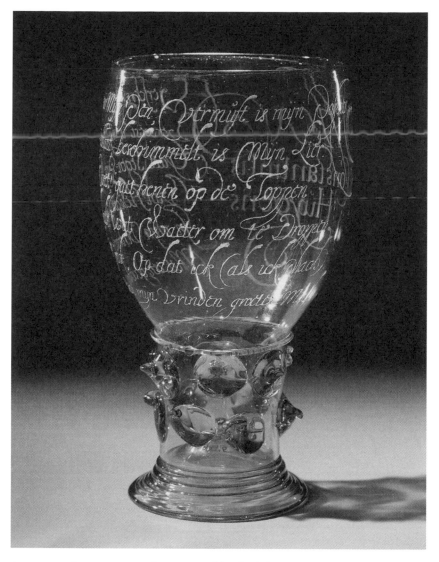

Antwerp when access to the city was blocked during hostilities between the Spanish and the Dutch Republic. He died when Susanna was only six years old. When she was eighteen, her mother also died, leaving Susanna wealthy and free to make her own decisions concerning marriage. Her wealth and social status made her an enviable catch, and she was soon being widely courted. In 1622 the entire Huygens family appears to have tried enthusiastically but unsuccessfully to persuade her to marry Constantijn's

older brother Maurits. Eventually she asked them to desist, informing Constantijn's sister Constantia that she had no intention of ever getting married.[4]

The families, however, kept in touch. In June 1624, Dorothea van Dorp, daughter of Constantijn's immediate neighbours in The Hague, told him in a letter that 'the only nice thing' about an otherwise dull trip to Amsterdam had been 'the Baerle girl: together we often drank your health'. Two years later, Susanna van Baerle succumbed to the considerable charms of Constantijn and consented to marry him. Letters and poems written around that time show Huygens to have been head over heels in romantic love. The marriage took place on 6 April 1627, to the delight of the Huygens family as a whole (though not that of Dorothea van Dorp, who had rather hoped that Constantijn might marry her).

In 1637, after less than ten years of contented marriage, Susanna Huygens died, leaving Huygens a widower with four small sons and a newborn daughter. Three stark entries in his diary for that year capture his grief:

> 10 May: She [Susanna] rendered her spirit to God 30 minutes after the fifth evening hour. Woe! My bliss. Woe my soul.
>
> 16 May: Her body has been committed to the earth with a huge crowd in attendance.
>
> 17 May: Moved into the new house. Alas! Without my turtle dove.[5]

Perhaps it was just as well that the demands of the court allowed Huygens little time for private grief: two days later his diary records him back on secretarial duty at the side of Frederik Hendrik. He never remarried. Shortly after Susanna's death, her sister's unmarried daughter, Catherina Sweerts, moved into the new house to take care of the five motherless children. Huygens never liked her, but tolerated her for the children's sake. When she died in 1680 he could find nothing better to say about her contribution to his household than that 'she hawked and harped and meddled and died'.[6]

After Susanna's death, Huygens referred to her as his precious companion, his equal and his helpmate (from early on in their courtship he referred to her affectionately as 'Stella', his 'star'), whose loss had cast a

permanent shadow across his life. In his most famous poem, 'Daghwerck' (The Day's Work), begun during Susanna's lifetime as a celebration of their domestic life together, and broken off unfinished when she died, Huygens characterises their relationship as one of harmonious reasonableness: 'Stella, by that reason guided/Which I always see in you'; 'If I find my burden easy,/So light, that had Stella wished it,/It could well have been avoided/Or by reason overcome.'[7] Their life together was, he writes, one of shared intellectual activity:

> How shall I stand my trial in the court of the world,
> Without you, Stella, the sharer and guide of my pen?
> Without you my quill is no wing, wing wet with salt of my tears
> Which flew the empyrean before, and followed your train in the skies.[8]

He and his wife were, he writes in another poem, 'two minds joined in a single mind' ('*una mens mentes duae*'). In spite of their emotional intensity as elegies for and reminiscences of a lost love, though, these poetic glimpses are bound to seem to us largely conventional, and offer few real clues as to the woman behind her bereaved husband's lasting regret.[9]

The real-life Susanna can be glimpsed in Huygens's correspondence with the French philosopher and long-term resident of the United Provinces, René Descartes, just a few months before her death in May 1637. Susanna was, it seems, understood by those close to her and her family circle to be both highly intelligent and capable of independent discernment in intellectual matters. The letters concern the printing and publication of Descartes' recently completed *Discours de la méthode*.

Writing to Huygens in early March 1637, Descartes asks him if he will kindly read the proof sheets of the *Discours* carefully, as he had promised when last they were last together, and annotate them with his own corrections. For the time being he is sending the two preliminary sections of the *Discours* (the 'Dioptrique' and 'Meteores'):

> You would oblige me enormously, if you were prepared to take the trouble to read them, to mark or have marked in the margin your corrections, and then to let me see them.

He expressly asks that Susanna should be included in this scrutiny of his work:

> If Madame de Zulichem [Susanna Huygens] would like also to add her own corrections, I would consider that an inestimable favour on her part. I would value her judgement, which is naturally excellent, far higher than that of many of the Philosophers, whose judgement art [formal training] has rendered extremely defective.[10]

In his next letter, responding to Huygens's effusive praise for as much of the *Discours* as he has read already, Descartes sends the remainder, and once again requests that Susanna, this time together with Huygens's sister Constantia, might be persuaded to read it:

> And because these Ladies understand better than men, I recommend the two enclosed [works] to them, with your permission, the one for Madame Zulichem and the other for Madame de Willelm [Constantia]. They [the works] were born at almost the same time as your newborn daughter [Susanna junior], and therefore share the same Horoscope, which means that I could not possibly have a poor opinion of the fortunes of my works, and I wish long life and happiness to all who are born under that constellation, as also to their parents.[11]

Alas, Descartes' astrological compliments were to no avail. Only a few months after this second letter reached Constantijn, his wife Susanna died, perhaps from post-natal complications. Towards the end of her final pregnancy, she may indeed have discussed the finer points of Descartes' hot-off-the-press publication with her husband, as 'the sharer and guide of [his] pen'. But we shall never know what contribution Susanna Huygens might have made to reshaping and polishing Descartes' most famous and widely known work.

This little vignette reminds us how, in spite of the fact that they have left little trace in the historical records, educated women in Dutch families like the Huygenses participated fully and on equal terms in the cultural lives of their menfolk and the circles they frequented. The influence they could thereby exert within the family extended to the particular cultural

and social background from which they came. Well-matched couples brought their shared interests to the joint household. In the case of an alliance between a Dutch man and an English wife – or vice-versa – both Dutch and English language, habits and culture would inform the ménage. It is to such 'mixed' seventeenth-century marriages that I now turn, but before I do so, here is one further story connected with the Constantijn Huygens–Susanna van Baerle marriage, to remind us how easily the women in my present story slide into historical oblivion, and how much work is required to retrieve them.

Double portrait of Sir Constantijn Huygens and his beloved wife Susanna van Baerle.

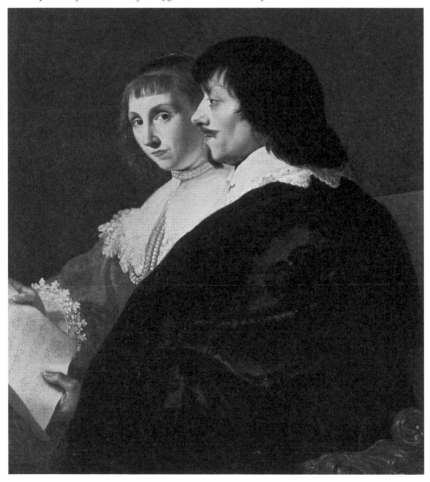

Some years ago, the eminent historian of seventeenth-century Dutch art Julius Held published an article in which he identified a double portrait in a private collection in England as 'a hitherto unknown portrait' of Constantijn and Susanna Huygens.[12] When the painting was put up for auction in April 1992, it was purchased by an anonymous Dutch benefactor and returned to the Netherlands.[13] Today, that painting hangs in the Mauritshuis at The Hague, and is so confidently identified as indeed a portrait of the couple by Jacob van Campen, dating from around 1635, that it needs no justification. It graces the cover of several books on Huygens, and is frequently reproduced in articles about him. Yet until its discovery, less than twenty years ago, there was no known surviving likeness of Susanna Huygens, although a 1785 inventory of Huygens family portraits included three of her.[14] Since her death she had simply disappeared from sight.

Huygens's relationship with Jacob van Campen dates from the early 1630s. In December 1632, a friend of Huygens's wrote to him from Leiden, asking him, in his official capacity in the administration of the Stadholder, to obtain a passport to travel for the artist van Campen. As a 'sweetener', perhaps, the letter concluded:

> He is a good architect and a good painter: à propos which, he would like to make you a gift of one of his paintings, asking you with affection to take the offer in good part.[15]

Six months later, van Campen's offer had been taken up, and the artist was proposing a portrait of Huygens to complement an existing one in Huygens's possession, by Jan Lievens:

> Master van Campen is very eager to paint a light one for your Honour, to match the dark one by Lievens, and requests to have that picture sent together with its frame and all, in order for him to see the size and the expression of the face and the pose.[16]

It is not hard to identify the Lievens portrait as the one associated with Huygens's earliest public praise for Lievens in his autobiographical fragment of 1631.[17] Huygens's friend and intermediary suggested that the

Lievens portrait should be shipped to a broker in Amsterdam, where he would supervise its forwarding to van Campen. A 'light one' suggests a painting whose mood is less sombre than that of the darkly melancholic Lievens portrait. It was another ten months before the van Campen portrait (now lost) was finished and shipped, with a note from Huygens's friendly intermediary:

> Here is the long-awaited painting by van Campen; the long delay he
> blames entirely on his innate negligence ... he hopes nevertheless that
> Your Honour will be somewhat pleased with it.[18]

The painting was evidently a success, and marks the beginning of a long and fruitful relationship between Huygens and van Campen, culminating in van Campen's designing and building Huygens's house in Het Plein in 1637. Along the way, he painted the double portrait of Constantijn and Susanna. At the end of 1635, Huygens penned three epigrams 'On the profile portrait of myself and my wife, on a sheet of paper, by J. van Campen'. The third reads:

> Brother and sister may differ
> as much as peace and friendship can stand:
> Man and Wife no more than here,
> Not the thickness of the paper.[19]

Here, thinks Held, we have the preliminary drawings for the double portrait he has re-identified.

In the course of 1635 Huygens and van Campen met regularly to discuss the plans and construction of Huygens's fashionable new neo-classical house in Het Plein, their shared interests in both architecture and painting bringing them increasingly close. While his neighbour Johan Maurits van Nassau-Siegen was abroad serving as Dutch Governor in Brazil, Huygens oversaw the completion of his house – adjacent to his own – also under construction by van Campen and Pieter Post. Although Huygens's house was demolished in the nineteenth century, we may consider the Mauritshuis as a memorial to the Huygens–van Campen architectural partnership.

Huygens later described how actively Susanna too had been involved in planning the layout and functions of rooms for their new family home. It was natural, then, that when plague broke out in The Hague in 1635, and Susanna had taken two of their four sons to stay with her brother-in-law in Arnhem, and needed temporary accommodation for herself and the other two boys, Constantijn junior and Lodewijk, she should seek refuge with the van Campen family on their estate near Amersfoort. They in their turn were only too happy to extend their hospitality to the Huygenses. It was while they were there that van Campen made a delightful drawing of the six-year-old Constantijn in a straw hat, in red chalk – one of the few surviving examples of his artistic prowess which can be securely assigned to him. On the back Constantijn Huygens junior has written (in later life): 'My portrait aged six or seven, drawn by Mr. van Campen'.

The sheet of manuscript music Susanna and her husband hold together in van Campen's double portrait is the basso continuo (the running instrumental accompaniment) to an unidentified song. Of course, a couple holding a piece of music in a Dutch painting may readily be taken simply to symbolise the harmonious relationship between them.[20] The painting's subject, one historian of music writes, 'is not that of domestic music making but the treatment of music as a mirror of matrimonial harmony'.[21]

LEFT: *Drawing showing the Huygenshuis and Mauritshuis adjacent to one another in the fashionable district of Het Plein in The Hague.*

RIGHT: *Drawing of the six-year-old Constantijn Huygens junior by van Campen.*

We may still allow that the musical reference in the double portrait is to actual musical activities shared by the young couple. The best-known portrait of Constantijn, painted by Thomas de Keyser on the occasion of Constantijn and Susanna's 1627 wedding, which hangs in the National Gallery in London, includes a theorbo (or theorbo-lute) alongside other carefully chosen objects connoting his interests and occupations. When, in 1647, Huygens sent his song collection *Pathodia Sacra et Profana* for publication, the Latin psalms and French and Italian airs it contained had accompaniments specifically for theorbo. The publisher persuaded Huygens to replace this with a figured bass, in an easier notation (of the kind shown in the double portrait), in order that the songs could also be accompanied by a keyboard player. So the two paintings together suggest that Constantijn and Susanna are united musically, as singer and accompanist. The painting, which rediscovers the engaged, intelligent face and direct, searching gaze of Susanna Huygens, also suggests that she shared her husband's love of music.[22]

It is when we begin to recover the sisters, wives and daughters in family histories during the periods of bi-directional migration of the 1640s and 1650s between England and the Netherlands that the extent of the interweaving of Anglo–Dutch social and cultural relations really becomes apparent. Because the lives of seventeenth-century women are so hard to

retrieve, this has proved the most difficult part of this book by far to research. What follows is a selection of specimen examples of the kind of Anglo–Dutch marriage, forged by political circumstances in the mid-seventeenth century, which ensured that many of those moving in élite circles at the time of the Glorious Revolution – both Dutch and English – felt thoroughly comfortable and at home with the mores of the partner nation. In this, as in so many other contexts, Sir Constantijn Huygens is the source for several characteristic and telling examples.

At least one of the flirtations in which Huygens indulged during the 1640s and '50s might have become a serious relationship – one which he could plausibly have hoped would lead to a second marriage. This was his friendship with Anna Morgan, daughter of the Governor of Bergen op Zoom, Sir Charles Morgan. Sir Charles (a Welshman) had married the Dutch heiress Elizabeth Marnix, daughter of the Protestant hero of the Dutch revolt (strategic adviser to, and personal emissary of, William the Silent), Philips Marnix, Heer van St Aldegonde, and was a member of Elizabeth of Bohemia's innermost court circle.[23]

Anna Morgan was born and raised in a bilingual and bicultural household in the northern Netherlands. Her first husband was another Welshman, Sir Lewis Morgan (no relation), who died in 1635, and who, like her father, had served with English regiments in the United Provinces. However, since he was Member of Parliament for Cardiff in 1628–29, and was knighted at Whitehall in March 1629, we may assume that Anna made her home in Wales (in 1652, Huygens wrote to her thanking her for 'the excess of civilities with which it has pleased you to shower my son [Lodewijk], extending as far as your beautiful country of Wales').[24]

In 1644, Anna was once again in the United Provinces, to commission a magnificent white marble funerary monument for her father, who had died the previous year, at Bergen op Zoom. She was advised on this project, and the creation and construction of the monument by François Dieussart (completed in 1645–46), by Sir Constantijn Huygens. He and Anna were already friends,[25] and in the course of their association over the funerary sculpture a romantic attachment developed between them. An elaborately conceited poem in Dutch by Huygens, 'Aen Mevrouw Morgan', written in 1645, on the occasion of Anna presenting him with the gift of a mosquito net to be used in the field during the annual summer military

campaigning, openly affirms his passionate love for her.[26] In 1646, in a gossipy letter written to Huygens around the time news broke of her impending second marriage to somebody else, Constantijn's brother-in-law (husband of his sister Constantia) referred to Anna Morgan as 'your would-be (or alleged) mistress'.[27] The monument Huygens and Dieussart designed and erected for Anna in the Grote Kerk at Bergen op Zoom is a uniquely imposing piece of Dutch neoclassical monumental sculpture, which remains enduring testimony to the passionate, creative relationship between Huygens and 'Mevrouw Morgan'.

Huygens remained on cordial terms with Anna Morgan after her marriage, in August 1646, to Walter Strickland, the English Parliamentary ambassador to the United Provinces between 1642 and 1651, and a prominent ally of Oliver Cromwell in the 1650s.[28] Anna was naturalised by Parliamentary ordinance in 1651, and took a further oath of naturalisation at the Restoration, in 1660.[29]

The two old lovers continued to correspond, in a mixture of English, French and Dutch, down to the 1680s. Occasionally, as often happens, disagreements over gifts exchanged during the love affair came between them, though not apparently for long. In October 1654, Huygens returned from a three-month trip to Spa, south of Maastricht, to find a letter from Anna demanding the return of 'some copper medals which [she] once generously gave to [him]'. Affecting amazement at the request, Huygens wrote:

> I am totally astonished, Madame, that having given them to me with the sweet and kind demeanour with which you were always pleased to honour me, you are now demanding their return.[30]

The medals were, he confessed, now intermingled with those which formed part of his considerable collection. However, if Lady Strickland (as she now was) was determined to have her gift returned, he would 'give her the whole cabinet, which is entirely at your service, if you should be pleased to receive it from my hand'. The abrupt communication Huygens had received from Anna – now firmly of the English Commonwealth party – was perhaps not unexpected: he had been at Spa with the Princess Royal, for weeks of court amusement with the itinerant future Charles II (to

whom Huygens refers consistently as 'the King of Great Britain'). Reporting the goings on at Spa to Amalia van Solms, Huygens told her with evident satisfaction that 'there is a lot of dancing, and this Prince performs better than anyone else at all, since he has a true ear, and understands and loves music with a passion, just like his Royal father'.[31] The Commonwealth government of Oliver Cromwell was not well pleased at the continued support for Charles on the parts of Amalia and the Princess Royal.

The intimate liaison between the Dutch Huygens and the Anglo–Dutch Anna Morgan bridged the divide between the United Provinces and the British Isles, binding the interests of the two families invisibly together – families with significant influence in their respective political administrations. In 1652, an incident at sea precipitated Commonwealth England and the United Provinces into naval confrontation, and eventually into the first Anglo–Dutch war. Required by the captain of an English ship to dip his flag as a sign of English supremacy at sea, the Dutch commander, Admiral Tromp, refused to comply. Relations were already tense between the two countries, and England immediately declared war.

The situation was extremely delicate. At the moment when hostilities were declared between the two countries, a diplomatic mission from the States General to Parliament was in London, and with it Huygens's third son Lodewijk. Huygens wrote to his old flame, Anna Morgan, begging her, from her influential position as wife to one of Cromwell's closest advisers, to take care of his son.

In the same letter, he did some shrewd informal diplomatic negotiating. The insult to English pride on the part of Admiral Tromp which had precipitated the crisis was, he assured Anna, nothing to do with the Dutch government:

> We have just learned with great displeasure about the misunderstanding between our fleets. Whatever the reasons given by either party in this disorder, we can say with absolute certainty that the State did not authorise anybody to commit any hostile action, and to judge otherwise would be to do us wrong. However, since the authority of the government cannot always control the will of the people, in case of emergency, I commit my son to your care.[32]

Although Huygens in the end remained single for the fifty years of his life after Susanna's death, in the middle decades of the century his name was frequently linked with those of his young female musician friends. Many years later his son Constantijn junior, on a visit to Antwerp, was mortified when his host hinted that his father's relations with the 'beautiful Duarte girls' might not have been entirely innocent.

In the spring of 1642, on the eve of the outbreak of civil war in England, the ten-year-old Princess Mary Stuart, eldest daughter of Charles I, arrived in the Netherlands with her mother, Queen Henrietta Maria, to join her teenaged husband, Frederik Hendrik's son Prince William of Orange, whom she had married in London the previous year. The two royal ladies established themselves at The Hague, surrounded by a large number of household servants and hangers-on. Princess Mary was attended by an entourage of eighty (the marriage agreement had stipulated only forty), while her mother, according to eyewitnesses, brought a total of three hundred followers.[33]

One of those who arrived at The Hague as lady-in-waiting to Princess Mary Stuart was Utricia Ogle, a spirited young woman born in Utrecht of an English father (Governor of Utrecht in 1610, and commander of the English garrison there for a number of years) and a Dutch mother, but raised in England.[34] Originally a member of the household of Katherine Wotton, Lady Stanhope (an English widow who had recently met and married William of Orange's leading negotiator in the matter of the English match), Utricia was an accomplished instrumentalist, with a lovely singing voice. She quickly became Huygens's protégée and close personal friend, and a regular visitor to his country retreat. He composed songs especially for her, and set them to music himself, coaching her in their performance. His one surviving published compilation of songs, the *Pathodia Sacra et Profana*, is dedicated to her as its musical inspiration.

In 1645 Utricia married Sir William Swann, an English professional soldier serving in the forces of the Prince of Orange. Swann was also a musician, and it is probable that he and Utricia met at one of Huygens's musical evenings (he and Huygens corresponded regularly – particularly, anxiously, concerning Utricia's health). Utricia and Constantijn continued to perform together, privately and publicly. Indeed, her husband seems to have encouraged them to combine their musical talents whenever possible,

probably to enhance his own prestige in court circles.[35] 'My wife presents her humbel service to you,' he writes in January 1647 from Breda, 'and greefs much for the loss of her voice, which a great could [cold] has taken from her ... But I hoope, eere long she will bee fitt againe to beare her part in musyck with your consort, which I long to heare.'[36]

Some years later, Huygens sent the English composer and lutenist Nicholas Lanier a copy of the *Pathodia Sacra et Profana*, flattering him with the assurance that Lanier could correct any deficiencies in his compositions as he performed them on his 'most excelent royal tiorba'. Huygens had met Lanier in London, at the home of Sir Robert Killigrew, in 1622.[37] Now Lanier, who was of Huguenot descent, was in Antwerp, jostling for some kind of place with all the other English exiles, and trying to eke out a musical living there (though he soon went north, to the more welcoming exile community at The Hague). Huygens again characterised the songs as particularly intended for Utricia:

> Or else, if you will bee so good to us one day, as to come where you may heare mylady Swanne and me make a reasonable beau bruict about some lessons on this booke. The Psalmes she most lovethe and doth use to sing are named here in the margent, as allso some of the songs.[38]

In a long Latin poem published in 1651, in celebration of his country estate 'Hofwijk', Huygens devotes an entire section to Utricia Ogle's musical presence there, recalling the extraordinary emotional impact of her singing, and likening her open-air performance to the thrilling sound of the nightingale in the charmed surroundings of the Hofwijk garden.

> Of women you the loveliest,
> Most worthy to be heard.
> The memory's so strong
> That I hear your song, first heard within this greenness,
> Heard in my calm of leaves below the stormy trees,
> That I still think it true that these, my finest trees
> Were drawn into the wood, all through your voice's power.[39]

Nicholas Lanier, accomplished English musician and courtier.

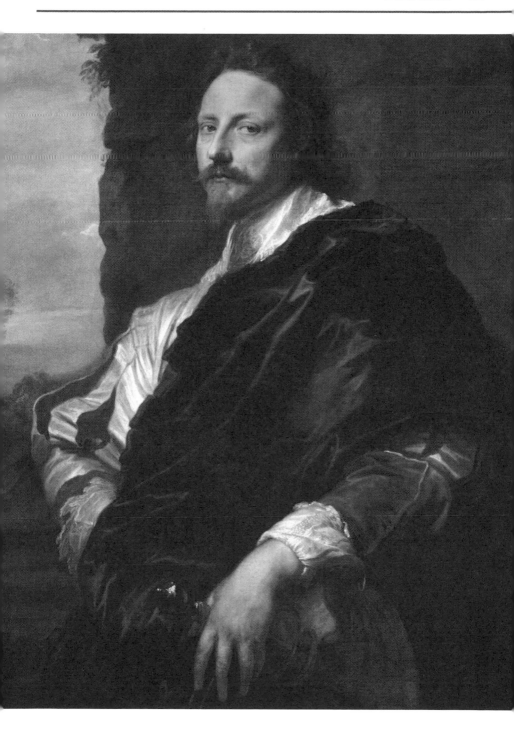

Huygens's poetic praise for Utricia beautifully captures the interwoven contexts of English and Dutch culture and taste, within which these enchanted moments in the Hofwijk gardens need to be understood. Utricia's singing voice 'eclipses the nightingale', her presence in the garden raises Huygens's spirits above his immediate surroundings, providing him with memories which endure beyond the moment:

> I'd linger in my wood a while; for here remains
> One thing to hear, when silenced still remembered.

Utricia and Constantijn sing in a variety of European languages (predominantly French and Italian), but they converse in English and share English experience of small consort and vocal musical performance. Both of their musical trainings and experiences are inflected with English taste and technique. All Huygens's surviving letters to Utricia are in fluent, colloquial English, and although she spent most of her life in the Netherlands, William Swann, whom she married in 1645 — and who, to Huygens's politely feigned annoyance, took her away from The Hague and her regular participation in his musical soirées — was an Englishman in the service of the Prince of Orange. Huygens and Swann also corresponded in English, with occasional French and Dutch interspersed. In the garden at Hofwijk, French and English Princesses, as well as Dutch gentry and nobility, joined their host in marvelling at Utricia's accomplishment, their delight easily fusing Dutch and English sensibilities.[40]

The tendrils of cultural exchange and mutual influence binding Huygens's virtuoso command of Dutch taste and style to equivalent circles in England extend into almost every corner of the cultural life of both nations. He seems unerringly to have bonded with others with equally ambitious international artistic interests and aspirations. During his regular early visits to England, one household in particular had shaped his musical appreciation. Huygens, we recall, had formed his impressions of England and its culture early, and with enthusiasm. During a visit to London in 1622, one of those whose hospitality he enjoyed was the English courtier Sir Robert Killigrew. The Killigrews' was a household full of excitement and activity —

music, conversation and entertainment. There were no fewer than twelve Killigrew children, and according to Huygens everyone in the family participated in their musical soirées. It was through the Killigrews that Constantijn met Nicholas Lanier, who helped organise the musical evenings. He also encountered the philosopher and natural scientist Sir Francis Bacon (the Lord Chancellor, and Lady Killigrew's uncle, whom Huygens disliked), the eccentric inventor and scientist Cornelius Drebbel, the poet John Donne, some of whose poetry Huygens later translated into Dutch, and possibly the poet and dramatist Ben Jonson.[41] In a Latin poem entitled simply 'My Life', and written when Huygens was in his eighties, he recalls his time spent with the Killigrews as a formative episode in his life, when he forged lasting bonds of friendship with the whole family, 'men and women alike': he particularly admired, and became deeply attached to, Robert's wife, Mary Killigrew, with whom, as a sign of intimacy, he sometimes corresponded in Dutch.[42]

In fact, it seems to have been rather fashionable for ladies in England to learn Dutch, which certainly must have made the young Huygens's life in London that much more pleasurable (though his English was becoming extremely good). By the 1620s, Charles I's sister, Elizabeth of Bohemia, was permanently domiciled at The Hague, with regular openings in her household for English ladies of rank. In a letter to Sir Thomas Roe, Elizabeth writes that she is 'glade [his wife] beginns to learne so good dutch'.[43]

Huygens was devastated when it came to his ears at The Hague that Lady Killigrew was blaming him for the death in some kind of accident of her son Charles, for whom he had found a position in Holland as a page in the personal household of Prince William. Huygens's first efforts on Charles's behalf had been made while he was still residing in London in 1622. Positions as page to the Prince were much sought after, and it was 1630 before Huygens was able to notify the Killigrews that he had been successful. He had, naturally, assured his English friends that he would keep a careful eye on their son. Charles, though, fell in with bad company, and turned out to be something of a liability. Huygens wrote to both his old friends – in French to William Killigrew, in English to his wife – personal and passionate letters assuring them that he had done all he could to protect their son:

Everyone here knows the pressure of business under which I, because of
my vocation, am obliged to live. To you, who might be ignorant of it, I
must insist upon the fact that … I was too busy to be able constantly to
supervise pages, even if they had been sons of my own father.

Had not Huygens written to the Killigrews with such regularity that
'you must have been as exhausted with reading everything I entertained
you with, covering so many sheets of paper, on the subject of your poor
son, as I was in writing it'? He had done everything he could on their son's
behalf. He could have treated his own children no better. Surely their
friendship is strong enough to withstand 'the black and malicious calumny'
which has given such a 'vile impression' of him to Lady Killigrew?[44]

There was also some question as to whether there was money owing
between Charles Killigrew and Huygens. Nor was this the only occasion in
the long Huygens–Killigrew family friendship when debts and misun-
derstandings troubled the otherwise cordial relationship. At some point
much later on, Huygens lent the Killigrews' daughter Elizabeth Boyle
(Lady Shannon) a large sum which she apparently failed to pay back. In
1671 Hugyens wrote to her brother Thomas in some indignation at 'this
foole business', protesting at the fact that no other member of the family
seemed inclined to settle the debt:

> I would faine know, if I am to go and tell it in Holland, that the whole
> family of the noble Killigrews could find it in their heart to deny in the
> behalf of a sister what one stranger did not deny unto that sister in
> consideration of the whole familie.[45]

His affection for Lady Killigrew in particular, however, survived the
occasional frictions caused by the more feckless of her children. He sent her
gifts of engravings, and after his wife's death he extended the hospitality of
his house to her. There was room enough, in the wing which had been
intended for Susanna, for Lady Killigrew to stay whenever she was passing
through The Hague.

Despite their occasional difficulties, generally Huygens was quick to
come to the support of his old friends. When their daughter Anne, lady-in-
waiting to Queen Henrietta Maria, drowned in a freak accident on the

Thames in August 1641 (the boat in which she was travelling attempted to shoot the turbulent waters under a bridge, and overturned, resulting in the death of all those on board), Huygens, who was away from home on military manoeuvres with the Stadholder, wrote three short poems bewailing the loss of the 'most beautiful Anne'.

Sir Robert was briefly appointed English Resident Ambassador to the United Provinces, though he apparently never took up the post. But in the second half of the 1640s and the 1650s, as the English Civil Wars and their aftermath unravelled the comfortable lives of many with Royalist sympathies, the fortunes of several of the Killigrew children became entwined with those of their Dutch neighbours. A letter Nicholas Lanier sent to Constantijn Huygens in 1646 captures the flavour of those unstable times. Lanier writes from Antwerp, where he and his family have just found a precarious refuge. They have been beset by calamities along the way: 'The common calamitie of our cuntrey and of every one of us in particular – espetially servants of the King – by odd and ill accidents are even become prodigious':

> My poore wife with her two maydes between Gand [Ghent] and Bruges by a partie of Hollands soldiers were pillaged of all they had; she lost two trunkes with her cloaths and all she had. Among others ther was one caried prisoner to Sluce; he was once Sir Antony van Dyke's man; he is releast and sent me word that he solicited the Rynegrave for my wives two trunks, telling him that she was a frend and retayner to Mylady of Arundell.[46]

The purpose of Lanier's writing to Huygens is to secure from him a passport in the Stadholder's name, to travel from Antwerp, which he considers a 'prison, or denne of theeves – for myselfe was robd returning from France hither', to the United Provinces. 'If this favour may be obtayn'd, I most humbly desier, it may be directed for me to Mr. Dewarte [Duarte].' He also hoped Huygens might be able to intervene in the matter of the missing trunks (these were eventually returned).[47]

In August 1646, Sir Robert Killigrew's daughter Elizabeth also travelled to the Netherlands, arriving at The Hague with her husband Francis Boyle, a son of the Earl of Cork, and his younger brother, the future scientist and

Fellow of the Royal Society, Robert Boyle. Elizabeth and Francis had been married at Whitehall Palace, where Elizabeth was one of Queen Henrietta Maria's ladies-in-waiting, in 1638. Francis had been only fifteen, his brother, in attendance at the formalities representing his family in Ireland, just ten.[48] The two boys had been packed off on a Grand Tour of the Continent with their tutor immediately after the wedding, deferring the consummation of the marriage for propriety's sake. On that tour, the party were joined by Elizabeth's brother Thomas Killigrew, who had recently lost his own wife tragically.

Now, as civil war raged in England, the young Boyle couple had been granted a passport to leave England to become members of the household of Princess Mary of Orange.[49] For them as for so many others, the English-speaking court across the water was a haven from the social and political upheavals at home.

Just a year and a half later, however, in February 1648, Robert Boyle left England for The Hague, at relatively short notice, 'to accompany his brother Francis in conducting his wife from the Hague'.[50] There was a Boyle family emergency. Following a rather public affair with the exiled Charles II – possibly the first of his many 'flings' during his European exile – Elizabeth Killigrew was pregnant. Robert Boyle went to help his brother to salvage his self-esteem as Elizabeth's husband, and to hush up, as far as possible, a Boyle family scandal.

We can pinpoint the birth of Elizabeth's baby to late summer 1648, because there was a family wedding at The Hague that autumn, which Francis and his wife ought to have attended, but from which they were noticeably absent. In October 1648, Frederik van Nassau-Zuijlenstein, the illegitimate son of the recently deceased Stadholder, Frederik Hendrik, and a person of considerable importance at the court, married Elizabeth Killigrew's cousin, Mary Killigrew, another English lady-in-waiting to Princess Mary Stuart.

The marriage between Mary Killigrew and Frederik van Nassau-Zuijlenstein was to prove particularly important for future relations between England and the Dutch Republic, since it was to this couple (conveniently bicultural and bilingual in English and Dutch, and loyal supporters of the Stuarts) that in 1659 Mary of Orange entrusted the raising and education of her nine-year-old son William (later William III), who

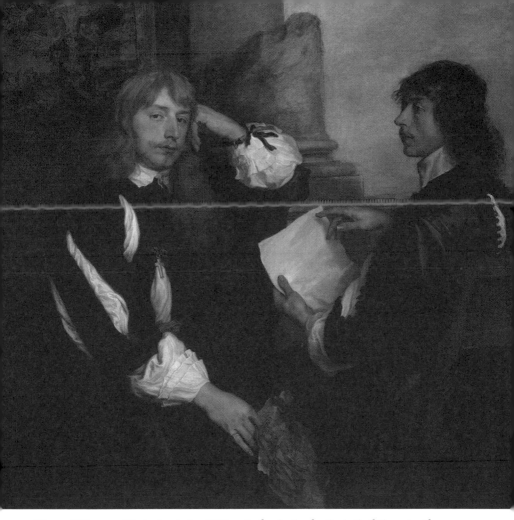

Thomas Killigrew and his brother-in-law William Crofts, shortly after the death of Thomas's wife Cecilia.

grew up, as a result, in a household of women who were native English-speakers. His faultless, if formal, English was to be a considerable asset when he arrived at Whitehall in 1688 to claim the English throne.

In summer 1648 Elizabeth Boyle returned to England in disgrace, before the Killigrew wedding guests were assembled, and was whisked out of sight to avoid awkward questions being asked about her thickening waistline. She and her husband spent the remainder of their lives mostly out of the public gaze, on their estates in Ireland. Her daughter, Charlotte Jemima Henrietta Fitzcharles — one of a number of illegitimate children Charles later acknowledged — was brought up as a Boyle.[51] Shortly after the

Restoration, Charles II elevated Francis Boyle to the Irish title of First Viscount of Shannon – a reward for his loyalty in not bringing his wife's unseemly behaviour to public attention twelve years earlier.

Six years after the hushed-up scandal of Elizabeth's royal affair, her brother Thomas Killigrew, soldier and dramatist, also joined the English exiles in the northern Netherlands. His experiences on both sides of the Narrow Sea formed his later interests, and offer a compelling example of the easy commerce through the middle of the seventeenth century between English and Dutch social and cultural circles.[52]

A courtier and dramatist, Thomas Killigrew became a page of honour to Charles I in 1632, and began composing plays for performance by Henrietta Maria's court circle in 1635. He married Cecilia Crofts, a maid of honour to the Queen, but she died, tragically, three years later (van Dyck's 1638 double portrait of Thomas and Cecilia's brother is a mourning picture). Thomas joined his brother-in-law Francis Boyle, his brother Robert and their tutor on their 'grand tour' of European cities.[53]

As the situation in England deteriorated for those with Royalist sympathies in the late 1640s, Thomas Killigrew again left for the Continent. In 1652 he was briefly in The Hague, in the entourage of Charles I's third son, Henry, Duke of Gloucester. He returned there in 1654, when he met and married Charlotte van Hesse-Piershil, the eldest and well-provided-for daughter of Johan van Hesse, gentleman of the Prince of Orange. The couple were married on 28 January 1655 – she had the good sense to draw up a prenuptial agreement, to protect the greater part of her inheritance from her new English husband – and shortly afterwards moved to Maastricht. Thomas Killigrew spent the rest of the Commonwealth years in the United Provinces, enjoying the lifestyle of the prosperous, cultivated families who moved in the circles of the princely courts at The Hague. He owed his appointment in 1655 as a captain in the service of the States General to Elizabeth, Queen of Bohemia's intercession with Charles II, her nephew, and to the latter's mediation with Willem Frederik of Nassau-Dietz, Stadholder of Friesland. He appears to have performed sensitive missions (including a spot of spying, perhaps for both sides) as groom of the bedchamber for the peripatetic, exiled Charles II.

In his diary for 24 May 1660, Pepys records meeting Thomas Killigrew, 'a gentleman of great esteem with the King', on board the *Charles*, the boat on which Charles II returned in triumph to England. Thomas's pregnant wife and the three children, however, prolonged their stay in Maastricht — Charlotte did not settle in England till after the birth in July of their son Robert. By the end of the year she and her three sons were naturalised, and in June 1662 Charlotte was made first lady of the privy chamber

Thomas was less successful than his Dutch wife in securing royal employment, and for a while he retained his Maastricht connections (including obtaining formal citizenship there). In July 1660, however, the English King issued Killigrew and Sir William Davenant with a royal warrant 'to erect two playhouses [in London], [and] to control the charges to be demanded, and the payments to actors … absolutely suppressing all other playhouses'. The two men thus obtained a virtual theatrical monopoly in London, authorised to form two companies of players, produce all and any dramatic entertainments, and license all plays submitted to them. This royal appointment marked the beginning of a successful career as a theatre manager for Thomas Killigrew, who enlisted the services of, among others, the poet John Dryden for his King's Company. Killigrew died at Whitehall on 19 March 1683. Charlotte Killigrew outlived her husband, living on in London for more than thirty years.[54]

In 1655, Mary Killigrew herself (widowed, and now remarried to Sir Thomas Stafford) left London for the United Provinces. With no sign that the situation in England would improve for those with Royalist sympathies, she opted for a life of exile 'amongst some of [her] obedient children' there. It was Constantijn Huygens who offered to help find her a suitable house in which to live. He was 'infinitly rejoyced to see your ladyship is in so good a health, that she hath the courage to thinke of a jorney beyond sea':

> In good faith, Madam, as the world goeth in your island, I doe imagine, you could as happily and quietly end your dayes in these parts amongst some of your obedient children as there, where publique and private troubles have agitated you till now. As for howses fit for such a family, I

make account your ladyship may be served here at her ease for 60, 70 or 80 pounds a yeare, more or lesse, as she shall thinke fit herselfe. If it please your ladyship to let me know, of what and how many and how large roomes you would desire to bee accommodated, I will make your ladyship acquainted of what is to bee had here at the Haghe, which, you may beleeve, Madam, to bee one of the sweetest and handsomest dwellings of the world.[55]

On the other hand, he continued, she might understandably prefer to 'live in one family with your sonne [Thomas Killigrew] and daughter in law', who were installed in some comfort in Maastricht. The drawback to this plan was that she would find herself entirely cut off from the kinds of society and entertainment she was accustomed to in London:

If so bee, another course is to be taken, for they seeme to have a mind to live at Maestricht, which is more than a hundred mile from hence, in an excellent aire indeed, but as far from the Queen of Bohemia as the Haghe from thence, and no such conversation there, nor such pictures, nor such performes, nor such musicke as we are able to afford you here.[56]

Consorts of Viols, Theorbos and Anglo–Dutch Voices

Although The Hague was the destination of choice and the centre of gravity in the lives of English Royalist exiles between the later 1640s and the Restoration of 1660, another important émigré English community established itself in Antwerp. After 1656, when Prince Charles was excluded entirely from the United Provinces (under an agreement between the English Commonwealth regime and the Dutch States General) and moved to Bruges, Antwerp's convenient access to the English court in exile drew itinerant Royalists to it. But even before that, its location gave its residents comparatively easy access to both the northern and southern Netherlands, making it an attractive place for those keeping an eye on the changing fortunes of exiled English political players (they were also exempt from taxes there). Throughout the 1650s, Antwerp acted as a gateway for those following the fortunes of the itinerant Stuarts. Mary Stuart, Princess Royal, and her entourage stopped regularly in the city on their way to take the medicinal waters – and meet up with her brother Charles – at fashionable Spa, a day's ride south of Maastricht.

Besides, it was a pleasant town to live in. John Evelyn, travelling through it in 1641, wrote in his diary: '[Antwerp is] one of the sweetest places in Europe. Nor did I ever observe a more quiet, clean, elegantly built, and civil place than this magnificent and famous city.' William Cavendish, Duke of Newcastle, found Antwerp's inhabitants 'the civilest and best-behaved people that ever I saw'.

Traditionally it has been taken as a given that the economy of Antwerp declined sharply after the treaty of Münster (between the Dutch and the Spanish) in 1648, with international trade shifting to Amsterdam in the United Provinces because of the blockading of shipping in the Scheldt estuary. In fact, the city's wealth did not vanish overnight (and indeed, movement of shipping and goods was significantly less severely constrained than is often implied). 'Antwerp was still affluent, still home to a number of families who had held on to considerable fortunes generated in better

days. They led a princely lifestyle which they were more than happy to demonstrate in the form of large houses, fine art collections and country estates.'[1]

Indeed, Antwerp enjoyed a minor economic boom in the years after 1648. 'In these years Antwerp's merchants were jubilant at the prospect of new economic opportunities. The riddertol, a tax levied on shipping on the Scheldt and a reliable fiscal parameter for gauging the volume of trade, particularly trade with the United Provinces, indeed points to a significant increase in harbour activity compared to the first half of the seventeenth century.'[2]

In particular, a market in luxury goods (small in bulk, and easy to transport) continued to thrive, with art dealers and dealers in precious stones and jewels enjoying a particularly buoyant period between 1648 and the 1680s. There remained in Antwerp a core community of extremely wealthy individuals – their wealth primarily established on trade – who continued to spend extravagantly.

The population of Antwerp in the mid-seventeenth century was around seventy thousand. The city was diverse, and impressively multi-cultural. Although it found itself on the threshold of the Catholic Netherlands, it was unusually tolerant of the religious observance of its Protestant population. The English Anglican divine, George Morley, canon of Christ Church, and later Bishop of Worcester, records that he 'read the Divine Service of our Church twice a day' at Antwerp in the 1650s (during which period he was also Elizabeth of Bohemia's private chaplain). He 'celebrated the Sacrament of the Eucharist once a month', 'did there bury the dead' and 'baptize children according to the form prescribed in our liturgy'; and 'besides this did once a week, at least, catechize the whole family wherein I lived, in the principles of Christian doctrine as they are taught in our Church Catechism'.[3]

Antwerp was also quietly tolerant of the Sephardic Jewish merchants who lived and conducted their successful businesses there.[4] Visitors commented on the freedom with which Jews observed their festivals (for example, they were able openly to set up huts in their gardens for the feast of Succoth). Prominent merchants like the diamond dealer Gaspar Duarte (who also dealt in paintings) were officially registered as Catholic, but they and their families seem to have continued discreetly to practise their

Judaism reasonably freely, under the tolerant eye of their Christian neigh-bours.[5]

Gaspar Duarte was born in Antwerp, the son of Diego Duarte and Leonor Rodrigues, who had come to the city as refugees, escaping religious persecution in Lisbon, around 1591. He built a flourishing business in gems and artworks, which was subsequently continued by his family. Around 1632 Gaspar established a business outlet in London, where he and his sons Diego and Jacob were granted 'denizen' status as nationalised Englishmen in 1634. From 1632 to 1639 Gaspar Duarte was jeweller (and gem procurer and supplier) to Charles I – a position which effectively made him agent for Charles's purchases and disposals of gemstones. He relocated the business to Antwerp after the outbreak of the Civil War, but remained in touch with many of his old clients from London.[6]

The imposing Duarte house on the broad boulevard which is still Antwerp's main shopping street today, the Meir, a family home that John Evelyn described as more like a palace, was the focus for the extravagant entertainment of visitors from all over Europe between 1650 and 1680 (when Gaspar died in 1653, Diego took over both the family business and

Possibly the Duarte family by Antwerp artist Gonzales Coques.

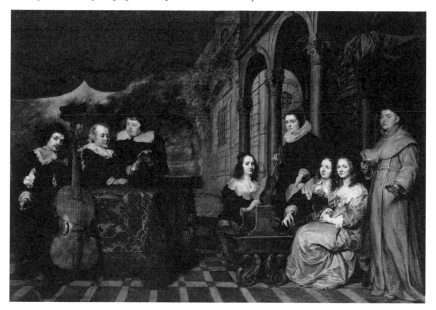

the social networking). Gaspar's three daughters were virtuoso musicians, and close friends with Utricia Swann, who often performed with them. Those fortunate enough to spend an evening in the Duarte musical salon were dazzled by the ostentation of the family's wealth, and enchanted by the quality of the lifestyle and the entertainment.

In 1641, John Evelyn recorded in his diary a concert held at the Duartes' home: 'In the evening I was invited to Signor Duerts [Duarte], a Portuguese by nation, an exceeding rich merchant, whose palace I found to be furnish'd like a prince's; and here his three daughters, entertain'd us with rare musick, both vocal and instrumental, which was finish'd with a handsome collation.'

More palatial than any other house in Antwerp, the home of the Duartes was where both Mary Stuart, Princess Royal, and her brother Prince Charles stayed when they were visiting, as befitting their royal status, although they might be lavishly entertained by the English community elsewhere in town.

Gaspar Duarte and his family's musical virtuosity made of their house and its circle a genuine 'salon' where connoisseurs assembled for concerts. Occasions on which Duarte's musically gifted daughters performed with voice and instruments brought together cultivated and influential individuals like Sir Constantijn Huygens, Frederik Hendrik and his wife Amalia van Solms, and subsequently their son Prince William and his wife Princess Mary Stuart. Huygens senior became a good personal friend of Gaspar Duarte, and his sons became equally close to the diamond merchant's children (one of Diego Duarte's daughters was named Constantia, after Sir Constantijn).

The intimate friendship and the musical soirées were part of an elaborate system of interdependencies among the individuals and families involved, which also extended to include a much more robustly commercial relationship between Huygens (representing the house of Orange) and Duarte as a powerful and extremely influential Antwerp merchant and international businessman.

Huygens regularly did business with the Duartes on behalf of his

Hélène Fourment, Rubens's second wife, wearing a magnificent wedding jewel comparable with that acquired by Gaspar Duarte.

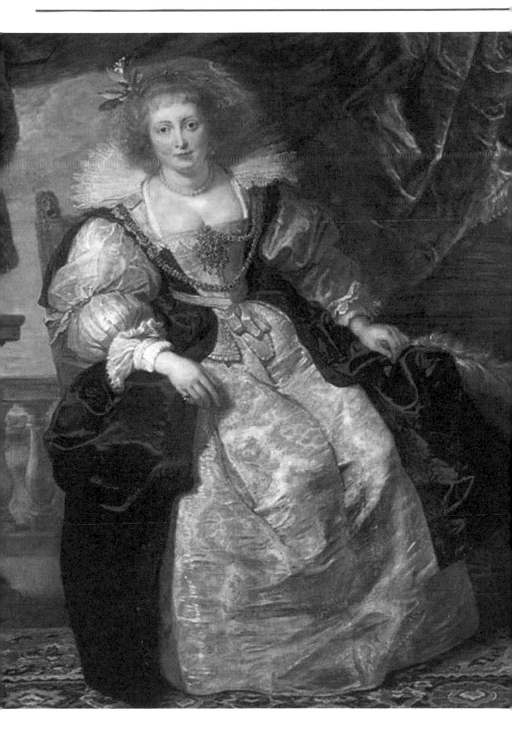

Stadholder employer. A single, delightful example of a transaction organ-
ised and carried out by them on Frederik Hendrik's behalf begins to reveal
the hidden tendrils of influence in matters of cultural exchange in the
1640s, originating in Antwerp, and extending across the water between
England and the United Provinces – and, indeed, back again.

In March 1641, Gaspar Duarte wrote from Antwerp to Sir Constantijn
Huygens in The Hague. The letter (in French) contains an appropriate
amount of musical small talk (the two men are exchanging the scores of
Italian songs for one or more voices), but a substantive item of Stadholder
business occupies most of its space.

Duarte writes to let Huygens know that, as requested by representa-
tives of Frederik Hendrik, his son Jacob in London has located a particularly
striking (and expensive) piece of jewellery – an elaborate brooch in the
latest fashionable style, comprising four individual diamonds in a compli-
cated setting, and designed to be worn on the stomacher of a woman's dress.

It emerges that the piece is to be a sensational gift for Frederik
Hendrik's teenaged son William to present to his bride-to-be, the nine-year-
old Mary Stuart, on the occasion of their marriage in London in May, the
details of which have just been negotiated and settled in London by Dutch
ambassadors. Duarte in Antwerp tells Huygens in The Hague that he has
identified the perfect piece for this purpose in London:

> One of my friends, Sir Arnout Lundi, has asked me for an important
> jewel ['joiau'] worth 80,000 florins, on behalf of His Highness, the Prince
> of Orange. I had delivered to the said Sir Lundi a mock-up [plomb] and
> pattern of a rich jewel, a fortnight ago, to show to His Highness, by way
> of a gentleman, a friend of the aforementioned Lundi, called Mr. Joachim
> Fiqfort. So far I have received no response. So your cousin advised me
> that it would be a good thing if I let yourself know about this, so that you
> could alert His Highness not to buy any other piece of equivalent value
> until he has seen this one. It is in London in the control of my son, who,
> if I instruct him to do so, will himself convey it to you. Their honours the
> Holland ambassadors saw it in London, and also told His Highness about
> it, because they were so delighted to see so magnificent a piece. For the
> four diamonds in combination have the impact of a single diamond of
> value 1 million florins.[7]

On 7 April, Gaspar Duarte's son Jacob arrived in Antwerp with the jewel, and the following day Huygens examined it.[8] A fortnight later, with Huygens discreetly facilitating the process, the deal had made progress. Huygens has agreed to take the jewel to The Hague, but the Stadholder's suggested best offer for it is still too low to be acceptable:

I remain greatly indebted to you [Duarte wrote to Huygens] for the great affection you have shown towards my son Jacob Duarte, by tomorrow showing His Highness that beautiful jewel which I mentioned to you previously. And although I understand that Mr. Alonse de Lope has already managed to sell His Highness four other pieces [of expensive jewellery], nevertheless I hope that your particular favour will have the power to be successful in this matter, since this is such an extraordinarily rare piece. It would be most gracious of you to represent [to His Highness] how thus far I see small appearance [of successful completion], not having been made an offer which is reasonable, [but] one much lower than what it cost me.

Which disappoints me, not thereby being able to serve His Highness. I was assured that His Majesty [the King] of England would have been more delighted with this piece than with all the other jewels, since he had already made an offer for it himself to my younger son, by way of Milord Chamberlain, if his brother had arrived in time. For His Majesty had even offered 6,500 pounds sterling, and would never imagine that His Highness could have acquired it for less.[9]

Duarte's suggestion that the English King had almost obtained the piece himself, and that he had offered a sum in excess of the one being proposed by the Dutch Stadholder, was a shrewd piece of commercial pressuring. It apparently clinched the deal. On 9 May, Duarte acknowledged receipt of payment by Huygens on the Stadholder's behalf.[10]

These exchanges of letters present us with the intriguing picture of a luxury object whose value – both financial and in terms of current taste and fashion – is being established by reference to the object's desirability in two locations, inside two fashionable societies. The Dutch Stadholder needs a gift which will greatly impress the English King. His agent has identified a suitable candidate which is actually in London, conveniently in the pos-

Detail from the wedding portrait of Princess Mary Stuart and William II of Orange, showing the jewel given her by William. (For the full portrait, see page 71.)

session of a Dutch diamond dealer who also operates out of England. The piece has already been seen and admired by the English King, who has allegedly tried to acquire it.

The Duartes are suppliers of gems and made-up pieces of jewellery to Charles I in London and Frederik Hendrik in The Hague. They also, again conveniently, have close family friends in place to help facilitate the deal – Joachim of Wicquefort, otherwise known as Joachim Factor, was a friend of Gaspar Duarte's daughter Francesca, and part of the 'firm'.[11] Huygens, who moves freely between England and the United Provinces, is fluent in English, and frequents the English and Dutch courts, provides his expert imprimatur to the deal.

On 19 April 1641, Prince William, with an entourage of 250 people, arrived at Gravesend for his 'royal' wedding. Some days later he was received in Whitehall Palace, where he presented members of the royal party with diamonds, pearls and other jewellery, worth close on £23,000.[12] These included the spectacular jewel for his bride which Huygens had

helped negotiate the purchase of in London, and which she wore on the front of her silver wedding dress.[13] Less than a year later, when Princess Mary and her mother joined her husband in The Hague, the jewel went with them. Thus in the space of a year, this distinctive, exquisitely crafted, expensive piece of jewellery crossed the Narrow Sea three times.

Cash settlement of this highly satisfactory piece of brokered purchasing was ingeniously executed using a second Duarte–Huygens business deal, this time carried out on Huygens's own behalf, which occupies a further part of the exchange of letters we have been looking at between the two men. Huygens, who had family in Antwerp, had a house just outside the town which he wanted to sell to finance the ambitious country house and garden he was in the process of creating at Hofwijk, outside The Hague.[14] This business was already under way, with Gaspar Duarte acting as Huygens's agent for the house sale in Antwerp, when the 'jewel affair' arose.

In the letter proposing the London jewel for Frederik Hendrik, Duarte asked permission to take 'the person who desires to purchase' around Huygens's house. This person, Duarte informed Huygens, 'has already two days ago bought a large house here in town for 45,000 florins, which still needs building work', and had made it clear to him that he wanted two such houses, one in town and 'yours in the country'. On 21 April he told Huygens that negotiations for the house sale were going well. When Huygens settled payment for the Stadholder's jewel purchase in early May, the sum sent was the total, less the agreed sale price on Huygens's property.

By the 1650s the Duartes had also acquired a considerable reputation as connoisseurs and collectors of fine art – and exactly as in the case of the gemstones and jewels, the dividing line between their activities as private collectors and dealers is blurred. Again, Sir Constantijn Huygens, this time together with his son Constantijn junior, is our witness. Between 1640 and the 1670s, both men regularly visited the Duarte picture gallery in their house in the Meir whenever they were passing through Antwerp. In the 1670s, Constantijn junior records in his diary how he would take time off from accompanying William III of Orange on his summer military campaigns against the French, in his capacity as secretary to the Prince, to look at the Duarte paintings and prints, to request Diego Duarte to appraise potential items for purchase he had himself located in the area, and to buy

from him himself. The pictures would then be shipped by the Duarte 'shop' to The Hague.

A 1683 inventory of the stock of paintings in the Duartes' home reveals a valuable collection, assembled by a discerning connoisseur of contemporary art, within which several outstanding items are identified as having been acquired from named aristocratic art collectors – particularly English émigrés. This ought not to surprise us. The Duartes bought pictures for much-needed cash from families who had carried the more portable of their valuable possessions out of England in the late 1640s, as well as paintings from the collections of those (like the Duke of Buckingham and the Earl of Arundel) whose collections had been broken up and sold as their political fortunes waned. The result is that the Duarte collection contains a striking number of portraits of English sitters by artists fashionable across the Channel – thereby in turn creating a demand in the Netherlands for such pictures.

At least one of the entries from this inventory, however, gives us a second insight into dealing and exchange strategies in Antwerp. It reveals an intriguing cross-over between the gem business and the art-dealing business. It also, incidentally, reminds us that the sums of money changing hands for gems in this period are generally in the region of ten times those being expended on artworks.

The first, and by far the most valuable, item in the Duarte 1683 inventory is a painting by Raphael of a Madonna and child with Joseph and St Anne (probably actually St Elizabeth, mother of John the Baptist). The inventory notes that the painting was acquired from 'Don Emanuel Prince of Portugal' (the husband of one of Prince William the Silent's daughters by his second marriage), in exchange for a diamond ring, the agreed value of which was 2,200 guilders.[15] The diamond alone, Duarte notes, cost two thousand guilders, and the elaborate setting included other stones, among them an engraved sapphire (together valued by him at two hundred guilders).

In other words, the Duarte 'shop' offered facilities for providing the agreed purchase price for an item for which a sale was being negotiated – in this case, an elaborate jewel – in the form of other expensive goods for which the Duartes were competent to provide a valuation. They thus performed a particular service for those with disposable income who liked to

follow fashion. Last year's piece of jewellery could be traded for a number of fashionable works of art (the Raphael was unusual in being a match for Don Emmanuel's ring).

One area of court culture over which Constantijn Huygens exerted particularly strong influence because it was close to his own heart was music both instrumental and for voices. An enthusiastic composer and performer himself (although, unfortunately, very few of his many known compositions survive), Huygens remained actively involved in music in the Low Countries throughout his entire life, absorbing influences from England, France and Italy and reshaping them into a quintessentially Dutch style and sentiment. He was also responsible for identifying, and helping the careers of, individual talented performers, just as he did those of talented painters. After William II's death in 1650, he clearly used his position as an influential and well-connected music connoisseur and practitioner in the same way as he did that in fine art, to sustain the cultural reputation of the house of Orange during its period of exclusion from public office.

In 1648, Sir Constantijn got wind of the fact that a young French singer, Anne de la Barre, daughter of the French court organist, who had already gained a considerable reputation in Paris, had been invited to travel to the court of Queen Christina of Sweden to perform (accompanied on various instruments by at least one of her younger siblings). In July, Huygens wrote to Anne, to persuade her to break her journey at the Stadholder's court in Holland:

> I beg you to accept this invitation to relax for a couple of weeks at my home, which is not perhaps the least convenient or least well-appointed at The Hague. There you would find lutes, theorbos, viols, spinets, clavichords and organs to divert you – almost as many as you could be provided with in the whole of Sweden.[16]

To encourage her to take up his invitation, Huygens enclosed a copy of his own recently published book of psalm settings and airs for soprano voice, *Pathodia Sacra et Profana*. Anne and her father, court organist to the French King, replied immediately (in separate letters). Anne had already

performed several of Huygens's new songs, to general acclaim. 'I believe that you understand perfectly all the languages you compose in,' she adds, 'judging from the beautifully expressive use of words, which I have tried hard to express in my performances.'[17]

More pragmatically, Anne's father asked Huygens to put in a word with the Prince and Princess of Orange, in the hope that they too might invite Anne to sing for them:

> We passionately desire to visit The Hague, in order to converse with someone of your merit and discernment … I make this request because, as my children have tried to acquire the Science of music, all that remains is for them to find some prince whom they may please, who will reward their endeavours. The Queen of England [Henrietta Maria] and the Prince of Wales [the future Charles II], who have heard us, bestowed on us as much honour as one could wish for. The said Queen [in exile] hoped to be back in power in England, so that she could bring us there.[18]

Anne's planned trip to Sweden in 1648 did not take place, and in the meantime, disaster struck Huygens in the form of the death of his Orange employer – he wrote in his diary: '*miserere populi hujus et mei, o Magnus Deus*' ('have mercy upon this people and upon myself, o Great God'). So by the time Anne did embark on her European tour in 1653, Huygens had yet stronger motivation for persuading her to spend some time in The Hague, frequenting the courts of Amalia and the Princess Royal, and performing for the city's élite. Huygens and Anne's father had kept in close touch during the intervening five years, and had formed a professional relationship. Just as painters were happy to secure the continuing favour of their clients and patrons by supplying them with works by other artists, la Barre acted as agent for Huygens, commissioning and procuring sought-after state-of-the-art musical instruments for him in Paris. These were shipped from France via Gasper Duarte in Antwerp, to add to the collection of fine instruments Huygens had boasted of to la Barre's daughter.

The la Barres did indeed eventually break their journey to Sweden at The Hague. As he had promised, Constantijn Huygens entertained Anne and her accompanying family members in his own home, 'so that I am able to see her often, as far as my official responsibilities allow'. And true to

his word, he recommended Anne enthusiastically whenever he had the opportunity, penning several eulogistic poems to her musical prowess, and preparing the way for her rapturous welcome at the court of Queen Christina, where the la Barres stayed for a year. 'Amarinthe [Anne],' he wrote, 'is admired and cherished here as she deserves':

> The Queen of Bohemia [Elizabeth] and her royal niece [Princess Mary Stuart] cannot get enough of her, and for the first time Madame la Princesse Mere [Amalia van Solms, widow of Stadholder Frederik Hendrik] attended a gathering which included the Queen [the exiled Henrietta Maria of England]. There that illustrious young singer had a solemn audience, at which she was a marvellous success.[19]

This meant, of course, that by the time the la Barres continued on their way, their stories of sophisticated musical soirées in The Hague, where the Princess Royal, her mother-in-law and her aunt all participated as 'a solemn audience', gratifyingly spread the word that all was continuing to prosper with the houses of Stuart and Orange in the United Provinces.

Music featured prominently in the masques and ballets which were a regular feature of the soirées and entertainments of the courts at The Hague, particularly as encouraged and patronised by Elizabeth of Bohemia. Spectacular combinations of theatre, elaborate scenery, song (solo and choral), dance and orchestral accompaniment, they were occasions for competition between royal patrons.

In 1624, the young Sir Constantijn Huygens himself wrote a verse introduction to a 'ballet' performed before Elizabeth, in which 'Amor' and a series of suitors played poetic court to the exiled Queen.[20] Such entertainments were popular at the English and French courts also, and by the 1650s the English exiles were vying with one another in their reports of elaborate entertainments in music and dance performed at the courts of Europe. Princess Mary, in Paris visiting her mother in 1655, reported, 'I have seen the masque again, and in the entry of the performances received another present, which was a petticoat of cloth of silver … Monday next there is a little ball at the Louvre, where I must dance.' While in 1656, James,

Duke of York wrote to his brother from Paris: 'I saw the ballett practis'd yesterday, in which there is some very fine entries; it will be danced on Sunday, and I will send the book on't; and the tunes of Baptist making, so soone as I can gett them.'[21]

A number of English writers migrated to The Hague in the later 1650s, to provide masques and entertainments in English for the exiles there. They included Sir William Lower, whose *Enchanted Lovers* was printed and published at The Hague in 1658. In 1659 he dedicated his English translation of the French romance *The Noble Ingratitude* to Elizabeth of Bohemia, in the hope that it would delight her enough to have it performed: 'Were I not fully perswaded that this Dramatick Piece in the Original is one of the best that hath been presented upon the French Stage, I should not have presumed to Offer the Copy to the best of Queens, and indeed the most Juditious of Women.'

One example of such a court masque for the performance of which we have an unusually full record shows the way in which the activities and interests of the three English-influenced courts were intertwined and interactive. On 17 January 1655, Elizabeth of Bohemia wrote to her nephew, Charles II (himself in exile), describing an entertainment at The Hague at which 'your sister [Princess Mary] was very well dressed, like an Amazon'. A portrait by Hanneman of the Princess Royal survives, which perhaps recalls this occasion, in which she is fabulously turned out in an Amazonian feather cloak, with sumptuous pearls and an elaborately exotic headdress, attended by an African boy page.

This masque or 'ballet' was conceived and performed during a particularly difficult period for both the house of Orange and, above all, the Stuarts. In July 1653, under renewed pressure from the government in England, the Estates of Holland and the States General passed resolutions decreeing that neither members of the Stuart royal family nor their loyal supporters should any longer be afforded shelter, assistance or maintenance on Dutch soil. The *Ballet de la Carmesse* was therefore carefully 'French' in taste and style – its music and verse devised in fashionable French style (Princess Mary had recently returned from a stay with her mother, Henrietta Maria, in Paris). At the same time, the entertainment was performed at a time when Mary was fighting for the survival of her five-year-old son's rights, as Prince of Orange, to the privileges of the

Princess Mary in masquing dress as an Amazon.

Stadholdership and command of the Dutch military. The continuing presence in The Hague of Mary's aunt, Elizabeth of Bohemia, was of the utmost importance to this campaign, and the masque's affirmation of the 'triumph' of the masquers over adversity was understood as a mark of Elizabeth's public support for Prince William.[22] *La Carmesse* provided an opportunity for a public display of support for Princess Mary and her son by leading Dutch nobility, at just the moment when the dynasty could well use a public acknowledgement of Dutch élite backing for the Orange–Stuart cause against the Dutch Republic.

The entertainment is a romance in verse, in which the gentlemen charm the beautiful ladies, and the ladies confess that their souls have been

ravished by the dashing young men and their dancing, and was printed for immediate circulation among the participants (two copies survive). Significantly (since traditionally historians tell us that the three royal Princesses and their entourages were constantly at odds with one another), it was an occasion for shared enjoyment between the three courts – Princess Mary attended, as did the Dowager Amalia's daughter, suitably chaperoned.

The ballet had the desired effect – its performance was reported with enthusiasm in the European capitals, and its success equated with the continued buoyancy of the Orange–Stuart cause. Sir Alexander Hume, the Princess Royal, Mary Stuart's head of household, described the event to Sir Edward Nicholas, Charles II's Secretary of State in exile:

> Her Royall Highnesse [Princess Mary] and the Princesse Dowager [Amalia van Solms] haue interchanged visites and converse very civilly together. Yesternight at her Highnesses desire the Princesse Dowagere gaue her daughter Mademoiselle d'Orange leaue to accompany our Princesse to a balette [ballet] that some 9 or 10 young gentlemen presented to the Queen of Bohemia and her Highnesse at a place in the town of purpose fitted for it, which lasted from 9 or 10 a clock at night till 4 of the morning, and if it had not been to satisfy our Princesse, the other would not have suffered her daughter to be so late abroad.[23]

The event made the gossip columns, including the social column of the Paris daily newspaper:

> Yesterday evening at The Hague, some noble gentlemen presented a grand Ballet of sixteen scenes, with an excellent musical score, followed by a formal dance performed by the most accomplished noble ladies in the region: amongst whom were the Queen of Bohemia, the Princess Royal, Princess Louise Palatine [Amalia van Solms's daughter], The Demoiselles of Orange, of Tremouïlle, of Mérode, of Berghen, and several others.[24]

Elizabeth of Bohemia herself gave an account of the masque to the exiled Charles II, while reassuring her nephew that his sister, the Princess

Royal, was finally recovering her health and spirits after the successive blows of the death from smallpox of her husband, William II, and the birth eight days later of her son, William III:

> My deare Neece recouers her health and good lookes extremelie by her excersice the twice dauncing with the maskers has done her much good. We had it two nights the first time it was deadlie colde but the last time the weather was a little better, the subiect your Majestie will see was not extraordinarie but it was verie well danced, our dutch old minister sayde nothing against it from the pulpet, but a little French preacher Carré saide in his sermon wee had committed as great a sinne as that of Sodome and Gomora, which sett all the churche a laughing.[25]

Later Elizabeth described in detail how well-turned-out the leading ladies had been at the masque:

> Your Sister was very well dressed like an Amazone the Princess of Tarente like a shepeardess Madamoiselle d'Orenge a Nimph, they were all very well dressed Mistris Lane was a Suiters wife, but I wish of all the sights Your Majestie had seene Vander dous, there neuer was seene the like, he was a Gipsie Nan Hide [Anne Hyde, later first wife of James II] was his wife, he had pantalon close to him of red and yellow striped with huffled sleeues he looked iust like a Jack a lent, they were 26 in all and did dance till five in the morning.[26]

Elizabeth also boasted to her nephew that her 'fidlers were better' than his.[27]

It has been suggested that after 1650 Elizabeth of Bohemia's court was sustained largely by wishful thinking, and that its activities were severely curtailed by the exiled Queen's lack of secure financial support. However, the most recent study of her correspondence has revealed that Elizabeth's 'celebrity' reputation, as the beloved and glamorous figurehead of Protestant hopes in Europe, ensured that ample private funds were made available to her by Lord Craven and others, to support a continuing lavish lifestyle, and thereby to sustain an aura of royal entitlement around the house of Orange–Stuart in the United Provinces.[28] The *Ballet de la Carmesse*

was a public demonstration that the extravagant Anglo–Dutch social life at The Hague continued, apparently undaunted by current political difficulties. 'We serve you alone, and you are victorious,' the performers in the masque proclaim triumphantly to their royal audience.[29]

Although the musical counterpart for the text no longer survives, it is clear that musically the ballet *La Carmesse* was particularly accomplished. It was written and performed by the French violinist Guillaume Dumanoir, a prominent figure on the musical scene at the royal court in Paris. Dumanoir had held his first position as 'dancing master' at The Hague, but had subsequently moved to Paris, where he became a member of the 'King's twenty-four violins' – the main string orchestra at court, which played at all court balls and masques, and on all other royal formal occasions. He perhaps accompanied Mary back to The Hague in 1655, where he wrote and performed in Elizabeth of Bohemia's ballet on two consecutive nights, after which he returned to Paris. His presence and involvement make it certain that the ballet was of a standard which would have been recognised as equalling the best such occasions at the courts of Paris or (formerly) London. Other musicians participating as string players, as voice soloists, or as members of the elaborately scored choruses for grouped men's voices can be recognised as outstanding performers in their own right, locally or abroad.[30]

The *Ballet de la Carmesse* elegantly fulfils Constantijn Huygens's requirements for a successful contribution to the glamorous lifestyle of his Orange and Stuart employers. Although there is no record of his attendance, we may picture his delight at the quality of the musicianship, and the elegance of the dancing by the court figures who participated. As Elizabeth reported to Charles II, 'the subject your Majestie will see was not extraordinarie but it was verie well danced'.

At the conclusion of the ballet, the 'Ladies' ball' began. When Dumanoir and his musicians once again struck up, Mary herself, followed by the high-ranking ladies in attendance, took the floor, and proceeded to dance the night away until four in the morning. From Dumanoir's surviving suites of dance music we may imagine the gavottes, courantes, sarabandes, allemandes, bourrées and gigues they danced – all vigorous dances carried out to the heavily rhythmic beat of the orchestra of violins.

As we watch Constantijn Huygens mediate the traffic in musicians and

fine instruments between Paris, London, Brussels, Antwerp and The Hague, we experience the process of international exchange under his tutelage, which resulted in the flowering of a coherent, continuous musical taste spanning these locations.[31] The illusion of separation – of distinct centres of musical development to which we may attach the designations 'Dutch', 'English' or 'French' – is belied by the easy commerce in taste-forming opinions, performers, composers and instruments between these locations, even (as we shall see) at times when officially the participants' countries of residence were at war. Musical historians have seen fit to judge Huygens a minor talent as a lyricist and composer, but that is not really the point. He presided over a formidable network of musical connoisseurs and practitioners, whose tastes and talents he 'played' with every bit as much virtuosity as the viol or the theorbo.

To close this chapter, let us return to that other vibrant centre of cultural activity in the Netherlands in the seventeenth century, Antwerp, and to probably the most famous, and certainly the most successful, of the artists working in the region at that time – Pieter Paul Rubens. Rubens set style standards in Antwerp in fine art in the first half of the seventeenth century – his influence extending to acceptable types of composition, and cost per figure by the hand of the master, rather than his studio – and as a prominent member of the local community he also did so in other areas of luxury expenditure, in particular in architecture.

By 1615, Rubens and his family occupied one of the most architecturally distinguished houses in the whole of Antwerp. He had acquired what became known permanently as the Rubenshuis, on the Wapper canal, in 1610, thereby confirming and consolidating his reputation as the most successful artist in the area. Before he and his first wife Isabella moved in, he added an entire Italianate wing to the already extensive and fine-looking dwelling. The frontage of the resulting mansion stretched 120 feet, divided by a central gateway. To the left, the Flemish façade was broken by narrow rectangular windows, lead-paned and quartered. To the right, the middle-storey windows of the Italianate addition were handsomely arched and set in banded masonry frames. The large studio on the ground floor measured fully forty-six by thirty-four feet, and was thirty feet high – an impressive

Portrait of Margaret Cavendish from the studio of Pieter Lely.

space in which to set up the large canvases on which Rubens and his artist-apprentices worked. The house also possessed the fashionably formal, classically themed Dutch garden which has already been noted, incorporating architectural features and antique statuary.

Again, this architectural project connects with the English émigrés in Antwerp. Between 1648 and 1660, an English family competed with the Duartes for the title of most lavish in its hospitality towards the English émigré community. This was the household of the émigré William Cavendish, Duke of Newcastle, and his much younger second wife, Margaret.

Cavendish, a trusted military commander in Charles I's army, had been forced to leave England precipitately after the battle of Marston Moor, at which the Royalists suffered their most crushing defeat of the entire Civil War, throwing into question Cavendish's competence as a general. He made his way to Henrietta Maria's court in exile in Paris, where in 1645 he contracted his second marriage, to Margaret Lucas, one of her ladies-in-waiting. From there the newlyweds had moved on to the Netherlands.[32] Having lived in some splendour on vast estates in the north of England, Cavendish now found himself reduced to living with Margaret in temporary lodgings in Rotterdam.

On a trip to Antwerp, probably in search of some art purchase, since he was in the company of the English agent Endymion Porter, Cavendish was shown Pieter Paul Rubens's elegant house on the Wapper canal, just around the corner from the Duartes' house on the Meir, which his widow was offering for rent (Rubens had died two years earlier). Although emptied of Rubens's own works, the room designated as his 'museum' may still have contained the many plaster casts of antique statues and friezes with which he had replaced the originals he had sold to the Duke of Buckingham twenty years earlier.[33]

Cavendish took a great liking to the baroque neoclassical style of Rubens's remodelling of an already appropriately grand residence. Returning to The Hague, he notified Prince Charles at the end of September 1648 (as he was required by court protocol to do) that he was leaving the court in exile and moving his entire household to Antwerp.[34]

Engraving of Rubens's house in Antwerp, rented by the Cavendishes in 1648.

There he and Margaret would remain 'till it shall please God to reduce the sufferings of England to such a condition of peace or war as may become honest men to return home'.[35]

The Rubens House was certainly suitable in scale and conspicuously fashionable style for the émigré who was the grandson of Bess of Hardwick, and whose own remodelling of the family estate at Bolsover Castle in England subsequently gained him a considerable reputation for its ostentation in the 'baroque mannerist' architectural style.[36]

Here the Cavendishes installed themselves ostentatiously. Margaret, an intellectual and poet, held soirées and entertained lavishly. William established a highly esteemed indoor riding school, possibly in Rubens's studio itself. There he would entertain the grandees of Antwerp and the Spanish Netherlands, demonstrating how to perform '*manège*', the art of elaborate formal patterned movement on horseback (still partially recollected in 'dressage' today), to the amazement of his audience – which sometimes included the enthusiastic horsewoman Queen Christina of

Sweden. The first edition of Cavendish's important work on horsemanship, *Méthode et invention nouvelle de dresser les chevaux*, was published in 1658 in Antwerp, in French. Lavishly produced, with large illustrative plates, it caused a sensation.[37]

The Cavendishes' houschold at the Antwerp Rubenshuis became a cultural magnet for displaced Royalists. By the mid-1650s, English émigrés, including the exiled King himself, were habitually making their way there for cultural solace. The intellectual soirées, musical recitals and balls there were also frequented by cultivated resident Dutch sympathisers like Huygens, who visited regularly. The Duarte family participated, and Utricia Swann joined them whenever she was in town, sometimes performing songs written by William Cavendish, and set by herself. The Cavendishes entertained on as grand a scale as they could under the circumstances, their household financed by large loans taken out against lands and goods sequestered in England (when finally William Cavendish rushed home to be part of the welcoming party for Charles II in 1660, he had to leave Margaret behind as 'surety' for his Dutch creditors).

One entertainment at the Cavendishes' Antwerp home for which records survive may serve to capture the scale and sophistication of the diversions on offer there during the English Commonwealth years. It was a soirée of glamour and revelry staged for Charles II and his court in February 1658, shortly after the death of Oliver Cromwell, when Europe was buzzing with rumours of the possibility of the English King's return to the throne. In the event, it was to be another two years before the continuing Commonwealth failed under Cromwell's son Richard, and Charles II was restored to power, but the premature celebration reminds us that those who eventually returned had developed their own characteristic, lavish forms of recreation in exile, whose fashions were closely linked to Dutch 'royal' circles in The Hague, and whose influence persisted when the participants returned to London.[38]

The occasion for the entertainment at the Cavendishes' Antwerp home was the installing of General Marchin as a Knight of the Order of the Garter, followed by a ball in his honour. A verse panegyric 'of the highest hyperbole' written by Cavendish was delivered by a former actor, 'Major Mohun', who wore 'a black satin robe and garland of bays'. There was dancing, and a performance by sixteen of the King's gentlemen. The high

point of the evening was a song by 'Lady Moore, dressed in feathers', who sang one of Cavendish's songs set to music by Nicholas Lanier.

Here, yet again, we have the threads of English and Dutch cultural activity becoming wound together in intricately complicated ways. As we saw in the previous chapter, the English musician Nicholas Lanier was an old friend of Sir Constantijn Huygens, whom he had met in London at the home of Sir Robert Killigrew in 1622, when Huygens was a young diplomat, dazzled by the cultural and social life of James I's court in England, and Lanier was a rising court star as musician and instrumentalist, destined to become the Keeper of the King's Music when Charles I ascended the throne.

In addition to taking charge of Charles I's music and instruments, Lanier become one of his key art procurers, brokering international deals to build up his fabulous collection of Italianate paintings and statuary – a lynchpin in the courtly web of patronage and acquisitions which shaped seventeenth-century European art connoisseurship, shuttling around Europe in search of costly treasures to enhance the courtly magnificence of his royal employer.[39]

In the 1650s, the exiled Lanier frequented the émigré community in Antwerp, helping to provide cultural continuity between those fallen on hard times from the élites of the houses of Orange and Stuart together. The guest list on this occasion was impressive. 'Along with the King and his entourage were his sister Mary (the Princess Royal), the Duke of York (later James II) and the youngest royal brother, Henry, Duke of Gloucester. In addition to the Stuarts, Béatrice de Cusance and her two children attended, a Danish nobleman, Hannibal Sehested and his wife (a Danish Princess), and members of the Duarte family.'[40] The context for the entertainment, its conception and execution, were strictly Dutch, and closely related to comparable documented performances at The Hague, at the court of Elizabeth of Bohemia, Charles I's widowed sister, of the kind we saw earlier. The occasion itself was resolutely 'English'.

Not all the Cavendishes' entertaining was musical. During his frequent visits to the Rubens House in the 1650s, Sir Constantijn Huygens and

Sir William Cavendish.

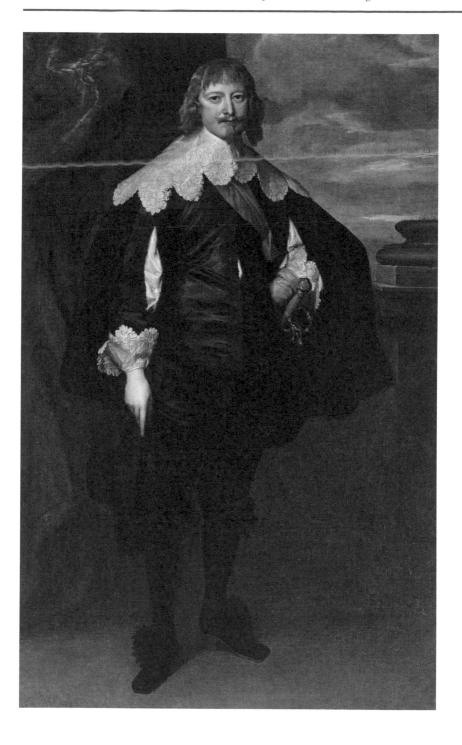

Margaret Cavendish developed an intense intellectual friendship, spending hours absorbed in conversation on scientific and philosophical matters.

In 1653, Huygens was one of those to whom Margaret and William sent the poems she had published in London. 'A wonderful book, whose extravagant atoms kept me from sleeping a great part of last night in this my little solitude,' he wrote to Utricia Swann from his country house at Hofwijk.[41] On his visits to Antwerp, Huygens often stayed at the Duarte family's house and kept the company of the Duchess of Lorraine. When he called at the Rubens House, conversation turned to learning, and in particular philosophy. He questioned Margaret closely about her own theory of natural philosophy, and joined her in her chemistry laboratory, where, he later recalled, her enthusiastic experiments led to her each week dirtying several of the white petticoats she wore there to protect her fine clothes:

> I could not forbeare to shew your Grace by these lines how verily mindfull I am of the many favours she hath been pleased to bestow upon me in former times, especially of those favours [in your laboratory], Madam, which I remember did cost you many a white petticoat a week.[42]

In the spring of 1657, following a visit to the Rubens House and an enjoyable session together discussing natural philosophy, Huygens sent Margaret some specimens of 'Prince Rupert's drops' — small teardrop-shaped glass vessels, with extraordinary physical properties. The drops could withstand the pressure of considerable weights placed on them, and were unbreakable even when struck squarely with a hammer. Yet if even the smallest tip of their tails was snapped off with a finger, the whole thing exploded into powder with a loud report. Huygens requested Margaret to study the properties of these curious glass baubles and to offer him a scientific explanation:

> I had the honour to heare so good solutions given by your Excellencie upon divers questions moved in a whole afternoone, she was pleased to bestowe upon my unworthie conversation, that I am turning to schoole with all speede, humbly beseeching your Exellencie may be so bountifull towards my ignorance, as to instruct me about the natural reason of these wonderfull glasses, which, as I told you, Madam, will fly into

powder, if one breakes but the least top of their tailes, whereas without that way they are hardly to be broken by any waight or strength. The King of France is as yet unresolved in the question, notwithstanding he hath been curious to move it to an assembly of the best philosophers of Paris, the microcosme of his kingdome.

With his customary exquisite decorum, Huygens explained in his letter how Margaret should handle the drops if her feminine sensibility made her nervous of the explosions caused when their tails were snapped off:

Your Exellencie hath no cause to apprehend the cracking blow of these innoxious gunnes. If you did, Madam, a servant may hold them close in his fists, and yourselfe can break the little end of their taile without the least danger. But, as I was bold to tell your Exellencie, I should bee loth to beleeve, any female feare should reigne amongst so much over-masculine wisdom as the world doth admire in her. I pray God to blesse your Exellencie with a dayly increase of it, and your worthie selfe to graunt that amongst those admirers I may strive to deserve by way of my humble service the honour to be accounted.[43]

Margaret replied a week later. She thanked Huygens for his letter and accompanying poems in Dutch, and gave at length her views on the causes of the violent reactions when the drops were broken. In her view there was a tiny quantity of volatile material trapped inside each drop, which exploded on contact with the air:

To myne outward sense these glasses doe appeare to have on the head, body or belly a liquid and oyly substance, which may be the oyly spirits or essences of sulpher; alsoe the glasses doe appeare to my senses like the nature or arte of gunns and the spirrit of sulpher as the powder; where although they are charged, yet untill they bee discharged, give no report or sound; the discharging of these glasses is by the breakeinge of a piece or part or end of the tailes, where the discharging of guns are by much [match?] firelockes, scrues or the like, which setts fire or gives vent to the powder, but these sulpherousse spirrits, having as it seemes a more force-able nature, it doth viollently thrust itselfe out, where itt findes vent, like

as wind, but rather like fire, being of a firy nature, and may have the effects of bright shining fire, which, when it has noe vent, lyes as dead, but as soone as it can ease out a passage, or findes a vent, it breakes forth in a violent crack or thundering noisse.

She suggested that the liquid was inserted into the drops using the same skill as that employed to make fashionable glass earrings:

Weomen weares at there eares for pendents as great wounders, although they make not soe great report, which are glasse bobbes with narrowe neckes as these glasses have tailes, and yet is filled with severall coullers silkes and coursse black cottonwooll, which to my senses is more difficult to putt into these glasse pendants, then liquer into these glasse gunnes.[44]

The explanation did not satisfy Huygens, who responded a week later. He did not detect any liquid inside the drops.[45] A week later again, Margaret reiterated her belief that there was some kind of combustible material inside the drops, but conceded that it might simply be compressed air.[46]

This exchange of letters is fascinating in itself, both for what it tells us about the involvement of women in seventeenth-century science, and for the additional light it sheds on Sir Constantijn Huygens's varied and wide-ranging intellectual and artistic interests. It is particularly interesting to note that Prince Rupert's drops were one of the earliest curious phenomena explored at length experimentally at the Royal Society after the return of the English exiles. On 4 March 1661 'glass bubbles' were produced to a meeting of the Society: 'The King sent by Sir Paul Neile five little glass bubbles, two with liquor in them, and the other three solid, in order to have the judgement of the society concerning them.'[47] Anxious to impress the King (whose active support for the Society was being sought), the members responded immediately. More drops were produced and experimented on two days later, and a full report of the experiments performed was given to the Society at its weekly meeting on 14 August by the President, Sir Robert Moray.[48] Two years later Henry Oldenburg, secretary to the Society, lent Moray's account to the French traveller Balthasar de Monconys, who made his own translation into French of the method described for making the drops.

It was the Society's curator of experiments Robert Hooke who produced a plausible (and largely correct) explanation for the phenomenon of the glass drops, based on the compression of the glass itself, and drawing an analogy with the way the locked stones in brick arches collapse instantaneously and violently once the keystone is removed.[49]

Historians of science are generally agreed that it was Prince Rupert (Elizabeth of Bohemia's son, and a prominent figure at the Restoration court) who brought the drops from mainland Europe, but are undecided as to where they originated. But a common name for the drops was 'Holland tears' — *lacrymae Batavicae* — and although the first known discussions of them come from the early scientific academies in France, it is suggested that they were brought to France from Holland in the 1650s.

The exchange of letters between Margaret Cavendish and Constantijn Huygens shows that the drops were indeed known in the Dutch Republic in the 1650s, and were also being discussed in France. But I hope that the story indicates how overdetermined the connections are between the Dutch and the English in the history of 'Prince Rupert's drops', and how many strands there are to the development of a plausible explanation of the causes of the drops' spectacular properties. In particular, when we find Christiaan Huygens trying to manufacture drops with the help of local craftsmen (they were largely unsuccessful), and investigating their properties in The Hague in 1665, and corresponding about them with Adrien Auzout in Paris, we need to factor into our account his father's enthusiasm for the same drops almost ten years earlier.

During the 1650s, the elegant, restrained neoclassical style of building cherished by Sir Constantijn Huygens in The Hague, and admired by him in the Rubenshuis in Antwerp, became the familiar backdrop to the complicated lives of exiled Englishmen and women. The Cavendishes' appreciation of their sumptuous rented home inspired them to remodel their own estate when they returned to England, replacing the late-Elizabethan of Robert Smythson's designs with more Continental classical influences, and doubtless influenced the architectural views of the many English courtiers and hangers-on who visited the Rubenshuis while they were living there.

The returning English exiles carried their memories of ten years in the stylish material surroundings of Antwerp and the northern Netherlands home with them in 1660. In 1658–59, the exiled Charles II stayed for some time at Frederik Hendrik's favourite country palace, at Honselaarsdijk, just outside The Hague, while he helped his widowed sister Mary, the Princess Royal, to organise suitable educational arrangements for her eight-year-old son, William III. Following the announcement of his reinstatement as King of England in March 1660, Charles spent four hectic weeks lodged at the Mauritshuis in The Hague, whose design and construction by van Campen Huygens had supervised just before the building of his own elegantly neoclassical house next door – the one he discussed by correspondence with Rubens in Antwerp. It was these buildings which helped shape the architectural aspirations of Charles II's court in the second half of the seventeenth century.

In this area of culture as in so many others, the Huygens influence permeated the experience of those returning to rebuild lives interrupted by the Civil War and its aftermath. Accustomed to the Dutch architectural aesthetic, it is hardly surprising that in so many of the post-Restoration houses William III visited after his arrival in 1688 the new King should have felt perfectly at home.

Masters of All They Survey: Anglo–Dutch Passion for Gardens and Gardening

In the course of the seventeenth century, English and Dutch townscapes and landscapes were transformed by an unprecedented surge of activity in house-building and garden design on the part of the newly prosperous business and merchant classes, eager to show themselves *au fait* with the very latest in styles and fashions. And just as consumer goods and luxury items were traded with growing enthusiasm in both directions across the English Channel or Narrow Sea, so specialist services in architecture and horticulture were freely interchanged, threading styles in building and garden design to and fro, weaving reciprocal influence increasingly tightly into the fabric of both territories.[1]

In architecture, in the early decades of the century, the families of de Keyser and Stone serve as characteristic examples of the easy social and professional exchange between the two countries. In 1607 the Amsterdam master mason Hendrick de Keyser arrived in London to study Thomas Gresham's Royal Exchange in preparation for designing and building a similar centre for commercial activity in Amsterdam. While there he met Nicholas Stone, a mason and sculptor, who returned with him to Amsterdam, where he completed his training (he had just finished his apprenticeship when he and de Keyser first met). Stone spent six years or so in Holland, and married de Keyser's only daughter. He and his wife then returned to England, where he established himself as a leading sculptor and architect.

The de Keysers became a dynasty of master masons – three sons and a grandson of Hendrick's subsequently held the position. As well as being responsible for a large number of important buildings, both private and public, in Amsterdam, Hendrick de Keyser designed the tomb of William the Silent at Delft, for which the young Sir Constantijn Huygens provided the Latin inscription in the 1620s. Hendrick's son Thomas painted the

portrait of Sir Constantijn and his clerk, associated with his marriage to Susanna van Baerle in 1627. This means that all three of the best-known surviving portraits of Huygens were painted by artists with experience of patrons and studios on both sides of the Narrow Sea – we might argue that Huygens chose them on purpose, as part of his agenda of taste-formation in common to the English and Dutch art-appreciating communities.[2]

The Stones and the de Keysers moved regularly and easily between England and the Dutch Republic, placing their considerable talents in art and design at the service of the cities of London and Amsterdam. Willem de Keyser, Hendrick's eldest son, was in England in the 1620s, probably shortly after his father's death, and married an Englishwoman. By 1640 he was back in Amsterdam, and became a member of the Stonemason's Guild there.[3] The de Keysers and the Stones maintained close family contacts, corresponded regularly, and acted as agents for each other in the shipment of building materials between the two countries. They also provided training for each other's children: Nicholas Stone's son Henry studied paintings for several years in Amsterdam under his uncle, Thomas de Keyser. In return, two of Hendrik de Keyser's sons appear to have been apprenticed to Stone in London.

Willem's younger brother Hendrick joined Nicholas Stone's workshop around 1634, and a few years later was carrying out alterations on behalf of Stone at Newstead Abbey in Nottinghamshire. There he married a local girl in 1639, remaining in Nottingham until at least 1643. He was in Holland in 1646–47, and as far as we know, never returned to England. However, Willem was back in 1658, and lived and worked there with his family for the next twenty years. When Charles II returned to London, and embarked on rebuilding his palace at Greenwich in 1661, he was keen to emulate the Dutch neoclassical architecture that he had encountered during his years of exile. It was Willem de Keyser who drew elevations of a proposed new scheme for the new King. In January 1661 Charles discussed de Keyser's ideas with John Evelyn, although the scheme was never built. Members of the de Keyser family were active in England and in Ireland until as late as the 1680s.

This kind of migration of artists and skilled craftsmen from one side of the Narrow Sea to the other was clearly market-led. Architects and masons went where the clients were. The ostentatious expenditure of the English

nobility under Charles I contrasted with the well-documented 'embarrassment' at too obvious a show of wealth in the Dutch Republic. The fact that members of skilled dynasties like the de Keysers married local women during their visits to England meant that they raised bilingual families of children who could work easily in either country. So the interchange in masons and architects became amplified in each successive generation. Whether we should call the buildings and carvings the de Keysers were responsible for 'Dutch' or 'Anglo–Dutch' is perhaps a moot point: local styles and guild skills had become intertwined to the point at which it is probably unhelpful to try to separate them.

Huygens's negotiations with Rubens for the acquisition of works of art for Frederik Hendrik and Amalia van Solms during the 1630s meant frequent exchanges on behalf of the Stadholder with the artist, by letter and via trusted intermediaries. They most likely involved one or more visits in person to the studio on the first floor of the new wing of the Rubens House in Antwerp, though a late letter suggests that Huygens and Rubens had never actually met face to face. Huygens certainly knew the house from its magnificent exterior, since he was in Antwerp regularly, and he was aware of Rubens's scrupulously antique-influenced plans for a neoclassical house befitting his status as Antwerp's most successful painter. An enthusiast for architecture, Huygens was evidently almost as impressed by Rubens's Antwerp house, and by the artist's expertise in ancient and modern architectural theory, as he was by his talent as a painter.

In 1633 Frederik Hendrik presented two lots of land he had recently acquired, in a prime location in The Hague, to Constantijn Huygens.[4] When Huygens set about building a substantial family home there under the direction of Jacob van Campen, next door to his uncle's much-admired Mauritshuis, he wrote to Rubens requesting his opinion on the design:

> Sir, I am building a house at The Hague, and it would give me great pleasure to hear your advice on my plans, even though they are almost completed – there remaining just two small galleries to be completed, which are intended to enclose a courtyard [bassecour] 70 feet in length, and to be attached to a main façade [front de logis] of approximately 90

feet. You would not be disappointed to learn that in my building I intend to revive in some part the architecture of antiquity, for which I nourish a passion.

This was to be no palace, Huygens hastened to add:

It will only be on a small scale, and to the extent that the climate and my coffers will allow. But the fact remains that, in the heat of these considerations, I hardly need tell you how eager I am to steer you in my direction here, since you excel in the knowledge of this illustrious field of study, as you do in everything else, and could give me many lessons in it. But the fates intend otherwise … If I manage to realise my plans successfully, I will in any case inform you further, on paper or in person.[5]

Huygens was true to his word. On 2 July 1639 (a year before the artist's death), he sent Rubens a set of engravings of his completed house: 'Here as I promised is the bit of brick that I have built at The Hague.'[6] His pride in the gracious home he has created is palpable, as is his respect for Rubens as a connoisseur of antique and modern buildings. At the end of the letter, almost as an afterthought, Huygens added the real business of his communication – a commission from Frederik Hendrik for a painting to be placed above the hearth in his palace, the subject to be of Rubens's choosing, but with three, 'at most four', figures, 'the beauty of whom should be elaborated con amore, studio e diligenza'.[7]

So when, in the 1650s, on his frequent visits to Antwerp, Sir Constantijn Huygens attended musical soirées at the home of William and Margaret Cavendish, or spent the afternoon with Margaret in her chemistry laboratory, he was able to take a particularly keen pleasure in frequenting the very house about which he and Rubens had corresponded – the home created by a kindred architectural spirit in his heyday. And the Cavendishes and Sir Constantijn undoubtedly carried back with them, upon their return to England and the United Provinces, an enhanced and deepened understanding of Rubens's carefully reconstructed architectural neoclassicism, to feed into future projects of their own.

Huygens took a connoisseur's interest in architecture throughout his life. The country house he designed for himself at Hofwijk, completed in

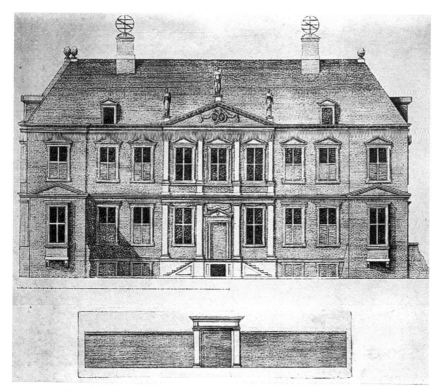

Engraving of Huygens's fine neoclassical house at The Hague.

1642, was his pride and joy, and he loved to invite close friends there to enjoy the beauty of the location, and to savour the elegance and congeniality of the building.[8] He worked tirelessly advising Frederik Hendrik and Amalia van Solms on their extensive and ambitious building works at the Dutch royal palaces – Frederik Hendrik had a reputation as a knowledgeable amateur of architecture himself, and involved himself closely in the design process.[9] It was Huygens, too, who, in consultation with van Campen, completed the careful integrated programme of architecture and painting for the Oranjezaal of the Huis ten Bosch on the outskirts of The Hague (designed by Pieter Post), where an elaborate cycle of paintings and decoration commemorated and glorified the achievements of Frederik Hendrik for his widow Amalia van Solms, following Frederik Hendrik's death in 1647 (the project was completed in 1652).[10] The Cavendishes, once back in England after the Restoration, retired from public life and devoted

themselves almost entirely to architectural projects for William's hereditary seats at his main Nottinghamshire home, Welbeck Abbey, and at Bolsover.[11]

The story of the interchange of talent and expertise in architecture between England and the Dutch Republic has been told a number of times. That of the close relationship between horticulture and garden design in the two countries, less often. In the case of Dutch and English gardens it is also possible to see that the similarities in practice are overlaid on a subtly different set of assumptions about the meaning and function of a pleasure garden. For the élites in the two countries with time and money to indulge their passion for plants and parterres, gardens represent different kinds of attitudes towards the labour needed to create a garden, and the leisure required to enjoy it.

Early in February 1642, Sir Constantijn Huygens invited a select company of close family and friends to a small celebratory gathering at his country house, Hofwijk, at Voorburg, just outside The Hague. His career was at its peak. He was secretary and chief adviser on all types of cultural and artistic matters to the Dutch Stadholder, Frederik Hendrik, consulted and deferred to whenever a matter of taste or aesthetic judgement was required.

The occasion was the completion of the garden design project that had comforted and consoled him in his leisure hours since the sudden death of his beloved wife Susanna less than two months after the birth, on 13 March 1637, of their only daughter (also named Susanna). That was the very year in which Huygens completed the imposing neoclassical house to whose detailed design he had given so much personal attention, alongside his architect van Campen, and he and his family moved in next door to the Mauritshuis on Het Plein. The loss of his wife had spoiled his pleasure at the completion of this ambitious architectural project, which had been intended to crown his glittering career at court.

Constantijn's beloved partner was gone, and for more than a year his poems – in Latin and Dutch – reveal him as mentally tormented by his loss, and virtually inconsolable. Instead of enjoying the family home he and Susanna had planned together, he had turned his mind to a country

Drawing of Huygens's summer house at Voorburg, outside The Hague, by his son, Constantijn junior.

retreat – a place where he could recover, reflect upon his loss and begin to rebuild his personal life.[12] The small gathering in early 1642 marked the end of this painful phase in his life, and the celebration was a muted and reflective one.

The party of visitors consisted of his older brother Maurits, his sisters Gertruyd and Constantia, their husbands, Philips Doublet (or Doubleth) and David de Wilhem, and an unnamed 'friend from The Hague'. There was a tour of the modest, classically inspired country house (whose designer, Pieter Post, was to become the Stadholder's official court architect in 1645, on Huygens's recommendation), and a much more extensive exploration of the garden, with its tree-lined avenues and canal-side walks, freshly planted ornamental flowerbeds and geometrically laid-out areas of what would one day be shady groves of trees. Over a generous meal, Huygens extolled the virtues of his garden as a source of emotional solace and a refuge from the cares of office.

Huygens's little garden launch-party was a small event in the studied

programme of activities he had begun to orchestrate for Frederik Hendrik and his circle since 1625 – the year Frederik Henrik became Stadholder of the seven provinces, and the year of his marriage to Amalia van Solms. Huygens's efforts were designed to set the tone for a Dutch courtly culture which would earn the respect and attention of the royal houses of Europe.

In the summer of that same year, ten-year-old Princess Mary Stuart arrived in The Hague with her mother, Queen Henrietta Maria.[13] Mary's father, Charles I, had given Huygens a warm welcome when as a youth he had visited Charles's father, James I's court in the 1620s. Huygens – passionate anglophile, personally acquainted with the Stuart royals, fluent in English and French – had played a major part in brokering the Anglo–Dutch marriage, as a member of van Aerssen's embassy to London in 1639. As the fortunes of the English royal family declined and the international standing of the house of Orange improved, he continued to proclaim his absolute loyalty and commitment to the Stuarts – 'an utterly committed and extremely passionate servant of the Royal House of Great Britain' ('*tres-acquis et tres-passionné serviteur de la Maison Royale de la Grande Bretaigne*'), as he described himself to Princess Mary's governess Lady Stanhope.[14]

Now Huygens found himself, as secretary to the Dutch 'royals', in charge of providing suitable entertainment for the refugee royals and their large train of followers. The royal palaces at The Hague and nearby Honselaarsdijk provided accommodation and recreation. Excursions to nearby Hofwijk for a select few were part of the programme on offer.

Although we have no explicit account of Princess Mary or her mother being among the earliest visitors to Hofwijk, we do learn from Huygens's correspondence that on at least one occasion during her several subsequent visits to the northern Netherlands in the course of the 1640s, trying to raise money for her husband King Charles I's doomed military offensive against his people, Henrietta Maria spent an enjoyable afternoon there. She joined her host in an entertaining game of quilles – an ancient cross between skittles and bowls – on the beautifully manicured bowling green, and consumed a bowl of freshly picked, home-grown cherries in a spontaneous *déjeuner sur l'herbe* – a high-class picnic. According to Huygens, she pronounced the garden a delight.[15]

Charming though the records make royal visits like Henrietta Maria's

to Hofwijk appear, there were social niceties to be observed which hampered the easy, informal atmosphere for which Huygens yearned. The house of Orange, although the most prominent family in the Northern Provinces, with claims to royal status, nevertheless ranked below the English royal Stuarts, as both Henrietta Maria and Mary were always quick to point out on Dutch formal occasions.

Still, away from the court, in the rural idyll of Hofwijk, studied informality prevailed, and mitigated courtly anxieties concerning rank, status and the ostentatious expenditure involved in fine living. The presence in Huygens's garden of royal Princesses and other English ladies of quality, enjoying its rustic pleasures, placed the seal of aristocratic approval on his scrupulously conceived and executed, yet comparatively modest, country retreat. Hofwijk came to stand, for him, for the difficult balancing act of remaining a person of modest aspirations and high ethical principles, a true Dutchman of integrity, while nevertheless striving to emulate and match the lifestyle of the increasingly 'royal' Stadholder he served. In Simon Schama's memorable terms, it allayed his characteristically mid-century Dutch 'embarrassment' at his own material good fortune.[16]

By a deliberate and self-conscious play on words that is entirely typical of the linguistically sharp-eared Huygens, 'Hofwijk', whose simplest meaning is 'a house with a garden', also means a place where one can 'avoid' (*wijck*) the 'court' (*hof*) of the Prince of Orange that Huygens served. The country seat's Latin name, 'Vitaulium', likewise means both '*vitae aula*' – the garden of life, or Garden of Eden – and also '*Vitruvii aula*', the garden of Vitruvius, the ultimate classically designed garden. For the rest of Huygens's long life, Hofwijk was where he went to recover from the buffetings of life in the political spotlight. It was where his family gathered and spent time at leisure together, to escape the summer heat of The Hague. It was also where his son Christiaan, the distinguished scientist, who had a tendency to periods of depressive collapse, found refuge in retirement, when his fragile health finally broke and he was obliged to give up his salaried place at the head of the French King Louis XIV's Académie des sciences. Christiaan died at Hofwijk in 1695.

We know a good deal about how intensely Sir Constantijn Huygens

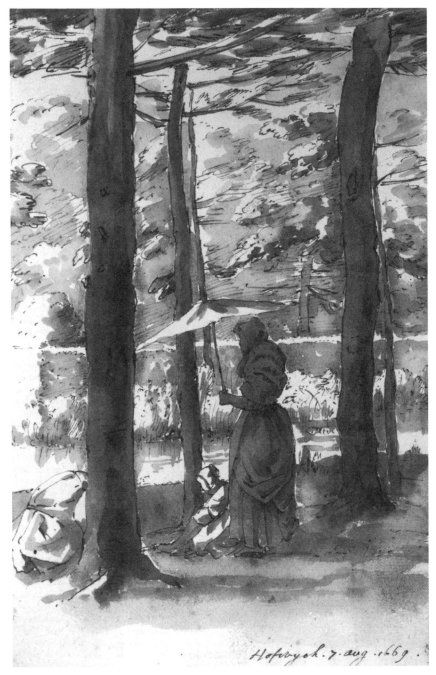

Pen and wash drawing by Constantijn Huygens junior of the groves of trees at Hofwijk.

senior felt about his garden, because around 1650 he completed a three-thousand-line Latin poem celebrating it in loving topographical detail. When he published this in 1653, Hofwijk was still a project in process, a ten-year-old planted paradise of shrubs and young trees whose glory lay in the future, an as-yet unrealised promise of mature, shaded avenues, secluded walks walled by espaliered shrubs, parterres patterned in box, and a densely wooded wilderness landscape stretching away before the gaze of the visitor. (The delightful pen and wash drawings of the Huygens family in Hofwijk's shady groves, by Constantijn junior and others, date from the late 1660s, by which time the trees were well-established, as Huygens senior had hoped.)

In his poem, it is Hofwijk's promise of future luxuriance that Huygens imagines with satisfaction and pride:

> I want to show you Hofwijk, as if it sprang by night,
> Grown sudden, like a mushroom, to maturity.
>
> And more than this, I want to make us walk it round
> As if our yesterday a century were past.[17]

A century on (in Huygens's poetic imagination), the trees which in 1650 have not yet fully developed into their mature splendour have become the glory of Hofwijk — a medley of varieties, framing views, providing elegant markers along the walks and avenues, and bestowing their welcome shade on the summer visitor. Huygens's poetic emphasis is one of pleasurable investment — storing up family emotional and commercial capital for the future. No man-made work of art will stand the test of time, according to Huygens: even a garden will eventually perish. His poem, though, will preserve the memory of its prime:

> So frail are human works, paper outlasts them all,
> Time wears the shrub and stone: in time it will be said,
> 'Here once his Hofwijk stood, now rubble, weeds and spoil.'[18]

Still, insofar as the garden will outlast its creator, standing, it is to be hoped, for several generations thereafter, the trees in particular represent an enviable durability:

So the desire for tameness is answered by four rides
Of serviceable oaks, my avenues complete
In thickness at their root, in eminence in air,
For spread of branches round, for cool green murmuring.

Perhaps I called them timber: but let nobody dare
To break my faithful refuge, fell my avenues.

Think of invested gold, this planted capital
Matures in centuries; grandchildren, let them stand
And never burn the trees I planted for you here.[19]

Here, according to Huygens, is art and artistry that outdoes the creations of the painter or the tapestry-maker. He describes taking his ease among the splendid trees which have grown tall and proud, sheltered from sun and sharp winds alike, surrounded by family and friends, reflecting on the important issues in life and revelling in the time for thought afforded, away from his office:

Here I may laugh secure at sweat the mower sheds,
Here with my canopy of elmcloth over me.

My roof of leaves protects me from full moons
And from the scorching sun, and from the tears of heaven.

Here do I flee for refuge, sheltered here and cool,
I suffer without harm the rages of the skies.

Here is my pleasure, knowing how close my joy.[20]

As in Andrew Marvell's 'The Garden' and 'On Appleton House' (written at roughly the same time as Huygens's 'Hofwijk'), the out-of-town garden estate is a refuge from care, a pastoral idyll. A gentleman's garden is a paradise of calm and tranquillity, a place of consolation and stability. There a man can reflect, can engage in reposeful conversation and reverie, alone or with friends. There too, urban pride, pomp and ceremony are transmuted into areas for modest recreation — shaded canals, limpid pools, green arbours — and simple foods are gathered from the kitchen garden (in

his poem at least, Huygens shows comparatively little interest in ornamental flower gardens).

Hospitality is a recurrent theme in Huygens's Hofwijk poem, as also throughout his prolific correspondence. He retains a particular place in his affection for garden-lovers like himself who have shared his enjoyment of his woods and walks: in 1680, when Huygens was an octogenarian, in a letter to the former English Ambassador to the Northern Netherlands and fellow gardener Sir William Temple, he refers to his old friend as 'an ancient Hofwijkist', a kindred spirit who has shared his garden pleasures over many years.[21]

Accordingly, making provision for the owner's table, and for his guests, was one of the duties made explicit in the contracts of the gardeners who kept the entire project going. A mid-seventeenth-century contract for the gardener at one of the Dutch Royal Palaces specifies:

> The gardener shall take care that sections pointed out to him in the gardens will be sowed and planted with all kinds of vegetables and Aertvruchten [fruits of the earth, perhaps the newly fashionable potato] in such a way that, depending on the season and time of year, they will daily provide the kitchen with fresh produce. The gardener is allowed to take his own share of all the Aertvruchten which the gardens and orchards will yield above the quantity necessary for the Table and Kitchen of Her Highness. But when it comes to the Artichokes, Melons, Strawberries and Asparagus, these will entirely be at the disposal of Her Highness and the gardener will not be able to enjoy them, except for what is allowed by Her Highness.[22]

Huygens's 'Hofwijk' includes all the familiar tropes of garden poetry, as they developed in England and Holland in the seventeenth century. But although the poem gives the illusion that the garden's walks and groves largely maintain themselves, in fact armies of labourers were required to create the illusion of rural simplicity.

A nice detail about the house itself at Hofwijk is to be gleaned from a letter Huygens wrote to his musical friend Utricia Ogle in 1653. He has, he writes, added two glass extensions to the original house, in which he spends most of his days. These allow him to spend even his time indoors in full

sight of the garden (these 'glass-windowed cabinets' no longer survive):

> In this my little solitude … since your ladyship hath seene it, I have built
> two lovely glass-windowed cabinets at the waterside, making now more
> use of them than the whole castle of Hofwijck, which by this meanes is
> growen to a mighty and stately building, as everything in this world is
> great or small onely by comparison.[23]

So far we have focused attention on the Dutch garden as it responded to Europe-wide initiatives in garden design in its own specific terms. But as we have already seen, the garden designers employed in the United Provinces, and particularly by the aspirational house of Orange, had already worked for similarly élite patrons in England, where the formative cultural currents influencing garden design were significantly different.

At the very same time Constantijn Huygens was celebrating the healing effects of time spent in a well-ordered garden, lovingly salvaged from a waterlogged landscape, across the water the fame of an English garden on a far grander scale was being broadcast in a series of dramatic engraved views. First published around 1645, Thomas Rowlett's elegant volume consisted of a series of twenty-six etchings showing the glories of the garden at Wilton, laid out between 1632 and 1635 by Philip Herbert, 4th Earl of Pembroke. In 1630 Pembroke had married the notable heiress Anne Clifford (a Baroness in her own right), thereby coming into possession of her vast estates in the north of England. Although the marriage had broken down by the time work began on the house at Wilton in 1636, and its plan was much reduced in scale, the magnificent gardens went ahead as planned.[24]

There are obvious affinities between the coffee-table-book version of Pembroke's Wilton and Huygens's literary version of Hofwijk. For one thing, we should notice that both are trying to stabilise the image and memory of what are, on the authors' and garden-owners' own admission, evanescent phenomena. Neither Hofwijk nor Wilton ever looked as depicted in its engraved or textual versions. As Huygens allows himself poetic licence to imagine his garden mature and fully grown, so de Caus's Wilton is an ideal snapshot, with everything orderly and neat, and

simultaneously at its optimal state of growth and flowering. In fact, it is quite possible that the Wilton garden engravings include versions of garden features that were never actually completed.

The Wilton volume was reissued in 1654, by Peter Stent, during the English Commonwealth, with a new title page. By this time ostentatious expenditure on private 'pleasure gardens' was entirely out of fashion, and we may suppose that one of the points of the publication was nostalgically to recall for Royalists the 'good old days', when the nobility's political and economic power was mirrored symbolically in the visible way in which they exerted control over vast tracts of the English countryside.

The engravings of the garden at Wilton certainly recall an era of calm, leisurely pursuits and élite diversions that was by that time (as far as anyone could know in the 1650s) permanently a thing of the past. The 4th Earl of Pembroke died in 1649, and even by the time of the first issue of the Wilton garden engravings, Charles I and his close courtiers no longer visited to divert themselves, away from the pressures of London court life. (The 4th Earl had in fact taken the Parliamentary side in the Civil Wars, but like Lord Fairfax, the owner of Nunappleton House and garden in Yorkshire – celebrated in Marvell's poem – he had retired to his country estate during the Commonwealth Period.)

A still closer publishing parallel than Huygens's 'Hofwijk' is Salomon de Caus's book of engravings of the Palatinate gardens at Heidelberg, which came out in that same year under the title *Hortus Palatinus*. In the very year in which Frederick and Elizabeth forfeited their claim to the Crown of Bohemia and were driven from the Palatinate, a lavish volume of engravings of that garden was published, which circulated widely across the Continent. By the time these popular engravings were on the market in northern Europe, the gardens they depicted had been devastated and the castle plundered. The engravings were permanent memorials to the lost hope of Protestants in the region, and were purchased as such by those loyal to the memory of the Winter King and Queen.

By the date of the second issue of the Wilton engravings, Wilton too was no longer a stately home, controlled by its noble owner. Lacking much of its former glory, it was now one stop on the circuit of visitors around England, who could visit it for a not insignificant sum.

In 1651, while Sir Constantijn Huygens's third son, Lodewijk, was in

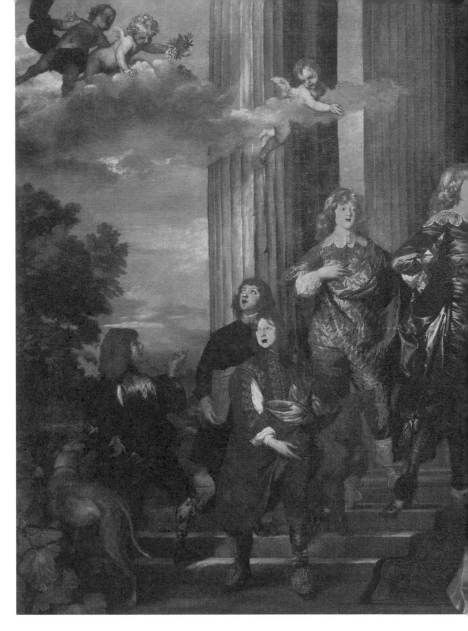

The 4th Earl of Pembroke and his family, owners of Wilton, before the Civil Wars.

England as part of the diplomatic initiative led by Jacob Cats to negotiate with the new Parliamentary government, he made the horticultural pilgrimage to Wilton. On 11 May, on his way home from a visit to Stonehenge, he paid 2s.3d to visit the house and tour its gardens, now open to the public (1s.3d for the house, 1s for the garden):

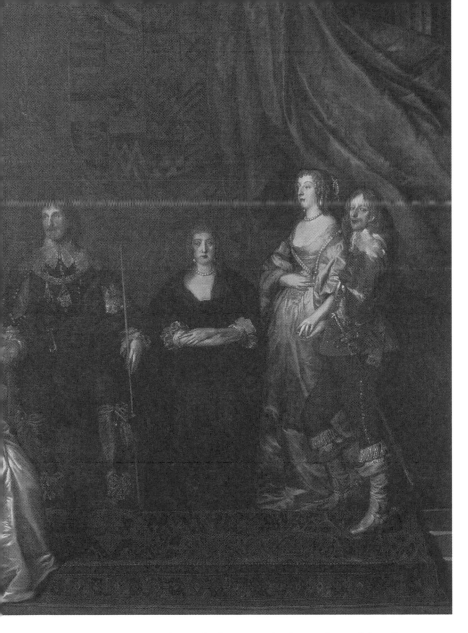

We entered the garden, which was indeed very beautiful and sym-
metrical, except for the fact that it did not correspond well with the
house. Near the house it was all flower garden with beautiful fountains,
which, however, did not work all the time. There were cypress trees
some 18 or 20 feet high in all the avenues and stone statues everywhere.
On the other side of the house were groves on either side with a lovely
wide stream running through them, besides ponds with fountains. At

the end of all this, however, there was a little house. On its roof reached by outside steps, was a pond with fish in it filled with fresh water running in through a pipe and running out through another continually. In this house was one of the finest and most charming grottos I recall ever seeing.[25]

At Wilton, once again, then, the emphasis is on a genteel struggle for stability and control of the land. But in the English case the battle is with political forces rather than with sea and sand. Driven into retirement on their country estates, deprived of office, and taxed severely for their Royalist involvement, old Royalists focused their energies into ambitious plans for their gardens. On their country estates, at least, they could continue to be masters of all they surveyed – though, fallen on hard times, they now charged the public for entrance to view their horticultural delights.

There are, nevertheless, significant differences in emphasis between the Dutch tradition and developing garden styles in England. It is striking how much attention is paid, both in Dutch garden poems and in gardening handbooks, to trees and shrubs as the most significant and admired features of any well-planned garden, taking precedence over gorgeous displays of flowers in ingeniously intricate arrangements of beds, or even exotic fruits and unfamiliar vegetables. Avenues of elms or limes (fast-growing, and producing a desirably strong, erect tree, with the foliage high and spreading) were pronounced by visitors to be the glory of many a European garden, and particularly of Dutch ones. André Mollet – gardener to Charles I and Charles II in England, Frederik Hendrik in Holland, and Queen Christina of Sweden – makes it a first requirement of any royal garden that the associated house 'be situated in an advantageous location, so that it can be adorned with all those things necessary for its beautification', of which the foremost is

> a grand double or triple avenue of trees, either elms, or limes (which are the two types of tree we consider suitable for this purpose), which avenue should be aligned at right angles to the front of the house, with a large semi-circle [bordered by trees] where it begins.

Engraving from Mollet's The Pleasure Garden *of one of his formal parterres.*

In the 1651 edition of Mollet's little book *The Pleasure Garden*, based on his most recent designs, for the gardens of the Queen of Sweden in Stockholm, there is a single chapter on 'the flower garden'. In it, Mollet proclaims tulips 'greatly to surpass even anemones in beauty and rarity, by reason of their being so admirably variegated and multi-coloured, in an infinity of colour-combinations – white, purple and blue, deep red and white, red and yellow, and many other diverse colours, up to five or six on the same flower – which makes them esteemed by the discerning above all other flowers'.[26] The rest of the book consists of discussions of trees and shrubs, including exotica like orange trees, lemon trees, myrtles and jasmines, which Mollet considers a worthy challenge for the skilled gardener to endeavour to grow successfully in cold northern climates.

Here is another reminder of the ease of to-and-fro flow of artistic talent and creativity, backwards and forwards across national boundaries, in this case in the field of garden design. André Mollet, whose father had been a royal gardener in France, first came to England in the 1620s, possibly as a member of Henrietta Maria's household. From there he went to the United Provinces, on the recommendation of Charles I (and most likely Constantijn Huygens), where he was responsible for garden designs at several royal palaces for Frederik Hendrik and Amalia van Solms as part of their self-conscious efforts to match other European royal houses in their ostentatious style of living. After five years designing gardens for the Queen

of Sweden (another aspiring style-setter among European heads of state), he returned to London in 1660, and took on an ambitious remodelling of the gardens at St James's Palace for Charles II.[27]

Garden historians have expended a good deal of energy in struggling to define the characteristically 'French', 'English' and 'Dutch' garden as it emerges in this period. In fact, decisions about what and how to emulate are in the hands of gardeners who shuttle between the great houses of various nations, and who adapt to the demands and tastes of their employers. By the time Mollet arrived back in England in 1660, Charles II expected a rectilinear expanse of water, or 'canal' (a channel, as opposed to a pond or fountain), as a focal point of any garden of modern design, thereby emulating the Dutch. Garden taste required it; Charles's peregrinations around northern Europe during his exile had tutored his eye to Dutch garden fashion. At the same time, we might argue that his endorsement of the Dutch style committed him to a version of gardening that pitted the enthusiast against an uncooperative nature and inhospitable surroundings (particularly the encroachment of water). The Dutch garden mentality, in other words, seeped into the English consciousness, shaping an English ideal of landscape beauty compatible with a Dutch one.

So, under Mollet's new English designs, St James's Palace and Hampton Court both got ornamental canals, where their Dutch counterparts had functional boundary drainage ditches, and raised walks and flowerbeds corresponding to the functional Dutch dykes. Trees are also used to give a highly visible geometry to both gardens, just as they had been used to line dykes and ditches at Honselaarsdijk. Nor was the flat, low-lying terrain at St James's a drawback, since in this respect it resembled a Dutch landscape. The canal Mollet introduced provided drainage for the boggy ground, exactly as in the gardens around The Hague.

Constantijn Huygens's correspondence reveals that while Frederik Hendrik employed André Mollet to design the ornamental beds and flower gardens at Honselaarsdijk in the 1630s, the Stadholder personally undertook the planting of trees himself – or rather, he assigned the tree-planting to a senior court official directly answerable to him.[28] Trees were the essential framework for a Dutch garden, stabilising the soil and at the same time, by marking corners and edges of dykes and canals, giving visual meaning to its necessary network of drainage channels.

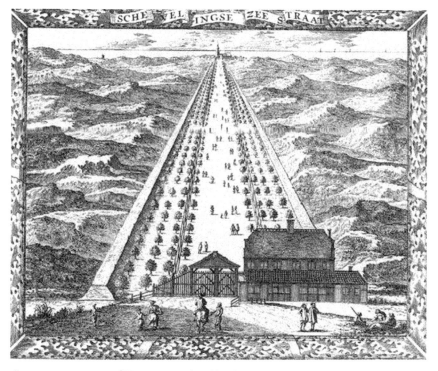

Contemporary engraving of Huygens's paved road lined with trees, linking The Hague to the port of Scheveningen.

The emphasis on trees as defining features in a Dutch garden lasted throughout the century. In the 1690s, a visitor to Hans Willem Bentinck's country estate (Jacob Cat's old estate), located between The Hague and Scheveningen, wrote of it:

> The Gardens consist of Many fine Rows of Sycamores, Ewes [Yews] and other Trees cut very handsomely ... very fine Ewe Trees and Hedges, with fine Orange and Bay Trees &ca finely sett out.[29]

Tree-lined walks bordering canals and framing avenue approaches also featured prominently in the landscaping of Dutch towns. Visitors to the Northern Provinces regularly commented on the way that Dutch towns resembled gardens — in the 1640s, John Evelyn found them 'frequently planted and shaded with beautiful lime trees, which are set in rows before

every man's house', and exclaimed: 'Is there a more ravishing, or delightful object then to behold some intire streets, and whole Towns planted with these Trees, in even lines before their doors, so as they seem like Cities in a wood?' Twenty years later in England, shortly after the Restoration, it was precisely such shady avenues of lime trees which met with Evelyn's admiration at Charles II's newly renovated and refurbished palace at Hampton Court, where he described the park as 'formerly a flat, naked piece of Ground, now planted with sweete rows of lime-trees, and the Canale for water now neere perfected'.

Another seventeenth-century visitor reported that the streets of Leiden were 'so many Alleys of a well-adorn'd garden', while yet another was so struck by the numbers of trees that he was quite ready to believe that people might ask 'whether Leyden was in a wood, or a wood in Leyden'.[30] One of Constantijn Huygens's public projects, of which he was immensely proud, was the design and execution of a paved road linking The Hague directly to the town's port at Scheveningen – 'our illustrious new way digged and paved through the sanddownes from hence to Schevering', as he described it in a letter to Utricia Swann.[31] An engraving of this project shows it too to have been bordered on either side with double avenues of trees for the whole of its length.

Expenditure on trees was a sensible long-term option – a way of making an investment with good prospects for future growth in value. As John Evelyn explains in his popular book on tree cultivation, *Sylva*, printed in London ten years after Huygens published his poem in praise of Hofwijk, when there was an acute timber shortage in England following the depletion of forests and gardens during the Civil Wars, the gracious avenues and groves of trees on a country estate were '*dulce et utile*' (pleasant and useful). Trees planted ornamentally could eventually serve 'for Timber and Fuel, as well as for shade and ornament to our dwellings'.[32]

Or they could be sold on to provide avenue trees for another man's ambitious garden plan. Evelyn describes the transplanting of full-grown oaks in this way, with considerable verve and brio:

> Chuse a Tree as big as your thigh, remove the earth from about him; cut
> through all the collateral Roots, till with a competent strength you can
> enforce him down upon one side, so as to come with your Axe at the

taproot; cut that off, redress your Tree, and so let it stand cover'd about with the mould you loosen'd from it, till the next year, or longer if you think good; then take it up at a fit season; it will likely have drawn new tender Roots apt to take, and sufficient for the Tree, wheresoever you shall transplant him.

[…] A little before the hardest Frosts surprize you, make a square Trench about your Tree, at such distance from the Stem as you judge sufficient for the Root; dig this of competent depth, so as almost quite to undermine it; by placing blocks, and quarters of wood, to sustain the Earth; this done, cast in as much Water as may fill the Trench, or at least sufficiently wet it, unless the ground were very moist before. Thus let it stand, till some very hard Frost do bind it firmly to the Roots, and then convey it to the pit prepar'd for its new station; but in case the mould about it be so ponderous as not to be remov'd by an ordinary force; you may then raise it with a Crane or Pully hanging between a Triangle, which is made of three strong and tall Limbs united at the top, where a Pully is fastned, as the Cables are to be under the quarters which bear the earth about the Roots.[33]

In 1662 Sir Constantijn Huygens's son Christiaan wrote to the newly established Royal Society in London, requesting a pre-publication copy of Evelyn's *Sylva* for his father.[34] By this time some of those precious saplings, lovingly planted in the 1630s, would have needed to be moved, to preserve the symmetry and perfect matching of trees which was an essential part of the garden's original conception.

In 'Hofwijk', Constantijn Huygens urges his children and grand-children to refrain from felling the trees that were his pride and joy, but still he refers to them as 'invested gold' and 'planted capital'. Felling and transplantation were recognised advantages of extensive wooded estates – substantial trees might be dug up (with a large clod of earth attached) and moved to furnish more avenues, while trees thinned to keep coppices airy and suitable to walk in could be sold for commercial use.

I close this exploration of Constantijn Huygens's beloved Hofwijk with a charming letter, written by the ageing diplomat to his friend Sir William Temple in 1676:

Be apprised of the fact that since some time ago the Hofwijck forest has been enlarged and beautified with four new shady avenues, and extended to impressive length, the result has been judged so beautiful and surprising, that those with most taste have concluded that it would be well worthwhile if the plenipotentiaries – both men and women – from Nijmeghen, instead of amusing themselves with trifles at Cleves, would abandon all matters of state there to come and admire Hofwijck's magnificence ... This forest has been decorated with numerous bowling balls, of such an exceptional size that they roll as if by themselve the length of these grand avenues, till they are lost from view, and quite otherwise than happens on the 'bowling alleys' and 'bowling greens' by the sea at Scheveling.[35]

Temple and his diplomatic colleagues should therefore rush to Hofwijck, concludes Huygens. And he signs himself off: 'the Marquis of Hofwijck, gobbler up of British ducats [won] at the game of quilles, "penny wise and pound foolish"'.

The topographically demanding conditions for Low Countries gardening coloured, consciously or unconsciously, Dutch appreciation of gardens. Dutch travellers' admiration was especially reserved for gardens that showed visible signs of a struggle between the aspirational owner and an unpromising location. We have a telling example of this during one of Constantijn Huygens senior's early trips abroad, in spring 1620, when he was travelling as part of a diplomatic mission to Venice in the train of François van Aerssen, Heer van Sommelsdijck.[36] Huygens's diary of the mission reveals that they visited a number of gardens on their journey, among them the celebrated ones designed by Salomon de Caus at Heidelberg, home of Frederick, Elector Palatine, and his wife Elizabeth Stuart, daughter of the English King James I.

The visit took place at a tense moment in the history of the Palatinate. In 1619, the Protestant Frederick had been persuaded to accept the Crown of Bohemia, rather than allow it to go to a Catholic claimant, and that autumn he and Elizabeth had left Heidelberg for Prague to take possession of their kingdom. Hardly had they arrived in triumph, when it became

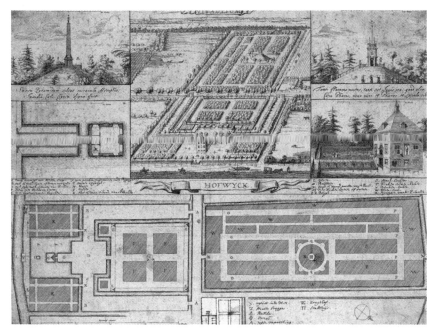

Engraved prospect and plans of Huygens's Hofwijk from the published version of his long poem of the same name.

clear that the Catholic Hapsburg powers would not sanction Frederick and Elizabeth's claim, and declared war against them. In November 1620 Frederick and his allies received a crushing defeat at the battle of the White Mountain, and the couple were forced to flee for their lives. Denied refuge by one northern state after another, they eventually arrived in The Hague, and the welcoming shelter extended by the Stadholder Frederick Hendrik to his nephew (his eldest sister's son) and his wife. There they settled for the remainder of both of their lives, Elizabeth outliving her husband by thirty years, and becoming an increasing financial burden on and embarrassment to the house of Orange.[37] Thus spring 1620 was the ominous calm before the storm, when it was all too clear how precarious was the hold of Frederick and Elizabeth upon power of any kind in the region.

When the Dutch mission reached Heidelberg, they were received in style as allies and supporters of the 'Winter King and Queen', as they would become known, by Frederick's mother, Louise-Juliana of Orange-Nassau, daughter of William I of Orange (William the Silent) by his first wife,

Charlotte de Bourbon-Montpensier, and sister of the Dutch Stadholder. The Orange delegation was welcomed effusively by the Dowager Electress herself, and Huygens records with pride in his journal how he was singled out for special attention:

> I presented her with a letter from Madame the Princess of Orange [Louise de Coligny, third wife and widow of William the Silent], which she read, and, knowing who I was, welcomed me most warmly: asking cordially after my father, his health, his household, his children; thanking him for the affection and good will which he continued to show towards the descendants of his Excellency Monsieur the Prince her Father [i.e. the house of Orange], with all kinds of other assurances of benevolence and good will towards our family.[38]

Taken on a tour of the castle grounds while the Ambassador was in closed conference, Huygens expressed special admiration for the way in which its renowned gardens had been created from 'bare rock' – evidence of a triumphant struggle against the natural limitations of the mountainous terrain:

> We were taken to see the beautiful Palace gardens, which are the more admirable for the fact that just four years ago there was nothing here but bare rock, like the rest of the mountain, which they had had to excavate to construct a fertile area of land. Which it presently is – bearing flowers, fig trees, orange trees, etc. in abundance. At the end of the garden are the grottos and fountains designed by Salomon de Caus, which are absolutely outstanding, outclassing all those in France in scale.[39]

So at this moment of acute political precariousness for the Palatinate ruling family in Heidelberg, Huygens turns to the similarly precariously sustained palace gardens as a kind of emotional surrogate. His admiration for the visible struggle in these dramatic gardens between art and nature substitutes for the intensity of feeling circulating in the group waiting anxiously for the outcome of events taking place in Prague – perhaps, indeed, the Dutch-born Dowager Electress and the visiting Dutch Ambassador made some kind of reference to the parallel themselves. Not

long after this visit, the palace and its grounds were laid waste by enemy invading forces, the remainder of the Elector's family driven out, and the glorious gardens destroyed.

Jacob Cats — Holland's favourite poet and prominent politician during the coming-of-age of the Dutch Republic in the first half of the seventeenth century — claimed that it was his own clear understanding of the symbolic meaning of gardening for a nation constantly at war with the elements which led him to persuade the Orange Stadholder to make gardening his chief (and very public) recreation. When, in his poetry, he characterised Frederik Hendrik as 'a sovereign much inclined to gardening' ('*een vorst tot planten seer genegen*'), he meant intentionally to consolidate the propaganda image of this symbolic struggle to retain Holland as a fruitful land against the invasive forces of sea and sand. In his poetic work on 'Age, Country Life, and Garden Thoughts', Cats claimed that he had encouraged the Stadholder to take an interest in gardens each time he visited Cats's own estate at Sorgvliet (also among the sand dunes close to The Hague, and like Huygens's rural retreat, self-consciously named: 'Flight from worldly care'). The Stadholder, Cats felt, should design great pleasure gardens, both for his own delight, and symbolically, to represent his role as guiding spirit of a nation dedicated to creating affluence and productivity out of unpromising packets of land rescued from the sea:

Prince Henry being a sovereign to gardening much inclined
Often came to see God's great blessings here [at Sorgvliet] to find.

His Highness was amazed when he would then discover
That rich and sumptuous woods once empty grounds did cover.

I told him, mighty Sovereign, you're buying various lands
And that at a high cost, but getting barren sands.

Do turn them into woods, and from this dust despised
Create a handsome arbour, let pleasure gardens rise.

This is true Princely work, with Holland's good in mind,
And leads you to be praised for what you left behind.[40]

As one historian of Dutch gardens puts it:

The fight for land, the constant effort to keep it safe from the sea and foreign intruders, whether perceived as a real or an abstract threat, is one of the general themes and thoughts which have permeated not only Dutch culture in general but the art of Dutch gardening in particular. Land reclamation and cultivation and the creation of a peculiarly Dutch geometrical landscape interspersed with canals lay at the foundation of the art of gardening in Holland, so much so that the country itself became identified with a garden and its people with gardeners.[41]

In a poem less well-known and anthologised than his garden poems, Andrew Marvell, who had travelled extensively in the Low Countries during the Civil War years, characterised Holland as a hapless piece of land created by its dogged people out of the detritus and leftovers of England:

Holland, that scarce deserves the name of Land,
As but th'Off-scouring of the Brittish Sand;
And so much Earth as was contributed
By English Pilots when they heav'd the Lead;
Or what by th' Oceans slow alluvion fell,
Of shipwrackt Cockle and the Muscle-shell;
This indigested vomit of the Sea
Fell to the Dutch by just Propriety.

Less negative commonplaces concerning the Dutch and their land suggested that with the help of 'Hollanders' land could be secured against the sea almost anywhere.

The Dutch garden was a triumph of endeavour and ingenuity over a fundamentally unpromising environment. As transposed to England after the Restoration, the emphasis on tree-lined avenues and walks, and the regular expanses of water (as, for instance, at Hampton Court and St James's) were a kind of homage to Dutch resilience and persistence. In combination with engineering-based drainage works at Hatfield Chase in Yorkshire, and in the East Anglian Fens, these features of the Anglo–Dutch landscape contributed a quality to the English countryside which has lasted down to the present day.

Paradise on Earth: Garnering Riches and Bringing Them Home

In the 1630s and '40s, in the Northern Provinces, writers like Constantijn Huygens and Jacob Cats dwell in their garden poems on the delights of rest and recreation as enjoyed by the owners of newly-fashionable garden estates and their visitors. Music and the visual arts help transform the country retreat into a place of intellectual and emotional pleasure. The topos of well-earned rest from the business of the court sustains an aesthetic of restful shade and eye-pleasing views, to be contemplated by grateful visitors and their host from a position of repose. As the century wore on, a certain competitive drive for magnificence increasingly colours the discourse of the Dutch garden, bringing it closer to its counterparts in France and England.

Nevertheless, the Horatian ideal of contemplative leisure following toil continues. And achieving a much-admired, idyllically pastoral Dutch garden did, indeed, require enormous amounts of toil, and even engineering.

In spite of the rhetoric of bucolic ease, gardening in Holland on the scale of Huygens's Hofwijk was carried out on the comparatively recently drained and reclaimed land west of The Hague. As such, it was fraught with difficulties for the horticulturalist, from the local topography and character of the soil, to inclement weather, consistently high winds blowing across the flat, low-lying ground, and generally inhospitable conditions for ambitious gardening. In spite of Huygens's insistence that his garden was intended for posterity, and was to be handed down from generation to generation for the delectation of his family, the odds against the enduring beauty of such a garden were high. Huygens admits in his poem that his verses are likely to outlive his beloved garden, and he was right. In fact, none of the gardens on which I concentrate here have survived. To appreciate them in all their glory we have to rely on the engravings which, fortunately for us, the proud owners had made of their country estates, and the loving recent recreations (in books, or occasionally of the gardens themselves) by garden history specialists.

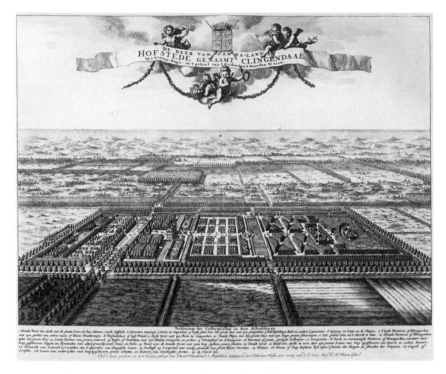

Engraving of Philips Doublet's ambitious gardens at Clingendael.

Formal garden design first became fashionable in seventeenth-century France, where space was not at a premium, and elaborately executed avenues, walks, coppices, wildernesses, ornamental beds and flower gardens could be devised to fit the garden designer's plans, however ambitious, so as to complement an attractively varied landscape. By contrast, the country house garden in the Northern Provinces was from the outset an exercise in overcoming hostile elements. Gardens like Hofwijk were fundamentally a bold public statement of a characteristically Dutch determination to secure and maintain a fertile, cultivated land in the face of decidedly unfertile sand, howling gales, and the ever-present threat of encroaching salt water.

Constantijn Huygens senior knew all about the problems of securely establishing a luxuriant garden in inhospitable terrain. Before he embarked on creating his own country retreat, he had already been closely involved with the planning of ambitious ornamental gardens at nearby

Honselaarsdijk – the country estate of the Prince of Orange, where the Stadholder first experimented with an elaborate programme of building and garden-design magnificence. It was Huygens who advised Frederik Hendrik on the design and execution of a completely new landscape-gardening project to complement his recently rebuilt house there. In this case we have extensive documentation of the re-landscaping and develop-ment of the house and garden following its acquisition as an out-of-town retreat for the Prince, conveniently situated a short ride from The Hague, between there and Delft.

Frederik Hendrik acquired the old castle of Honselaarsdijk, near Naaldwijk, from the Count of Aremberg in 1612, while his brother Maurits was Stadholder. In 1621, building work started on a new palace there. Between 1621 and 1631 the old castle was pulled down in stages and replaced by an imposing modern U-shaped design which was not, however, completed during Frederik Hendrik's lifetime. By contrast, the gardens were fully achieved by the 1630s – as with all such grand estates, the design and planting of the garden were carried out well ahead of the house, to allow it to mature.[1] This was the first of Frederik Hendrik's great 'pleasure gardens', and, typically for such enterprises in the flat, low-lying terrain of the United Provinces, he began with an extensive programme of drainage and making good of the land surrounding the original castle garden, and the laying of approach roads and planting of avenues of trees, for access.[2]

A leading historian of seventeenth-century courtly gardens in Holland has characterised the early development of the Honselaarsdijk as 'a con-stant struggle with water'. As Frederik Hendrik went about enthusiastically clearing the land surrounding the house for garden development, there was mounting concern about the provision of an appropriate drainage system. It was not simply a matter of plants and trees failing to flourish, as they did in waterlogged or marshy locations. The garden's proximity to the sea meant there was a danger of the even more devastating effect of sea water on trees' roots – the least suspicion of salt in the water, and delicate saplings would not thrive. Without adequate drainage, in the first years of the new garden layout, most of the newly-planted trees died from exposure to salt water which had seeped into the ground.[3]

In the summer of 1631, just as the gardens at Honselaarsdijk seemed well established, the most recently acquired lands were spoiled by salt-

Seventeenth-century engraving of the royal gardens at Honselaaarsdijk.

water flooding, and many valuable trees were lost. The royal accounts record repeated expenditure on digging additional drainage channels and sewers in an effort to control the flow of 'redundant water which spoils the trees'. New drains were also constructed to 'complete the drains in the two palm gardens laying next to the house Honselaarsdijk'.

In its original form, the garden at Honselaarsdijk consisted of a rectangular plot with a moat around it. As the garden was expanded, drains and water channels had to be improved and added to accordingly. First the ground was surveyed by professional surveyors, then the areas of land were rearranged so as to straighten out the existing erratic divisions of plots, and create a neatly organised collection of squares and rectangles, bordered by canals. To achieve this, marshy ground had to be reclaimed by digging ditches and throwing up small dykes. Irregular canals and streams which crossed the land were filled with earth. Once the ground had been reorganised in this way, trees and shrubs were planted, and the garden was

ready for plants, urns, garden structures and statues, to create a pleasure garden proper.

When André Mollet arrived from Charles I's court in London to lay out the parterres (the ornamental beds constructed out of box hedges, grass and fine gravel) at Honselaarsdijk, he insisted on a further drainage system being installed in the main ornamental garden, to prevent his intricate boxwood hedges from becoming waterlogged. Nevertheless, accidents continued to happen. A late-seventeenth-century tourist, visiting Honselaarsdijk, reported the forlorn state of all the plantations in the orangery due to salt-water seepage. Throughout the lives of these coastal Dutch gardens there was a continuing need for replanting, and for the replacement of damaged or dead trees. Dutch nurserymen developed a specialism (still current today) in growing trees for transplantation. They gained an increasing reputation for being adept at successfully digging up and replanting well-grown specimens to fill gaps in avenues or formal plantings. As John Evelyn enthused in his *Sylva*:

> In Flanders they have large Nurseries of [white poplar trees], which first they plant at one foot distance, the mould light, and moist. [...] As they increase in bulk, their value and price advance likewise; so as the Dutch look upon a Plantation of these Trees as an ample portion for a Daughter, and none of the least effects of their good Husbandry.[4]

By the seventeenth century, Dutch expertise in drainage and land reclamation was recognised Europe-wide. Not only were surveyors from the northern Netherlands professionally well-qualified, on the basis of their extensive experience at home, to advise on the drainage of low-lying and flood-susceptible land abroad, but investors from the United Provinces regarded loans for such ventures as a reliable source of profit.

The Dutch surveyor and embankment engineer Cornelius Vermuyden was summoned to England in 1621 by James I when the Thames overflowed its banks near Dagenham, and settled in England, marrying an English wife (his son of the same name became a Fellow of the Royal Society, and was an investor in the Royal African Company).[5] Five years later, Charles I appointed Vermuyden to drain waterlogged land at Hatfield Chase in Lincolnshire, the so-called 'Isle of Axholme'. The project was financed by a

consortium led by Vermuyden himself and Francis Russell, Earl of Bedford, whose role seems to have been to find marketable lands for Charles I, to provide much-needed funds for the royal exchequer.[6] Not only did Vermuyden apply Dutch engineering techniques to the reclamation, but he employed Dutch, rather than English, workmen.

Vermuyden's financial terms for the undertaking were well-established ones in the Netherlands. The engineer would receive one third of all lands reclaimed on his own behalf, another third went to the Crown, while the remaining third was allocated to the investors who had put money into the venture. Most of these were Dutch; their return on their investment was a significant area of reclaimed land, which they could then dispose of to realise a handsome profit. The Dutch financers included Jacob Cats, Sir Constantijn Huygens and Johan van Baerle, an Amsterdam entrepreneur from an Antwerp mercantile background who had already invested heavily in drainage projects in the Northern Provinces. Within a year of investing together at Hatfield Chase, Huygens senior married van Baerle's sister Susanna.[7]

On successful completion of the drainage project at Hatfield Chase, van Baerle, Huygens and Cats each received a thousand acres of land in return for their investment. In 1630 all became English 'denizens', entitling them to own − and sell − land in England. Symbolically we have here the Dutch man of means laying claim to fertile land freshly recovered from the water − becoming a 'landowner' (in England an entitlement to rank) by literally reclaiming unusable land from flooding. Strikingly, then, acquisition of a significant tract of land as a consequence of astute, informed investment allowed Huygens to realise his youthful dream of 'Englishness' − he became a *bona fide* English gentleman, with estates to his name, although he and his fellow investors very shortly afterwards disposed of their land interests and realised their profits.

Vermuyden went on, under the continued direction of the Earl of Bedford, to drain the Great Fen, or Bedford Level, in Cambridgeshire. In 1642, during the English Civil War, Parliament ordered the dykes to be broken and the land flooded in order to stop a Royalist army advance. In 1649 Vermuyden was once again commissioned to reclaim the Bedford Level, this time by the Commonwealth administration, after the execution of Charles I.

In France and England, specialist garden designers undertook a project as a whole, selecting suitable locations for the various garden elements, drawing out the designs and overseeing their execution. Not so in the Low Countries, where the opinions of surveyors and drainage engineers were sought before any ambitious garden programme was undertaken. Only after the surveyor had secured the terrain and tested the possibilities for safely planting and sustaining valuable plants and trees did the garden designer take over.

Right up to the end of the century, foreign visitors to the celebrated gardens between The Hague and the dunes of the North Sea remark on a certain precariousness in the great Dutch coastal gardens, and on the ever-present danger of its being invaded by sand. Visiting the gorgeous gardens at Sorgvliet, which Hans Willem Bentinck had bought from Jacob Cats in the 1670s, and which lay conveniently just off the famous road to Scheveningen, only half an hour from the centre of The Hague, several English tourists commented on the way the gardens struggled against the natural terrain. The absence of decent paths was a drawback – 'good gravel walks could scarcely be made without a great deal of trouble', noted Justinian Isham, while John Leake complained that 'the hotness and looseness of their sand is very unpleasant to the eyes and feet'. Another visitor sank up to his ankles in sand, in a place where moles had burrowed under the path.[8]

Altered fashions and tastes in pleasure gardens reflected changes in Dutch outlook and temperament in the latter part of the seventeenth century. After the marriage in 1677 of the Stadholder William III (reinstated officially in 1672) and Charles II's eldest niece, Princess Mary Stuart, it was widely assumed, in the absence of direct heirs, that William would eventually ascend the English throne. Peace and prosperity in the United Provinces allowed the burgeoning commercial economy to flourish, and with it the fortunes of mercantile families and those who invested heavily in new money-making ventures at home and overseas. From the early 1680s, the growing international aspirations and economic self-confidence of the United Provinces were echoed in ever grander and more extensive garden plans on the part of Dutch country estate owners – the emerging northern Netherlandish nobility.

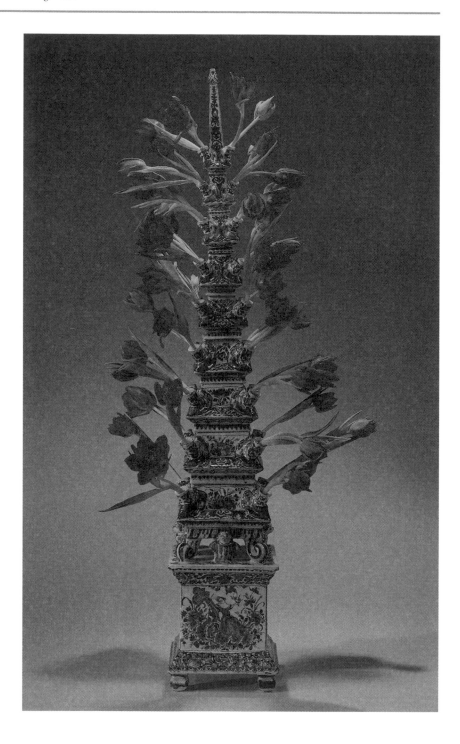

Pyramid vase of blue Delft faïence designed to display exotic flowers.

Meanwhile the Dutch East and West India Companies were playing an increasingly important role in international global commerce, their market aspirations exerting considerable influence over the politics of terri tories as far removed as Surinam and the Moluccas. Rare and unusual plants, fruits and vegetables from the new Dutch colonies became as sought-after – and as expensive to acquire – at home in the United Provinces as comparably fashionable porcelain and lacquerwork. Wealthy garden enthusiasts dealt directly with contacts at the East India Company headquarters at the Cape and, via the West India Company, at Paramaribo in Surinam, to obtain well-grown specimens, transported on Company ships at the owner's expense, to grace their terraces and hothouses for the delight of their visitors. The practice became so widespread that the directors of the Dutch East India Company attempted (unsuccessfully) to forbid the use of their ships for the transport of private goods. In October 1677 its officials reported that the deck of a ship recently returned from the Cape was

> covered and obstructed in such a way with boxes, and in such great numbers, as if they were whole gardens, resulting in so great a weakening and damaging of the ship by all the weight on top that we were obliged to write off and prohibit herewith the sending of all those cuttings, trees and plants.[9]

Garden design metamorphosed and became ever more ambitious to match the aspirations of the Dutch élite. Philips Doublet and Susanna Huygens's gardens at Clingendael and Hans Willem Bentinck's acquisition and modernisation of Jacob Cats's beloved garden at Sorgvliet are elegant examples of this transformation. Engraved panoramic views of these two neighbouring garden estates between The Hague and the coast – both substantially redesigned during the last quarter of the seventeenth century – show Dutch self-confidence and national pride renewed and reflected in ostentatious displays of wealth and magnificence.

William III's Honselaarsdijk, whose early struggles with the environment paved the way for general Dutch garden enthusiasm, was also com-

Frontispiece to a published series of engravings of the gardens at Clingendael, which names as its owners both Philips Doublet and his wife Susanna, Sir Constantijn Huygens's daughter.

pletely redesigned in the 1680s, matching William's increasingly 'royal' aspirations. The redesigned gardens were openly intended to match in splendour, if not in scale, Louis XIV's world-renowned gardens at Versailles.

Increasingly elaborate and extensive gardens like these also mirror another Dutch development of this period – the consolidation of wealth and power through marriage, which produced prominent and powerful families whose influence was exerted on both sides of the Narrow Sea. Both Susanna Huygens and her brother Constantijn Huygens junior made extremely advantageous marriages, which also lead to their association with particularly magnificent Dutch gardens.

Susanna Huygens married her cousin Philips Doublet (son of her father's sister, Gertruyd) in April 1660. The Doublets were hugely wealthy, and Constantijn Huygens, describing his daughter's wedding in meticulous detail in a letter to a friend, made no attempt to hide his intense satisfaction at the match, nor how expensive the wedding celebrations had been. It was, he confided, 'a matter of importance and serious consideration in the

service of the State'. The wedding celebrations were sumptuous, and were attended by several ambassadors and personages of note. Huygens's unusually colourful account of the lavish dining arrangements and after-dinner dancing (preceding the bedding of the bride, which her father recounts in rather excessive detail) captures the spirit of the occasion:

> The dinner guests assembled in the room facing the garden, while the food was carried into the room facing the street. The ambassador escorted the bride to the table, and each gallant gentleman and his lady was served with a first course which each judged entirely to their liking, as also the second course and the dessert. The French ambassadorial party did our chef Mater Jacques the honour of declaring his culinary prowess a match for even the most able kitchen-managers in Paris.
>
> There were forty-two complete place settings for the guests – knife, fork and spoon, as well as glassware, plate and napkin, all set out on white damask on an L-shaped table. The wedding feast consisted of a pig's head, over 100 partridges, capons, turkeys, pheasants and hares, all stuffed and larded, followed by astonishing quantities of sugar and marzipan dainties.[10]

Wedding portrait of Susanna Huygens by Gaspar Netscher.

[…] While this glorious meal was taking place, yet more glorious rooms were being prepared, laid out, perfumed and lit with between five and six thousand torches, to serve as the dance floor for the young people. And after the five hours spent eating, drinking and embracing, everyone was delighted to escape from the cooking smells and the heat of such a crowd, seated for so long together. Then, after time to stretch our legs, Monsieur the Ambassador and the other older guests having taken their seats, the dancing began.[11]

Six hundred candles illuminated the great hall for the ball, which went on into the small hours – well after the bride and groom had been escorted to the decorated bedchamber. The whole thing cost Sir Constantijn over three thousand guilders.

A man of considerable means with a good deal of leisure time at his disposal, Philips Doublet invested extravagantly in a number of his personal enthusiasms, among them a passion for fast carriages. He corresponded at length with Susanna's brother Christiaan Huygens in Paris, exchanging sketches and designs for ever more streamlined horse-drawn conveyances. But his gardens were the dominating passion in his life, and he became a gardening advisor to William III, at Honserlaarsdijk and his other palaces near The Hague.

The Doublet country estate at Clingendael had been designed for Philips Doublet senior and his wife (Philips junior's parents) in the 1630s, by the same architect and garden designer – Pieter Post – who was responsible for Constantijn Huygens's Hofwijk. Like Hofwijk it was characterised by the classical form and style of the house, standing in water at the centre of the gardens.[12] Like Hofwijk, it aspired to offer shade, tranquillity, walks and groves, and eschewed ostentation, both in its layout and in the stocking of its flowerbeds.

After the death of their father, the Doublet children embarked upon an elaborate redevelopment of the parental garden, turning for inspiration to the same French models that were exerting considerable influence in England. By the later 1670s this had become an explicit plan to modify the garden layout at Clingendael to include features drawn from le Nôtre's fabulous gardens at Versailles.

In late July 1678 Susanna wrote to her brother Christiaan Huygens in Paris, describing her pleasure at the family's move from their town house in The Hague to Clingendal for the summer, and pressing Christiaan to describe the redesigned gardens at Versailles:

Two days ago we arrived here with the whole household, hoping that the good weather will last for another month or two. I like it here enormously, and our children are as enthusiastic to be here as I am. It seems to me that the garden is beautiful at the moment – the trees are growing wonderfully well. My husband is astonished at the changes you talk about when you visited Versailles, and continues to hope that he might return one day, so that he could admire all these added beautifications with you, and many other beautiful things that I fear I myself will never see.[13]

A few months later, Philips Doublet himself wrote to Christiaan, asking him to purchase and send complete runs of engravings of the gardens at Versailles, so that Philips could use them as models for his own garden redesign. They would also be useful, Philips added, for the remodelling of William's palace at Huis ten Bosch, for which he was an adviser.[14] It took a large number of exchanges of letters, and some false starts with sending the plates (one consignment got badly damaged in transit), but in the end Philips was the proud owner of precise and detailed representations of all the newest and most significant buildings and gardens in Paris.[15]

Christiaan Huygens also sent his brother-in-law diagrams and descriptions of innovative designs for fountain-driving machinery in use in Paris. Where once canals and drainage ditches had defined the contours of the Dutch pleasure garden, now elaborate waterworks, fountains and pools provided more picturesque focal points for the visitor. In the exchanges of information between Huygens and Doublet — brothers-in-law and fellow enthusiasts for the modern and innovative — we see two Dutchmen, in the forefront of design activities in a variety of areas, both closely involved with the house of Orange and its aspirations towards sovereignty in the British Isles, collaborating at a distance to interpret and develop French ideas, influencing in peculiarly Dutch ways evolving garden projects in the United Provinces.

Christiaan and Susanna's brother Constantijn junior married Susanna Rijkaert in August 1668. Once again, a member of the influential and politically well-placed Huygens family married into a prosperous merchant family, acquiring its network of commercial connections. Among these were the families of Gaspar Fagel (who acquired his garden at Leeuwenhorst in 1676) and Magdalena Poulle (whose garden at Gunterstein was celebrated throughout the 1680s).[16]

In the latter half of the seventeenth century, men on the rise in politics and power created grand country estates to match their ambitions. Gaspar Fagel, Grand Pensionary of Holland from 1672, was one of the close advisers to William III in the period leading up to the seaborne invasion of the British Isles in November 1688. With Bentinck and Gilbert Burnet, he shaped the polemic surrounding the Orange claim to the English throne,

and may be credited with some of the 'spin' that ultimately made the invasion acceptable to the English.

On the rising tide of his influence over the young William, Fagel took possession of the country estate of Leeuwenhorst in 1676. There he presided over the creation of one of the most remarkable gardens in the United Provinces. Throughout the period of feverish planning and preparation for William and Mary to take by force the throne of England which they believed theirs by right, Fagel, who suffered from bouts of ill-health and persistent gout, would retire to his estate near Noordwijk to hunt and to occupy himself with the delights of gardening.

The international renown of the Leeuwenhorst gardens came not just from the ostentation and complexity of its design, but above all from Fagel's collection of exotic plants. He spent enormous sums on acquiring many species newly introduced from the Dutch colonies, which could be seen nowhere else in Europe. Later commentators remarked that in spite of his not inconsiderable annual income, and his moderate way of life, at his death in December 1688 (just weeks after the invading armada he had been so closely involved in planning set out) he left almost nothing to his heirs, having squandered everything on plant rarities, and the equipment and accommodation to support them at Leeuwenhorst.[17]

Although his magnificent estate was rented, rather than owned outright, Fagel made sure to sign an undertaking with the landowner that all the plants introduced and cultivated there belonged to himself. He had selected the location with care, in a fertile, sheltered region already known for its market gardening, and from the outset his ambition was successfully to cultivate species hitherto unknown to Europeans – both flowering plants and fruiting shrubs. Over the twelve remaining years of his life he worked in close collaboration with horticulturalists in the service of the Dutch East India Company, paying for plants secured in the Far East to be tended in an intermediate garden at the Cape, to assure their robustness before they were transported to the Netherlands.

A visitor to the Cape en route for China in 1685 was astonished by the Dutch East India Company's thriving botanical garden:

We were mightily surprised to find one of the loveliest and most curious Gardens that I ever saw. It contains the rarest Fruits to be found in the

several parts of the World, which have been transported thither, where they are most carefully cultivated and lookt after.[18]

In his enthusiasm for the exotic, Fagel did not confine himself to trawling the colonies for new items for his gardens. In 1684 he took advantage of his fellow adviser to William of Orange, Hans Willem Bentinck's being in London on a diplomatic mission, to request that he look out for plants for him in England. Bentinck replied that he was only too happy to oblige, and that he had already begun to make enquiries – it would help, he added, if Fagel could send him a list of the individual plant-species he was interested in.[19] Eventually, the Leeuwenhorst gardens contained plants from the Cape of Good Hope, from Europe, the Mediterranean, North and South America, south and south-west Asia, the Canary Islands, Africa and Japan. Numerous overseas visitors record how impressed they have been by the facilities and the plants in Fagel's gardens. His hothouses were the foremost in Europe at the time, and the orchids and pineapples he raised there were regarded as contemporary marvels. Shortly before his death a set of water-colours of the most exotic of his rarities was commissioned on behalf of William III himself, from the artist Stephanus Cousyns.[20]

Fagel died on 15 December 1688 (new style), just a week before the triumphant William III took up residence, first at St James's Palace, and then, because his asthma made prolonged residence in smog-congested central London impossible for him, at Hampton Court Palace. Fagel's family immediately sold the contents of his garden to William and Mary. By 1690 much of the collection was installed at Hampton Court. It is first recorded there on 26 April, when a group of 'botanick acquaintances' from Northamptonshire visited Hampton Court gardens by appointment, 'to see the famous collection ther of the rare Indian plantes which mine Heer Fagel had gathered together':

> There is about 400 rare Indian plants which were never seen in England; and there is scarce any desirable Indian plant, but a specimen may be seen ther, and some very curious Indian plants are in so great perfection it is very wonderfull and scarce credible. The stoves [hothouses] in which they are kept are much better contrived and built than any other in England.[21]

Watercolour by Stephanus Cousyns depicting rarities from Gaspar Fagel's garden.

The process of transplanting Fagel's garden contents to Hampton Court was a protracted one, particularly since adequate facilities (for example, the extensive hothouses and glasshouses) had to be constructed ahead of the plants' arrival, to assure the minimum of shock and damage to the fragile blooms. Two years later, some of the plants were still at Leeuwenhorst, waiting for suitable accommodation. On 3 March 1692, the remainder of Fagel's collection, consisting of 'orange trees, lemon trees, and other outlandish trees as well as shrubs, plants and herbs', was valued, and 4,351 guilders paid to Fagel's heirs. In August and September, when the weather was fine enough not to damage the trees and shrubs, they were transported to The Hague. Thence they were shipped to England in October. Garden tubs and their bulb contents, which William and Mary had not required, were sold to the Amsterdam Botanical Garden in 1691, and transported there in 1692.

In spite of the fact that, like Fagel, the twice-widowed Magdalena Poulle had no direct heirs, her extensive gardens at Gunterstein, complete with exotic plants, an orangery and hothouses, have, unusually among the Dutch seventeenth-century gardens, survived down to the present day. She

acquired the ruined manor outside Utrecht in 1680 at public auction, and over the next two years built a classically-influenced country house for herself on the foundations of the old medieval one, and designed an extensive garden around it.

In a letter to Henry Wotton, John Evelyn reproached antiquity for its lack of interest in exotic plants and the nurturing of rarities under hothouse conditions. Where gardens were concerned, the ancients 'had nothing approaching the elegancy of the present age':

> What they call their gardens were only spacious plots of ground planted with plants and other shady trees in walks, and built about with porticos, xystia, and noble ranges of pillars, adorned with statues, fountains, piscariae, aviaries, etc.
>
> But for the flowery parterre, beds of tulip, carnations, auricula, tuberose, jonquills, ranunculas, and other of our rare coronaries, we hear nothing of; nor that they had such store and variety of exotics, orangeries, myrtle, and other curious greens; nor do I believe they had their orchards in such perfection, nor by far our furniture for the kitchen.[22]

On 16 July 1686, Evelyn sent a friend a list of the most famous gardens in the Dutch Republic, which he must see without fail. These included those of Hans Willem Bentinck (Sorgvliet), Lord Beverning, Gaspar Fagels, Daniel Desmarets, Madame de Flines (i.e. Agnes Block), Magdalena Poulle, Pieter de Wolff, and the Leiden *Hortus Botanicus*, as well as the Duke of Arenberg's garden.[23]

Gardening enthusiasts like Gaspar Fagel and Magdalena Poulle sent out their specialist search parties across the known world, looking for exotic botanical specimens and exploiting every possible avenue for access to much-desired, difficult-to-get-hold-of items, which they would then rear lovingly in their hothouses and display ostentatiously in the outdoor urns that graced their terraces during the warm summer months.

In 1685 the Bishop of London, Henry Compton, sent his head gardener,

Rachel Ruysch still-life, showing the rich diversity of the flowers to be found in a grand Dutch garden.

George London, on a trip to the Dutch Republic to view and report back on gardening innovations there. One of the gardens he visited was Magdalena Poulle's, where he compiled an inventory of the rarest and most remarkable plants he saw there, headed: 'These elegants which stand together in the garden of the Lady of Gunterstein at Breukelen in the province Utrecht'. They included a coconut palm, *Sesbania grandiflora* (a shrub from Kerala with edible leaves and flowers), a coral tree from Brazil, sugar cane, carob, a clematis from Argentina or Paraguay, *Fritillaria crassa* (one of the fritillary family much featured in Dutch flower still-lifes), *Leonurus Capitis Bonae Spei* (from the Cape of Good Hope), hibiscus, delphinium, *Thlaspi sempervirens et florens* (from Persia), papaya and tamarind. All or most of these needed special conditions for successful raising, and indeed the hothouses at Gunterstein set a standard for those at the Physic Garden in Chelsea.

When Magdalena died, her brother put part of her orangery collection up for auction. It included 'diverse sorts of Orange, Lemon, Myrtle, Jasmine, Camphor, Arbutus and double Oleander trees, together with many extremely rare and exotic shrubs, plants, roots and bulbs, collected over many years from many distant regions of the world'.[24]

George London's close study of garden features and remarkable plants in Dutch gardens on behalf of Compton later stood him in good stead. After the 1688 invasion he became royal gardener to William III, and deputy to Hans Willem Bentinck as Intendant of the royal gardens.

Gaspar Fagel's collection of exotic plants and shrubs, transported (or perhaps one should say 'translated') from Holland to Hampton Court Palace, was as much a part of William and Mary's Dutch 'invasion' as the 1688 flotilla and the Torbay landing. That extended sense of the transfer of authority – cultural, aesthetic, intellectual as well as political – from one location to another is also illustrated by another Dutch garden, established with typical Dutch fortitude and determination in an overseas 'settlement' – Johan Maurits van Nassau-Siegen's garden at Recife, in newly conquered Brazil.[25]

A distinguished Dutch military campaigner, friend and fellow art-amateur of Constantijn Huygens senior, and a distant cousin of the

Stadholder, Johan Maurits became Governor-General of Dutch Brazil in 1637.[26] Delighted by the topography around Recife, where he established his headquarters, which at once resembled the Netherlands in its water-surrounded flatness, and far exceeded it in the lushness of its flora, Maurits occupied the island of Antônio Vaz, where he set about establishing a model Dutch-style 'new town', with a regular grid of streets, central public squares and a system of gardens and canals, to be called 'Mauritsstad'. He also built himself a palace in Recife, which he called the Vrijburg Palace, organised on as lavish a scale as the colonial context allowed, with extensive formal gardens around it.

A surviving description of the Vrijburg Palace garden shows how closely it conforms, in design and execution, to the gardens of Johan Maurits's close friends Constantijn Huygens and Jacob Cats in a similarly flat, water-encircled landscape outside The Hague:

> In the midst of that sterile and unfruitful sand a garden was planted, and all the species of fruit trees which grow in Brazil, and even many that came from other parts, and the strength of much other fruitful soil, brought from outside in shallow boats, and much addition of manure, made the place as well conditioned as the most fruitful soil.[27]

As at home in Holland, Maurits had trees brought in full-grown to form avenues for his new garden – only here in Brazil the trees were coconut palms:

> The Count ordered [the coconut palms] to be fetched from a distance of 3 or 4 miles, in four-wheeled wagons, cleverly uprooting them and trans-porting them to the island, on pontoons set up across the rivers. The friendly soil accepted the new plants, transplanted not only with work, but also with ingenuity, and such fertility was passed to those aged trees, that, against the expectation of everyone, soon in the first year after transplanting, they, in a marvellous eagerness to produce, gave very copious quantities of fruit.[28]

In his handbook of tree husbandry, *Sylva*, John Evelyn cited Johan Maurits's mature-tree transplanting with approval:

A seventeenth-century Dutch painting of the Brazilian landscape.

But before we take leave of this Paragraph, concerning the Transplanting of great Trees, and to shew what is possible to be effected in this kind, with cost, and industry; Count Maurice (the late Governour of Brasil for the Hollanders) planted a Grove neere his delicious Paradise of Friburge, containing six hundred Coco-trees of eighty years growth, and fifty foot high to the nearest bough: these he wafted upon Floats, and Engines, four long miles, and planted them so luckily, that they bare abundantly the very first year; as Caspar Barlaeus hath related in his elegant Description of that Princes expedition.[29]

Both these accounts were second-hand (Barlaeus never travelled to Brazil). A first-hand description of the Vrijburg garden by the Portuguese missionary Manuel Calado confirms that the effect of these ambitious garden-creating moves was a pleasure garden on the Dutch model – though there is some disagreement as to just how many palm trees were uprooted to frame its shady groves:

> In this garden they put 2000 coconut palms, bringing them there from other places, because they asked the inhabitants for them, and they ordered them to bring them in carts, and with them they made some long good-looking rows, in the style of the tree-lined path of Aranjués,

and elsewhere many trellised vines and beds of vegetables, and of flowers, with some summerhouses, and entertainment, where the ladies and their friends would go to pass the summer festivals, and to have their treats, and make their picnics and drinks as they do in Holland, with their musical instruments.[30]

In this recreation of the space of repose beloved of Dutch noblemen, Johan Maurits would walk 'for pleasure' with his guests to 'show off' his curiosities. Vrijburg became his favourite palace, and the garden his preferred place for spending any time he could spare from the business of government. As with those northern Netherlandish gardens, though, the pleasure offered by the Vrijburg gardens was short-lived. Even before they left Brazil in 1654, the Dutch themselves had begun to remove trees from the gardens, and by the end of the seventeenth century there was almost nothing left.

The to-and-fro exchange in garden lore nevertheless continued. Johan Maurits brought quantities of garden materials back with him to Europe on his return in 1644, where they contributed to his remarkable gardens at the Mauritshuis and at his palace at Cleves, where he became local Stadholder.[31] It was he who advised Bentinck in detail on the design of his magnificent gardens at Sorgvliet, gardens which by around 1700 summed up the Anglo–Dutch collaborative project.

In May 1700 Bentinck married his second wife, the widow of Lord Berkeley of Stratton, Martha Jane Temple, the niece of the pro-Dutch diplomat, and connoisseur of gardens and garden art, Sir William Temple. She brought with her a dowry of £20,000, a large fortune which enabled Bentinck to enlarge his social ambitions considerably. Several of those writing to congratulate him on his remarriage suggested that in the pleasant retreat of a companionate marriage blessed with shared interests (i.e. gardening) he could indulge his passion for horticulture to the hilt. His gardens outside The Hague fully realised such aspirations.

In the academic literature on gardens and gardening in the seventeenth century, there tends to be a certain reluctance to tackle the financial side of the subject – not just the sheer size of expenditure, but the commercial and

organisational arrangements for producing perishable goods for the horti-
cultural market and purveying them to eager customers. I have touched
several times on the high cost of designing, establishing and stocking a
country estate, but I have been aware myself of a tendency to cite this with
admiration, as evidence of passion and commitment to the enterprise. This
is the point to talk about prices, and attitudes to the cost of maintaining so
ephemeral a luxury as an ornamental garden, in constant need of replen
ishing and upkeep. And how better to do so than by describing so-called
'tulipmania' — the escalating price of tulip bulbs in the Dutch Republic in
the 1630s.

In the mid-1630s the Dutch went wild about tulips.[32] As Anne Goldgar
describes in the most recent study of the subject, tulips were new to Europe
(they were introduced in the mid-sixteenth century from Turkey), and
they were rare. They were therefore expensive.

> To us the ultimate in Dutch domesticity, in the 1630s this fragile and
> changeable bloom represented novelty, unpredictability, excitement — a
> splash of the exotic east, a collector's item for the curious and the
> wealthy.[33]

For a short period, starting around the summer of 1636, prices for the
bulbs of some particularly highly prized varieties of tulips rose to enormous
heights. Tulip bulbs are by their nature objects on which it is possible to
speculate financially. Those which promised to produce the most highly-
sought-after variegated red-and-yellow, purple-and-white or red-and
white flowers — because they had produced such blooms in the past, or
were the offsets from bulbs that had — could be sold for very large sums.
But the promise of the bloom lay resolutely in the future. What changed
hands was a few small brown bulbs the size of an onion. The purchaser was
obliged to accept the promise of a spectacular bloom on trust, and to pay
upfront.

In early 1637 the bottom fell out of the tulip market. Speculative sellers
who had bought bulbs at high prices to sell on at a profit found themselves
with worthless items on their hands. Those who had purchased at the top
of the market, and who would indeed see flowers as soon as the summer
blooming season came around, nevertheless refused to pay the balance on

Seventeenth-century still-life of exotic tulips.

the exorbitant amounts they had been foolish enough to part with for their prize purchases in the overheated market. Among those – from humble artisans to nobility – who had been caught up in the tulip craze, many were ruined, reduced to bankruptcy by purchase prices far beyond anything reasonable for a mere flower.

That is the story as it has traditionally been told. In fact, the truth was far less sensational. Prices of tulips did indeed inflate in the 1630s, and there was a 'crash' in 1637, but tulip bulbs continued to command serious prices throughout the seventeenth century, until they were finally displaced by the newly fashionable Oriental flower, the hyacinth. The tulip buyers and sellers were on the whole professional horticulturalists, and they sold to keen gardeners. One of the beauties of bulbs of any kind is that they can be bought in quantities to suit the pocket of the buyer. Where André Mollet bought tulip bulbs by the thousand to stock the parterres at St James's Palace in London, owners of a small plot of land could purchase them individually to add colour and dash to a modest bed.

Bulb-buying represents the ordinary Dutch man or woman in the street's access to and aspiration towards gardening, and control of their own little piece of earth. Since all paid taxes towards dykes and securing the borders of the nation, what could have been more natural than to join the élite in tilling one's own garden? And indeed, it has been argued that the collapse of the tulip 'bubble' was the result of the market gardeners over-producing, thus driving prices down. By the time of the collapse of the tulip-speculation bubble, nursery gardeners' initiative in this thriving market meant that tulips produced from seed were freely available for purchase, and the rarity value of particular varieties had disappeared.

In the contemporary imagination, the ephemeral bloom of the gorgeous tulip and the high price attached to it, simply for its rarity, symbolised the moral dilemma of expenditure. If one accumulated wealth by legitimate means, was one entitled to 'squander' it on useless decorative rarities like paintings and tulips? Ought one not to dispense it more ethically, on good works, or invest it for the future? Dealers could soothe the conscience of their clients by surrounding themselves with the very luxuries their clients guiltily desired – as Gaspar Duarte hung the paintings

he offered for sale in his own gallery, where his visitors could wander in a leisurely fashion, admiring both the works of art and the ambiance, before deciding to purchase. Market gardeners, similarly, surrounded their shops with ornamental gardens, filled with the very blooms their visitors were eager to acquire, and which they would collect only later, after the blooms had died, and the bulbs were lifted for the winter. Inflated prices for tulips were generated at auction, exactly as we saw high prices being realised for paintings in the same period.[34] So it is hardly surprising to find the same individuals buying and selling both art and tulips.[35]

Fascination with the soaring price of tulips reminds us of the strenuous connection between wealth and fashionably ambitious gardening. Both Dutch and English gardens came at considerable expense. On top of the price of plants and labour, there was the cost of the plundering of the raw materials required to create it − and its accompanying country house − from the new territories which yielded the exotic, the rare and the sought-after for keen collectors and horticulturalists.

Here I use the career and rise of the Englishman William Blathwayt as representative of the complicated relationship between desirable goods from overseas and money-making, the passion for collecting and the ruth-less pursuit of power and office. Because he had served in the Netherlands, and was fluent in the Dutch language, Blathwayt self-consciously modelled his tastes in fine things, including art and gardens, on those of the Dutch. He also unashamedly exploited his position as controller of import-export from the colonies to amass an extraordinary profusion of luxury articles, commodities and curiosities to adorn his country house at Dyrham Park near Bath, and his magnificent gardens there, which in his day were the talk of the region.[36]

William Blathwayt was Clerk of the Privy Council, head of the Plantation Office, Auditor and Surveyor General of the plantation revenues, and Secretary of War, beginning in 1676 and running on into the new century. He was a somewhat prosaic government official with expensive tastes, who married a considerable heiress. William III, whom he served with exceptional efficiency as Secretary of War, and Auditor General at the Colonial Office, pronounced him 'dull'. John Evelyn called him 'a very proper person, and very dextrous in businesse', adding, 'and has besides all this married a very great fortune'. Old money looked down on him, pro-

nouncing his expenditure on Dyrham Park excessive and unwise: 'My Lord Scarborough thinks he lays out his money not very well.'

Blathwayt was William and Mary's 'imperial fixer'. His successful career was based on the way he could make things happen, at long distance, throughout English-administered territories, from the American colonies to the farthest-flung island outposts. For that he was handsomely remu nerated between the 1680s and the end of the century. But Blathwayt's salary did not stretch to cover his magnificent lifestyle at Dyrham Park. That was maintained by systematically extracting backhanders from his 'clients'.

If you want him to act, one of Blathwayt's agents advised the Governor of the island of St Christopher (now St Kitts) in the Caribbean in the 1680s, it will cost you: 'Without a gratification of twenty or thirty guineas for himself at least,' he wrote, 'I much doubt the effect of anything else.' The Governor duly sent thirty guineas on behalf of the colony, and added another ten of his own with an accompanying note: 'to buy you a pair of gloves in acknowledgement of the favour you did me in my business at Court'. 'I have not named you in the bill,' he went on, 'that no notice might be taken to whom the money goes.'

Which explains a good deal about Dyrham Park as it can still be found today. Even three hundred years after the original owner's death, the surroundings are sumptuous: glorious walnut panelling and a sensational cedar and cypress staircase; gilded embossed-leather wall coverings, inlaid furniture, tapestries and rugs. On the walls are fine Dutch landscapes and perspective paintings in a manner that was enormously fashionable at the end of the seventeenth century. And there are fantastic pieces of blue-and-white Delft faïence everywhere, including a pair of waist-high pagoda-like pyramid vases designed for the display of rare tulips – another expensive seventeenth-century fad on which William Blathwayt was happy to spend a small fortune.

The receiving rooms in Blathwayt's mansion are panelled in black walnut, courtesy of the Governor of Maryland. The cypress and cedar wood for the baluster and stair risers of the grand main staircase were a gift from the Governor of South Carolina; the walnut treads were the contribution of the Governor of Virginia. The juniper floorboards came from Jamaica. The extensive gardens, which once boasted some of the most

impressive fountains and cascades in England, were planted with exotic plants collected for Blathwayt by colonial officials engaged in business which needed the Secretary of State's blessing.

Blathwayt did choose and purchase the Delft ware, the ornamental tiles and fine china himself – as well as Oriental silks and large quantities of tea – whenever he accompanied King William to The Hague on royal business. But he made sure that he paid absolutely no customs duties on them, remonstrating in indignation should anybody so much as try to make him do so.

Determinedly ferrying their precious cargoes of exotic plants and elaborate garden designs across broad and narrow seas, the industrious Dutch distributed their own peculiar, highly developed system of cultural and aesthetic ideas, carried more or less explicitly along with the material objects themselves. Long before the house of Orange set its sights on the throne of England, the British Isles had absorbed, and come to take delight in, a controlled garden landscape and the associated idea of a conscientious struggle to master the forces of nature.

When William III interrupted his military campaign, breaking off from the march to conquer London to walk in the gardens at Wilton, he must have felt in familiar surroundings, and an accompanying sense of comfort and relief. In terms of ambiance and lifestyle, he was coming home. The outstretched hands of the welcoming orange-sellers among the crowds thronging the streets of London, as he made his way along Knightsbridge towards Whitehall, will have reassured him further: the studied, self-conscious garden symbolism of the house of Orange was already recognisable and in place in England.

Mutual recognition cushioned the impact of the Dutch invasion of England. Retrospectively, it blurred and diffused the national memory: here was no conquest, here was an affinity – a meeting of minds and sensibilities.

Anglo–Dutch Exchange and the New Science: A Chapter of Accidents

When William III of Orange regained his place as Stadholder of the United Provinces in 1672, Sir Constantijn Huygens's eldest son, Constantijn junior, was installed in his father's place as the Prince's trusted personal secretary.

In 1676, while campaigning with William of Orange in military operations against the French on the Dutch–French border, Constantijn Huygens junior wrote home to his wife to get her to order one of his brother Christiaan's new balance-spring watches at The Hague, and to have it sent to him in the field:

> Wednesday. 17 [June 1676]. I presented Monsieur the Prince with a letter to the Court in favour of my brother [Christiaan], but he set it aside together with other things that he was delaying signing. I wrote to my father telling him this, and to my wife concerning my watch.[1]

His new timepiece reached him a month later:

> Saturday. 18 [July 1676]. This evening we began trench engagement. Major de Beaumont, called Merode, and the Surgeon of Rhinegrave were killed there. His Excellency's attack was undertaken by the regiment of guards; the Duke of Osnaburg's was undertaken by the regiments of Offelen, Beaumont and Hofwegen. It is openly said that His Excellency ought to rejoin the other army. My watch, that I had had made at The Hague, arrived.[2]

Already this adds a curious edge to a familiar period of early-modern scientific discovery: at the same time Constantijn was corresponding with Christiaan and other members of his family about the new '*monstre*', he was

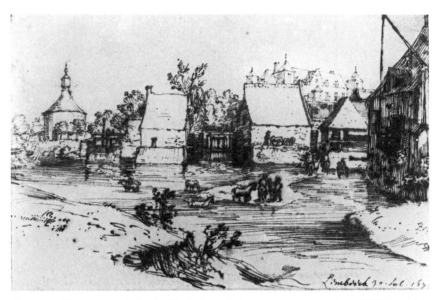

Constantijn Huygens junior's sketch of Lombeek, made during a military campaign with William of Orange.

procuring safe-conducts for Christiaan and Lodewijk to travel from France (where Christiaan's presence was increasingly an embarrassment as tensions rose between France and the United Provinces), through Spanish-governed territory, to The Hague. While England, France and the United Provinces were on a war footing with one another on-and-off throughout the second half of the seventeenth century, national boundaries in no way inhibited, apparently, the free traffic and exchange of innovative science and technology.

The picture I am painting in this book as a whole, of an ongoing to-and-fro exchange of ideas, influence and taste between the United Provinces and England throughout the seventeenth century, provides a particularly clear context for the history of science. There is a large literature on Dutch and English scientific innovation in the seventeenth century, and some work on the affinities between the two sets of practitioners.[3] The contributions of outstanding Dutch scientists like the microscopists Anton van Leeuwenhoek of Delft and Jan Swammerdam, and all-round 'virtuosi', or scientific amateurs, like Sir Constantijn Huygens's son Christiaan, were reported regularly to the Royal Society in London. The entrepreneurial

Henry Oldenburg's journal, *Philosophical Transactions of the Royal Society*, was available on the Continent almost as soon as it left the London presses – individuals often requested sections of an issue they were particularly interested in, which could be sent even more easily by post.

Nor ought we to forget the tourists. In the summer of 1668, Thomas Browne's son Edward went to the United Provinces on an extended sight-seeing tour. He made a point of visiting distinguished Dutch medical men, as part of his preparation for his intended future career as a physician. In Amsterdam, he records in his diary, he saw at first hand the work of the anatomist and microscopist Frederik Ruysch, internationally famous for his invention of a method for injecting the fine vessels in cadavers with tinted wax for display purposes:

> Dr Reus [Ruysch] showed us many curiosities in anatomy, as the skeleton of young children; foetuses of all ages so neatly set together and as white as your frogs' bones which my brother Thomas prepared; the lymphatic vessels so preserved as to have the valves seen in them; the liver so excarnated as to show the minute vessels, all shining and clear; the muscles of the children dissected and kept from corruption.[4]

Browne also met the famous Dutch microscopist and anatomist Jan Swammerdam:

> Dr Swammerdam showed us many of his experiments which he has in his book De Respiratione; he includes a bladder in a glass, the bladder represents the lungs, the glass the thorax; draw out the air out of the glass and afterward the bladder will receive no air by the greatest force whatsoever. It is hard to relate all his experiments with syringes and double vessels without figures and a long discourse. Besides these he showed us a very fair collection of insects, a stagfly of a very strange bigness, an Indian forty-foot [snake], the fly called ephemeron and many other curiosities.[5]

Yet Dutch and English scientists have largely been treated by historians as though they operated in separate spheres, their work intersecting or overlapping only when correspondence between parties on either side of

the Narrow Sea brought information to each other's attention. What I shall show in this chapter and the next, in two extended examples, both involving a particular scientific favourite of mine, Robert Hooke (for which I make only a mild apology), is how very much more interestingly and closely involved these activities were.

On 23 January 1675, Sir Constantijn Huygens's second son, Christiaan, who had for almost ten years been the leading scientist at the Royal Society's French counterpart, the Académie royale des sciences in Paris, drew in his notebook a sketch of a coiled hair-spring with one end attached to the centre of the balance of a pocket watch, and wrote underneath it, 'eureka'. The exclamation signified his triumph at having devised a method of harnessing the isochronous properties of an oscillating balance attached to a coiled spring, to allow it to be used to regulate the mechanism of a compact timekeeper, just as a swinging pendulum could regulate a clock.[6]

A week later Huygens sent a letter to Henry Oldenburg, secretary of the Royal Society in London, officially lodging with the Society an anagram cryptically containing the secret of his spring-driven balance. On 20 February, having heard that his French clockmaker Isaac Thuret had gone to the authorities claiming the clock he had made to Huygens's technical specifications was his own, Huygens went public with his timekeeping breakthrough. He rapidly secured a French *privilège*, or patent, and published an account of it, with diagrams, in the next issue of the journal of the Académie royale des sciences.

On 20 February Huygens also wrote to Oldenburg disclosing the solution to the cipher: 'The arbor of the moving ring [the balance wheel] is fixed at the centre of an iron spiral.' He proceeded to enlarge on this with a verbal description:

> The fact is, this invention consists of a spring coiled into a spiral, attached at the end of its middle [i.e. the interior end of the coil] to the arbor of a poised, circular balance which turns on its pivots; and at its other end to a piece that is fast to the watch-plate. Which spring, when the Ballance-wheel is once set a going, alternately shuts and opens its spires, and with the small help it hath from the watch-wheels, keeps up the motion of

the Ballance-wheel, so as that, though it turn more or less, the times of its reciprocations are always equal to one another.[7]

London's leading expert in timekeeper development, the Curator of Experiments at the Royal Society, Robert Hooke, learned of Huygens's claim to be the first to invent a spring-regulated clock while dining with Robert Boyle (son of the Earl of Cork, and a distinguished scientist who had once employed Hooke as his laboratory assistant) on 25 February 1675 (old style). The following day Hooke lodged a formal complaint at a meeting of the Royal Society. He reminded the members that he had himself pro-duced spring-regulated clocks at their meetings on several occasions in the

The mechanism of Huygens's balance-spring watch, printed in the London Royal Society's Philosophical Transactions, *thereby establishing Huygens's priority.*

1660s, and declared that Huygens's version was 'not worth a farthing'. The affair rumbled on for several years. In the end, Huygens's priority claim was by and large accepted, even in England. Although, in spite of Oldenburg's best efforts, he was never granted an English patent for his balance-spring watch, he was issued with patents or licences in France and the northern Netherlands, and is today generally credited with this significant innovation in horology.

But was this really how it was? Instead of rushing to look for a 'winner' in the 'race' to find a precise longitude timekeeper (a clock accurate enough over long periods to allow calculation of a vessel's east–west position on the open sea), perhaps we should take our cue from the draft notes for a lecture by Hooke delivered around 1676, responding to Huygens's 'eureka moment', and preserved in the treasure-trove of Sloane scientific papers in the British Library. In it he queries Huygens's claim to single-handed solution of the problem:

> He should also have Remembered that Golden Rule to doe to others as he would have others doe to him & not to have vaine gloriously & most Disingenuously Indeavourd to Deprive others of their Inventions that he might magnify himself and with the Jack Daw pride himself in the plumes of others.[8]

In the spirit of which, and in the light of the fact that my story so far has shown that there was a free flow of ideas and culture to and fro between London and The Hague throughout the period in question, I propose to take another look at the evidence, to try to decide whether Hooke might have been right. Did that Anglo–Dutch exchange of ideas effectively amount to an international collaboration, and ought the two men in fact have been given the credit for a groundbreaking horological invention, the balance-spring regulator for a pocket watch? The story begins in the Netherlands in the 1650s, almost twenty years before Huygens's eureka moment.

Almost a decade after the execution of Charles I, and at the height of the English Commonwealth, the Scottish courtier Sir Robert Moray and his old friend Alexander Bruce (later 2nd Earl of Kincardine) were both living in exile in the Low Countries.[9] Bruce was attached to the itinerant

court of Charles II, while Moray had settled in Maastricht, where he was part of a substantial English garrison assisting the Dutch Orangists to protect the southern Protestant Dutch border.[10] The two were staunch Royalists whose families had been closely involved in the fortunes of the Stuarts. Now, cut off from familiar social circles, and with no likelihood (or so it seemed) that they would ever be able to return to Britain, both were occupying their spare time in recreational scientific activities – Moray had a chemistry laboratory complete with a number of stills, and both men were interested in pharmaceuticals and medical remedies.[11]

They were also interested in precision timekeepers. In April 1658, Moray wrote to Bruce (who was at this point in Bremen, where his family had salt and coal business interests):

I haue a second=watch can measure pulses, but no art can make a watch measure 2 minutes equally, unless yong Zulicom [Christiaan Huygens] at The Hague have found it out, who they say makes clocks that fail not a minute in 6 moneths. But this you will beleave as litle as I do, for I can demonstrate that it must go wrong to keep foot with the sun.[12]

A week later, Moray was able to tell Bruce (who had moved on to Hamburg) that he had now seen and handled one of the new pendulum clocks:

I have yet to tell you that I have this day seen an exceeding pretty invention of a new way of watch, which indeed I take to be the very exactest that ever was thought upon. The Rhyngrave shew it me. It is long since I heard of it, but did not expect what now I see. The inventor undertakes it shall not vary one minute in 6 moneths, and verily I think he is not much too bold. He is a young gentleman of 22, second son to Zulicon [Sir Constantijn Huygens], the Prince of Orange's secretary, a rare mathematician, excellent in all the parts of it. I need not describe it to you till we meet, and then I believe I may get you a sight of it.[13]

Moray's brief examination of the clock had whetted his horological appetite. The local Commander had shown it to him because it had a defect, and Moray could see what that was:

I find the greatest matter I have at hand to do it with, is that clock I told you of in my last. It is one of the prettiest tricks you ever saw. It stayed no longer here than just to let me see it, as if God had sent it hither of purpose. It was a good part of the time in my hands. It hath a defect and the Rhyngrave sent it to me to considder of, for all that buy them oblige themselves not to put them into workemen's hands. I needed not look upon it long to know all was in it. I needed no more for that than the very first glance I had of it. The rest is but matter of adjusting of numbers for the wheels and pinions.

However, he had thought it best to advise that the clock be returned to its maker, Solomon Coster. But if Bruce were prepared to put up the money, he went on, the two of them together could easily construct an improved version of Huygens's clock:

If I thought you had a mind to bestow 40 dollars or some less on one of them I would think to have it ready for you against you come. Never any other design made wanrests[14] go so equally … If I make any, I will make it beat another time than this doeth, for it beats at the rate of 80 strokes of the wanrest or thereby to a minute, and I will make it beat just 60 which will be the seconds, and will put an index to shew them. But there is no end of tricks of this kind. When you come to the shop you may perhaps find there will and weal.[15]

Moray had clearly not at this point met Christiaan Huygens in person, but he was aware of his reputation. Since Christiaan's father, the diplomat and lifelong servant of the Princes of Orange Sir Constantijn Huygens, boasted about his son – his 'Archimedes', as he called him in letters to the eminent French thinkers Mersenne and Descartes – on every possible occasion, and Moray and he moved in the same circles, this is not surprising.[16] It is likely that Bruce already knew the Huygens family too, as they were supporters of Charles II and his sister Mary Stuart, and frequenters of the social and cultural court circle of Elizabeth of Bohemia. By September that year he certainly had met Christiaan, and they had established a shared interest in maritime timekeepers. Bruce was one of the recipients of a presentation copy of Huygens's *Horologium*

(1658), the book in which he announced his invention of the pendulum clock.[17]

In any case, it is Moray who is urging Bruce to take an active interest in the new pendulum clocks, which he himself clearly understands a good deal about already. And Bruce soon had ample occasion to follow his friend's advice.

The following year, in 1659, Alexander Bruce married Veronica van Aerssen van Sommelsdijck, daughter of Cornelis van Aerssen, Heer van Sommelsdijck, the wealthiest man, and one of the most politically prominent, in the United Provinces, and set up home in The Hague. The van Aerssens were a distinguished diplomatic family, who had served the house of Orange for three generations. They were neighbours of the Huygenses in het Plein, the smartest quarter of The Hague, close to the Mauritshuis.[18] On the eve of the Restoration of Charles II, Bruce – now the Earl of Kincardine – became an extremely rich and influential man in Holland, and a family friend of one of the most celebrated horologists in Europe. He retained his Scottish rank and position also – Samuel Johnson's friend and biographer James Boswell was a direct descendant.

From Moray's correspondence we learn that Alexander Bruce and Christiaan Huygens began working on clocks together almost as soon as they met. In early 1660 Moray (now in Paris, probably helping negotiate the terms of the return to the English throne of Charles II), wrote responding to a description of this work by Bruce:

If all Mr Zulicom's addition to his invention be no more but the making of a clock of the size that the pendule beats the seconds, that is every stroak takes up a second, I do not considder that of all. For I know the pendule must be about a yard long to do that, and it is believed here that all the church clock's in The Hague are made after his way, so that they ever strike all at once, for so it hath been said here to our Queen [Henrietta Maria]. I have not seen his book, nor think it can be bought here. therefore think of sending me one. If you recommend it to Sir Alexander Hume[19] and bid him send it by some of the Earl of St Albans's servants it will come safe. If I see him here I will talk to him of his perspective glasses, and mean to make my court with him upon your account.[20]

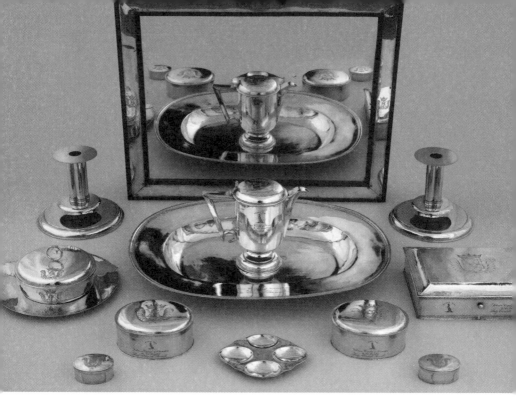

The silver dressing-table vanity set belonging to Veronica van Aerssen van Sommelsdijck, Alexander Bruce's wealthy Dutch wife.

So Moray and Huygens had still not met, though Moray was intent on their doing so, to discuss lenses and telescopes, and in order that he might 'make [his] court' on Bruce's account.

In summer 1660, Sir Robert Moray returned to London, where he was given a senior Scottish appointment in the new government of Charles II, and became part of the close inner circle of courtiers, with lodgings within Whitehall Palace itself.[21] By now Bruce has ordered a Huygens-designed clock for Moray, at his own expense, the delivery of which Moray was eagerly awaiting:

> I am well pleased with Mr Zulicem's ordering of my clock. Let it be so, and I will thank him when I see him. I have not time now to talk of that curiosity you mention,[22] but where people think it needless and that those watches are best that have the pendule fast to the axeltree that hath the two pallets,[23] but I am not yet of their mind, nor for that advantage he speaks of in the stoppers[24] you mention. I shall onely say

more of this that if the watch do not mark the inequality of the days, it goes not equally.[25]

Alexander Bruce and his Dutch wife, meanwhile, settled into a well-to-do international lifestyle which involved moving between the family home in The Hague, London, and Bruce's family home (and coalmines) at Culross (Fife) in Scotland.[26] In 1668, for example, Veronica's mother, in a letter to Constantijn Huygens congratulating him on the marriage of his son Constantijn junior, tells him that she is currently staying with her daughter and son-in-law at Culross:

> [Dutch] I shall be going home shortly, because the winter is coming on. I regret that I did not come here three months earlier, then I would have made a little progress with the language. [French] And I would have had the contentment of spending [more] time with the Count of Kincardine and my daughter, and this agreeable peace and civility. [Dutch] It is very beautiful and fruitful here. The Lord of Kincardine's house lies on a high hill and the park is delightfully close by. My daughter is extremely sad that I am leaving.[27]

To make herself feel more at home, Veronica laid out the garden at Culross in the Dutch style, and planted it with imported Dutch tulips.

The Royal Society was established in London on 28 November 1660 by a group of scientific enthusiasts that also included John Wilkins, Robert Boyle and Christopher Wren.[28] Sir Robert Moray and Alexander Bruce were founder members. The records show them to have been extremely active, usually together, in the Society's early meetings.[29] Precision timekeepers were on the agenda of these from the outset, particularly Huygens's new pendulum clocks. The pendulum improved the accuracy of mechanical clocks dramatically: from a variance of fifteen to thirty minutes a day, to less than a minute.[30] Its potential for naval and military use looked extremely promising.

Throughout the 1660s, the records of the Royal Society document a steady sequence of experiments involving pendulums and other isochronous oscillators in timekeeping.[31] Moray was not the only enthusiast, but his prominent position (he chaired the meetings) meant

that his encouragement of improvements to Huygens's published designs was important.

Christiaan Huygens paid his first visit to London in April 1661, as part of the official United Provinces delegation attending Charles II's coronation. His existing Anglo–Dutch social connections helped him to develop cordial social relations with those with similar scientific and technological interests to his own in London. Almost the first courtesy call he paid was on Bruce's Dutch wife Veronica, to fulfil a commission from a Dutch mutual friend he had spent time with in Paris.[32] The next day Bruce took Huygens to a meeting of the Royal Society at Gresham College, at which Moray was presiding, following which Dr Goddard (a prominent member) took Huygens to his Gresham rooms and showed him three handsome pendulum clocks.[33]

Thereafter Huygens spent much of his time in the company of Bruce and Moray, both of whom, we should remember, spoke fluent French and good Dutch and had many Dutch social connections, and other Fellows of the Royal Society.[34] He did not even bother to attend the coronation of Charles II, preferring to observe a lunar eclipse with members of the Society. Bruce showed Huygens pendulum clocks of his own design, in which the Dutchman took a particular interest.[35] John Evelyn tells us in his diary that he and Huygens visited the clockmaker Ahasuerus Fromanteel on 3 May, 'to see some pendules'.[36]

By the time Huygens returned to The Hague in late May, a deep and lasting friendship had been established between himself and Moray, his relationship with Bruce had been consolidated, and he was also well integrated with other leading members of the Royal Society. Thereafter he took a close personal interest in advancing the cause of pendulum clocks in Britain, both scientifically and commercially. Shortly after his return to The Hague, Huygens asks Moray in a letter how the long-pendulum clock, ordered from Huygens's clockmaker and paid for by Bruce, was performing (Moray confessed in a separate letter to Bruce a month later that he had still not had time to have it properly set up by a clockmaker);[37] Huygens also helped procure clocks for Lord Brouncker, the President of the Royal Society.[38] In June 1661 Henry Oldenburg paid a courtesy visit to Huygens at The Hague, on his way back to England from unspecified business in Bremen and elsewhere in the Netherlands (Oldenburg had received his

CHRISTIANUS HUGENIUS
natus 14 Aprilis 1629.
denatus 8 Junii 1695.

LUGD. BAT. Apud JANSSONIOS VAN DER Aa. Bibliopolas.

university education at Utrecht). He too conducted a vigorous correspondence with Huygens following his return to London.[39] There was talk of Moray and Brouncker visiting The Hague later in the same year. These plans came to nothing, but the point is, there was a regular to-and-fro of like-minded individuals, with Anglo–Dutch interests going back ten or more years, and with an interest in science, between London and The Hague throughout the 1660s.

In October 1662, Bruce arrived in The Hague on one of his regular round trips to and from his home in Culross, having used the journey in both directions to test pendulum clocks modified to his own design for their suitability as longitude timekeepers.[40] According to Bruce, it was the success of these first trials which convinced Huygens that it was worth pursuing the possibility of adapting his new clocks to determine longitude at sea. He reminded Huygens later:

At my first arivall at the Hage, after the tryall I had made betwixt Scotland & [The Hague] of my watch, when you did me the favour to see me at my chamber, we fell upon the subject of the going of the pendule watches at sea; & you told me positively then that it was your opinione that it was impossible, that you hade been making experiments of it, and all the effects of them was, to be settled in that opinion by them: you did lykewise urge reasons of the impossibility of it.[41]

It is not clear whether Bruce's marine clock had been built for him in Holland or England, by Dutch or English technicians, but it was certainly pendulum-regulated.[42] He later told Huygens that this clock of his was the same one he had had in his possession in London eighteen months earlier when he and Huygens met there, and that it differed significantly from Huygens's:

I came afterwards to see that watch by which you hade made your experiment; & I believe you will acknowledge that it was so farre different from mine in the whole way of it that it is not lyke they should ever have met. And the rather I thinke this, that I showed you at London 18 moneths before that tyme the same watch which receaved very small amendments thereafter; & if you hade thought that way able to bring it to passe, you might from that view have ordered one to be made for your tryell.[43]

Encouraged by their mutual interest and complementary expertise, Bruce and Huygens now began working collaboratively at The Hague, adapting pendulum clocks for sea travel. Bruce favoured clocks with short pendulums for portability; it was he who added a 'double crutch' to keep the pendulum swinging in a single plane, and designed the methods of support and suspension which it was hoped would protect the clocks from the most violent of motions arising from storms and high seas – Huygens had simply tried suspending them from ropes.[44]

It was the wealthy Bruce who paid for two state-of-the-art pendulum clocks, made by Huygens's current preferred Dutch clockmaker, Severijn Oosterwyck, which they agreed Bruce would test on his next journey to Britain, this time to London. By December the clocks were almost ready,

and the two men were spending a lot of time together. On 4/14 December 1662, Christiaan told his brother Lodewijk that he had been slow responding to a letter 'because of several visits I have received, and principally by that of Mr Brus [Bruce], who did not leave me alone for a single moment all afternoon. And he has been doing that quite often, ever since we set about perfecting our invention for [measuring] Longitudes.'[45]

In other words, the earliest trials of pendulum-regulated longitude timekeepers – much discussed by historians of science – began as a robustly Anglo–Dutch venture. And once Bruce arrived in London, the correspondence with Huygens that followed demonstrates an extraordinary level of continuing Anglo–Dutch collaboration, with the English contributors now making the running.

For two weeks Huygens waited anxiously for news from London. He consulted the van Aerssens, but even they had not yet heard from their son-in-law. Eventually he received a letter from Bruce, written on 2 January 1663 (old style). He apologised for having 'forgotten' to write, blaming this on the fact that he had nothing very positive to tell Huygens about the performance of 'his' (that is, Bruce's) clocks. The sea trials of the two pendulum timekeepers during his journey to London had not been a success. As they left the harbour, the 'packet-boat' which Bruce had secured for the crossing was hit by a contrary wind, 'and the boat was so small that even though it really was not a storm, the ship was shaken more strongly than one can shake a cradle, so that the suspending shaft [*vis*] that went into the ball and socket [*boule*] broke under the vibrations of the ship, and the older [clock] fell, while the newer [clock] stopped'.[46]

A flurry of letters from Bruce and Sir Robert Moray to Huygens followed, detailing what had happened during the trials, and describing work the two Scots were now carrying out together in London to improve the clocks' performance against the next trials. On 9/19 January Moray wrote to Huygens from London to tell him that he and Bruce were in discussions about 'your clocks', and 'the design which would make them succeed at sea'. More modifications, then, were being undertaken, this time with the help of the English clockmaker Ahasuerus Fromanteel, whose son John had recently returned from several years' training in The Hague,

learning to manufacture the new pendulum clocks with Huygens's original clockmaker Salomon Coster.[47] The clock which had fallen during the journey was too badly damaged to be repaired, and was replaced by one entirely manufactured in London by Fromanteel.

'I advised [Mr Bruce] to try the clocks two at a time,' wrote Moray to Huygens, 'and to adjust them well beforehand on land.'[48] This must have irritated Huygens, who had made precisely these preparations before Bruce set sail.[49] He replied immediately, assuring Moray that Bruce had already told him exactly what had happened to the clocks, and that he, Huygens, was undeterred and keen to conduct further, longer-distance trials. In a postscript he added that he was about to write to Bruce, as soon as he had finished some further modifications to 'my clock'.[50]

On 16 January 1663 (old style) Bruce wrote to tell Huygens that the damaged clocks were about to arrive (they had been held up at customs): 'I expect them to morrow and then I shall show them to Sir Robert Moray & lett yow know their [his] opinions of them.'[51] Huygens remained optimistic. 'The lack of success you have had does not bother me,' he responded, 'nor does it diminish my good opinion of our undertaking'.[52] He told Bruce that he had begun modifying his clock design in consultation with his Dutch clockmaker Severijn Oosterwijk, and would let him know how the improved mechanisms behaved.[53]

At the beginning of March 1663, Moray wrote to Huygens letting him know that he and Bruce were going to conduct further trials 'at sea, going as far as the Dunes, to try out Mr Bruce's clocks, which he is trying to adjust to the best of his ability'.[54] (Note that for Moray, 'your clocks' (Huygens's) have now become 'Mr Bruce's clocks', though essentially the same two timepieces are involved.) The usually conciliatory and tentative Moray continues, somewhat testily:

> You are right in saying that the movement of large boats is gentler than that of small ones, but in heavy swells, particularly when the wind is head on, or when the ship is at anchor, the shocks are stronger and more violent. But what I fear most is not the agitation the ship gives to the whole body of the clock (though I am worried that that may have its effect also) but rather that the sudden movements of the ship downwards, and in the contrary direction, which in the one case will make the

pendulum slow down, in the other will accelerate it, sometimes making it heavier, sometimes lighter, and either way unequally, which it seems to me is bound to cause deregulation in the mouvement of the clock's mechanism. But it still seems worth testing this experimentally.[55]

This critical commentary on the whole Bruce–Huygens project suggests that Moray, usually genial and urbane, is drawing on broader Royal Society discussions which had taken place concerning the performance of the clocks. Indeed, I'm afraid this sounds awfully as if it was drafted by Hooke.[56]

Sure enough, we learn that Lord Brouncker (President of the Royal Society) and Robert Hooke (Curator of Experiments) had both taken part in those trials 'at sea, going as far as the Dunes' on 'one of his Majesties Pleasure-Boats'.[57] And according to Hooke, they 'experimentally found [the method of suspension] useless to that effect', though Hooke claimed he could see ways to correct the deficiencies of Bruce's ball-and-socket suspension arrangement.[58] Both Hooke and Brouncker had experience working with precision timekeepers, and both had an interest in perfecting their use to determine longitude at sea.[59] Both were now collaborating with Bruce (who, we recall, had impeccable connections on both sides of the Narrow Sea, in London and The Hague) in the hope of achieving a clock-based solution to the longitude problem.[60]

So by early 1663, Robert Hooke has joined the team of Dutch, Scottish and English clock experts collaborating in the development of precision longitude timekeepers. As he later insisted, he had been conducting experiments with clock design for several years; now that experience is funnelled into the Bruce–Huygens project.

As far as Huygens was concerned, Hooke was a background figure in the activities of the Royal Society, an experimentalist and instrument-maker, who was inclined to make exaggerated claims about his technical competence. Both Moray and Brouncker were well-informed amateurs, with a private and a professional interest in precision timekeepers (both owned state-of-the-art clocks and watches themselves, and knew how to look after them).[61] For the purposes of the longitude-timekeeper develop-

ments and trials, Hooke was their expert technician, acting as adviser and consultant at the English end of design and testing, who fed his results into Moray and Brouncker's dealings on this topic with the Royal Society (including Bruce and Huygens). Everything Hooke told Moray was directly communicated to Huygens; all Huygens's comments were relayed back to the Royal Society. The fact that England and Holland were at war for much of this period was apparently irrelevant.[62]

This two-way investigative traffic between London and The Hague provides a context for the collection of scattered papers belonging to Hooke which are now in the Wren Library at Trinity College, Cambridge. These are undated, but the first section seems to correspond to a period of ongoing discussions between Hooke, Brouncker and Moray (with some interventions by Wilkins and Boyle), preparatory to Hooke's lodging a patent claim for a longitude clock of his own design on behalf of the Royal Society, during the period 1663–65.[63] After Hooke's death, his friend and executor Richard Waller claims to have seen the draft patent document in Moray's hand among Hooke's papers.[64] We are now in a position to note that Moray was also the person who had drafted a competing patent on behalf of Bruce and Huygens for their longitude timekeepers, which was being negotiated at exactly the same time.

On 13 January 1664, ten months after Hooke had assisted at the trials of the Bruce–Huygens clocks and pronounced them unsatisfactory, Brouncker reported to the Royal Society that Hooke had 'discovered' to himself, Sir Robert Moray and Bishop John Wilkins (Hooke's mentor, and a founder of the Society) in confidence 'an invention which might prove very beneficial to England, and to the world'.[65] The Society agreed to pay up to £10 for trials. Moray later described it as 'an invention of his for measuring time at sea better than pendulum clocks can, and indeed as well as they do on land', and told Huygens that Hooke had been working on it for some time. He had 'given a proof [*preuve*] of it to the President, on a watch which I lent him'. However, Moray added that 'having compared it to his own pendulum clock [the President] found that [Hooke's] did not keep good time'.[66] On 15 September Hooke wrote to his patron Robert Boyle that he hoped 'shortly to make some observations ... with an exact timekeeper, which, I have some reason to believe, shall not be much excelled by any whatever. But these are not yet completed.'

On 18 January 1665, it was announced at the Royal Society meeting that Hooke was ready to apply for a patent for his longitude timekeeper.[67] At the meeting in question doubts had been expressed as to how satisfactorily the Bruce–Huygens clocks had performed during lengthy trials to Guinea and back (I will return to these trials shortly). The Society had backed the Guinea trials heavily, and staked a lot on their success; now Hooke offered them an alternative timekeeper.

Hooke's first biographer, Richard Waller, has preserved a fragment of a memoir by Hooke himself, describing what happened next:

> I shew'd a Pocket-watch, accommodated by a Spring, apply'd to the Arbor of the Ballance to regulate the motion thereof; concealing the way I had for finding the Longitude; this was so well approv'd of, that Sir Robert Moray drew me up the form of a Patent, the principal part whereof, viz. the description of the Watch, so regulated, is his own hand Writing, which I have yet by me.[68]

Waller goes on to confirm Hooke's statement on the strength of original documents then in his possession, shortly after Hooke's death:

> In confirmation of what is abovesaid, I met with a Draught of an Agreement between the Lord Brouncker, Mr. Boyle, and Sir Robert Moray, with Robert Hooke Master of Arts to this purpose, that Robert Hooke should discover to them the whole of his Invention to measure the parts of Time at Sea as exactly and truly as they are at Land by the Pendulum Clocks invented by Monsieur Huygens [...] as also of a Warrant to be granted by the King to Robert Hooke, M.A. &c. for a Patent for the sole use of the said Invention for fourteen Years, and sign'd by his Majesty's Command, William Morrice.[69]

This last document surfaced briefly at auction some years ago, only to disappear again to a private buyer.[70] It clearly confirms all the key points from Waller's account: it describes (in Hooke's hand, inserted into a document largely in Morrice's) a spring-regulated longitude timekeeper, 'different from all other watches or clockes by hauing instead of a Ballance a Spring of mettall/wood/quill/bone/glass or other fit matter so aplied to

the Arbor of the Ballance that it makes it moue alwise equally'; it is signed by William Morrice in his capacity as Secretary of State, a position he held until September 1668; and it also invokes the names of Sir Geoffrey Palmer 'Attorney Generall' and Sir Heneage Finch 'Solicitor Generall' (both men left these posts before 1670). It allows us to say with reasonable confidence therefore, though sadly without the evidence before us, that Hooke had indeed come close to applying for such a patent, in direct response to the Bruce–Huygens pendulum-clock-based attempts at a longitude time-keeper, during the first half of 1665.

There is no doubt that Hooke's idea of using springs as isochronous regulators in place of pendulums was transmitted to Huygens by both Moray and Oldenburg. On 30 September 1665, for example, the very day on which Moray told Huygens in a letter that Hooke had demonstrated a spring-regulated clock or watch to himself and Lord Brouncker two years earlier, Moray wrote to Oldenburg, in a letter, now lost, that Waller saw:

> You will be the first that knows when his [Huygens's] Watches will be ready, and I will therefore expect from you an account of them, and if he imparts to you what he does, let me know it; to that purpose you may ask him if he doth not apply a Spring to the Arbor of the Ballance, and that will give occasion to say somewhat to you; if it be that, you may tell him what Hooke has done in that matter, and what he intends more.[71]

Hooke's not-so-confidential negotiations with Brouncker, Moray and Wilkins to obtain a patent on behalf of the Royal Society for Hooke's longitude timekeeper broke down in mid-1665. The senior officers of the Society were of the opinion that because Hooke insisted on stating that a spring regulator could be applied to a timekeeper in many different ways, no patent would be granted, since to do so would be to inhibit developments other than Hooke's based on the same principle.

At precisely the same time that they were dealing 'in secret' with Hooke's proposed revolutionary designs for longitude timekeepers, Brouncker and Moray had taken it upon themselves to move the Bruce–Huygens clock

trials onto a more systematic footing, with the Royal Society's official backing. They arranged for Robert Holmes, captain of the *Jersey*, to carry the two pendulum clocks to and from Lisbon in 1663, and then on a longer voyage to Guinea and back in 1663–64.[72]

For the history of development of longitude timekeepers these trials were a turning point. By contrast with Bruce's trials, those conducted during Holmes's voyages, particularly on the voyage to Guinea, were spectacularly successful. The clocks ran well throughout the journey, Holmes set them regularly and kept them running, and crucially, the clocks allowed Holmes to make a calculation of his position at a key moment in the Guinea voyage which revealed the inadequacy of traditional longitude-finding methods.

On the return journey, Holmes had been obliged to sail several hundred nautical miles westwards in order to pick up a favourable wind. Having done so, the *Jersey* and the three ships accompanying her sailed several hundred more miles north-eastwards, at which point the four captains found that water was running worryingly low on board. Holmes's three fellow captains produced three conflicting calculations of their current position based on traditional dead-reckoning, but all agreed that they were dangerously far from any potential source of water. Not so, declared Holmes. According to his calculations – based on the pendulum clocks – they were a mere ninety miles west of Fuego, one of the Cape Verde islands. He persuaded the party to set their course due east, and the very next day, around noon, they indeed made landfall on Fuego, exactly as predicted.[73] Huygens's clocks had saved the day.

This was exactly the kind of publicity the pendulum timekeepers needed in order to capture the public imagination. Moray's report of this dramatic success, in a letter to Huygens dated 23 January 1665, is clear as to its impact: 'At last Captain Holmes has returned, and the account he has given us of the experiment with the pendulum clocks leaves us in absolutely no doubt as to their success.'[74]

The following day Huygens replied. He was delighted to hear of Holmes's triumph with the clocks; every line of the account gave him the greatest pleasure, and he thanked Moray for being the bearer of such good tidings.[75] Holmes's report was published verbatim in the Royal Society's *Philosophical Transactions* and in French in the *Journal des sçavans*, and eventually

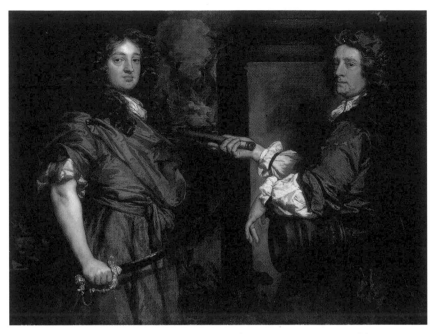

Sir Robert Holmes in Turkish dress, holding his baton of command, in the company of fellow naval adventurer Sir Frescheville Holles.

featured as the unique account of a sea trial of pendulum clocks to be included in Huygens's landmark book the *Horologium Oscillatorium*, published in 1673.[76] Right down to the present day, the spectacular success of these trials is invoked as the crucial evidence on the basis of which Huygens's pendulum-clock timekeepers take their place as a significant step in the progression from the theoretical aspiration to determine longitude at sea using a precision clock, to the realisation of that dream with John Harrison's longitude timekeeper in the following century.

The success of the Holmes trials probably led directly to Moray and Brouncker abandoning attempts to agree a patent document with Hooke. By this time too, ironically, Moray had given up hope of getting Bruce and Huygens to agree a fair distribution of financial reward, and abandoned their patent bid also.[77]

So it might appear that there is some justice in the fact that Huygens has continued to receive most of the credit for early longitude clock trials, and developments culminating in the balance-spring-regulated pocket

watch, ever since. But my own research has recently uncovered evidence to suggest that Hooke deserves more credit, and Huygens perhaps a little less.

The problem with the story I have just recounted is that Sir Robert Holmes (as he later became) was not known as a person who could be relied upon. He is, in fact, infamous as the hot-tempered, violent and uncontrollable commander of the English fleet whose impetuous exploits were responsible for starting both the second and the third Anglo–Dutch wars. He had served under Prince Rupert and James, Duke of York, and eventually rose to the rank of Admiral. In 1664, on the very voyage on which he was supposed to be testing the Bruce–Huygens clocks, he sacked the Dutch trading stations along the coast of Guinea one by one, seizing goods and property and laying waste the settlements.[78] On his return he was twice imprisoned in the Tower of London (on 9 January and 14 February 1665), either for having gone beyond orders or for failing to bring back adequate amounts of booty, it is not quite clear which. His actions led directly to the Dutch declaring war on 22 February 1665, by announcing that they would retaliate against any British shipping in the Guinea region, at which point Holmes was released and pardoned, in order to command his Majesty's forces. In August 1666 he attacked and destroyed by fire 150 East Indiamen in the Vlie estuary and sacked the town of Westerschelling on adjacent Terschelling island.

Samuel Pepys (at that time in overall charge of supplies at the Navy Board) was afraid of Holmes: 'an idle, proud, conceited, though stout fellow'. On several occasions he expressed reluctance at having to deal with him on matters of naval discipline. After the second Dutch war Holmes was rewarded for his exploits with the Governorship of the Isle of Wight; he eventually became extremely rich and somewhat more respectable.[79]

It was Huygens himself who was the first to raise concern about Holmes's report (as a Dutchman, he might be expected to have a particularly low opinion of Holmes's integrity). On 6 February 1665, in his first response to Moray, after expressing his delight at the dramatic outcome of the trials he added a small caveat:

> I have to confess that I had not expected such a spectacular result from these clocks. To give me ultimate satisfaction, I beg you to tell me what

you and your colleagues at the Royal Society think of this Relation [of Holmes's], and if the said Captain seems a sincere man whom one can absolutely trust. For it must be said that I am amazed that the clocks were sufficiently accurate to allow him by their means to find such a tiny island [as Fuego].[80]

On 6 March, Huygens was still pressing Moray for 'something of the detail of what you have learned from Mr Holmes, principally in order to know how the clocks behaved in a storm, and if in that climate rust did not eventually cause them to stop'.[81]

The matter of Holmes's trustworthiness was raised at the 8 March meeting of the Royal Society, at which Huygens's concerns were raised, and his letter of 6 March read:

There being also mention made again of Major Holmes's relation of the late performances of the pendulum watches in his voyage to Guinea, it was affirmed by several of the members, that there was an error in that relation, as to the island named therein; and that it was not the island of Fuego, which the Major's ships had touched in order to water there, but another thirty leagues distant from it.[82]

Samuel Pepys (recently elected a Fellow) was 'desired to visit the Major, and to inquire farther concerning this particular for the satisfaction of the society'. This meant visiting Holmes in the Tower, where he was imprisoned for his conduct towards the Dutch settlements at Guinea during his voyage.[83] On 14 March Pepys attended 'a farewell dinner which [Sir John Robinson, Lieutenant of the Tower] gives Major Holmes at his going out of the Tower', 'Here a great deal of good victuals and company.'[84]

On 15 March both Pepys and Moray reported on their dealings with Holmes. Pepys had spoken to the Master of 'the Jersey ship' – that is, Holmes's own vessel:

The said master affirmed, that the vulgar reckoning proved as near as that of the watches, which [the clocks], added he, had varied from one another unequally, sometimes backward, sometimes forward, to 4, 6, 7, 3, 5 minutes; as also that they had been corrected by the usual account. And

as to the island, at which they had watered, the said master declared, that it was not Fuego, but another thirty miles distant from the same westward.[85]

According to the Master of Holmes's ship, then, there was not much to choose between the old way of calculating longitude, and that using the new clocks. Moray, who had spoken to Holmes himself, corrected 'some mistakes in the number of the leagues formerly mentioned'. He confirmed

Samuel Pepys, Clerk of the Acts to the Navy Board.

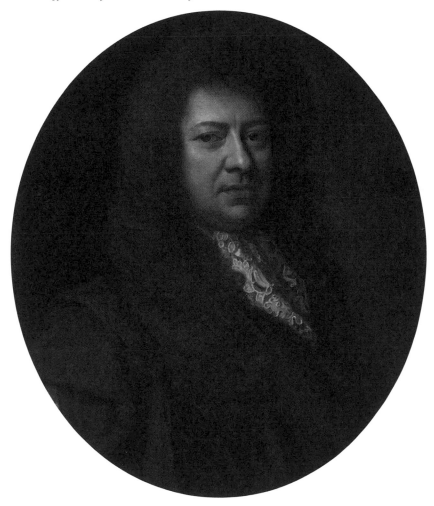

that the ships had not watered on Fuego, 'yet they had made that island at the time, which the Major had foretold, and were gone from thence to another, more convenient, for watering'.[86]

This was the meeting at which, immediately following Moray's rather obviously fudged report, Hooke told the Royal Society 'that he intended to put his [own] secret concerning the longitude into the hand of the president, to be disposed of as his lordship should think fit'. In his opinion, 'no certainty could be had from [pendulum] watches for the longitude'.

At the very next meeting, on 22 March, 'Mr Pepys was desired to procure the journals of those masters of ships, who had been with Major Holmes in Guinea, and differed from him in the relation concerning the pendulum watches.'[87] Nothing further is heard, however, of discrepancies between the ships' journals and his 'relation concerning the pendulum clocks'. Had that convivial dinner a week earlier perhaps predisposed Pepys to draw a veil over the matter? Holmes's account has been firmly lodged on the record ever since.

However, a presentation copy of Holmes's Guinea voyage journals, which Pepys had indeed procured, as instructed by the Royal Society, survives in the Pepys Library at Magdalene College, Cambridge. This is a fair copy of the journal, prepared for James, Duke of York. I believe that I am one of the first scholars to have consulted it in the context of the Holmes trials, on that voyage, of Huygens's longitude clocks.[88]

Holmes's journal is extremely full and specific. It is also rather well written – Holmes has a nice line in racy narratives, particularly where bombarding and plundering Dutch merchant ships is concerned.[89] Day by day he chronicles the progress of his band of ships, the *Jersey*, the *Brill*, the *Golden Lyon* and the *Expedition*. Only once in the course of the entire journal does he mention the pendulum clocks (in connection with the incident we have already heard about), and it is hard to see how they could have been kept going steadily throughout, given naval battles with Dutch East Indiamen in which (for instance) Holmes's topmast and mainsail were shot away.

In July Holmes was on San Thome off the west coast of Africa, reprovisioning and rewatering. He set out for home on 11 August. For more than a month strong currents, contrary winds and becalmings bedevilled him. By the third week of September his small fleet was well and truly lost on the open seas. There is a full sequence of entries relating to Holmes and his

fellow captains getting lost and running short of water, which does, uniquely in the entire journal, mention 'pendula'. It was with great reluctance that Holmes's companions agreed to turn westwards. It was three days before they sighted land, during which time variable winds took them in several different directions. As Pepys had learned, they did not land on Fuego, but some time later on another of the Cape Verde Islands, Brava. Holmes had, at the very least, made greatly exaggerated claims for the part the clocks had played in the incident.

But once Holmes had lodged his misleading report, with its bravura account of the spectacular accuracy of the pendulum clocks, Huygens's claim to priority in relation to longitude timekeepers was assured. The account was prominently reprinted in 1673 in his *Horologium Oscillatorium*, and was followed within the year by the announcement from Paris of the balance-spring watch. Huygens's impressive sequence of horological innovations − pendulum clock (1658), longitude pendulum timekeeper (1665) and balance-spring regulator (1674) − entitled him to precedence over others working close to him, and assured his lasting reputation as the pre-eminent figure in the field. By this time, however, both Moray and Oldenburg were of the opinion that Huygens was overstating his personal claims for priority. When the *Horologium Oscillatorium* appeared, strong protests were lodged by the most senior members of the Royal Society. The President, Lord Brouncker, John Wallis and Sir Christopher Wren all wrote to Huygens, reminding him − with chapter and verse − of the contributions made to his unfolding horological theory and practice by English virtuosi. They reminded him that Hooke's circular pendulum had been demonstrated and discussed at several meetings, that Bruce's modifications to the marine timekeepers had been crucial to their success, that Brouncker and Huygens had together debated the tautochronism of the cycloidal pendulum at length, that Wren had rectified the cycloid ahead of Huygens. All of these contributions were inadequately acknowledged in Huygens's work, or (in the case of Hooke) not at all.[90]

On 27 June 1673, Oldenburg himself urged Huygens to be more generous in his acknowledgements, and urged a more collaborative approach in the interest of scientific progress: 'If candour reigned everywhere, what friendships might we be able to establish amongst the learned, and what advantages might the public derive?'[91]

What is most extraordinary about the vexed (and still unresolved) issue of who was really entitled to claim priority, first for allegedly accurate pendulum clocks carried at sea, and subsequently for the spring-regulated pocket watch, is how little the Anglo–Dutch wars apparently impinged on intellectual exchange between the participant scientists and technicians. It is as if the ferocious naval battles, marauding gangs invading colonial settlements, and predatory incursions into each other's national territories had little or no impact on the lives of those engaged in professional life in either country. How else could it have been proposed that Dutch clocks be given to an English naval commander to test while on a confrontational expedition to the west coast of Africa whose stated aim was to seize Dutch goods and assets?

Equally, the unanimous chorus of Fellows of the Royal Society chastising Christiaan Huygens in 1673 for having, in his claiming of priority for longitude clocks, been ungenerous in his acknowledgements of English (or at least Scottish) efforts in the same field surely needs to be taken with a pinch of salt: 'what friendships might we be able to establish amongst the learned, and what advantages might the public derive?'

The *Horologium Oscillatorium*, in which Christiaan Huygens made his full and final claims to priority in pendulum clocks and timekeepers designed to determine longitude, was published in France and ostentatiously dedicated to the French King, Louis XIV. At the time of publication, France was at war with the United Provinces, and England was temporarily allied with the French. If Huygens's position in Paris was tenuous, his relations with the English were doubly so. Unable to cope with the emotional pressures, in 1676 Christiaan Huygens succumbed to some sort of nervous illness, of a kind which had caused his collapse some years earlier (on that occasion he had been granted a year's sick leave by the French authorities). This time his brother-in-law, sister Susanna's husband Philips Doublet, was sent to Paris to cheer him up, to no avail. Instead he brought Christiaan back to The Hague in July. 'The life that I lead there [in Paris] disagrees with me,' Christiaan wrote to his brother Constantijn junior, who was in the field with Prince William on military manoeuvres against the French. 'I left as if I would return. But I do not believe I shall ever go back to Paris'.

Science Under the Microscope: More Anglo–Dutch Misunderstandings

It was not only in matters concerning pendulum clocks and balance-spring watches that Christiaan Huygens interfered in the affairs of British scientific practitioners like Alexander Bruce and Robert Hooke. In this chapter I offer a further example of the way the story of scientific advance is altered once we recognise that a Dutchman, resident mostly in Paris, and an Englishman employed by the Royal Society, were effectively engaged in a long-range collaboration, in spite of the body of water, national ideologies and differences of temperament that separated them.

In this instance, the fortunes of a set of scientific ideas depend on the movement of a copy of a published book – Hooke's *Micrographia, or Some Physiological Descriptions of Minute Bodies Made by Magnifying Glasses with Observations and Inquiries thereupon* (1665). This reminds us that books moved around the Continent of Europe with a speed and efficiency that almost match those achieved by online booksellers today. In August 1655, for example, the antiquarian William Dugdale received a letter from Sir Edward Walker, Garter King of Arms and loyal servant of Charles II, exiled in Amsterdam. Walker congratulated Dugdale on his recently published antiquarian history book, a copy of which he had seen in the hands of a friend to whom Dugdale had sent a personal copy. In reply Dugdale wrote that 'God be thanked that we have disposed of above 400 of these allready, (though it came out but in Easter Terme,) the one half whereof are gone beyond sea; but our money for them will not come in till ye next spring.'[1]

What this second example of Anglo–Dutch scientific interaction shows is the way our understanding of the trajectory of development in emerging science has tended to get deflected and sidetracked, because accounts of the scientific debate are overly preoccupied with the local communities – treated as enclosed and self-sufficient – in which those who played a leading role (in this case, the Dutchman Christiaan Huygens in Paris, and the

Englishman Robert Hooke in London) worked at the time.

The end of this particular story also reminds us how political upheaval can dramatically alter the perceived importance of an individual's work, and thus posterity's opinion of its significance. At the Royal Society, the arrival of William III of Orange in England at the end of 1688 resulted in a significant reorganisation in every English institution, as we might expect when a foreign invasion is followed by long-term occupation. The result for the Society was a particularly dramatic version of 'régime change': the meteoric rise of figures hitherto of only middling importance within the institution, while others were swiftly and permanently marginalised, the significance of their scientific work downgraded and thenceforth diminished in importance in the historic records.

The design, manufacture and skilled use of microscopes, like that of clocks, developed very much in parallel, in the seventeenth century, in England and the United Provinces. To the Dutch goes the credit for initially perfecting a lens-based device which could provide a high level of magnification of objects too small to be appreciated using the naked eye.[2]

There is a measure of consensus amongst historians of science that the Dutch use of magnifying lenses originated in the hands of painters involved in creating 'lifelike' representations of natural phenomena, particularly plants and insects. The names regularly associated with the meticulous rendering of detail only accessible with a microscope are Jacob de Gheyn II and Joris Hoefnagel. Intriguingly for the present story, both men and their families were closely associated with the Huygens family. Sir Constantijn Huygens's mother was a Hoefnagel, and he himself took lessons in miniature painting with a Hoefnagel uncle. The de Gheyns were neighbours in The Hague, and the young Jacob de Gheyn III was Constantijn's companion on his first diplomatic visit to London. Huygens himself took a keen early interest in microscopy in the 1620s.

In the 1670s and '80s, both Christiaan Huygens and Constantijn Huygens junior became enthusiastic grinders of lenses for telescopes and microscopes, and practising microscopists. Both corresponded with and visited the famous Dutch microscopist Anton van Leeuwenhoek in Leiden. So it is hardly surprising to find the entire Huygens family captivated by the

newly published English book with which Robert Hooke's name and reputation are most lastingly associated, *Micrographia*.

Although Robert Hooke's reputation as an experimentalist and instrument-maker was already considerable at home in England in the early 1660s, he became a figure of note in the Europe-wide community of virtuosi beyond the Royal Society, particularly that in the United Provinces, with the publication of *Micrographia* in January 1665. The sump-tuously illustrated book established his reputation in the international scientific community virtually overnight.[3] Immediately it appeared, intel-lectuals across Europe began exchanging views on the book, and above all its magnificent engravings, in their correspondence.[4]

The interest of Christiaan Huygens, still at this time domiciled in the family house at The Hague, was immediately aroused when his London-based Scottish friend Sir Robert Moray mentioned *Micrographia* to him – and the fact that it included information on lens-making (a topic Christiaan was particularly interested in) – in January, and promised to send him a copy shortly thereafter. Moray expressed his satisfaction with the book, one of the first publications licensed by the new Royal Society, but confessed that he had not had time to do more than glance at it himself.[5]

On 26 February Moray dispatched a copy of *Micrographia* to The Hague with a covering letter, entrusting it to the English diplomat Sir William Davidson to deliver.[6] Because Huygens somehow missed Davidson, how-ever, the book and letter did not reach him until 25 March. The following day he wrote an enthusiastic letter to Moray telling him that he had had no idea the book was of such consequence, and particularly praising the quality of the illustrations and engraving.

But before the book reached him and gained his immediate respect, Christiaan Huygens had unfortunately had some less flattering things to say about Hooke's abilities in general, based on face-to-face encounters with the Curator of Experiments while Huygens was visiting London some years earlier. Between the dispatch and arrival of his copy of *Micrographia*, Christiaan had formed some superficial views on it based on selected

OVERLEAF: *Hooke's* Micrographia *title page.*

By the Council of the ROYAL SOCIETY
of *London* for Improving of Natural
Knowledge.

Ordered, *That the Book written by* Robert Hooke, *M.A. Fellow of this Society,*
Entituled, Micrographia, or some Physiological Descriptions of
Minute Bodies, made by Magnifying Glasses, with Observations and
Inquiries thereupon, *Be printed by* John Martyn, *and* James Allestry,
Printers to the said Society.

Novem. 23.
1664. BROUNCKER. *P. R. S.*

MICROGRAPHIA:

OR SOME

Physiological Descriptions

OF

MINUTE BODIES

MADE BY

MAGNIFYING GLASSES.

WITH

OBSERVATIONS and INQUIRIES thereupon.

By *R. HOOKE*, Fellow of the ROYAL SOCIETY.

Non possis oculo quantum contendere Linceus,
Non tamen idcirco contemnas Lippus inungi. Horat. Ep. lib. 1.

LONDON, Printed by *Jo. Martyn*, and *Ja. Allestry*, Printers to the
ROYAL SOCIETY, and are to be sold at their Shop at the *Bell* in
S. *Paul's* Church-yard. M DC LX V.

extracts from the text sent to him by his father, Sir Constantijn Huygens, who happened to be in Paris on Stadholder business in February 1665 and had swiftly obtained a copy.[7] Christiaan had at this point not yet had sight of the vital accompanying engravings of a whole sequence of natural phenomena much-magnified, nor had he any idea that the illustrations were the glory of the entire publication.

Writing to his son, Sir Constantijn was full of praise for *Micrographia*. Christiaan, by contrast, basing his judgement on the selected extracts, expressed surprise at the 'rashness' of some of Hooke's conjectures. Hooke was neither amiable, nor a good enough mathematician for his activities in any field to be taken seriously, he confided to his father: 'Thanks for the extracts from Hooke [*Micrographia*]. I know him very well. He understands no geometry at all. He makes himself ridiculous by his boasting.'[8]

In Paris, Sir Constantijn did not keep his scientist son's doubts about *Micrographia* to himself. Among the French virtuosi who seized eagerly upon *Micrographia* was Adrien Auzout, a talented observational astronomer and instrument-maker whose name is associated with the development of the eyepiece micrometer for long telescopes. As soon as he heard about Hooke's book, he arranged to borrow Sir Contantijn's copy.[9] Shortly after Huygens senior had returned to Holland, Auzout wrote from Paris to Christiaan Huygens in The Hague: 'A few days ago I received a letter from Monsieur de Zulichem [Sir Constantijn], who told me that you, like myself, had found a quantity of interesting things in Hooke's book.'[10]

Auzout's interest in *Micrographia* and its author began a chain of events which had a lasting effect on Hooke's long-term reputation, largely without his own intervention or even participation. It is important to note that right at the start, Auzout had been shown Christiaan's less than generous letter to his father about *Micrographia*, expressing reservations about some of Hooke's findings and claims.

Among the 'quantity of interesting things' which had caught Auzout's attention in *Micrographia* were those parts of the text dealing with Hooke's technological innovations in microscope manufacture, rather than the extraordinarily minute details of natural phenomena seen under the microscope and reproduced in the plates. A description of a machine for grinding accurate lenses, interpolated into the preface, particularly intrigued Auzout, since he was already involved in a critique of a similar

machine advertised by Giuseppe Campani in Italy, and was himself pro-
posing one to the circle of astronomers lobbying for the setting up of the
new Royal Observatory in Paris.[11]

In the course of some passing remarks on telescopes in the preface to
Micrographia, Hooke had been drawn into an aside on the need for readily
available, high-quality lenses. The way of meeting this need, he went on,
was to invent a 'ready way' (a machine) for making telescope object glasses.
And he announced that he was in the process of refining such an 'engine',
'by means of which, any Glasses, of what length soever, may be speedily
made'.[12]

In an elaboration of these remarks, marked off from the main body of
the text by its distinctive typography, Hooke sets down the technical details
of his machine, illustrating his remarks with an engraving on the first plate
of the volume alongside the well-known images of Reeves's microscope
and scotoscope.[13]

Auzout was a man on the make, eager to make a splash scientifically –
in fact, he was trying hard to get himself made a member of the new French
Académie des sciences (he succeeded in 1666, although he resigned from it
in 1668). He read the preface to *Micrographia* in February 1665, and hurriedly
inserted a critical response to it into a letter he had composed the previous
year on the subject of the Italian Campani's improved telescopes which he
was preparing for publication.[14] The expanded version of his 'Letter to the
Abbé Charles' appeared in print in Paris in April or May 1665, and Auzout
immediately sent a copy of the pamphlet to Oldenburg, with whom he was
already in correspondence concerning Campani's observations of the 1664
comet.[15] Oldenburg produced a summary in English, including the criti-
cisms of Hooke at length, and passed it to Hooke. Hooke responded with a
letter to Oldenburg rebutting all Auzout's criticisms, and this letter –
preceded by Oldenburg's English summary of Auzout's published letter –
was published in the *Philosophical Transactions of the Royal Society* of 5 June 1665
as 'Mr Hooke's Answer to Monsieur Auzout's Considerations, in a Letter to
the Publisher of these Transactions'.[16]

So now Hooke had a scientific 'quarrel' of a rather fashionable kind on
his hands (intellectual quarrels in print were all the rage in London and
Paris). The accusation which most exercised him at this stage was that he
had not conducted proper trials of his lens-grinding machine, and that to

have published an account of such an untried instrument, thereby claiming its priority, was unworthy of the Royal Society, given the Society's commitment to experimental accuracy. As official Curator of Experiments, and having been admitted as a full Fellow of the Society only a year previously, Hooke was extremely anxious to clarify his position. He was quick to point out that there was a clear disclaimer placed prominently at the beginning of *Micrographia*, entirely dissociating the Royal Society from any 'Conjectures and Quaeries' of his own. Perhaps, he suggested, Auzout's English had not been good enough to follow the text.[17]

As it turned out, Hooke's suspicion was entirely correct. Auzout responded in a letter to Oldenburg of 22 June. He admitted that his English was indeed poor, and that, besides, he had only had *Micrographia* in his possession for two days. Inevitably he had not read it all, particularly since the illustrations were so captivating, and drew his attention away from the text.[18]

On 1 July Auzout wrote again, expressing the hope that this letter was with Oldenburg, and announcing his eager anticipation of meeting Wren, who was expected in Paris at any moment.[19]

Auzout's public accusation of premature publication was unjust. There is firm evidence that Hooke had conducted proper trials of his machine and was continuing to do so. On 3 November 1664 Oldenburg told Boyle: 'Mr Hooke is now making his new instrument for grinding Glasses, the successe whereof you will shortly heare of.'[20] By the end of November Moray was giving detailed descriptions of Hooke's machine and the trials being conducted with it to Christiaan Huygens. On 30 January 1665 (just before he dispatched Huygens's copy of *Micrographia*) Moray told him that Hooke was being prevented from conducting further trials on his lens-grinding machine by his duties as Curator of Experiments to the Royal Society:[21] 'Mr Hooke has had so many matters on his plate these past days that he has not been able to carry through to completion his new invention for the lenses for telescopes.'[22]

By September Huygens was reporting to Auzout that there were problems with the operation of the 'iron circle' Hooke proposed using.[23] Again Moray admitted to Huygens that the demands the Royal Society was making on Hooke's time were hampering his ability to complete projects undertaken:

Engraving of a louse attached to a human hair as seen under the microscope, from Hooke's Micrographia.

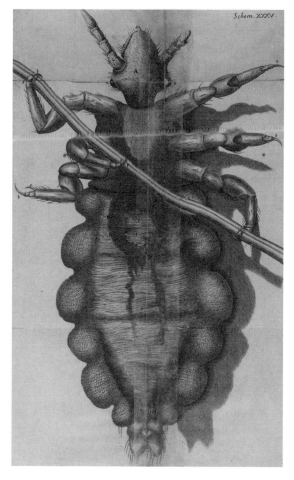

We keep Mr Hooke so fully occupied with a thousand little things that he has not yet given me the description he promised me of his machine for measuring the refraction of light in water [a machine undertaken at the same time as the lens-grinding machine, and also announced and illustrated in *Micrographia*]. As soon as he does so I will forward it to you.[24]

The repeated claims that Hooke's machine had never been tested were, as Hooke always insisted, entirely without foundation.

In fact, Auzout knew far more about Hooke's lens-grinding machine than he was letting on in his letters to Oldenburg, even before the publication of *Micrographia*. Throughout the latter half of 1664 he had been

receiving copies, at least in part, of the letters being exchanged about it between Huygens and Moray. The Anglo–Dutch connection had once again prepared the way, just as it had done in the case of the pendulum clocks. A vigorous correspondence in French between Moray and Huygens, who sometimes wrote to one another several times a week, ensured that whatever Hooke was doing in London, Huygens knew all about it within days. And whereas Moray was a scientific amateur, who enjoyed participating in events at the Royal Society but had little expertise in any specialism, Huygens was well able to pick up, adopt and adapt experimental details passed to him by Moray.

Huygens and Moray had begun corresponding about lens-making machines in summer 1664.[25] Huygens reported to Moray Campani's claim to have 'a new way of making lenses using a lathe or turning device, and without using any kind of a mould'. Moray responded with the news that Hooke had shown such a machine to the Royal Society 'five or six months earlier', although it had yet to be demonstrated in action.[26] Two months later he gave Huygens a much fuller account of the lens-grinding machine, presumably because by November he had had sight of the diagram and description given in *Micrographia* (licensed by the Society that month):

> I think I told you earlier that a few months ago Mr Hooke proposed a sort of lathe for making the lenses for telescopes without using any form or mould. His invention is, to place the lens on the end of a rod which turns on two pivots, then to have a circle of iron attached to the end of another rod which turns in the same fashion, in such a way that the edge of the circle covers the centre of the lens, then applying pressure with the circle upon the lens so that the two rods make whatever angle is desired; according to how big or small the angle between the rods is, the surface of the lens has the section of a large or small sphere.[27]

In December Moray enlarged on this description in response to a further enquiry from Huygens. By now Hooke had built a prototype, which he had shown to the Royal Society:

> Mr. Hooke's machine is set up and I will keep you informed as to the success of this invention, and of all the details of its structure, if it warrants

the effort of describing it to you. Concerning moulds or forms, he claims not to use any. But if it turns out to be necessary to use moulds to give initial shape, and then to polish them, as you suggest, on [an iron] circle, be assured that I will keep you informed. But it looks as if the circles will shape the lenses much more quickly than moulds could do, and so moulds are unnecessary, and as you told me, Campani does not use them at all.[28]

Huygens copied at least one of these letters to Auzout, keeping him up to date with the information Moray was supplying, in connection with Auzout's interest in Campani's machine.[29] He also made a note to himself that the use of the iron circle was an exceptionally good idea, and one that he would consider incorporating into an equivalent machine himself, which in typical Huygens fashion he subsequently did.[30] At the end of December he devoted a whole letter to Auzout to 'explaining the iron circle for working lenses'.[31] A minute for another letter to Auzout, written on 15 January 1665, shows that they were still discussing refinements to the circle.[32] From his further correspondence with Moray it is clear that by now Huygens had built his own prototype machine, and was experimenting with Hooke's 'iron circle'.[33]

Here, as in the case of the balance-spring watch, we have Christiaan Huygens – eager for recognition in the new Paris Académie – absorbing technical detail gathered from informants in London, and incorporating it in his own scientific instruments without acknowledgement. This is precisely the period during which Hooke later accused Oldenburg and Moray of having leaked details of his balance-spring watch to Huygens, and Huygens of having adapted his own prototype watches accordingly.

Hooke was entirely unaware of this correspondence. He knew nothing of the swift transmission to Holland (and thence to Paris) of material he was presenting to the Royal Society in his official capacity as its recently appointed Curator of Experiments.[34] In Moray's eagerness to be seen by Huygens to be fully *au fait* with new scientific developments in England, he freely communicated construction details of Hooke's lens-grinding machine, which an expert instrument-designer like Huygens could readily seize upon and adapt. So Moray was transmitting troubling levels of detail concerning a patentable machine, in whose development there was already

significant European competition, to his friend Huygens, who in turn discussed technical details with Auzout.

Meanwhile, Oldenburg replied to Auzout's letter of 22 June 1665 on 23 July, detailing Hooke's further rebuttals of Auzout's continuing refusal to accept the practicality of the lens-grinding machine. In view of Auzout's lack of knowledge of English, and Hooke's of French, Oldenburg offered himself as epistolary intermediary: 'If you wish, I will be the go-between, since you do not know enough English to write to him nor he enough French to reply.'[35]

But all was not as it seemed. For by 15 July Hooke and the other curators had been instructed to move out of London, to Epsom, in the company of John Wilkins and William Petty, to continue Royal Society experiments safely away from risk of the plague.[36] Even if Oldenburg had shown Hooke Auzout's second letter before he left, there is nothing to suggest that Hooke either drafted notes to it or wrote a full answer.[37]

Emergency measures were in place restricting the post during the plague epidemic. The most secure route for getting letters to Hooke was apparently via Wilkins. In September Moray told Oldenburg that he intended 'to write within a day or two to Dr Wilkins, to put Mr Hook to the finishing his observations &c concerning the Cometes'.[38] Two days later Moray advised Oldenburg: 'I think you will do well to let Mr Hook know what [Huygens] sayes of Glasses [lenses] & what else concernes him by writing to Dr Wilkins.'[39]

At the end of September Hooke went to the Isle of Wight to attend to family business (his mother had died at the beginning of the summer), taking him even farther out of range of regular correspondence with Oldenburg in London. He remained there till the end of the year, occupying himself with geological investigations on and under the cliffs of Freshwater Bay. He returned briefly to London at the end of December, before once more returning to Epsom, finally rejoining the Royal Society circle in London in late February 1666.[40]

From July 1665 onwards, then, it appears that Hooke is being ventriloquised by Oldenburg in his absence in the Auzout–Hooke 'controversy'.

On 13 August Auzout wrote once again to Oldenburg, again responding to Hooke point by point. Oldenburg's translation of this letter into English survives. It is apparently intended for Hooke's use, since it carries

marginal annotations goading Hooke to respond to supposed 'slights' by Auzout in the text (which Oldenburg has made rather more provocative than the original): 'What say you to this?'; 'A handsome sting again will be necessary'; 'Me thinks, here you may toss railleries with him'; 'To this I say, He will needs make you say, what you say not'; 'Non sequitur. You must rally with him again.'[41] Perhaps Oldenburg hoped to have Hooke respond to Auzout himself when he returned to London. Perhaps he intended to act once more as intermediary, and to write another letter to Auzout, incorporating remarks of Hooke's provoked by his own deliberately antagonistic annotations and prompts. Neither thing happened, because Auzout now acted pre-emptively. In July or August 1665 he republished his original 'Letter to the Abbé Charles', together with the entire correspondence to date between himself and Hooke (via Oldenburg) in French in Paris.

Oldenburg reacted indignantly, claiming he had never intended his last letter for publication. Auzout replied in some puzzlement – surely the correspondence had always been intended as part of a public epistolary controversy:

> I am very upset that you are not happy that I have, at the request of my friends, published the letter that you were gracious enough to write to me to explain Mr Hooke's feelings [concerning my continuing criticisms]. I did not consider this letter to be something belonging entirely to you, but rather as the reply of Mr Hooke, and because we had already both of us begun to print material on that topic, I saw no harm in supplying the rest, since our friends wanted so much to have sight of the continuation of the dispute.[42]

It seems clear from Oldenburg's discomfiture that he had indeed himself composed the detailed arguments attributed to Hooke in the letter to Auzout of 23 July. He now found himself embarrassed by their being made public, which risked bringing the fact to Hooke's attention. Fortunately, as we know, Hooke's French was limited. In what was probably an act of damage limitation, Oldenburg summarised the arguments of Auzout's new book in English, abbreviating and omitting parts Hooke might have construed as betrayals of trust, and published his synopsis in *Philosophical Transactions*.

Meanwhile Moray, Huygens and Auzout were corresponding vigorously about the affair, savouring every contentious sentence in the exchanges, often passing each other's letters on as enclosures, and including copies of the *Journal des sçavans* and *Philosophical Transactions* where appropriate. In early June 1665, Auzout told Huygens that he was eagerly awaiting the arrival of *Philosophical Transactions*, which he gathered would contain the first instalment of his exchanges with Hooke:

> I am told from England that Mr Hooke has taken up my objections against his machine in the first book of Philosophical Transactions which I hope will arrive on Sunday. We shall see what he says.

On 23 July Moray added a postscript to a letter to Oldenburg, written from Hampton Court, whence he was about to accompany the King to Salisbury:

> I had almost forgot to desire you to send to Mr Hugens either the whole former Transaction [June issue], or so much of it as containes Hooks answer to Auzout & withall to let him know what Hook is doing as to his glasses [lenses and telescopes]. I have told him I would give you that task. L. Brounker will let you have hugens's letter.[43]

The exchanges amongst this group shaped received opinion concerning the possibility of machine manufacture of precision lenses, and has continued to be treated as the authoritative account of the episode by historians of science ever since.[44] Yet, although Hooke played a starring role in these exchanges, this was an extended conversation in which he had no direct voice, and over which he could exercise no control.

And although Hooke's close friend Christopher Wren was in Paris throughout this period, in daily contact with the Auzout circle, he apparently did nothing to clarify the nature of Hooke's machine, nor did he communicate the fact that Hooke was now absent from Royal Society circles. Wren was certainly consulted over the Auzout/Hooke affair. In April 1666 Auzout reported to Oldenburg that he had spoken to Wren shortly before he returned to England, concerning Hooke's proposed method for increasing the focal length of lenses by filling the space between

two lenses with liquid (a topic associated with the lens-grinding machine debate).[45]

By the end of July the Royal Society members had almost all dispersed because of the plague. Hooke, Wilkins and Petty were at Epsom, together with a substantial amount of experimental equipment, and assistant operators. Boyle was briefly with them, then retired to Oxford. Moray was with the King, first at Hampton Court, then at Oxford. For much of the period we are looking at Brouncker was on a ship off Greenwich seeing to navy business. Oldenburg stayed in London with his family, in a state of considerable agitation about the possibility of his succumbing to the plague (he made a will carefully separating his personal affairs from those of the Royal Society). During this time the Royal Society had two locations: a correspondence address with Oldenburg in London; and a transferred 'real' centre of operations in Oxford, where Moray and Boyle had established weekly meetings of a caucus of members.[46] Huygens was in The Hague throughout, corresponding with Oldenburg, Moray and Auzout (his father, however, was in Paris for three months in early 1665).[47]

Wren visited Paris on behalf of Charles II, to inspect new building projects in train there, on 28 July 1665. We know he was frequently in the company of Auzout.[48] From then on he provided a direct epistolary route for information from Auzout and his circle in Paris to both Oldenburg and Boyle.[49]

So we have an epistolary circuit of transmission, detailed explication, claim, counter-claim, assertion, surmise and response, which by mid-1665 has effectively developed a life of its own. The participating correspondents and the readers of the published versions are actually aware of only a small part of the network of exchanges which constitute the 'controversy', and the complex webs of influence these create.

Auzout and Oldenburg's investment in all of this is pretty clear. From the *Journal des sçavans* in Paris and *Philosophical Transactions* in London was emerging an entirely new form of intellectual debate, one which reached beyond the bounds of coterie and nation into what was apparently a genuine Republic of Scientific Letters. Both Auzout and Oldenburg had a stake in establishing such an intellectual organ to enhance their own reputations, and both were remarkably successful at doing so. Hooke was more or less caught in the crossfire. As a result of Oldenburg's letter-writing,

translating and publications he acquired a reputation for making boastful claims he could not sustain. Controversy also became associated with his name on the Continent, at just the moment when *Micrographia* was establishing him as a formidable scientific presence.

The story of the simultaneous attempts in London, Paris and The Hague to develop a machine-method for manufacturing optical lenses is a minor one for the history of science. But we should note that this correspondence, circulating vigorously in Hooke's absence, and without his knowledge, contains the 'insider' remarks supplying clues to the construction of his balance-spring watch which were later to cause him such personal grief and anger.

Indeed, the first 'leaked' information concerning the use of a coiled spring to regulate a pocket watch comes in a letter from Moray to Huygens which forms part of the lens-grinding exchanges, sent shortly after Hooke had left London. Hooke, Moray explains, has not yet been able to complete the collating of data on the 1664 comet, collected by virtuosi across Europe, which Huygens has asked for.[50] As if to distract his somewhat demanding friend from the fact that he is unable to supply information on this topic, Moray changes the subject:

> Up to now I have not ever spoken to you about another thing that he has suggested in his lectures on mechanics (which he gives every Wednesday outside the University term).[51] It is an entirely new invention [...][52]

And Moray proceeds to explain how Hooke uses a spring (*'un ressort'*) as the regulator for his new watch. Like the 'iron circle' Huygens seized on for his lens-grinding equipment, this was quite enough to set Huygens off on the right track – particularly since, as in that case too, Moray proceeded to describe the balance-spring watch to Huygens in increasing detail in succeeding letters.

Hooke and Auzout, by the way, remained on cordial terms during this sequence of events and orchestrated controversies, despite Oldenburg's promptings to the contrary. Throughout the exchanges, Auzout continued to refer to Hooke in the most respectful of terms, and Oldenburg consistently deleted these from his racy English translations. On 18 December 1666, for instance, writing to Oldenburg to communicate an

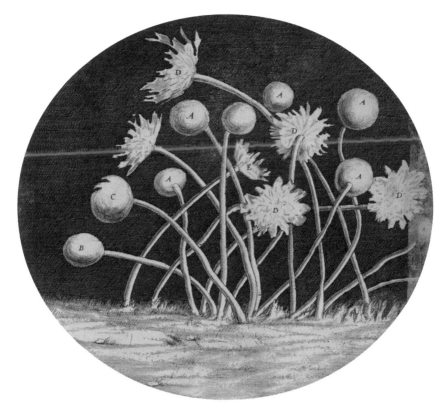

Engraving of blue mould as seen under the microscope, from Hooke's Micrographia.

important astronomical observation, Auzout wrote: 'I think that Mr Hook, whom I salute wholeheartedly, as well as Mr Wren, will be very interested.' Oldenburg omitted the phrase 'whom I salute wholeheartedly' from the version he published in *Philosophical Transactions*.[53]

By contrast with Oldenburg's tendency to edit the two protagonists' pronouncements, so as to present Hooke's work as controversial and his relationship with Auzout as abrasive, the issue of the *Journal des sçavans* published on 20 December 1666 contained a review of *Micrographia*, praising it unreservedly and at length, in extravagant terms. Uniquely for the *Journal* up to that point, the review reproduces two reduced-size versions of the 'cuts' or plates for which it expresses enormous admiration (the louse and blue mould).[54]

The controversy conducted in the pages of the *Philosophical Transactions*

and the *Journal des sçavans*, and in Auzout's pamphlet publications issued in the course of 1665, achieved what Auzout wanted: to bring his astronomical expertise to the attention of Colbert and the King of France and secure himself a royal appointment. His opportunism is clear, and is supported by the fact that within two years he had quarrelled with other members of the Paris Académie and left France for Italy.

Oldenburg was more than content that the *Philosophical Transactions* should have become essential reading among virtuosi across Europe as soon as he began publishing them – by the fourth issue, the one containing the first adversarial exchange of letters between Auzout and Hooke, there was an absolute scramble to get hold of copies immediately they appeared. The élite, high-minded virtuosi Moray and Huygens cemented their intimate Anglo–Dutch friendship by exchanging sought-after information, and keeping each other 'in the know'.

In spite of his forebodings, after his breakdown of 1676 Christiaan Huygens did return to the Académie des sciences in Paris for a brief period in late 1678. In spring 1681, however, he collapsed again. This time it was his sister Susanna, accompanied by her husband and their three children, who was sent to rescue him. She stayed three weeks – finally realising her dream of visiting the French capital – then brought Christiaan home for the last time. In 1684 the Académie, tired of his absence, dismissed him. He joined his father in the big family house in The Hague, keeping the aged Sir Constantijn company until his death in 1687.

Thereafter, Christiaan retired to his father's estate, with its wonderfully serene and restorative garden, at Hofwijk. But with the Dutch invasion of England, his reputation as a brilliant scientific innovator enjoyed one final flowering abroad. For while Hooke was an old-style divine-right-of-kings man (like his close friend Sir Christopher Wren), and had, right up to William of Orange's arrival, steadfastly backed James II as England's legitimate monarch, Christiaan Huygens, his scientific adversary, was the clever younger brother of William's private secretary, Constantijn Huygens junior, who had played a prominent role in the successful invasion.

In London, Constantijn junior was now a senior figure in the new

administration, with real political power. The fact that all Sir Constantijn Huygens's children spoke excellent English was now a further distinct asset. The young English scholar Thomas Molyneux, visiting Christiaan during his final period in Paris, reported that he had received a warm welcome: 'When he understood after a few words that I was English, he spoke to me in my own language, beyond all expectation, and moreover, extremely well.'[55]

Constantijn's new position in England tempted his brother Christiaan out of retirement, with the prospect that he could now be assured of real respect from the English virtuosi, and could finally take his place among the Fellows of the Royal Society (he had been elected an overseas member in 1663 – the first foreigner to receive that honour).

Christiaan had a further reason for allowing himself to be tempted away from the seclusion of Hofwijk. For two years he had been poring over Isaac Newton's *Philosophiae Naturalis Principia Mathematica*, or the *Principia*, of which the author had sent him a presentation copy, working painstakingly through its mathematical calculations. Shortly after he read it, Huygens told Constantijn that he had enormous admiration for 'the beautiful discoveries that I find in the work he sent me'.[56] When John Locke came to visit him, and asked him if he thought Newton's mathematics, which he admitted he could not himself follow, were sound, Christiaan told him emphatically that they were certainly to be trusted. Newton, to whom Locke recounted this, proudly repeated the Dutch mathematician's endorsement in London. A visit to London would enable Huygens to meet Newton face to face.

In preparation for his trip, Christiaan resuscitated and rewrote his ten-year-old treatise *Traité de la lumière* (Treatise on Light), to provide him with his credentials for re-entering English intellectual life. He wrote to Constantijn:

> I had intended to stay here at Hofwijk for the whole winter ... However, you might have an opportunity to see Mr. Boyle. I would like to visit Oxford, if only to make the acquaintance of Mr. Newton [in fact, of course, Newton was at Cambridge] for whose excellent discoveries I have the greatest admiration, having read of them in the work [*Principia*] which he sent me.[57]

Christiaan arrived in London on 6 June 1689. He joined Constantijn junior and Constantijn junior's son in lodgings close to Whitehall. A week later the three of them went together to stay at Hampton Court Palace, where the new King and Queen were in residence. On 12 June Christiaan travelled by boat back along the Thames to London for a meeting of the Royal Society. He recorded in his diary:

> Meeting at Gresham College in a small room, a small cabinet of curiosities, over-full but well kept. Hoskins President, Henshaw Vice-President, Halley Secretary. Van Leeuwenhoek's letter was read. Newton and Fatio were there too.[58]

In the period of uncertainty leading up to the Dutch invasion and William's claiming the English throne, Isaac Newton had already begun to emerge from his sheltered position as a solitary scholar at Trinity College, Cambridge. In 1687, when James II's interference with the university roused even those as aloof as Newton from their political indifference, he found himself nominated to act for the university in what turned out to be a critical piece of resistance to James II's policy of installing Catholic cronies in key administrative positions. Newton was one of nine prominent members of Cambridge University who in April 1687 – at the very moment when Edmond Halley was seeing the *Principia* through the press – confronted the notorious 'Hanging Judge' Lord Jeffreys, and refused to allow James II to appoint his personal nominees, without qualification or oath, to senior academic positions.[59]

So at the beginning of 1689, Isaac Newton was already one of the most prominent, Protestant-supporting members of the university community, with impeccable credentials to serve the incoming regime. On 15 January he was elected one of the three university representatives to the national Convention appointed to settle the legitimacy of William and Mary's claim to the English throne.[60]

Two weeks after his arrival in London, having returned to Hampton Court, Christiaan Huygens had an audience with King William and dined with his Dutch favourite, William Bentinck, Earl of Portland, the most powerful man at court. It had been suggested beforehand that, as an esteemed virtuoso particularly well-connected with the Dutch royal

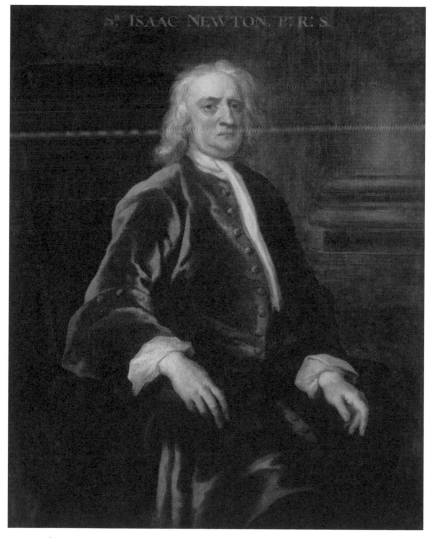

Portrait of Sir Isaac Newton, who came to prominence politically with the arrival of William III.

household, Christiaan might put a word in with William III on Isaac Newton's behalf, putting the mathematician's name forward for a senior academic promotion. Two days later, on 10 July, Christiaan, Nicolas Fatio de Duillier and Newton met at seven in the morning in London, 'with the purpose of recommending Newton to the King for the vacant Mastership of a Cambridge College'.[61] On 28 July, Christiaan attended a fashionable

concert at which he was introduced to the Duke of Somerset, Chancellor of the University of Cambridge, and Newton's preferment was once more discussed.[62]

So Christiaan Huygens was directly involved in the political game of snakes and ladders, in which Newton – hitherto a small player, politically – moved centre-stage, while formerly powerful intellectuals like Wren and Boyle were nudged to the margins.

The Cambridge college whose headship Newton had ambitions to fill was King's, and John Hampden, the court lobbyist on Newton's behalf who approached Huygens, was a leading Parliamentary player. Huygens's approach evidently had the desired effect. Shortly thereafter, William wrote to the Fellows of King's College, informing them of his desire that they appoint Newton as their new Provost. The new foreign King was, however, roundly rebuffed by the Fellows, who selected another candidate. This was probably just as well for Newton's future career as a public figure, since imposed royal appointments were deeply unpopular.[63]

Even though this personal intervention of Huygens's to advance Newton's career did not succeed, the scientific relationship between the two men was thereby significantly strengthened. In August, before he left for home, Huygens received two papers from Newton on motion through a resisting medium. At some point during the visit they also had lengthy discussions of optics and colour.[64] Huygens told the German mathematician Leibniz that Newton had communicated 'some very beautiful experiments' to him – probably his experiments with thin films similar to the ones Huygens himself had performed twenty years earlier, and to those Hooke had recorded in his *Micrographia* even earlier.[65]

After Christiaan Huygens had returned to The Hague, at the end of August 1690, Nicolas Fatio de Duillier spent a month with Newton in London, followed by fifteen months in the Netherlands, mostly with Huygens.[66] Over the next several years, Fatio facilitated the exchange of ideas between the two men. Huygens came to regard Fatio as his direct link through which he learned Newton's latest thoughts on mathematics, gravity and light.

Although Christiaan Huygens retreated rapidly to his self-imposed life as an intellectual invalid at Hofwijk, his brother Constantijn continued to be a person of influence at the court of William and Mary.[67] Newton, mean-

while, became Master of the Royal Mint, and a formidable figure in London political circles. He was also by now an international celebrity as the author of the *Principia* – the man who had finally unlocked the secret of the motion of the heavens. In terms of his own continuing career, Hooke now found himself between a rock and a hard place: between the City and the Royal Society. In neither did he any longer command any kind of authority, and in neither could he find powerful protectors who had survived the change of dynasty.[68]

So when, on 12 June 1689, Huygens, Newton and Hooke found themselves together at a meeting of the Royal Society, Newton and Huygens were, unbeknown to Hooke, about to embark on a new, yet more intense phase of their intellectual relationship. Hooke, meanwhile, was increasingly ill at ease with the Royal Society, where all but a few of his oldest friends among the members seemed to take him less and less seriously.[69]

Of all Hooke's claims to scientific breakthrough, and to have anticipated Huygens's and Newton's ideas, those in optics were probably the most convincing and well-documented. Both Newton and Huygens had started their work on thin coloured films in 1665–66 after having read Hooke's suggestive discussion in *Micrographia*.[70] Similarly, both men had pursued the wave theory of light proposed in that book, and the associated calculation of the velocity of propagation of light. In the early 1670s, when Newton first wrote to the Royal Society with his theory of colour, and first crossed swords with Hooke, who inevitably challenged him, Newton was open about having been influenced by Hooke's work.[71] By 1675, however, egged on by Oldenburg, Newton was denying Hooke's influence and claming that any ideas the two men shared were simply 'common thoughts': 'I desire Mr Hooke to shew me therefore ... [that] any part of [my hypothesis] is taken out of his *Micrographia*.'[72] Nevertheless, Hooke's experiments in optics were an authoritative contribution to the reputation of the Royal Society, and some important intervention from him at that auspicious meeting of the Society in which Huygens and Newton participated was to be expected. None is recorded.

Following the meeting of the Royal Society on 12 June, Hooke worked through the arguments propounded in Huygens's Treatise on Light with even more than his usual punctiliousness. We can surmise that he was discouraged and depressed by the confident authority with which Huygens

and Newton had conducted themselves at the Royal Society meeting. He responded by drafting two lectures defending in detail his own 'philosophical' views: the first dealing with those concerning light and its properties (wave theory and thin films), the second dealing with planetary motion (orbits of the planets, and shape of the earth). Hooke's health that year was particularly bad. According to Richard Waller, he was 'often troubl'd with Head-achs, Giddiness and Fainting, and with a general decay all over, which hinder'd his Philosophical Studies'.[73]

Eight months later, on 19 and 26 February 1690, Hooke delivered his response to the Society.[74] The first lecture includes a particularly poignant restatement of his own originality, which appeals to his listeners to assess his own contribution before deciding that Huygens's competing views are correct:

> This is in brief what I thought necessary to be considered before what I have formerly Deliverd concerning Light be rejected and before what is here Deliverd be Received, for though I doe readily assent that Monsieur Huygens & others much more Able than myself may penetrate farther into the true causes of the Phenomena of Light than I had done at that time; yet I confesse I have not yet found any phenomenon or hypothesis propounded by any writer since that time that has given me cause to alter my sentiments concerning it. However I should be very gladd to meet with any such and shall be as Ready to Relinquish this Upon the meeting with a better as I was in making choice of it for the best at the time of publication.[75]

In the second lecture, Hooke went on to analyse Huygens's *Discours sur la cause de la pesanteur* (Discourse concerning the cause of weight). Here Hooke fastens onto Huygens's treatment of gravity:

> For what follows afterwards is additionall to that Discourse as he himself Declares in his preface, which is concerning those proprietys of Gravity which I myself first Discovered and shewed to this Society many years since, which of late Mr. Newton has done me the favour to print and Publish as his own Inventions. And Particularly that of the Ovall figure of the earth was read by me to this Society about 27 years since upon the

occasion of the Carrying the Pendulum Clocks to Sea And at two other times since, though I have had the Ill fortune not to be heard, and I conceive there are some present that may never well Remember and Doe [not] know that Mr. Newton did not send up that addition to his book till some weeks after I had read & shewn the experiments & Demonstration thereof in this place.[76]

As usual, Hooke insists that he had himself long ago made every one of the discoveries Huygens and Newton claim for themselves. This time he had clear justification for maintaining his influence, and documented the indebtednesses with measured intelligence. A group of well-disposed members attended the lectures in question, including Sir Robert Southwell, Sir John Hoskins, Waller, Edmond Halley, John Wallis, Hans Sloane 'and divers others'.[77] But Huygens and Newton had moved on.[78] According to the records, Hooke's intervention was barely registered, and nobody bothered to respond.[79]

The mercurial Dutch virtuoso Christiaan Huygens floats in and out of other people's stories from his adolescence, through the Europe-wide acclaim accorded him in his prime (while he resided in Paris, as Louis XIV's favourite scientist), down to his decline, depression and death. From his childhood he had been his influential and ambitious father's favourite. Sir Constantijn was determined to find his second son a lucrative appointment to enable him to utilise his scientific talents, and as an anglophile his first preference would have been for Christiaan to join the scientific community in London. Between October 1661 and April 1665, Sir Constantijn shuttled between Paris and London as he negotiated the return of Orange (seized by Louis XIV) to the house of Orange. While he was at it, he lobbied people in high places to try to secure a position for his son.[80]

Christiaan preferred Paris. Even the festivities surrounding Charles II's coronation did not make London seem glamorous to him. After his first visit, he wrote to his brother Lodewijk:

I had little pleasure of my visit to London ... The stink of the smoke is unbearable and most unhealthy, the city poorly built, with narrow

streets having no proper paving and nothing but hovels … There is little
going on and nothing compared with what you see in Paris.[81]

In December 1666, Christiaan Huygens was appointed to a salaried
position in the new Académie royale des sciences in Paris, though he was
made a foreign Fellow of the Royal Society, and remained in active contact
with his fellow scientists in London throughout his life.

If it is hard to imagine a biography of Christiaan's father Sir Constantijn
which does not straddle the Narrow Sea and consider him in a robustly
Anglo–Dutch historical context, the same is even more true of Christiaan,
whose life and career as represented in the literature of the history of
science are both shadowy and contradictory – depending on whether he is
being looked at in a Dutch, English or French context and milieu.

The events described in this and the preceding chapter have made it
clear, I hope, that Christiaan Huygens's claims to priority in the matter of
the spring-regulated pocket watch, and pre-eminence in the field of lens-
grinding, microscopy and telescopy, are inseparable from his sometimes
uncannily close connections with his British and French counterparts. So
let it be another of Christiaan Huygens's involuntary international collab-
orations at a distance that takes us forward to the final chapter of this story
– Anglo–Dutch relations in the New World.

In a letter written on 25 October 1660 from Hartford, Connecticut,
where he was governor of the English colony, John Winthrop junior, son of
the founder of the English colony at Jamestown, and a considerable sci-
entist in his own right, told the English scientist and educator Samuel
Hartlib that he was disappointed that his 'Telescope of [focal length] about
10 foot doth shew little of Saturne'.[82] He asked Hartlib, who acted as an
intellectual go-between for scientists and practitioners across Europe, to
tell him if he knew 'the manner of the fabrique of that new Telescopium in
holland', expressing the hope that Christiaan Huygens might have des-
cribed such an instrument accurately in his *Systema Saturnium* (System of
Saturn), which Winthrop had not yet read. Huygens's book, announcing
his remarkable discovery of Saturn's rings, had been published the previous
year. Winthrop's anticipation of a copy arriving in Connecticut is further
evidence of the ease with which new publications circulated across the
known world. It was another year, however, before Hartlib wrote telling

Winthrop that 'some weeks agoe' he had sent him 'the Systeme of Saturne with all the Cuts [illustrations]'. Winthrop was gripped by the contents of Huygens's book, and was keen to observe the phases in Saturn's appearance himself.

His astronomical observations were interrupted by more pressing local political concerns. Connecticut had been founded during the Protectorate of Oliver Cromwell. Now, in 1661, Winthrop was obliged to return to England to negotiate a new charter for the colony with the returning King, Charles II. He was away for almost two years, during which time he was successful in gaining for the inhabitants of Connecticut a charter from the King, assigning them lands from the Pawcatuck River all the way westwards to the Pacific Ocean. While in England he was also made a Fellow of the Royal Society. He returned to Connecticut in 1663, and in 1664 assisted in Charles II's seizure of the thriving Dutch settlement on Manhattan Island for the English.[83]

In January 1665, in the midst of unfolding events following the seizure of Manhattan, Winthrop wrote to Sir Robert Moray at the Royal Society, sending him observations of the moons of Jupiter which he had made with a refracting telescope of '3 foote and [a] halfe with a concave ey-glasse'. Inspired by Christiaan Huygens's book, he had, it seems, brought the English-made telescope back with him from London:

> Having looked upon Jupiter with a Telescope upon 6th of August last I saw 5 Satellites very distinctly about that planet; I observed it with the best curiosity I could, taking very distinct notice of the number of them, by severall aspects with some convenient time of intermission; and though I was not without some consideration whether that fifthe might not be some fixed star with which Jupiter might at that time be in near conjunction, yet that consideration made me the more carefully to take notice whether I could discern any such difference of one of them from the other four that might by the more twinkling light of it or any other appearance give ground to believe that it might be a fixt star, but I could discern nothing of that nature.[84]

Winthrop turned out to be mistaken – although a fifth moon of Jupiter was indeed discovered in the nineteenth century, his telescope could not

have detected it, and he is indeed most likely to have taken a fixed star, crossing the face of Jupiter, for a satellite circling the planet.

But the accuracy or otherwise of John Winthrop's observations of Jupiter is not our concern here. What is, is that more than three thousand miles from London, in an American colony, an English astronomical enthusiast's passion for telescopic observation had been kindled by a young Dutch astronomer who had made an exciting discovery about the planet Saturn. In 1671, Winthrop presented his reflecting telescope as a gift to the new Harvard University – its first recorded astronomical instrument. So the emerging science of astronomy in North America, with a long and distinguished future stretching ahead of it, was, it seems, in its earliest days equally indebted to English and Dutch astronomers back home.

Anglo–Dutch Influence Abroad: Competition, Market Forces and Money Markets on a Global Scale

We have observed the development of an unplanned affinity between the English and the Dutch in the course of the seventeenth century. As a result, encounters between them could ordinarily be eased into some kind of agreement. This was, however, decidedly not the case with relations between the two nations overseas. Aggressive commercial competition meant that wherever the paths of Dutch and English financial interests crossed, there was almost bound to be trouble. This in spite of the fact that on the whole the Dutch did not have imperial ambitions along their newly established trade routes.

The Dutch Republic was a seaborne, trading nation at heart, and its expansionist energies were driven by the search for new goods and markets, and a keen eye for potential profit. It regarded the outposts it established as a result of the highly successful activities of its Dutch East India Company (Vereenigde Oostindische Compagnie, or VOC) and West India Company (West-Indische Compagnie, or WIC) as first and foremost well-ordered trading posts, rather than colonies. These were settled points of exchange for goods and services, whose profits could be returned to the *patria* (homeland), where wealth would be invested and accumulated long-term for the benefit of the nation – or at least for the benefit of the wealthy speculators who financed long-distance, high-risk ventures.

The Royal Society's first historian, Thomas Sprat, noted this difference between the English and the Dutch away from home. English merchants carried their way of life with them, establishing it in the new communities they encountered. Dutch merchants were entirely preoccupied with trade:

> The Merchants of England live honourably in forein parts; those of Holland meanly, minding their gain alone: ours converse freely, and learn from all; having in their behaviour, very much of the Gentility of

the Families, from which so many of them are descended: The others, when they are abroad, shew, that they are onely a Race of plain Citizens, keeping themselves most within their own Cells, and Ware-houses; scarce regarding the acquaintance of any, but those, with whom they traffick.[1]

Sprat's characterisation of the Dutch as focusing all their efforts in this period on trade and gain, thereby enriching the nation, is in many ways a fair assessment of the United Provinces' place in seventeenth-century Europe – though here we are, readers will recall, being careful not to attribute temperaments too narrowly to nations. In this final chapter we shall see how the new initiatives in finance, taxation and exchange, which had fuelled the Dutch 'golden age' of culture and commerce, were gradually transferred to Britain by a process of more or less conscious emulation, long before the arrival there of William and Mary in 1688.

There was one clear exception among Dutch trading outposts overseas to their general mercantile strategy of living abroad 'meanly, minding their gain alone', in the first half of the seventeenth century. This was the settlement of New Netherland, strategically located at the mouth of the Hudson River, on the east coast of America.[2] New Netherland was unique among the 'factories' or trading locations established by the Dutch East and West India Companies in developing into a thriving and productive community, closely modelled on its Low Countries roots: 'Whereas most Dutch colonies in the seventeenth century never developed into much more than trading posts, New Netherland became the first Dutch settlement colony, preceding that of the Cape of Good Hope.'[3]

New Netherland fits Sprat's description of a colony with a civilising mission and a commitment to replicating a European way of life in the New World. It was in every respect resolutely Dutch. From the style of roof-truss used in family homes and public buildings, to the manner of grinding corn and the type of bread baked for the community, New Netherland adopted the habits and mores of the homeland, and specifically those of the mercantile hub from which its ships set out, and which was the home of the Dutch trading companies: Amsterdam.

It was an English adventurer and explorer, Henry Hudson, employed by the Dutch East India Company to look for the fabled North-West Passage to the Spice Islands, who discovered New Netherland. Thwarted in his first attempts to journey eastwards to find a North-East Passage to Russia, Hudson decided to head instead westward towards North America. He directed his attention to the area between the thirty-seventh and forty-second parallels, between Chesapeake Bay and Cape Cod, looking for an inlet promising enough to suggest a route through the continent to the Spice Islands, which allegedly lay beyond. In September 1609 he arrived at the mouth of what we now know as the Hudson River, sailing up it as far as what is today Albany, where it became too shallow for a seagoing ship to pass.

In 1615 the States General of the United Provinces granted a patent to the New Netherland Company, authorising it to undertake voyages to establish trading relations, particularly in furs, with the new trading posts precariously established at the mouth of the Hudson, followed, in 1621, by the formation of the Dutch West India Company. In response to protests from the English ambassador at The Hague, Sir Dudley Carleton, that the English had prior claims to this stretch of coastline, the new company sent a small vanguard of settlers to New Netherland, who established Dutch trading posts near Manhattan Island (as it later became) and a fortified headquarters for the region at Fort Orange, close to modern-day Albany.

The most hospitable and fertile place for settlement, however, lay on the coast, at the mouth of the north Hudson River. In early 1626, Paul Minuit, the newly appointed commander of the settlers in the Dutch colony of New Netherland, famously exchanged the small, sheltered island of Manhattan, tucked in between the river mouth and what the Dutch called 'Lange Eylant' (Long Island), for goods to the value of sixty guilders with the Indian tribe which lived there.

A contemporary account of the deal is preserved in records of the Dutch West India Company – the organisation responsible for settling the area on behalf of the Dutch, as a trading post for beaver pelts and other commodities to be shipped to Europe for profit. In the last week of November 1626, a Company official in Amsterdam reported in a letter (in Dutch) to his superiors at The Hague the arrival of a ship, the *Arms of Amsterdam*, which had left New Netherland in late September:

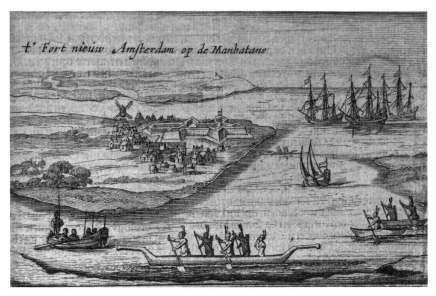

View of New Amsterdam shortly after its acquisition in 1626.

They report that our people are in good heart and live in peace there; the Women also have borne some children there. They have purchased the Island Manhattes [Manhattan] from the Indians for the value of 60 guilders; it is 11,000 morgens in size. They had all their grain sowed by the middle of May, and reaped by the middle of August. They send thence samples of summer grain; such as whet, rye, barley, oats, buckwheat, canary seed, beans and flax.

The ship in question carried a gratifyingly rich cargo of furs from the colony – beaver, otter and mink – as well as 'Oak timber and Hickory'.[4]

From this report we gather that within a year of gaining ownership, the residents of Manhattan Island were farming their newly acquired land profitably, and consolidating their trade in lucrative furs with the Indians. Within two years, under the direction of Minuit, they had established a permanent settlement: thirty wooden houses along 'The Strand', on the flattish south-eastern flank of the island, and one stone building with a thatched roof of river reeds, as the West India Company headquarters, where the precious pelts collected from the interior could be stored before being shipped back to Europe. A fort was built on the south-western point

of the island, whence enemy vessels could be attacked as they entered the harbour. Two mills were constructed at the southernmost tip, one for grinding grain, the other for sawing lumber. In contemporary drawings the sails of the windmill can be clearly seen behind the small cluster of Dutch-style cottages – this could almost be a landscape in the United Provinces themselves.

Manhattan Island turned out to have a richly varied terrain, with ample fertile land for cultivation. There was thick forest from which protruded large vertical rocks, grassy meadowlands, high hills in the centre of the island, babbling brooks and reedy ponds. Oaks, chestnut trees, poplar and pine studded the landscape, the inlets teemed with fish, and in summer the meadows were carpeted with wild strawberries. In this hospitable landscape Minuit established the settlement of New Amsterdam, and it duly prospered, its population increasing to 2,500 by the early 1660s.

Numbers in the settlement were swelled by new arrivals not directly involved in the WIC's commercial business, but rather bent on making a new life there. In April 1637 a ship arrived from Amsterdam and sailed up the Hudson to Fort Orange. On board were some thirty-seven people, hired by their Dutch '*patroon*' or master, Kiliaen van Rensselaer, to establish a settlement in his name, and there to trade with the Indians on his behalf. By 1642 around one hundred people had settled in the dispersed community around Fort Orange known as Rensselaerswijck, building and equipping a '*bijeenwoninge*' – literally a 'living together', a community. In 1652 this spread-out settlement became the village of Beverwijck, a WIC company village. Eight years later this village had become a small town, inhabited by more than a thousand people. Among those who came to live in Beverwijck were Dutch settlers from Recife in Brazil, once governed by Johan Maurits van Nassau-Siegen, but lost in 1654 to the Portuguese, who expelled the Dutch traders, including a group of twenty-three Jews, men, women and children, who were allowed to settle in New Amsterdam on Manhattan Island.[5]

Between the early years of settlement and the 1650s, the population of New Netherland as a whole grew from a handful to almost eight thousand, a thriving, self-sufficient, Dutch-speaking community.[6] That growth in population gradually led to a process of development of forms of government and social structures derived from the 'old country' – specifically

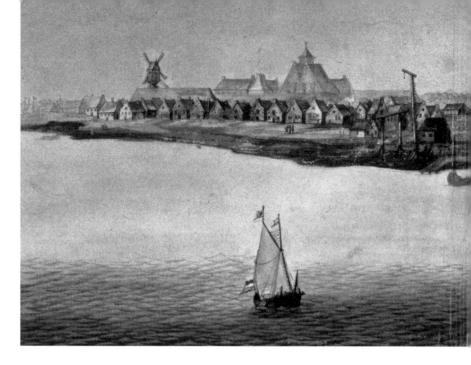

Watercolour showing the settlement of New Amsterdam on Manhattan island.

the city of Amsterdam. According to Dutch custom, the settlements in North America were supposed to be directly controlled by the 'nineteen lords' of the Dutch West India Company (drawn predominantly from the governing chambers of Amsterdam and Zeeland). In fact, since most of the voyages to New Netherland were organised by Amsterdam merchants, New Netherland was largely under the administration of the twenty directors of the Amsterdam chamber. In addition to managing the wharves, the equipping of the ships and the sales of the cargoes brought in, they were also expected to administer the colony on the other side of the Atlantic Ocean.

The settlement at Rensselaerswijck, however, considered itself to be under the direct administration of its patron, Kiliaen van Rensselaer, just as van Rensselaer considered himself entitled to trade directly with the local inhabitants for beaver pelts, rather than via the WIC. In practice, therefore, administration of New Netherland came increasingly to be provided from among its Dutch residents. It was not until the arrival of Petrus (Peter) Stuyvesant in 1645, as the official representative of the WIC, that the situation was eventually regularised and an official voice was given to the population of New Netherland, in the form of an advisory committee of

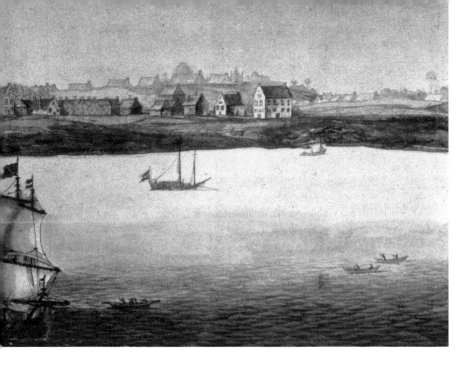

'the Nine Men'. The colonists were asked to draw up a list of eighteen nominees, from which Stuyvesant selected nine. These *gemeentsmannen* or *gemeijnsluijden* (councillors of the community) were not entitled to meet on their own initiative, but had to wait to be summoned by the director general 'as is customary in our fatherland'.[7]

By the 1660s, when the scattered settlement of Rensselaerswijck had been consolidated into the thriving small township of Beverwijck, anyone encountering the settlers would have appreciated the thoroughgoing Dutchness of their way of life, from the language spoken to dress and habits. The records contain specific references to the customs of Amsterdam, in the appointment locally of *burgemeesters* and *schepenen*, rather than the representatives of the States General and the West India Company. Methods and manners of taxation and the regulation of trades were also closely modelled on those in the Dutch Republic.

The administrative and legal system of New Netherland, the structure of ecclesiastical life, the method in which the economy of the colony was ordered, and the way burgher rights were used as expressions of differences in status, were all based on those in the Dutch Republic. So too were the patterns of daily life.

Births, marriages and deaths were celebrated in New Netherland with simplified versions of the practices back home in the old country. The

naming of children, choice of godparents and baptismal gifts display clear parallels with the customs in the Dutch Republic. Misdemeanours – from drunkenness to whoring – were punished with penalties modelled on those at home, as were breaches of promise, and marital discord. Where disputes arose between neighbours, or complaints were laid for insulting behaviour or swearing, both the behaviour and the methods of resolution are those of the Netherlands. Even the nursery rhymes sung by the children of New Netherland for many generations are recognisably those of urban Amsterdam.[8]

One curious consequence of the introduction of a robustly Dutch administration in New Netherland was its extension to a group of small communities almost entirely peopled by English immigrants. In order not to over-extend their small group of settlers, the WIC had allowed Long Island to be colonised by men and women from neighbouring English settlements. These communities were among the first to be granted autonomous administrative bodies and local courts, since it was inappropriate for the WIC to try to extend its Dutch powers to them. Nevertheless, the forms of administration and courts adopted were those also favoured by the neighbouring Dutch settlements. So by the 1660s, in spite of growing tension between England and the United Provinces at home, there was an unacknowledged Anglo–Dutch accord in New Netherland, extending to a merging of English and Dutch local interests.

And then, in August–September 1664, a small flotilla of heavily armed ships, laden with well-equipped soldiers, arrived off the shore of New Netherland from London. Without warning, as part of Anglo–Dutch hostilities on the other side of the world, brought about by commercial greed and ambition, New Netherland was taken by force by the English, and Dutch colonial ambitions in North America came abruptly to an end. New Netherland was absorbed into New England, New Amsterdam became New York, and Fort Orange became Albany (named after Charles II's brother, Admiral of the Fleet and a keen investor in the English East India and Royal African Companies, James, Duke of York and Albany). Until comparatively recently, history had all but forgotten about the fundamental role played in the region by pioneering souls from the United Provinces.

Here a short digression is needed concerning Sir Robert Holmes, whom we encountered in Chapter 10, testing sea-going pendulum clocks

for the Royal Society. For the catalyst for the seizure of New Netherland was an assault on Dutch settlements on the east coast of Africa by Holmes, under orders from the warmongering factions surrounding the recently returned English King, Charles II. This group had its eye on what it perceived to be extremely lucrative trading opportunities along the coast of Guinea, where, however, the Dutch were firmly installed already in fortified positions at Goree and elsewhere. The profitable commodity – eyed particularly covetously by James, Duke of York, who had acquired a considerable taste for speculative investment in overseas trade – politely known as 'black gold' was, of course, African slaves, to be transported at enormous profit to the new European plantations in the West Indies.

Holmes was first dispatched in 1661 with a small, heavily armed contingent of ships, to 'assist' in the Royal African Company's trading ventures along the Guinea coast. He sailed from Portsmouth in January, reaching the Gambia in early March. On 18 March he forced the surrender of the Dutch fort of St Andreas, and after an unsuccessful attempt to find a legendary store of gold, he returned to England. The expedition brought a storm of diplomatic protest from the Dutch. Samuel Pepys regarded Holmes as fundamentally untrustworthy: 'He seems to be very well acquainted with the King's mind and with all the several factions at court. But good God, what an age is this, that a man cannot live without playing the knave and dissimulation.'

In May 1663, Holmes embarked on another voyage to Guinea, whose real purpose was to disrupt Dutch trade in the region and to seize Dutch possessions along the Guinea coast. On 21 January 1664 he attacked Goree, sinking two ships and taking two others, and the island surrendered on the following day. He went on to take the Dutch fort of Anta and a number of other Dutch positions before sailing for England in late June. We get some flavour of Holmes's naval style from a letter he sent to one of the Duke of York's officials on the way home. Undisciplined behaviour of a kind which seemed to follow him around had led to a nasty incident. In spite of assurances to the contrary, after seizing the Dutch trading posts at Aga and Anamaboa by force, Holmes's men had begun to plunder their assets. The Dutch retaliated by blowing up the post, resulting in casualties to the tune of '80 or 90 whites and blacks'. Which, Holmes reports nonchalantly, 'the blacks rewarded by cutting off all their heads':

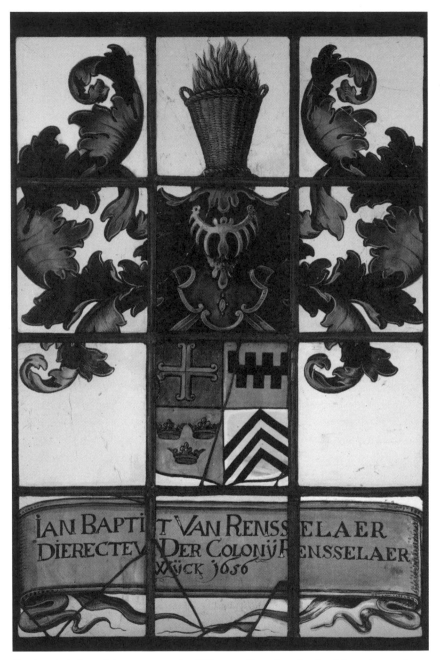

Dutch stained-glass window commemorating Kiliaen van Rensselaer, founder of the settlement of Rensselaerswijck in New Netherland.

Since my Letters from Cape Coast wee have taken in Aga & Anamaboa
the former by storm, and after promiseing Quarter to the Flemins &
taken possession our men being somewhat greedy of Plunder, the Flemins
treacherously blew up the Powder & withall 80 or 90 whites and blacks,
which the blacks rewarded by cutting off all their heads [...] I know not
how my Actions vpon the Coast of Guyny are resented at Court, nor how
my Condicion stands [...] My service to all friends I am sir, yours. R.H.[9]

It was on this return voyage that Holmes produced the story that has
earned a permanent place in the history of science, about the amazing
accuracy of Huygens's pendulum clocks, and how they had saved the
returning ships from disaster by enabling him to predict how long it would
take, in precisely which direction, to make landfall on the Cape Verde
islands. The clocks had been kept assiduously wound and to time, he
claimed, throughout his marauding adventures.[10]

Anti-Dutch feeling was already running high among the hawks in
Charles II's government by 1662–63. But it was Holmes's buccaneering and
unscrupulous naval action off Guinea that brought matters between
England and the United Provinces conclusively to a head, and triggered the
declaration of war by the Dutch in February 1665 (Holmes was also to
provoke the confrontation which led to the third Dutch war in 1672).

So much for Holmes's disreputable behaviour on behalf of the English
off Africa. As part of the same initiative, the continuing state of heightened
Anglo–Dutch tension led to Charles II's resolving to put an end to Dutch
settlement in North America. While Holmes was on the high seas, the King
was putting together an expedition to seize New Netherland and give it to
his brother James, Duke of York and Albany. In January 1664 a committee
set up to consider the likely outcome of an attack concluded that 'if the
King will send three ships and three hundred soldiers under good officers',
the Dutch could be vanquished and their colonies seized. Charles assigned
to his brother James ('his Heirs and Assigns') not only all the lands cur-
rently held by the Dutch in New Netherland, but vast tracts of the new
continent, from Maine to Delaware.

A convoy of ships was equipped, and a contingent of soldiers heavily
armed for the enterprise, under the Duke of York's command. James appoint-
ed his groom of the bedchamber Richard Nicolls his deputy governor, and

Nicolls set off from Portsmouth in May 1664, arriving off Cape Cod ten weeks later, where he informed the English inhabitants of his intentions.

The English settlers along the east coast of North America had managed to co-exist remarkably amicably with their Dutch neighbours for more than thirty years, exchanging essential goods with one another, and cooperating in the defensive and other measures needed to prevent the precariously established colonies from destruction, by either hostilities with the local Indian population, or the depredations of the climate.

When the English ships arrived at the English Massachusetts Bay Colony and Nicolls's forces disembarked, John Winthrop, the English governor of Connecticut (whom we met at the end of the last chapter, observing the moons of Jupiter through his telescope), was taken entirely by surprise. On his recent trip to London, the King had granted him much of the territory which he had now given with a flourish to James. Winthrop's Connecticut colony charter was reneged on with a simple message transmitted by Nicolls, who had been ordered to 'putt Mr Winthropp in mind of the differences which were on foot here'. Nicolls's arrival with three frigates and three hundred combat-ready, heavily armed forces threatened to destabilise the entire region. Deeply disappointed on behalf of the community he had worked so hard for, John Winthrop was forced to cut his losses and step in as negotiator for Nicolls on the English side, to try to persuade Peter Stuyvesant, governor of New Netherland, to surrender rather than provoke a full-scale colonial war.

There was, however, one further, gratuitous piece of double-dealing by the English homeland administration to be coped with by the beleaguered Winthrop. One of the chief instigators of the aggressive move to seize New Netherland turned out to be his own cousin George Downing, who had grown up in New England, and graduated in the first year of the colony's new university, Harvard. Now Resident English ambassador at The Hague, having managed to regain the post he had also held under the Commonwealth, Downing was one of the loudest voices arguing that Dutch commercial expansion could only be curtailed by striking at their trading posts across the world:

[The Dutch] discourse very publicly [...] 'we shall wholly destroy the English in the East Indies, we are masters of Guinea, we shall ruin the

English trade in the caribee islands and western parts, and we doubt not but now by the order sent to Cadiz and the Streights, to be masters of those seas and to take and ruin all the English shipping there'.[11]

Downing, who was deeply unpopular with the Dutch, expressed vociferous concern at what he characterised as their damaging expansionist ambitions. 'From 1661 to 1665 his insistence upon resolute English action against Dutch pretensions was sufficiently aggressive to be accounted a principal cause of the ensuing war.'[12] His intervention in the Dutch colonial venture in North America was well-informed and effective. He knew both New Netherland and the governor of Connecticut at first hand, and he knew how to dupe them into submission.

From The Hague, Downing had taken the trouble to inform the States General that the Dutch colonies had nothing to fear from the English forces: Charles II was merely sending a commander to overhaul the administration of the New England colonies. The Dutch administration was suitably reassured: the directors of the WIC informed Stuyvesant that Nicolls's mission would not affect him.[13] Winthrop, who was on cordial terms with Stuyvesant, also reassured him on the strength of Downing's briefing. So Stuyvesant, who had been at Fort Orange on business when the English troops disembarked, returned to Manhattan to find English gunboats at the entrance to the lower harbour, cutting off the river and Manhattan island. In response to a letter from him asking for reassurance that nothing 'of prejudice' was intended against them, Nicolls replied:

> In his Majesties Name, I doe demand the Towne, Situate upon the Island commonly knowne by the Name of Manhatoes with all the Forts there unto belonging, to be rendered unto his Majesties obedience, and Protection into my hands.

The King, he went on, did not relish 'the effusion of Christian blood', but if the Dutch did not surrender they would bring upon themselves 'the miseryes of a War'. Stuyvesant would have preferred to hold out against the gunships on his doorstep. In the end, though, the leading men of New Amsterdam opted to surrender without a fight, rather than suffer 'misery, sorrow, conflagration, the dishonour of women, murder of children in

their cradles, and in a word, the absolute ruin and destruction of innocent souls'. Apart from a brief period when the United Provinces regained New Netherland in the early 1670s, the Dutch colonisation of America was over.

Charles II received the news with delight. Although he can have had no idea of the long-term global significance of having acquired the 'island at the centre of the world' without a shot being fired, he did appreciate its significance as a trading destination on the expanding English imperial map. 'You will have heard of our taking of New Amsterdam,' he wrote to his sister in Paris. "'Tis a place of great importance to trade, and a very good town.'

And yet, forms of Dutch-based regional government continued on English-administered Manhattan island and in surrounding territories, to which they had been adapted over forty years of confrontation and compromise with the authorities of the Dutch West India Company. So did familiar patterns of everyday life, rituals of birth, marriage and death, and even the names of particular localities: Breuckelen (Brooklyn), Deutel Bay (Turtle Bay), Neuw Haarlem (Harlem), Yonkers, the Bronx.

Many of the Dutch residents of New Netherland did not leave. They adjusted to the new regime as to so much else since they had left their homeland. So did the mingled community of those from other countries, of other ethnicities and with other faiths, who had washed up in the Dutch colony, where the spirit of toleration that had been brought from Amsterdam continued to sustain them. Although the Dutch language did not survive as the language of daily life in America, American English still carries traces of its Netherlandish ancestry – a 'cookie' is a *koekje* (small cake) and your 'boss' is your *baas* (master) – just as its culture still contains within it those foundational ideals and aspirations of tolerance, inclusiveness and fairness which had been the defining characteristics of the Dutch settlements in the New World.

Competition for trade fuelled Anglo–Dutch conflict throughout the seventeenth century, in spite of the obvious shared characteristics of the two countries, as commercial competition escalated into international confrontation. And trade rather than territorial expansion was the driving force behind English and Dutch adventures in North America. It was the lifeblood of the new communities. Finding ways of exploiting local

resources commercially or as part of an exchange economy came as second nature to the residents of the villages and townships springing up along the eastern Atlantic seaboard. When Maria van Cortlandt from New Amsterdam married Jeremias van Rensselaer, the director of the Rensselaerswijck colony on the upper Hudson River in 1661, and moved inland, she sent regular shipments of apples to her brother in New Amsterdam, in exchange for barrel-loads of the 'very large oysters' so plentiful in her home town, but unavailable upriver.[11]

Since it is a while since Sir Constantijn Huygens has made an appearance in this story, his correspondence provides us with a more elite example of long-distance gift-exchange in the Dutch trading company context. While Johan Maurits of Nassau-Segen was governor of the Dutch West India Company at Recife in Brazil between 1637 and 1644 (we saw him laying out his Dutch garden there in Chapter 9), Sir Constantijn took charge of overseeing the building of a great neoclassical mansion for him – today simply known as the Mauritshuis – back home in The Hague, next door to Huygens's own comparably elegant house in Het Plein. The architect-builder of both was van Campen.

In May 1642 Johan Maurits wrote to Huygens, thanking him for having supervised the laying of a slate roof for the Mauritshuis, 'for it would have been an intolerable inconvenience to have a house ill-roofed'. He asked Sir Constantijn to go on keeping an eye on his house's progress, and he ended by assuring him that as a token of his gratitude he was sending him ample quantities of Brazil's most desirable commodities: 'some fine hardwood and some sugar'.[15]

Across the Atlantic Ocean from New Netherland, in the Dutch homeland, Amsterdam was the trading hub for the United Provinces from the beginning of the seventeenth century. Its role as the key port in the Netherlands had expanded at extraordinary speed in the course of the early decades of the century, not least because of Spanish pressure on its competitor Antwerp, whose position on the Scheldt river meant that it was vulnerable to blockading by hostile forces from the south. In the course of the century, Amsterdam achieved dominant status as the gateway through which foodstuffs, raw materials and finished products arrived in the Low Countries from surrounding territories. It was the main outlet for goods processed or manufactured in the Low Countries to be sold elsewhere. By

mid-century, Amsterdam had also become the place to which goods were brought back from all over the world by the East and West India Companies. There they were stored (stapled) to await the moment when a demand for them would emerge somewhere and they could be re-exported.[16]

Amsterdam was a gigantic warehouse for the known world, 'the indispensable buffer in international trade'. The power of the city's position in the international trading network, however, rested on more than simply warehousing and distributing goods. As a leading expert in Dutch economic history has argued, Amsterdam was a centre of information exchange as well as a staple market for goods. In other words, knowledge of potentially marketable products, the demand for them and their present and future potential prices, were concentrated in the highly literate, well-connected, diverse Amsterdam community. The scale and quality of the flow of

information in Amsterdam were supported and encouraged by the city's function as the gateway for goods. But the increasing importance of Amsterdam as a centre of distribution for everything from goods to ideas depended on people and correspondence flowing through the city.

At the Royal Society in London it was believed that established patterns of trading and trafficking in Amsterdam explained the dramatic growth in knowledge there, and the corresponding growth in wealth:

> The Hollanders exceed us in Riches and Trafic: They receive all Projects, and all People, and have few or no Poor: We have kept them out and suppress'd them, for the sake of the Poor, whom we thereby do certainly make the poorer.[17]

Admiration for Dutch financial and commercial institutions was widespread in England after the Restoration. In 1668, Sir William Temple, newly appointed English Resident Ambassador to the United Provinces, wrote:

> In this city of Amsterdam is the famous Bank, which is the greatest Treasure either real or imaginary, that is known any where in the World. The security of the Bank lies not only in the effects that are in it, but in the Credit of the whole Town or State of Amsterdam, whose Stock and Revenue is equal to that of some Kingdoms.[18]

Seventeenth-century clavichord lid, decorated with an allegory of Amsterdam as the centre of world trade.

Temple was probably exaggerating, but his envy of the financial resources Amsterdam could muster, particularly in time of war, was sincere, and was shared by others in England looking to improve the position of the English crown and government in relation to the large amounts of wealth in private hands. The superior administrative arrangements in the Dutch Republic were appreciated even before 1660. In the late 1630s an observer in Holland, William Brereton, reported that:

> The customs and excise here [Amsterdam] are very great, but I could never attain to an exact knowledge thereof, though I applied myself to enquire; but this I heard, that this town affords as great revenues, to maintain the wars to the States, as four provinces – Zeland, Utrech, Overlsell and Friseland.[19]

While a petition to Cromwell during the Commonwealth period expressed admiration for the commercial shrewdness of the Dutch, and complained that:

> It is no wonder that these Dutchmen should thrive before us. Their statesmen are all merchants. They have travelled in foreign countries, they understand the course of trade, and they do everything to further its interests.[20]

The pivotal role that Amsterdam played on the world stage as a hub of exchange for goods and knowledge, down to the 1688 Dutch invasion of England (and some years beyond), is well represented symbolically by the Amsterdam Bourse, or stock exchange. The magnificent Bourse – an open central courtyard, surrounded by colonnaded neoclassical buildings – opened for business in 1611.

Apart from grain, for which there was a separate corn exchange, every other kind of commodity was traded at the Bourse. It was the place to charter ships, to insure their cargoes, to obtain credit, to make payments, to rent warehouse space and to hire labourers for loading and unloading vessels. One went there to learn what was going on politically, at home and abroad. 'The concentration of functions made the Bourse the nerve centre of Amsterdam's commerce. No one who was in any way involved in

The Amsterdam Bourse by de Witte.

wholesale trade could afford not to appear on the Bourse.'[21]

The Bourse was also where information of all kinds, from all around the globe, was exchanged and discussed, and turned into knowledge of prices, markets and trading opportunities. Recently, historians of science have argued convincingly that it was the concentration of precise, highly specific information on an astoundingly wide range of topics, from all over the world, that provided the conditions for the growth of modern science and medicine.[22]

The Bourse opened for only one hour a day – from 11 a.m. till noon – further adding to the sense of an urgently concentrated occasion and location for the transaction of goods and knowledge. At noon, tourists

were allowed in, to admire the building and the activities with which it would still be humming after the merchants and brokers had stopped trading. Outside trading hours too, some of the more exotic objects which had arrived for trading were taken away for scrutiny, to assess their value to learning and their potential for the learned professions.

Economic historians are broadly agreed that after the Restoration, England introduced financial systems and institutions in London modelled on the Dutch, though they differ somewhat in their accounts of how closely emulative the English arrangements were, and how successfully the organisational arrangements were transplanted. Such detail need not, though, concern us here. What matters for the present story is that by the 1680s there was a recognisable similarity between financiers and their organisation in London, and those in Amsterdam. What this produced was a mutual sense of understanding and compatibility which eased and facilitated financial transactions. Dutch bankers could do business with their counterparts in London, and vice versa. By contrast, French business with both nations declined over the same period.

The beginnings of those distinctive and much-emulated Dutch mechanisms governing trade and finance are to be found in arrangements put in place in the founding charter of the Dutch East India Company (VOC). 'The origin of modern stock exchanges that specialise in creating and sustaining secondary markets in the securities issued by corporations goes back to the formation of the Dutch East India Company in the year 1602.' So writes one of the foremost authorities on Anglo–Dutch economic history.[23]

The immediate motive for the formation of the VOC was twofold: to avoid the strain on financial resources caused by competition between commercial trading ventures operating independently, and to consolidate profit in order to finance the military objectives necessary to withstand the expansionist ambitions of France and Spain.[24] The founders of the VOC took advantage of the fact that a willingness to pool resources against weighty outside odds was a deeply ingrained Dutch habit. Taxation on a per capita basis, to raise the money to repair dykes, or to secure vulnerable borders against foreign aggressors, was a standard Dutch practice – one for which

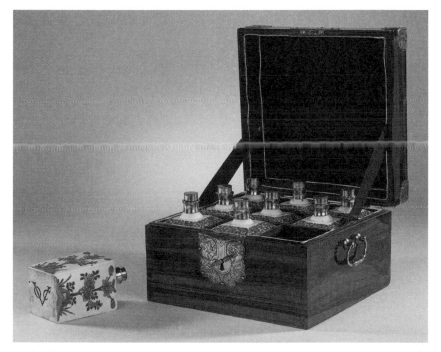

Bottle cabinet containing decorated Japanese porcelain bottles, decorated with tendril and plant motifs, each base marked with the initials of the Dutch East India Company.

successive English administrations expressed envy down to 1688, after which similar taxes were levied in England.

Economic historians today on the whole agree that the activities of the VOC and its English competitor, the East India Company, in the seventeenth century established the conditions for and management of international trade which have endured to the present day. Fundamental to these were the innovative arrangements for distributing risk evenly among investors.

Under the charter of the VOC, the States General empowered the new company to build forts, maintain armies, and conclude treaties with the rulers of the Asian territories with which it traded. To this end, the charter of the Company provided for a venture which would continue for twenty-one years, with a financial accounting only at the end of each decade (instead of following each completed voyage). All investors would be responsible for the Company's debts, in proportion to their investment. This

made the VOC what we now call a limited liability company.

It was further decided that the capital invested at the beginning of the venture would be fixed, and that investors who wished to liquidate their interest in the VOC could sell their share to a buyer at the Bourse, as if it were a physical commodity. In the early years, a large number of small founding shareholders exercised this option.[25]

While the WIC had sole charge of the New Netherland colony, and administered it on behalf of the States General, until forced to relinquish some control to local residents, the VOC was enormously successful in trade in Indonesia, the Moluccas and around the coast of India, where it maintained virtual commercial monopolies against the English and Portuguese who also traded in the region. At the end of its first ten-year trading period, during which the original trading capital had been enlarged by more than 40 per cent, dividends were paid to shareholders in the form of a distribution of pepper and mace. By the Company's calculation, the value of the distributed spices amounted to a 125 per cent dividend – though many shareholders doubted whether they could actually realise that return in cash. Later returns settled down, and after 1650 they ran at about 4 per cent per annum.

After the mid-seventeenth century the VOC's importance to the Dutch economy resided chiefly in its enormous size. It paid dividends and interest averaging nearly two million guilders a year throughout the period 1660–1780. It employed thousands of men, injecting between three and five million guilders of wages into the otherwise flat Dutch economy, while between one and two million guilders more went into the economy in the form of orders for supplies.

Competition between the VOC and the English East India Company was intense, and was responsible to a large extent for Anglo–Dutch friction throughout the seventeenth century. Given the financial power of both Companies in their home nations, it is not surprising that each exerted pressure on its respective government at key moments – notably in 1650 and 1688 – when it appeared possible that a close alliance between the English and Dutch states might amalgamate the two trading companies as part of one joint endeavour. And competition between the two Companies ensured that the financial mechanisms developed by the Dutch quickly found their way into the English methods of dealing with import–export,

customs and excise, taxation, record-keeping and accounting by emula-
tion. By the time the two nations effectively came under one sovereign rule
in 1688, it was a comparatively easy matter to integrate – or at least, harmo-
niously operate side by side – their administrative and business systems.

While the Dutch West India Company and the English King were at
loggerheads over New Netherland and the island of Manhattan, and while
the English East India Company was casting an increasingly envious eye on
the trading activities of its Dutch VOC rival along the west coast of Africa,
farther to the east the Dutch East India Company was developing a robust
international trade in an area close to its gardening-nation heart: horti-
cultural exotica and pharmaceuticals. Once again, its interest in the region
came into collision on a regular basis with the English, who were also intent
on securing exclusive rights to new, lucrative types of merchandise and
accompanying forms of new knowledge in medicine and horticulture.

We saw in the context of gardens and gardening how global trade
literally transformed the English and Dutch landscapes, introducing
species of trees, shrubs and flowers previously entirely unknown in Europe.
The biggest transformation, however, was in the realm of new knowledges
– particularly medical knowledge. Here, as so often before, Sir Constantijn
Huygens may serve as our witness.

In 1674 the elderly Sir Constantijn paid a visit to the English Resident
Ambassador, Sir William Temple, at his home in The Hague. Temple was
housebound with a bad attack of gout, an affliction that had troubled him
for a number of years. He later published an account of the visit:

> Talking of my illness, and approving of my obstinacy against all the
> common prescriptions; [Sir Constantijn] asked me whether I had never
> heard the Indian way of Curing the Gout by Moxa? I told him no, and
> asked him what it was?
>
> He said it was a certain kind of Moss that grew in the East-Indies; that
> their way was, when ever any body fell into a Fit of the Gout, to take a
> small quantity of it, and form it into a figure, broad at bottom as a
> twopence, and pointed at top; To set the bottom exactly upon the place
> where the violence of the pain was fixed, then with a small round

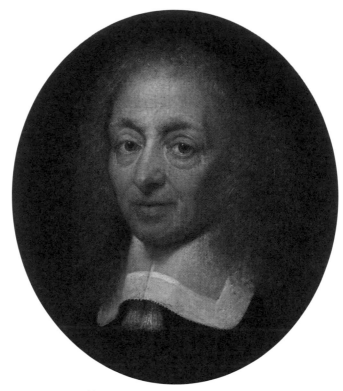

Sir Constantijn Huygens in old age.

perfumed Match (made likewise in the Indies) to give fire to the top of the Moss; which burning down by degrees, came at length to the skin, and burnt it till the Moss was consumed to ashes.

That many times the first burning would remove the pain; if not, it was to be renewed a second, third and fourth time, till it went away, and till the person found he could set his foot boldly to the ground and walk.[26]

Temple asked Huygens how he had heard about this remedy, and he told him that he had read about it in a book recently published by a Dutch physician who had spent a lot of time in the East Indies and Japan. 'Though he could not say whether experiment had been made of it here, yet the Book was worth reading; and for his part, He thought He should try it if ever he should fall into that Disease.'

The next day Huygens brought a copy of the book, which Temple, a fluent Dutch-speaker, read at one sitting. He was sufficiently impressed by its argument to agree to try the remedy himself. He placed the pellet of prepared moxa 'just upon the place where the first violence of my pain began, which was the joint of the great toe', and lit it, as instructed. The treatment was a considerable success:

> Upon the first burning I found the skin shrink all round the place; and whether the greater pain of the fire had taken away the sense of a smaller or no, I could not tell; but I thought it less than it was: I burnt it the second time, and upon it observed the skin about it to shrink, and the swelling to flat yet more than at first. I began to move my toe, which I had not done before; but I found some remainders of pain.
>
> I burnt it the third time, and observed still the same effects without, but a much greater within; for I stirred the joynt several times at ease; and growing bolder, I set my foot to the ground without any pain at all.[27]

The book Huygens had given Temple was by Hermann Busschoff, a Dutch minister of the Reformed Church who had served in Taiwan, where he had been persuaded by his wife to try moxa for his own painful gout, with considerable success. He published his short treatise on the subject in Utrecht in 1674, so it was hot off the press when Huygens passed this brand new medical knowledge from the Far East to his English friend.

Some time later, Huygens wrote to the secretary of the Royal Society in London, sending him a copy of Busschoff's book, which the Society had translated into English. The Dutch miscroscopist Anton van Leeuwenhoek, who had also read it, proceeded to examine the moxa pellet under his microscope, and sent his observations to the Royal Society in 1677. So by this time the use of moxa to treat gout had passed by print and word of mouth from the VOC's factories in the Far East to the Dutch Republic, and thence to Dutch and English individuals, who passed the information and Busschoff's book to London. There the Royal Society took it up, and pursued it 'scientifically'.[28]

In July 1681, Willem ten Rhijne, a physician and botanist who had served with the VOC in Java and Japan and had known Busschoff personally, wrote to the secretary of the Royal Society in London to say that

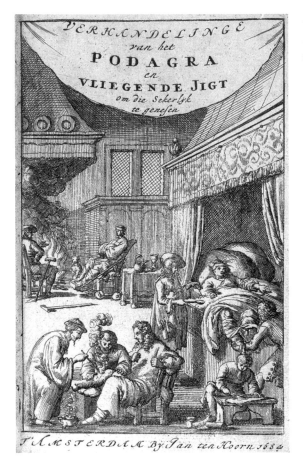

Frontispiece of Willem ten Rhijne's Dutch edition of his treatise on gout (1684).

he had various observations, collected during his time in the Far East, which he would be happy to communicate to the Society, and that he had a treatise of his own on the use of moxa and acupuncture, as well as on methods of diagnosis by taking the pulse, as practised by the Chinese, which he would like to send to be printed in England.

The letter was brought to a meeting of the Royal Society on 18 January 1682, and its contents were discussed at considerable length. A medical member thought that the virtue of the moxa lay in the burning and cauterising effect alone, but the acting secretary, Robert Hooke, believed that the plant must have some 'peculiar virtue' in its substance, perhaps in its 'solid oil'. Ten Rhijne's remarks about Chinese use of the pulse in diagnosis led the President, Sir Christopher Wren, to note that the Chinese

'were extremely curious about feeling the pulse of the patient', not only via the wrist, 'but in divers other parts of the body, by which they pretended to make great discoveries about disease'. Hooke then suggested that in feeling the pulse one might discern the different states of the parts of the body.[29]

Such was the interest aroused by ten Rhijne's communication that the Fellows requested that it be followed up immediately. A letter of reply was written, in which ten Rhijne was asked to supply any further observations he had about the medicine or natural history of Asia, and was given a list of subjects the Society was particularly interested in. At the end of March the manuscript of ten Rhijne's treatise arrived. It was published in Latin, with some additional materials in the original Dutch, in 1683. The book contained not only ten Rhijne's work on acupuncture, but also a general discussion of gout, and its treatment using moxibustion, including four Japanese diagrams showing the points to which the moxa and the acupuncture needles ought to be applied.[30]

There could, surely, be no more eloquent an example of the enthusiastic exchanges, amounting to a fusion of knowledge and practice, between Dutch and English medical men and scientists. The fact that the understanding acquired from Asia of the application of moxa, and acupuncture therapeutically, soon receded within the European medical repertoire, not to re-emerge until the twentieth century, only adds piquancy to its enthusiastic seventeenth-century reception.

A number of those to whom I have spoken as I have been writing this book have been quick to raise the one area of Anglo–Dutch development of which they are already aware – the adoption of Dutch forms of banking after 1688, leading to the foundation of the Bank of England in 1694. So I close this chapter with a story, to suggest that like so much else I have talked about, Dutch influence on English banking methods predates by some years the landing of William III's invading army at Torbay. Intriguingly, the person who greatly admired Dutch banking, and was responsible for the adoption of its methods in London, is better known for his alleged intense antipathy for all things Dutch.[31]

We met George Downing earlier in this chapter, as the man who used his upbringing in and understanding of the English and Dutch colonial

settlements in the New World to mislead Peter Stuyvesant into not appreciating the gravity of the threat to New Netherland in 1664, thereby contributing to the end of the Dutch colonial venture in North America. As his contemporaries were quick to point out, Downing's life fails to fit conventional accounts of the career of a prominent seventeenth-century politician. One called him 'a sider [turncoat] with all times and changes, well skill'd in the common cant', another 'a crafty fawning man … ready to turn to every side that is uppermost, and to betray those who … thought they might depend on him'. In other words, he crossed boundaries, in the way this book has been highlighting, and therefore escapes classification as belonging to any single faction, allegiance, or even nation.

As a recent scholarly assessment of Downing's career perceptively suggests, 'he did not live a national life', but rather straddled England and Holland, Europe and America. He was born in Dublin, and educated in Massachusetts. His professional career began in Scotland, where he was Scoutmaster General of the English army – all-purpose intelligence and information gatherer. He was English Resident Ambassador at The Hague under Cromwell's Commonwealth from 1657 to its demise, and again from the Restoration on and off until the declaration of the third Anglo–Dutch war in 1672, as representative of Charles II. By the 1660s he was a baronet, and by his death in 1683 he was the wealthiest landowner in Cambridgeshire.[32]

Downing was clearly not a nice man. Samuel Pepys, who worked for him in the Exchequer office, has left us a colourful picture of an ambitious, avaricious man, who summoned Pepys on the day he was made a baronet to make sure that henceforth he was always addressed by his title. As a former supporter of the Commonwealth, he has gone down in history as the ultimate turncoat, for his kidnapping of two of the regicides in The Hague in 1661 and shipping them back to London, where they were hanged, drawn and quartered for treason. During his two periods of residency as ambassador to The Hague he took his duties as collector of intelligence extremely seriously, employing a network of local spies. He later boasted to Pepys that he had 'had so good spies, that he hath had the keys taken out of De Witts [the republican head of the Dutch government] pocket when he was a-bed, and his closet opened and papers brought to

him and left in his hands for an hour, and carried back and laid in the place again and the keys put in his pocket again'.[33]

His intensive surveillance of Dutch affairs, coupled with his early upbringing cheek by jowl with the Dutch settlers in North America, gave Downing an unparalleled insight into the operations of the Dutch republican state – a state he regarded as significantly more efficient and financially buoyant than its English monarchical counterpart. What is of particular interest to us here is the way Downing's close contact with the Dutch Republic, coupled with his experience as an administrator during the Commonwealth period, led him to advocate explicitly Dutch-derived fiscal measures for the consistently financially embarrassed government of Charles I, in particular a system of taxation which would support an adequate military force to protect the state. 'Two things coloured and shaped Downing's approach. The first was his experience of this in the Dutch context. The second was his understanding that this was driven by a Dutch commitment to finance its military endeavours as a matter of priority.'[34]

From The Hague, Downing explained to his English correspondents time and again that a precondition for the success of the Dutch VOC and WIC was the States General's willingness and ability to protect it with military convoys, paid for by the state. The profit and prosperity this produced led in turn to the Dutch being prepared to put up with heavy taxes. 'It is strange to see,' Downing reported, 'with what readiness this people doe consent to extraordinary taxes, although their ordinary taxes be yet great.' He noted with approval that Dutch finance relied upon excise duties (exacted pro rata on all goods imported through Dutch ports), while keeping customs duties (charged to individuals carrying goods into the Republic and based on discretionary valuation) low. And he encouraged the English administration to adopt a similar strategy.

Downing's most important contribution to English fiscal policy, however, was the importation of the underlying principles of state banking that led ultimately to the formation of the Bank of England. The details of this are beyond the scope of this book, but recent academic studies agree that his influence laid important groundwork for reforms introduced after 1688. 'Downing's scheme used parliamentary legislation to underwrite loan repayments with the authority of the state (rather than simply of the monarch personally)'. The Earl of Clarendon, historian of this period, and

passionate opponent of Downing's fiscal policies, has left us a clear account of the innovative nature of his new measures:

> Downing [...] told them [that] by making the Payment with Interest so certain and fixed, that [...] it should be out of any Man's Power to cause any Money that should be lent To-morrow to be paid before that which was lent Yesterday [...] he would make [the] Exchequer (which was not Bankrupt and without any Credit) the greatest Bank in Europe.[35]

'All Nations would sooner send their Money into [it],' Clarendon continued, 'than into Amsterdam or Genoa or Venice.' Such an English bank, in other words, would be as powerful and profitable as those of the three most prosperous European republics. The tone of Clarendon's remarks makes it clear how opposed to such strategies the old Royalists were after the Restoration. But it was Clarendon who fell from office, and Downing who continued to rise, carrying with him his enthusiasm for fiscal reform on a Dutch model.

Throughout his career – whatever the form of government in England, and whichever political party was in power – Downing worked tirelessly to reform English financial institutions so as to bring them in line with those he regarded as so supremely successful in the United Provinces. He did so in spite of the fact that England was a monarchy, while the United Provinces was a long-established republic. In so doing, he put in place the machinery for the 'constitutional monarchy' which would follow the arrival of William III in England in 1688.

There is, surely, no small irony in the fact that the foundations for modern English banking, to whose rise has been attributed the eventual eclipse of the Dutch in what had once been their area of greatest power and influence in the world, were laid by a man who has gone down in history for his hatred of the Dutch. I use this story to close, as a reminder of the many curious and varied ways of 'going Dutch' there were in the course of the seventeenth century – adoptions and assimilations of Dutch ideas and mores, which shaped the fortunes and futures of both the English and Dutch nations.

Conclusion

I began my story with an invasion, a violent interruption of the historical narrative of a nation, theatrical, unexpected and disruptive. Yet it was an invasion whose political and cultural consequences were accommodated and smoothed over with extraordinary rapidity, melding the life-worlds of invader and invaded into an unbeatable blend of tough political realism and commercial acumen – with a dose of tolerance thrown in – which within little more than a generation would turn the conquered nation into a great power.

Because by 1688 England and Holland were already so closely inter-twined, culturally, intellectually, dynastically and politically, that the invasion was more like a merger. It had after all been attempted by treaty before, in the 1650s, when the United Provinces took the initiative, and tried to persuade Cromwell that the shared interests of the two nations made a political union obvious. Although that attempt failed – England had all too recently freed itself from the dominion of the Stuarts to be prepared to give up its independence – the idea was revived more than once over the follow-ing decades. The two East India Companies (Dutch and English) made several attempts prior to 1688 to bring about a political union which might rationalise their seaborne activities and commercial operations, making them one company under one flag. It was one of the many ironies of the 'Glorious Revolution' that William III chose to keep his lucrative English and Dutch maritime enterprises separate and in competition.

So deep ran the connections between England and Holland in the run-up to the invasion that the subsequent merger of dynasties and cultures was almost seamless. Constantijn Huygens junior's delight, as he recorded Prince William's enthusiastic welcome from the 'ordinary folk' of England, was the delight of recognition:

> Alongside the roads the people had gathered, as on the previous day, women, men, and children alike, all shouting: 'God bless you' and wav-ing to us a hundred good wishes. They gave the Prince and his entourage

apples, and an old lady was waiting with a bottle of mead and wanted to pour his Highness a glass.

That, at least, is what I have argued here. I am also of the opinion that in excavating the subterranean ties that bound the English and the Dutch in the seventeenth century, I have barely scratched the surface of my subject. Once we discard history's customary petty nationalism, and survey fields like art, music, science and medicine more broadly, we find ourselves returning again and again to close collaborations between individuals and groups separated (but only sometimes) by the Narrow Sea.

So I bring this story to a close with a couple of decidedly odd examples of Anglo–Dutch collaboration (as usual, involving that assiduous facilitator Sir Constantijn Huygens, father of the diarist who witnessed the 1688 invasion from start to finish from the Dutch side). They may stand here for all the other unexpected connections I am confident readers will begin to find all around, once they begin to look.

Between early November 1670 and mid-September 1671, Sir Constantijn Huygens, at the age of seventy-two, was in London with his twenty-year-old charge, Prince William of Orange, attempting to retrieve monies owed to William by his uncle Charles II.[1] It was William's first visit to his mother Mary Stuart's country of birth. Strictly speaking he travelled as a commoner. He had not yet regained the position of Stadholder of the Low Countries, of which he had been stripped as an infant, following his father's death in 1650, but now that he had declared himself 'of age', complex political manoeuvring by the Orange faction seemed likely to achieve that end.[2]

As far as Charles II was concerned, his young Dutch relative was a potential bit-part player in his complicated power-brokering negotiations with France and the Dutch Republic: 'According to the Sommier Verhael ["Summary Relation"] of William's journey, Charles II had repeatedly kissed his nephew when he arrived in England in early November 1670.'[3] The King was particularly insistent that William be treated with all ceremony.

When the Prince of Orange was to dine with the lord mayor [of London] in [January] 1671, there was much consideration of the seating arrange-

ments; the King was consulted and he gave his ruling on the matter – that the Prince should rank before the mayor. A fifteenth-century precedent was then unearthed which, showing Henry V's brothers had ceded place to the lord mayor, apparently contradicted Charles's decision on the matter, but 'notwithstanding the King kept his first opinion; alledging that forms of Ceremonies were changed in the world since that time; & that those Dukes were the Kings own brothers; yet they were his subjects; which the Prince of Orange was not'.[4]

When the City of London refused to give way on the matter, the King simply declined to attend and the dinner was cancelled.

Still an 'ordinary' visitor, though a nephew of the King, William was fortunate to have with him the elder statesman who had served both his father and his grandfather as secretary, and who was as thoroughly conversant with English court ways as Huygens.

The debts owing to the House of Orange which Huygens undertook to recover included the dowry Charles I had contracted to pay William's grandfather when William's father and mother were married (hastily, on the eve of the first English Civil War, in 1642), and substantial sums later advanced to Queen Henrietta Maria for ships and weapons to assist the Royalist cause: 'The English King owed [William] 2,797,859 guilders, a debt which included the unpaid dowry of his mother, worth 900,000 guilders ... From the financial viewpoint William's journey had little result. The King and his nephew agreed to reduce the debt to 1,800,000 guilders, but the English King again proved to be a bad payer.'[5]

Among the Huygens letters in the Royal Collection at The Hague is a copy of the final letter from Charles II to William, who had returned to the Low Countries ahead of his old retainer, written during that residency. It displays real affection for the elderly diplomat, whom the English King has known from boyhood, which is presumably why Huygens carefully kept a copy among his papers:

> I am not a little ashamed that I have delayd Monsieur de Zulichem from time to time with promise of a speedy dispatch, and according to what I haue written to you in my former letters. The funds giuen me by the Parliament haue fallen infinitely short of their first computations which

hath disturbed and made almost ineffectuall all my orders; so that it were
to abuse you to giue you any of them.

In spite of Huygens's best efforts, Charles is evasive about the repayment. But he lets Prince William know that Huygens has been tireless in pursuit of the debt:

> I cannot finish this letter, which I meane to communicate to the bearer before I seal it up, before I lett you know how troublesome a sollicitor he hath been to me, though a most zealous one for you and consequently how worthy he is of the continuance of your esteem and good will.

Charles writes to William in English, which Huygens spoke and wrote with almost native fluency. In his archive, Huygens heads it in French, the language of the Dutch élite. The exchange is clear evidence of Stuart–Orange understanding at a 'family' or domestic level, and of Huygens's pivotal role in crafting that relationship, vital to William's national and international political future.

The money, as I said, was never forthcoming (Charles II rarely settled his debts, and the 1670s were a particularly parlous time for his exchequer), but the sentiments expressed by the Stuart King towards Huygens may be taken to be sincere. Since the long-term result of this visit was the marriage alliance between James, Duke of York's daughter Mary (Charles's niece) and William, the anglophile Huygens's negotiations and bridge-building between the House of Orange and the Stuarts may be judged to have been a success overall. Indeed, I want to argue that Huygens's activities on either side of the Narrow Sea represent a version of Anglo–Dutch intellectual, cultural and political accord in the seventeenth century which, whilst unfamiliar, actually sums up the age.

Recently, I came across another piece of epistolary evidence for the way the unexpected closeness of Anglo–Dutch accord – the almost cosy personal relations between William's circle and the Stuart court – had (or in this case, almost had) remarkable historical consequences, leeching away the national protocols separating English affairs from Dutch.

While in London, in December 1670, and presumably following an unrecorded face-to-face encounter, Huygens wrote (in English) to Sir

Christopher Wren, the Royal Surveyor, responsible for the rebuilding of London after the Great Fire, as follows:

> The King hath been pleased to keepe a copie of this poor project, and would doe me this morning the honour to commend it with the character of 'a very good paper'. If it doe but chance to pass for half so good in your liking, Sir, I will hold my paines happily bestowed. I pray you to peruse it, that we may have occasion to conferre about [it], while I am here.[6]

No further mention of this 'project' is to be found in the Huygens archives around this date, but in February 1678 there is a further, clarifying reference, this time in a letter in French to Monsieur Oudart:

> It matters little whether my inscriptions have been used for the Column or not. I remain extremely well satisfied that so distinguished a person as Monsieur the Surveyor [Wren] found them to be to his taste, to the point that he produced them to the City officials, and thereby demonstrated to them my good will towards their great and most noble City. I beg you to assure that most excellent personage of my boundless esteem for his great talent and my most ardent affection in his service.[7]

So, remarkably, the 'poor project' which both Wren and Charles II, according to Huygens, found so much to their taste was a set of proposed inscriptions for the plinth of the Monument to the Great Fire.

Sure enough, if we trawl through Constantijn Huygens's literary works for this period (he was a prolific writer of poetry in four or five languages), there we find two draft Latin inscriptions composed by Huygens in 1670 for this purpose. The second of these concludes: '*Lignea consumpta es, surgis de marmore: tanti,/O bona, Phoenicem te perijsse fuit./Urbis an exustae clades. dubitabitur olim,/An restauratae gloria maior erat*' (In wooden form you have been consumed [by fire], you are resurrected in marble... etc.).[8]

The Prince of Orange's arrival in London in late 1670 followed awkwardly on the heels of Charles II's signing of the secret Treaty of Dover with Louis XIV against the Dutch, in June of that year. Strictly speaking, England and Holland were on the brink of war (the third Anglo–Dutch

war was eventually declared following France's invasion of Holland two years later). Yet here is William's most senior adviser, closely involved in discussions with the English King and his Royal Surveyor concerning Dutch involvement in the memorial to England's most recent national calamity.

Neither Huygens's commemorative inscription, nor remarkably similar ones which Wren himself proposed, were in the end used.[9] On 4 October 1677 the Court of Aldermen of the City of London minuted their final decision as to the inscriptions:

> This Court doth desire Dr Gale Master of the Schoole of St Paul to consider and devise a fitting inscription to be set on the new Pillar at Fishstreet Hill, and to consult therein with Sr Christopher Wren Knt his Matie's Surveyor Generall and Mr Hooke And then to present the same unto this court.[10]

'Within three weeks of the first meeting of the inscription committee, the Court of Aldermen, having heard from the lord mayor that Charles II had "very well approved" the inscriptions' drafts, decreed that the inscriptions be carved "forthwith". On October 25, the Court rewarded Gale with "a handsome peice [sic] of plate".'[11]

In addition to his reputation as a cultivated diplomat, a man of good taste and a considerable musician, Huygens was renowned, particularly in his native Holland, as an accomplished poet in Latin, Dutch, French, English and Italian. The lines he had suggested and crafted for the as yet unbuilt Monument, the construction of which was indeed being widely discussed during the period of his 1670 stay in London,[12] were not the first he had been encouraged to propose for an internationally famous memorial. Indeed, in all likelihood it was his poetic involvement in an earlier memorial project which had led to the subject of the Monument inscription becoming a topic of conversation at the English court.

In 1620, the twenty-two-year-old Huygens, with the support of his older poetic colleague Daniel Heinsius, had been given the task of composing the epitaph for the magnificent tomb of William the Silent (assassinated in 1584), erected by the States General in the New Church at Delft, designed by Hendrick de Keyser. The imposing monument was

commissioned and built during the period 1618–23, as the inscription stresses, to commemorate the 'Father of the Fatherland', who had defended the Low Countries against the threat to freedom and Protestant religious practice. It became the key national monument to the House of Orange, a tourist destination for Netherlanders from all over the country, and was regularly depicted in fashionable 'church interior' paintings of the Neue Kirk in Delft by a whole range of fashionable artists.

We might reflect on the fact that both William's tomb and the Monument to the Great Fire were conceived of by those who erected them as standing to posterity in remembrance of such a threat to freedom, and as focal points for Protestant national fervour. Be this as it may, this book has, I hope, begun to explain how a Dutchman in his seventies, in the service of the Prince of Orange, almost came to have his most fervently patriotic (English) thoughts inscribed for posterity on the emotionally-charged memorial to a terrible calamity inflicted on the City of London, almost certainly (so it was thought at the time) at the hands of Catholic foreigners.

I choose this episode as the foil for my concluding remarks because it would have seemed entirely unlikely to me, at the beginning of the intellectual journey which gave rise to the present book, that a man as passionate in the service of the Dutch house of Orange as Sir Constantijn Huygens, and so patriotic an Englishman as Sir Christopher Wren, should in the 1670s have unselfconsciously collaborated in a project like the London Monument to the Great Fire of 1666. Or that Huygens should have been so sensitive to English mores, and so attuned to English attitudes and beliefs, that he could confidently propose his own cultural creation, seamlessly to be incorporated into the lasting fabric of England's memorial history.

And this is not the end of the story of the interwoven interests and activities of Sir Constantijn Huygens and Sir Christopher Wren, and their impact on the cultural life of London in the 1670s. A second instance, dating from 1674–75, which once again came to my attention as I was conducting my research on Anglo–Dutch cultural and intellectual collaboration and exchange, is equally unexpected.

In March 1674, Huygens wrote a letter to Wren from The Hague, which was carried to him by the eminent Sephardic rabbi and scholar from

Amsterdam, Jacob Judah Leon (known, because of his expertise in ancient places of worship, as 'Templo'):

> This bearer is a Jew by birth and profession, and I [am] bound to him for some instructions I had from him, long ago, in the Hebrew literature. This maketh me grant him the addresses he desireth of me; his intention being to shew in England a curious model of the Temple of Salomon, he hath been about to continue these manij ijears. Where bij he doth presume to haue demonstrated and corrected an infinite number of errors and paralogismes of our most learned scholars who haue meddled with the exposition of that holij fabrick, and most specfiallij of the Jesuit Villalpandus.

Leon's exhibition of models of the Biblical buildings was famous — Edward Browne, who we encountered sightseeing in the Netherlands in 1668, made sure to visit his 'model of the Temple of Solomon, of Solomon's house, the Fort of the Temple, the Tabernacle and many other curiosities' while he was in Amsterdam.[13] Now Huygens's letter introduced Leon to Wren, in the hope that he might bring the exhibition to London:

> Before all, I have thought I was to bring him acquainted with yourself. who are able to judge of the matter upon better and surer grounds than any man liuing. I give him also Letters to the Portingal Ambassador to Mylord Arlington and Mr Oldenburg, that some notice may be taken of him both at the Court, and amongst those of the Royal Society. If you will be so good as to direct him unto Mylord Archbishop of Canterbury.[14]

Huygens's letter of introduction was written in response to a direct approach made to him at the court of William of Orange by Leon himself the previous year.[15] And his intervention was successful. Through his and Wren's efforts, the contents of Leon's museum of architectural models, including his much-admired wooden model of the original Temple of Solomon in Jerusalem, based on descriptions in the sacred texts, together with his extensive 'museum' of models of other historic buildings, were shipped to London. Leon died while on a return trip to the Netherlands in 1675, but his exhibition remained for many years in England.[16]

The arrival of Leon's models produced a flurry of interest in reconstructed ancient Biblical architecture. Robert Hooke recorded in his diary, early in September 1675: 'With Sir Chr. Wren. Long Discourse with him about the module of the Temple at Jerusalem.'[17] A good deal has been written by Dutch historians of architecture about the influence of the reconstructions of the Biblical buildings on Dutch church architecture in the second half of the seventeenth century. It is perhaps time for a similar kind of exploration of the effect of the collection of models brought to London by Leon on Wren and his contemporaries' ecclesiastical architecture.

On a number of occasions while I have been writing this book, distinguished Dutch academics have expressed the hope to me that I would provide a picture of how, in the seventeenth century, Dutch fortunes declined as English fortunes grew, which was more sensitive to the Dutch side of the story.

The Dutch have always felt aggrieved at the way in which wealth, power and influence seeped away from the United Provinces at the beginning of the eighteenth century, as those of Britain increased. They have seen their diminishing role on the international scene as directly related to England's rise. I hope that I have shown here that they are broadly right in thinking so. William III and his wife Mary Stuart carried with them into England not just the hopes and aspirations of a generation, but much of their tax revenue and wealth. Hence the word 'plundered' in my subtitle, though the process was, as I hope I have shown, considerably more subtle and extended than that word perhaps implies.

I hope I have indeed managed to paint a more colourful and varied picture of Anglo–Dutch relations and their outcome at the end of the seventeenth century, and thereby done something towards setting the record straight. It was the case then, and remains the case today, I believe, that the English and the Dutch share a remarkable amount in terms of outlook, fundamental beliefs, aspirations and sense of identity.

In the twentieth and twenty-first centuries, it is fascinating to watch British and Dutch commerce continuing to share fundamental attitudes and outlooks, which have facilitated large-corporation mergers to produce

major Anglo–Dutch interests – the formation of Corus Steel in 1999 by the merger of British Steel and Koninklijke Hoogovens, for instance, and most recently the ongoing negotiations towards a proposed merger between a British bank and the Dutch bank ABN Amro, to create one of the world's biggest financial institutions.

I have come to feel a deep sense of shared values and common purpose with the people of the Netherlands in the course of carrying out my research. In the end this book is intended to be a celebration of our equal sharing in events in history at the beginning of our modern mercantile and consumerist age – our 'going Dutch'.

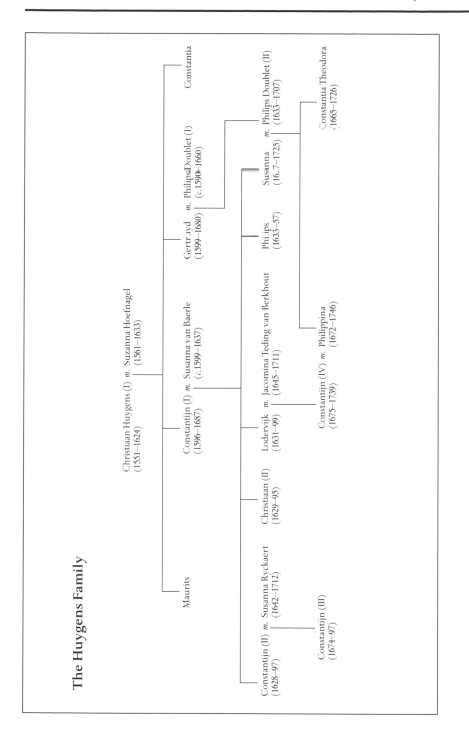

The Huygens Family

Christiaan Huygens (I) *m.* Suzanna Hoefnagel
(1551–1624) (1561–1633)

Maurits

Constantia

Constantijn (I) *m.* Susanna van Baerle
(1596–1687) (c.1599–1637)

Gertruyd *m.* Philips Doublet (I)
(1599–1680) (c.1590–1660)

Constantijn (II) *m.* Susanna Ryckaert
(1628–97) (1642–1712)

Christiaan (II)
(1629–95)

Lodewijk *m.* Jacomina Teding van Berkhout
(1631–99) (1645–1711)

Philips
(1633–57)

Susanna *m.* Philips Doublet (II)
(16.7–1725) (1633–1707)

Constantijn (III)
(1674–97)

Constantijn (IV) *m.* Philippina
(1675–1739) (1672–1746)

Constantia Theodora
(1665–1726)

The House of Stuart

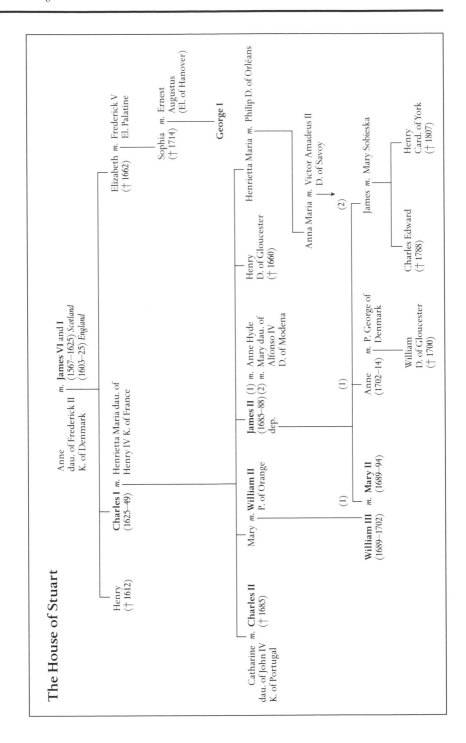

The House of Orange

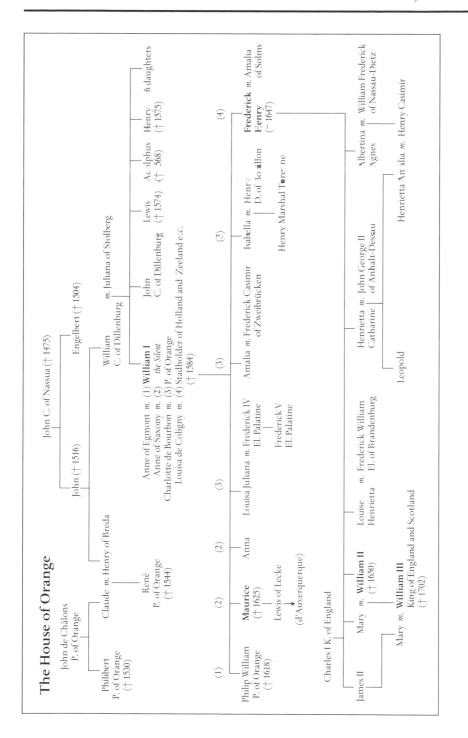

Notes

1: England Invaded by the Dutch

1 Robert H. Murray (ed.), *The journal of John Stevens containing a brief account of the war in Ireland 1689–1691* (Oxford: Oxford University Press, 1912).

2 E.S. de Beer (ed.), *The Diary of John Evelyn*, 6 vols (Oxford: Clarendon Press, 1955; reprinted 2000), 4, p.582. On Evelyn see G. Darley, *John Evelyn: Living for Ingenuity* (London: Yale University Press, 2006).

3 Hoak, 'The Anglo–Dutch Revolution of 1688–89', p.17.

4 Gilbert Burnet, cit. Israel and Parker, 'Of Providence', p.351.

5 Israel and Parker, 'Of Providence', p.336.

6 J.I. Israel, 'The Dutch role in the Glorious Revolution', in J.I. Israel (ed.), *The Anglo–Dutch Moment: Essays on the Glorious Revolution and its World Impact* (Cambridge: Cambridge University Press, 1991), pp.105–62; 106.

7 S. Groenveld, '"J'equippe une flotte très considerable": The Dutch side of the Glorious Revolution', in R. Beddard (ed.), *The Revolutions of 1688* (Oxford: Clarendon Press, 1991), pp.213–45; 240.

8 *Diary of John Evelyn* 4, p.597.

9 Groenveld, '"J'equippe une flotte"', p.241.

10 See D.M. Swetschinski and L. Schönduve, *De familie Lopes Suasso: Financiers van Willem III* (Zwolle: Waanders, 1988).

11 *Journaal van Constantijn Huygens, den Zoon, van 21 October 1688 tot 2 Sept. 1696 etc.*, *Historisch genootschap te Utrecht Werken uitgegeven door het historisch genootschap, gevestigd te Utrecht*; nieuwe reeks, 23, 25, 46, 32. Derde serie 22, 35 (Utrecht: Kemink & Zoon, 1876-1915); I, p.13.

12 J.I. Israel and G. Parker, 'Of Providence and Protestant winds', in J.I. Israel (ed.), *The Anglo–Dutch Moment*, pp.335–63; 361.

13 For a full discussion of the various computations of troop and ship numbers see Israel and Parker, 'Of Providence', pp.337–8.

14 Israel and Parker, 'Of Providence', pp.353–4.

15 Saturday, 13 November 1688 (n.s.), *Journaal van Constantijn Huygens, den Zoon* I, 13.

16 Ibid.

17 Ibid.

18 D.M.L. Onnekink, *The Anglo–Dutch Favourite. The Career of Hans Willem Bentinck, 1st Earl of Portland (1649–1709)* (PhD dissertation, University of Utrecht), p.37. M.E. Grew, *William Bentinck and William III (Prince of Orange): The Life of Bentinck Earl of Portland from the Welbeck Correspondence* (London: John Murray, 1924), p.134.

19 *Diary of John Evelyn* 4, pp.603–5.

20 'A true and exact relation of the prince of Orange his public entrance into Exeter' (1688), cit. Claydon, *William III*, p.55.

21 Grew, *Bentinck*, pp.137–8.

22 *Calendar of Treasury Books* 8, pp.2126, 2129.

23 R. Beddard, 'The unexpected Whig revolution of 1688', in Beddard (ed.), *The Revolutions of 1688* (Oxford: Clarendon Press, 1991), pp.11–101; 14; see also Beddard, *A Kingdom without a King*, pp.33–4.

24 Beddard, *A Kingdom without a King*, p.35.

25 S.B. Baxter, *William III* (London: Longmans, 1966), p.246. *Journaal van Constantijn Huygens, den Zoon* I, 50.

26 Beddard, *Kingdom without a King*, p.180.

27 Roger Morrice, cit. ibid.

28 Israel, 'The Dutch role', p.126.

29 *Diary of John Evelyn* 4, p.612.

30 Israel, 'The Dutch role', pp.125–6.

31 Israel, 'General Introduction', in Israel (ed.), *The Anglo–Dutch Moment*, pp.1–43; 2.

32 See Claydon, *William III*, p.57, for the view that this change of route was a misunderstanding or mistake.

33 See below, Chapter 5.

34 See L. Pattacini, 'André Mollet, Royal Gardener at St James's Park, London', *Garden History* 26 (1998), 3–18.

35 Cit. ibid., p.10.

36 See below.

37 On Anglo–Dutch gardens see below, Chapter 4.

38 Israel, 'The Dutch role', p.128.

39 *Diary of John Evelyn* 4, p.600.

2: From Invasion to Glorious Revolution

1 Israel, 'The Dutch role', p.128.

2 Schwoerer, *The Declaration of Rights*, p.109.

3 See T. Claydon, *William III and the Godly Revolution* (Cambridge: Cambridge University Press, 1996), pp.24–8.

4 Israel, 'The Dutch role', pp.121–2.
5 J.I. Israel, 'Propaganda in the making of the Glorious Revolution', in S. Roach (ed.), *Across the Narrow Seas: Studies in the History and Bibliography of Britain and the Low Countries* (London: The British Library, 1991), pp.167–77; 167–9.
6 L.G. Schwoerer, *The Declaration of Rights, 1689* (Baltimore and London: The Johns Hopkins University Press, 1981), pp.115–16.
7 Israel, 'General Introduction', pp.15–16.
8 See L. Jardine, *The Awful End of Prince William the Silent: The First Assassination of a Head of State with a Handgun* (London: HarperCollins, 2005).
9 Quoted in R. Beddard, *A Kingdom Without a King: The Journal of the Provisional Government in the Revolution of 1688* (Oxford: Phaidon, 1988) pp.124–49.
10 P. Laslett (ed.), *Locke's Two Treatises on Government* (Cambridge: Cambridge University Press, 1960), p.155; B. Rang, 'An Unidentified Source of John Locke's Some Thoughts Concerning Education', *Pedagogy, Culture and Society* 9 (2001), 249–77.
11 Onnekink, *The Anglo–Dutch Favourite*, p.32.
12 Israel, 'The Dutch role', p.115.
13 Ibid., p.120.
14 Ibid., p.110.
15 Ibid., p.109.
16 Ibid., p.160.
17 Claydon, *William III*, p.29.
18 Cit. ibid., p.54.
19 R. Strong, *The Artist and the Garden* (New Haven: Yale University Press, 2000), pp.183–92. See below, Chapter 6.
20 *Journaal van Constantijn Huygens, den Zoon* I, p.35.
21 Ibid.
22 Ibid.
23 *Journaal van Constantijn Huygens, den Zoon* I, p.36.
24 De Jong, *Nature and Art*, p.49.
25 Onnekink, *The Anglo–Dutch Favourite*, p.26.
26 See e.g. J. Israel, *The Dutch Republic: Its Rise, Greatness, and Fall, 1477–1806* (Oxford: Oxford University Press, 1995), pp.648–9.
27 See F. and J. Muller, 'Completing the picture: The importance of reconstructing early opera', *Early Music* 33 (2005), 667–81; 670.

3: Royal and Almost-Royal Families

1 See J.R. Jones, 'James II's Revolution: Royal politics, 1686–92', in J.I. Israel (ed.), *The Anglo–Dutch Moment*, pp.47–72; 55–6. See also R. Oresko, 'The Glorious Revolution of 1688–9 and the House of Savoy', in ibid., pp.365–88.

2 The story of the warming-pan plot here is based on R.J. Weil's essay, 'The politics of legitimacy: Women and the warming-pan scandal', in L.G. Schwoerer (ed.), *The Revolution of 1688–9: Changing Perspectives* (Cambridge: Cambridge University Press, 1992), pp.65–82. I am grateful to Rachel Weil for introducing me to the warming-pan plot at the Davis Center Seminar at Princeton University, in 1988. See S.B. Baxter, *William III* (London: Longmans, 1966).
3 See ibid.
4 B.C. Brown (ed.), *The Letters and Diplomatic Instructions of Queen Anne* (London: Cassell and Company Ltd., 1935), p.34.
5 Ibid., p.35.
6 Weil, 'Politics of legitimacy', p.67.
7 For an interesting argument concerning the inevitable impossibility of 'proving' the legitimacy of any birth without total confidence in women's testimony, see ibid.
8 *Diary of John Evelyn*.
9 Baxter, *William III*, pp.233, 234.
10 D. Hoak, 'The Anglo–Dutch Revolution of 1688–89', in D. Hoak and M. Feingold (eds), *The World of William and Mary: Anglo–Dutch Perspectives on the Revolution of 1688–89* (Stanford University Press, 1966), pp.1–26; 23.
11 S. Groenveld, '"J'equippe une flotte très considerable": The Dutch side of the Revolution', in R. Beddard (ed.), *The Revolutions of 1688* (Oxford: Clarendon Press, 1991), pp.213–45, at p.234.
12 Weil, 'Politics of legitimacy', p.68.
13 On William the Silent see Wedgwood, *William the Silent* (London: Jonathan Cape, 1967); L. Jardine, *The Awful End of Prince William the Silent*.
14 *Journaal van Constantijn Huygens, den Zoon* (1673, 1675, 1677 en 1678), 8. See D. Hoak, 'The Anglo–Dutch revolution of 1688–89', in D. Hoak and M. Feingold (eds), *The World of William and Mary*, pp.1–26; 272, note 92.
15 Ibid., p.272, note 97.
16 Ibid., p.23.
17 S. Groenveld, 'The house of Orange and the house of Stuart, 1639–1650: a revision', *Historical Journal* 34 (1991), 955–72. I have largely accepted Groenveld's revised view of the relationship between the two houses during this period, correcting that of Geyl.
18 P. Geyl, *Orange and Stuart 1641–1672* (London: Phoenix Press, 2001; first English edition 1969), p.7.
19 See Groenveld, 'The Dutch side of the Revolution', p.217.

20 Geyl, *Orange and Stuart*, p.32.
21 Many historical accounts give William's age as twelve in May 1641, although he was born on 27 May 1626 (n.s.). This is presumably because he was indeed twelve at the beginning of negotiations in 1638–39.
22 On comparative costs of clothes and paintings see J. Brotton, *The Sale of the Late King's Goods* (London: Macmillan, 2006). See also R. Malcolm Smuts, *Court Culture and the Origins of the Royalist Tradition in Early Stuart England* (Philadelphia, 1987), pp.60, 130–1; David Howarth, *Images of Rule: Art and Politics in the English Renaissance, 1485–1649* (London, 1997), pp.9–10.
23 *Parentalia*, p.133.
24 Geyl, *Orange and Stuart*, pp.32–3.
25 On the conscious strategy of Frederik Hendrik and Amalia van Solms to create a court culture in the Low Countries to give dynastic prominence to the house of Orange see M. Keblusek and J. Zijlmans, *Princely Display: The Court of Frederik Hendrik of Orange and Amalia van Solms* (Zwolle: Historical Museum, The Hague, 1997).
26 Geyl, *Orange and Stuart*, p.35.
27 Groenveld, 'The house of Orange and the house of Stuart', p.961.
28 Ibid., p.963.
29 Ibid, p.964.
30 W.A. Speck, *Reluctant Revolutionaries: Englishmen and the Revolution of 1688* (Oxford: Oxford University Press, 1988), pp.102–3.
31 Weil, 'Politics of legitimacy', pp.71–2.
32 Hoak, 'The Anglo–Dutch Revolution of 1688–89', p.20.

4: Designing Dutch Princely Rule
1 T. Sprat, *The history of the Royal-Society of London for the improving of natural knowledge* (London, 1667), pp.88–9.
2 On the court of Frederik Hendrik and Amalia van Solms see Keblusek and Zijlmans, *Princely Display*.
3 'An autograph Memorandum from M. le Blon, in the handwriting of Rubens, Concerning a Picture for the Princess of Orange. The Subject The Marriage of Alexander the Great with Roxane'. See J.G. van Gelder, 'Rubens Marginalia IV', *Burlington Magazine* 123 (1981), 542–6.
4 Ibid., p.545.
5 P. van der Ploeg and C. Vermeeren, '"From the 'Sea Prince's' Monies": The Stadholder's Art Collection', in P. van der Ploeg and C.

Vermeeren (eds), *Princely Patrons: The Collection of Frederick Henry of Orange and Amalia of Solms in The Hague* (Zwolle: Waanders Publishers, 1997), pp.34–60; 34.
6 J. Israel, 'The United Provinces of the Netherlands: The Courts of the House of Orange', in J. Adamson (ed.), *The Princely Courts of Europe. Ritual, Politics and Culture under the Ancien Régime 1500–1700* (London: Weidenfeld & Nicolson, 1999), pp.119–40; 126.
7 See K. Ottenheym, 'Architectuur', in J. Huisken, K. Ottenheym and G. Schwartz (eds), *Jacob van Campen: Het klassieke ideaal in de Gouden Eeuw* (Amsterdam: Architectura & Natura Pers, 1995), pp.155–99; 175.
8 Ronald G. Asch, 'Elizabeth, Princess (1596–1662)', *Oxford Dictionary of National Biography*, Oxford University Press, September 2004; online edn, May 2006 [http://www.oxforddnb.com.catalogue.ulrls.lon.ac.uk:80/view/article/8638, accessed 27 March 2007].
9 For Huygens's youthful experiences in England see below. For the masques and ballets performed for the courts at The Hague see below, Chapter 7.
10 J. Israel, 'The United Provinces of the Netherlands', pp.119–40; 130.
11 16 August 1649, Worp, letter 4969.
12 See below, Chapters 11 and 12.
13 For Sir Constantijn Huygens's early life see A.G.H. Bachrach, *Sir Constantine Huygens and Britain*, 1 (Leiden and Oxford: Brill and Oxford University Press, 1962); J.A. Worp (ed.), *De briefwisseling van Constantijn Huygens (1608–1687). 1 (1608–1634)* ('s-Gravenhage: Martinus Nijhoff, 1911).
14 They had left The Hague on the evening of 7 June: 'En Angleterre aveq Carleton', 7 June 1618 (Dagb., p.9).
15 J.A. Worp (ed.), *De briefwisseling van Constantijn Huygens (1608–1687). 1 (1608–1634)* ('s-Gravenhage: Martinus Nijhoff, 1911), p.21.
16 A.G.H. Bachrach, *Sir Constantine Huygens and Britain*, 1 (Leiden and Oxford: Brill and Oxford University Press, 1962), pp.113–17.
17 See H.J. Louw, 'Anglo-Netherlandish architectural interchange c.1600–c.1660', *Architectural History* 24 (1981), 1–22 and 125–144; 4.
18 Bachrach, *Sir Constantine Huygens*, p.139.
19 Bachrach seems to suggest that this occasion followed immediately after the June encounter with King James, but that is not what is suggested by the documents. See ibid., pp.139–40.

20 Ibid., p.218.

21 See ibid., pp.179–80. Huygens also had a significant encounter with Charles, Prince of Wales (the future Charles I). See Bachrach, *Huygens and Britain*, p.161.

22 Fifty years later, Huygens expressed admiration for another solo viol-player in the English style, Dietrich Stoeffken. See T. Crawford, '"Allemande Mr. Zuilekom". Constantijn Huygens's sole surviving instrumental composition', *Tijdschrift van de Vereniging voor Neederlandse Muziekgeschiedenis* 37 (1987), 175–81; 177.

23 See J. Zijlmans, 'Life at the Hague Court', in Keblusek and Zijlmans, *Princely Display*, pp.30–46; 37.

24 On shared and distinctive musical traditions in England and the northern Netherlands in this period see J.A. Westrup, 'Domestic music under the Stuarts', *Proceedings of the Musical Association* (1941–42), 19–53; R.A. Rasch, 'Seventeenth century Dutch editions of English instrumental music', *Music and Letters* 53 (1972), 270–3. On Huygens's own musical production see T. Crawford, '"Allemande Mr. Zuilekom"', 175.

25 See Brotton, *The Sale of the Late King's Goods*.

26 See e.g. Bachrach, *Sir Constantine Huygens*, p.110 and footnote 1.

27 George Gage, Toby Matthew and Inigo Jones accompanied the Earl of Arundel on his art-collecting travels around Italy, where they acquired their expertise as Continental agents buying and selling art (see also Toby Matthews's letter to Carleton about acquiring Rubens and van Dyck in 1620).

28 Cit. Muller, 'Rubens's museum', p.571.

29 Ibid., p.575.

30 This account of Rubens's transaction with Carleton is based on Simon Schama, *Rembrandt's Eyes* (Harmondsworth: Allen Lane for Penguin Press, 1999), pp.175–6.

31 W.N. Sainsbury (ed.), *Original Unpublished Papers illustrative of the Life of Sir Peter Paul Rubens, as an artist and diplomatist, preserved in H.M. State Paper Office* (London: Bradbury & Evans, 1859), p.27.

32 Ibid., p.39.

33 Ibid., p.45.

34 Muller, 'Rubens's museum', p.575.

35 Sainsbury, *Original Unpublished Papers*, p.38.

36 See Bachrach, *Sir Constantine Huygens*, p.142. See also S. Schama, *The Embarrassment of Riches: An Interpretation of Dutch Culture in the Golden Age* (London: Collins, 1987), p.258.

37 R. Hill, 'Ambassadors and art collecting in early Stuart Britain: The parallel careers of William Trumbull and Sir Dudley Carleton, 1609–1625', *Journal of the History of Collections* 15 (2003), 211–28; 216.

38 A.G.H. Bachrach, *Sir Constantine Huygens and Britain*, 1 (Leiden and Oxford: Brill and Oxford University Press, 1962), pp.110–11.

39 SP 84/85/176 Mytens to Carleton, London, 18 August 1618, cit. R. Hill, 'Sir Dudley Carleton and his relations with Dutch artists 1616–1632', 255–74; 268; (SP 84/86/103).

40 P. McEvansoneya, 'The sequestration and dispersal of the Buckingham collection', *Journal of the History of Collections* 8 (1996), 133–54.

41 See Keblusek and Zijlmans, *Princely Display*.

42 According to Schama it was in the course of this art-buying spree that Huygens discovered Jan Lievens and Rembrandt as Protestant, Dutch Republic artists whose virtuosity matched that of the Catholic, Spanish-sympathising Rubens.

43 See S. Groenveld, 'Frederick Henry and his entourage: A brief political biography', in van der Ploeg and Vermeeren, *Princely Patrons*, pp.18–33; 30–1.

5: Auction, Exchange, Traffic and Trickle-Down

1 J. Thurloe, *A collection of the state papers of John Thurloe, Esq; secretary, first, to the Council of State, and afterwards to the two Protectors, Oliver and Richard Cromwell. In seven volumes...To which is prefixed, the life of Mr. Thurloe...By Thomas Birch*, 7 vols, Vol. 1 (London, 1742), pp.182–3.

2 See J. Brown, 'The Sale of the Century', in *Kings and Connoisseurs: Collecting Art in Seventeenth-Century Europe* (New Haven and London: Yale University Press, 1995), pp.59–94.

3 See A.G.H. Bachrach and R.G. Collmer (eds), *Lodewijk Huygens: The English Journal 1651–1652* (Leiden: Brill, 1982), p.61

4 J.M. Montias, 'Art dealers in the seventeenth-century Netherlands', *Simiolus* 0.18 (1988), 244–56; 245. See also J.M. Montias, *Art at Auction in Seventeenth Century Amsterdam* (Amsterdam: Amsterdam University Press, 2002); J.M. Montias, *Vermeer and His Milieu: A Web of Social History* (Princeton: Princeton University Press, 1989); E.A. Honig, *Painting and the Market in Early Modern Antwerp* (New Haven and London: Yale University Press, 1998).

5 For more on the Duartes see below, Chapter 7.

6 *Diary of John Evelyn.*

7 Montias, 'Art dealers in the seventeenth-century Netherlands', p.245.

8 Montias, *Art at Auction*, pp.234–42.

9 Honig, *Painting and the Market*, p.195.

10 S. Slive, 'Art historians and art critics – II: Huygens on Rembrandt', *Burlington Magazine* 94 (1952), 260–4; 261.

11 I am placing the Lievens painting around 1625, in spite of the opinions of art historians. Held gives the date as 1629. The Rijksmuseum website gives 1626–27. A recent PhD dissertation on Lievens dates it at 1628–29: L. De Witt, *Evolution and Ambition in the Career of Jan Lievens (1607–1674)* (University of Maryland PhD, 2006). I place it a couple of years earlier for a number of reasons. Huygens says he was particularly melancholic at the time Lievens painted his portrait (see below), and his demeanour and dress as depicted resemble Dutch mourning paintings of the same period. He appears to wear a mourning ring around his neck. Huygens's father died in 1624, and the Stadholder Maurits died in 1625. Huygens would have been doubly in mourning for these two highly significant losses. In late 1625 he was appointed secretary to the new Stadholder Frederik Hendrik. This would have been an appropriate occasion for a portrait.

12 Once again, this specific account by Huygens justifies his having his portrait painted in spite of his being in a period of mourning, since it places the onus for proceeding with the painting immediately on Lievens.

13 Pieters, 'Among ancient men: Petrarch, Machiavelli, Sidney and Huygens', in *Speaking with the Dead: Explorations in Literature and History* (Edinburgh: Edinburgh University Press, 2005), p.41.

14 Ibid.

15 For the most recent account of Lievens's career, see L. De Witt, *Evolution and Ambition in the Career of Jan Lievens (1607–1674)*, unpublished PhD, University of Maryland, College Park (2006), especially Chapter 2, 'Lievens in England, 1632–1635'.

16 Ibid., p.110. Reproduced in *Princely Patrons*, p.170.

17 Cit. De Witt, *Evolution and Ambition*, p.118.

18 Ibid., p.123.

19 Ibid., pp.121–2.

20 M.R. Toynbee, 'Adriaen Hanneman and the English court in exile', *Burlington Magazine* 92 (1950), 73–80. See also M.R. Toynbee, 'Some

early portraits of Princess Mary, daughter of Charles I', *Burlington Magazine* 82 (1943), 100–3.

21 A. Sumner, 'Hanneman, Adriaen (c.1604–1671)', *Oxford Dictionary of National Biography*, Oxford University Press, 2004 [http://www.oxforddnb.com/view/article/122 15, accessed 19 February 2007].

22 BL Add. MS 16174: 'Proposal to the parliament of Sir Balthazar Gerbier, knt., Peter Lely and George Geldorp concerning the representing in oil, pictures of all the memorable achievements since the parliament's first sitting', c.1651.

23 D. Dethloff, 'Lely, Sir Peter (1618–1680)', *Oxford Dictionary of National Biography*, Oxford University Press, 2004 [http://www.oxforddnb.com.catalogue.ulrls.lon.ac.uk:80/view/article/16419, accessed 2 April 2007].

24 C. Hofstede de Groot, *Die Urkunden uber Rembrandt* (The Hague: M. Nijhoff, 1906).

25 Cited in F. Scholten, 'François Dieussart, Constantijn Huygens, and the classical ideal in funerary sculpture', *Simiolus* 25 (1997), 303–28; 309.

26 See full account in A.-M.S. Logan, *The 'Cabinet' of the Brothers Gerard and Jan Reynst* (Amsterdam: North-Holland Publishing Company, 1979), pp.75–86.

27 For a concise account of this dispute see Montias, *Vermeer and His Milieu*, pp.207–9.

28 See D. Mahon, 'Notes on the "Dutch Gift" to Charles II: 1', *Burlington Magazine* 91 (1949), 303–5; 'Notes on the "Dutch Gift" to Charles II: 2', *Burlington Magazine* 91 (1949), 349–50; 'Notes on the "Dutch Gift" to Charles II: 3', *Burlington Magazine* 92 (1950), 12–18.

29 Cit. G. Schwartz and M.J. Bok, *Pieter Saenredam: The Painter and His Time* (London: Thames & Hudson, 1990), p.206.

30 H. Macandrew and K. Andrews, 'A Saenredam and a Seurat for Edinburgh', *Burlington Magazine* 124 (1982), 752–5; 755.

31 Schwartz and Bok, *Pieter Saenredam*, p.128; pp.149–54.

32 Mariët Westermann, 'Vermeer and the interior imagination', in *Vermeer and the Dutch Interior* (Madrid, 2003), p.225.

33 John Michael Montias, *Vermeer and His Milieu: A Web of Social History* (Princeton: Princeton University Press, 1989).

34 *Diary of John Evelyn* 3, p.262.

35 See R. van Leeuwen (ed.), *Paintings from England: William III and the Royal Collections* (The Hague: Mauritshuis & SDU Publishers, 1988), p.79.

36 Mrs Burnett, wife of Gilbert, in 1707. Cit. C.D. van Strien, *British Travellers in Holland during the Stuart Period: Edward Browne and John Locke as Tourists in the United Provinces* (Leiden: Brill, 1993), p.153.

37 R. van Leeuwen (ed.), *Paintings from England: William III and the Royal Collections* (The Hague: SDU Publishers, 1988), pp.78–80.

38 J. Israel, 'The United Provinces of the Netherlands: The Courts of the House of Orange', in J. Adamson (ed.), *The Princely Courts of Europe 1500–1750* (London: Weidenfeld & Nicolson, 1999), pp.119–140; p.136.

39 Van Leeuwen, *Paintings from England*, pp.21–2.

6: Double Portraits

1 For an interesting account of Schurmann's artistic activities see E.A. Honig, 'The art of being "artistic": Dutch women's creative practices in the 17th century', *Woman's Art Journal* 22 (2001–02), 31–9.

2 See below.

3 5 August 1642. Worp, letter 3092.

4 For details of Susanna's background see J.S. Held, 'Constantijn Huygens and Susanna van Baerle: a hitherto unknown portrait', *Art Bulletin* 73 (1991), 653–68; 659–60.

5 Cit. ibid., p.661.

6 C.D. Andriesse, trans. S. Miedema, *Huygens: The Man behind the Principle* (Cambridge: Cambridge University Press, 2005), p.51. See also E. Keesing, 'Wanneer was wie de heer van Zeelhem?', *De zeventiende eeuw* 9 (1993), 63–5.

7 Davidson and van der Weel, *A Selection of the Poems of Sir Constantijn Huygens*, p.101.

8 Ibid., p.109.

9 For a poetic analysis of their relationship, as evidenced by Huygens's 'Daghwerck', see R.L. Colie, *'Some Thankfulnesse to Constantine,' A Study of English Influence upon the Early Works of Constantijn Huygens* (The Hague: Nijhoff, 1956).

10 See L. Roth (ed.), *Correspondence of Descartes and Constantyn Huygens 1635–1647* (Oxford: Clarendon Press, 1926), pp.37–8.

11 Ibid., 29 March 1637, p.43.

12 J.S. Held, 'Constantijn Huygens and Susanna van Baerle: a hitherto unknown portrait', *Art Bulletin* 73 (1991), 653–68.

13 The American-born Dutch art historian Gary Schwartz spearheaded the campaign to return the painting to the Dutch. See Schwartz's account of the discovery, in Loekie Schwartz's Dutch translation, in *Het*

Financieele Dagblad, Amsterdam, 15 January 2005.

14 Held, 'Constantijn Huygens and Susanna van Baerle', p.658, footnote 20.

15 Ibid., p.664 (my translation).

16 Ibid.

17 See above, Chapter 3.

18 Held, 'Constantijn Huygens and Susanna van Baerle', p.665.

19 On the three poems see F. Noske, 'Two unpaired hands holding a music sheet: A recently discovered portrait of Constantijn Huygens and Susanna van Baerle', *Tijdschrift van de Vereniging voor Nederlandse Muziekgeschiedenis* 42 (1992), 131–40.

20 See ibid.

21 Ibid., p.138.

22 On Huygens and the theorbo see R. Spencer, 'Chitarrone, theorbo and archlute', *Early Music* 4 (1976), 407–23; 413. See also L. Sayce, 'Continuo lutes in 17th- and 18th-century England', *Early Music* 23 (1995), 666–84.

23 For Marnix's influence on William see L. Jardine, *The Awful End of William the Silent*.

24 6 June 1652. Worp, letter 5230.

25 See Huygens to Mevr. Morgan. Worp, letter 3239.

26 J.A. Worp (ed.), *De gedichten van Constantijn Huygens, naar zijn handschrift uitgegeven*, 9 vols (Groningen, 1892–99), Vol. 4, pp.53–4: the poem was later retitled 'Een minnaer aen een weduwe op een mugge-net hem bij haer vereert'.

27 D. de Wilhem to Huygens, The Hague, 1 August 1646. Worp, letter 4417.

28 Huygens to Mevr. A. Morgan. D. de Wilhem to Huygens, The Hague, 1 August 1646. Worp, letter 4417.

28 Huygens to Mevr. A. Morgan, Worp, letter 4438.

29 See Edward M. Furgol, 'Morgan, Sir Charles (1575/6–1643)', *Oxford Dictionary of National Biography*, Oxford University Press, 2004 [http://www.oxforddnb.com.catalogue.ulrls.lon.ac.uk:80/view/article/19217, accessed 7 April 2007].

30 To Lady Strickland, 2 October 1654. Worp, letter 5370.

31 Huygens to Amalia van Solms, 3 August 1654. Worp, letter 5363.

32 6 June 1652. Worp, letter 5230.

33 See P. Geyl, 'Frederick Henry of Orange and King Charles I', *English Historical Review* 38 (1923), 355–83; 364.

34 Utricia Ogle (1616–74) was the daughter of

Sir John Ogle and Elizabeth de Vries. She married captain Sir William Swann in 1645.

35 See J.A. Worp, 'Nog eens Utricia Ogle en de muzikale correspondentie van Huygens', *Tijdschrift der Vereeniging voor Noord-Nederlands Muziekgeschiedenis* 5 (1896), 129–36.

36 24 January 1647. Worp, letter 4527.

37 On Lanier's career in the household of Charles I see J. Brotton, *The Sale of the Late King's Goods* (London: Macmillan, 2006).

38 20 January 1654. Worp, letter 5324.

39 'Hofwijk', lines 413–18. P. Davidson and A. van der Weel (eds and trans.), *A Selection of the Poems of Sir Constantijn Huygens (1596–1687)* (Amsterdam: Amsterdam University Press, 1996), p.143.

40 See J.A. Worp, 'Nog eens Utricia Ogle en de muzikale correspondentie van Huygens', *Tijdschrift der Vereeniging voor Noord-Nederlands Muziekgeschiedenis* 5 (1896), 129–36.

41 J.P. Vander Motten, *Sir William Killigrew (1606–1695): His Life and Dramatic Works* (Gent: Universa, 1980), pp.22–7. F. Blom (ed.), *Constantijn Huygens: Mijn Leven verteld aan mijn Kinderen*, 2 vols (Amsterdam: Prometheus/Bert Bakker, 2003), 1: pp.124–6; 2: pp.216–18.

42 Blom, *Constantijn Huygens: Mijn Leven* 1, p.124. I can find no evidence, aside from Contantijn Huygens's letters to her, for how Lady Killigrew came to know Dutch. But see Elizabeth of Bohemia's letter confirming that English noblewomen were learning Dutch at this time (Nadine Akkerman, personal communication).

43 Elizabeth of Bohemia to Sir Thomas Roe, The Hague, 24/14 June 1639. I am grateful to Nadine Akkerman for this reference.

44 1630. Worp, letter 566.

45 20/30 April 1671. Worp, letter 6794.

46 18 March 1646. Worp, letter 4295.

47 Lanier to Huygens, 3 April 1646. Worp, letter 4304.

48 *The Life of the Honourable Robert Boyle* by Thomas Birch, MA and FRS, London: Printed for A. Millar, over-against Catharine-Street in the Strand MDCCXLIV. (This later appears as the first part of Vol. I of the *Works*.) For Francis's marriage, see p.34.

49 Lords Journal: 'Boyle et al – pass to go to Holland, 22. Car. 1 viii 648 a. "Ordered, That Mr. Boyle and his Wife shall have a pass to go in to Holland; carrying with them Servants, and such Necessaries as are fit for his Journey."'

50 See Birch, *Life of Boyle*. Birch adds the footnote: 'Mr. Boyle's letter to Mr. Marcombes, dated from London, Febr. 22, 1647–8, in which he mentions his intentions of setting out for Holland the next day.'

51 Charlotte's birth date is generally given as 'around 1650', since the actual birth took place discreetly, and her status as a royal bastard was not made public till many years later.

52 J.P. Vander Motten, 'Thomas Killigrew's "lost years"', 1655–1660', *Neophilologus* 82 (1998), 311–34.

53 See above for the marital disgrace of Thomas's sister, Francis Boyle's wife.

54 J.P. Vander Motten, 'Killigrew, Thomas (1612–1683)', *Oxford Dictionary of National Biography*, Oxford University Press, 2004 [http://www.oxforddnb.com.catalogue.ulrls.lon.ac.uk:80/view/article/15538, accessed 8 April 2007].

55 Endymion Porter, who we are told actually found the house for the Cavendishes, was an agent involved in numerous art purchases made in the Low Countries on behalf of noble English clients. He was certainly well known to Huygens, and had served in the same capacity in purchases for the Dutch Stadholder. Huygens mentions Margaret Cavendish in a letter to Utricia Swann in 1653, when he has not yet met her in person.

56 4/14 October, 1655. Worp, *De briefwisseling van Constantijn Huygens (1608–1687)*, 5, 244–5, letter 5432.

7: Consorts of Viols, Theorbos and Anglo–Dutch Voices

1 B. van Beneden, 'Introduction', in B. van Beneden and Nora de Poorter (eds), *Royalist Refugees: William and Margaret Cavendish in the Rubens House 1648–1660* (Antwerp: Rubenshuis & Rubenianum, 2006), p.10.

2 I. van Damme, 'A city in transition: Antwerp after 1648', in ibid., pp.55–62; 58.

3 See P. Major, 'A Church in exile: Anglican survival and resistance in Antwerp, 1650–53' (in press).

4 On Jews and Jewish practice in the Netherlands in the seventeenth century, see the many articles by J.I. Israel, particularly those in *Studia Rosenthaliana*.

5 On the Duarte family and its art collections see Edgar Samuel, 'The disposal of Diego Duarte's Stock of Paintings 1692–1697', *Jaarboek Koninklijk Museum voor Schone Kusten-*

Antwerpen (1976); 'Manuel Levy Duarte (1631–1714): An Amsterdam Merchant Jeweller and his Trade with London', *Transactions of the Jewish Historical Society of England* XXVII, 11–31. See also G. Dogaer, *Jaarboek Koninklijk Museum voor Schone Kusten-Antwerpen* (1971), for the 1683 inventory of the Duarte picture collection.

6 See entry for Gaspar Duarte on the website of the Joods Historische Museum of Amsterdam: http://www.jhm.nl/.

7 'Anvers, ce 24e de Mars 1641'. Gaspar Duarte to Huygens. Worp, letter 2677.

8 J. Duarte to Huygens, 7 April 1641. Worp, letter 2686.

9 G.F. Duarte to Huygens, 21 April 1641. Worp, letter 2677.

10 G.F. Duarte to Huygens, 9 May 1641. Worp, letter 2703.

11 I owe this connection to Nadine Akkerman, who is editing the letters of Elizabeth of Bohemia, for whom Wicquefort also worked.

12 £9 sterling = 100 Dutch guilders.

13 See Marika Keblusek, 'Mary, princess royal (1631–1660)', *Oxford Dictionary of National Biography*, Oxford University Press, 2004 [http://www.oxforddnb.com.catalogue.ulrls.lon.ac.uk:80/view/article/18252, accessed 9 April 2007].

14 See below, Chapter 8.

15 See G. Dogaer, 'De inventaris der schilderijen van Diego Duarte', *Jaarboek van het Koninklijk Museum voor schone Kunsten Antwerpen* (1971), 195–221; 203.

16 21 July 1648. Worp, letter 4845. On Huygens and the de Barres, see J. Tiersot, 'Une famille de musiciens français au XVIIe siècle les de Barre. III. Les enfants de Pierre. Anne de la Barre. chez Huygens', *Revue de musicologie* 9 (1928), 1–11; 7.

17 31 July 1648. Worp, letter 4850.

18 Tiersot, 'Une famille de musiciens français', pp.7–9 (not in Worp).

19 30 January 1653. Worp, letter 5271.

20 C. Huygens, 'Dessein de l'entrée du ballet presenté à la reine de Boheme à la Haye', in Huygens, *Otiorum libri sex* (The Hague, 1625), pp.49–54.

21 Cit. M. Keblusek, '"A divertissiment of little plays": Theater aan de Haagse hoven van Elizabeth van Bohemen en Mary Stuart', in J. de Jongste, J. Roding and B. Thijs (eds), *Vermaak van de elite in de vroegmoderne tijd* (Hilversum: Verloren, 1999), pp.190–202; 198.

22 N.N.W. Akkerman and P.R. Sellin, 'A Stuart Masque in Holland, Ballet de la Carmesse de La Haye (1655)', Parts 1 and 2, *Ben Jonson Journal* 11 (2004), 207–58; 227 and 12 (2005), 141–64.

23 Ibid., Part 1, p.227.

24 Ibid., p.228.

25 Ibid., p.229.

26 Ibid., p.231.

27 On such entertainments see M. Keblusek, '"A divertissment of little plays": Theater aan de Haagse hoven van Elizabeth van Bohemen en Mary Stuart', in J.A.F. de Jongste et al., *Vermaak van de Elite in de Vroegmoderne Tijd* (Hilversum: Uitgeverij Verloren, 1999).

28 See N.N.W. Akkerman, *The Letters of the Queen of Bohemia* (unpublished dissertation, Free University of Amsterdam, 2008).

29 Akkerman and Sellin, 'A Stuart Masque in Holland', Part 2, 158.

30 Ibid., pp.142–3.

31 For Huygens's musical dealings with Brussels, see R. Rasch, 'Constantijn Huygens in Brussel op bezoek bij Leopold Wilhelm van Oostenrijk 1648–1656', *Revue belge de Musicologie/Belgisch Tijdschrift voor Muziekwetenschap* 55, 'six siècles de vie musicale à Bruxelles/Zes eeuwen muziekleven te Brussel' (2001), 127–46.

32 See Lynn Hulse, 'Cavendish, William, first Duke of Newcastle upon Tyne (bap. 1593, d. 1676)', *Oxford Dictionary of National Biography*, Oxford University Press, Sept 2004; online edn, May 2006 [http://www.oxforddnb.com.catalogue.ulrls.lon.ac.uk:80/view/article/4946, accessed 9 April 2007].

33 See above, Chapter 4.

34 In October 1648 Frederik Nassau-Zuijlenstein (natural son of Frederik Hendrik) married Mary Killigrew, lady-in-waiting to Mary Stuart, at The Hague, and there was a large gathering of English nobility.

35 K. Whitaker, *Mad Madge: Margaret Cavendish, Duchess of Newcastle, Royalist, Writer and Romantic* (London: Chatto & Windus, 2003), p.113.

36 On Bolsover see T. Mowl, *Architecture Without Kings: The Rise of Puritan Classicism under Cromwell* (Manchester: Manchester University Press, 1995), pp.167–9. See also T. Raylor, '"Pleasure reconciled to virtue": William Cavendish, Ben Jonson, and the decorative scheme at Bolsover Castle', *Renaissance Quarterly* 52 (1999), 402–39.

37 L. Worsley, U. Härting and M. Keblusek, 'Horsemanship', in Beneden and de Poorter, *Royalist Refugees*, pp.37–54.

38 J. Knowles, '"We've lost, should we lose too our harmless mirth?" Cavendish's Antwerp Entertainments', in ibid., pp.70–7.
39 On Lanier's career in the household of Charles I see J. Brotton, *The Sale of the Late King's Goods* (London: Macmillan, 2006).
40 Knowles, 'We've lost, should we lose too our harmless mirth?', p.77.
41 5/15 September 1653.
42 Huygens to Margaret Cavendish, 9/19 September 1671. On this exchange of letters see now N.N.W. Akkerman and Marguérite Corporaal, 'Mad Science Beyond Flattery: The Correspondence of Margaret Cavendish and Constantijn Huygens', *Early Modern Literary Studies* Special Issue 14 (May, 2004), 2.1-21 [http://purl.oclc.org/emls/si-14/akkecorp.html].
43 Huygens included some poems in English (now lost).
44 Antwerp, 20 March 1657.
45 27 March 1657.
46 30 March 1657.
47 L. Brodsley, C. Frank and J.W. Steeds, 'Prince Rupert's drops', *Notes and Records of the Royal Society* 41 (1986), 1–26.
48 This report was published by Christopher Merrett as an appendix to his translation of Antonio Neri's *Art of Glass* (1662), pp.353–62.
49 R. Hooke, 'Observatiion vii. Of some Phaenomena of Glass Drops', *Micrographia or Some Physiological Descriptions of Minute Bodies made by Magnifying Glasses with Observation and Inquiries thereupon* (London, 1665), pp.33–44.

8: Masters of All They Survey

1 For a vivid sense of the new consumer culture getting under way in the course of the seventeenth century, see J. Styles and A. Vickery (eds), *Gender, Taste, and Material Culture in Britain and North America, 1700–1830* (New Haven and London: Yale University Press, 2006).
2 See H.J. Louw, 'Anglo–Netherlandish architectural interchange c.1600–c.1660', *Architectural History* 24 (1981), 1–23.
3 See PRO, WORK 5/2; D. Knoop and G.P. Jones, *The London Mason in the Seventeenth Century* (1935), 71; H. Colvin, *A Biographical Dictionary of British Architects 1600–1840*, 3rd edn (New Haven and London: Yale University Press, 1995), p.299.
4 K. Ottenheym, '"Possessed by such a passion for building", Frederik Hendrik and architecture', in Keblusek and Zijlmans,

Princely Display, pp.105–25; p.110.
5 '[13?] November 1635'. Worp, letter 1301.
6 'Au camp soubs Philippine, le 2e de Juillet 1639' (Worp, letter 2149), and 14 November 1639 (Worp, letter 2272).
7 See K.A Ottenheym, 'De correspondentie tussen Rubens en Huygens over architectuur (1635 40)', *Bulletin Koninklijke Nederlandse Oudheidkundige Bond* 1997, pp.1–11.
8 Utricia Swann sang at Hofwijk in 1642, and Huygens wrote a poem of lavish praise of her singing, which put the nightingale to shame. T. van Strien and K. van der Leer, *Hofwijk: Het gedicht en de buitenplaats van Constantijn Huygens* (Zutphen: Walborg Pers, 2002), pp.82–3.
9 See Koen Ottenheym, '"Possessed by such a passion for building": Frederik Hendrik and Architecture', in Keblusek and Zijlmans, *Princely Display*, pp.105–25.
10 Ibid., pp.121–5. See also J. Adamson (ed.), *The Princely Courts of Europe 1500–1750* (London: Weidenfeld & Nicolson, 1999), p.130.
11 See L. Worsley, '"His magnificent buildings": William Cavendish's patronage of architecture', in Beneden and de Poorter, *Royalist Refugees*, pp.101–4.
12 See above, Chapter 3. See also Held, 'Huygens and Baerle', p.662.
13 See P. Geyl, 'Frederick Henry of Orange and King Charles I', *English Historical Review* 38 (1923), 355–83; 364.
14 15 February 1651. Worp, letter 5100.
15 To Princess Elizabeth of Bohemia. Worp, letter 5323. See also K. van der Leer, *Hofwijk: Het gedicht en de buitenplaats van Constantijn Huygens* (Zutphen: Walburg Pers, 2002), p.89.
16 S. Schama, *The Embarrassment of Riches: An Interpretation of Dutch Culture in the Golden Age* (1987).
17 P. Davidson and A. van der Weel (eds and trans.), *A Selection of the Poems of Sir Constantijn Huygens (1596–1687)* (Amsterdam: Amsterdam University Press, 1996), p.137.
18 Ibid.
19 Ibid., p.139.
20 Ibid., pp.151–3.
21 2 June 1682. Worp, letter 7188.
22 Cit. Sellers, *Courtly Gardens in Holland*, p.107.
23 Huygens to Utricia, Hofwijck, 5/15 September 1653.
24 R. Strong, *The Artist and the Garden* (New Haven and London: Yale University Press, 2000), pp.183–5.
25 A.G.H. Bachrach and R.G. Collmer (eds), *Lodewijk Huygens: The English Journal 1651–1652*

(Leiden: E.J. Brill/Leiden University Press, 1982), pp.132–3.

26 A. Mollet, *Le Jardin de Plaisir, contenant plusieurs desseins de Jardinage tant Parterres en Broderie, Compartiments de gazon, que Eosquers, & autres* (Stockholm: Henry Kayler, 1651), fol. D4v (author's translation).

27 See L. Pattacini, 'André Mollet, Royal gardener in St James's Park, London', *Garden History* 26 (1998), 3–18.

28 Sellers, *Courtly Gardens in Holland*, p.170.

29 Cit. J.D. Hunt, 'Anglo–Dutch garden art', in D. Hoak and M. Feingold (eds), *The World of William and Mary: Anglo–Dutch Perspectives on the Revolution of 1688–89* (Stanford, Calif.: Stanford University Press, 1996), pp.196–7.

30 Cit. ibid., p.195.

31 Cit. Davidson and van der Weel, *A Selection of the Poems of Sir Constantijn Huygens*, p.199.

32 J. Evelyn, *Sylva* (1664), p.115, cit. S.M. Couch, 'The practice of avenue planting in the seventeenth and eighteenth centuries', *Garden History* 20 (1992), 173–200; 176.

33 Evelyn, *Sylva* (1644), p.13.

34 Christiaan Huygens, *Oeuvres Complètes* 4, p.176.

35 14/24 September 1676. Worp, letter 7032.

36 This is the distinguished Orangeist diplomatic family, living in The Hague, into which Alexander Bruce married in 1659. See above, Chapter 5.

37 See above, Chapter 2.

38 F.R.E. Blom (ed.), *Constantijn Huygens: Journaal van de Reis naar Venetië* (Amsterdam: Prometheus publishers, 2003), p.64 (author's translation).

39 Ibid., pp.64–6.

40 J. Cats, *Ouderdom, buyten-leven en hof-gedachten, op Sorghvliet* (Amsterdam: J.J. Schipper, 1656), pp.14–15, cit. V. Bezemer Sellers, *Courtly Gardens in Holland 1600–1650* (Amsterdam: Architectura & Natura Press, 2001), p.12.

41 Sellers, *Courtly Gardens in Holland*, p.9.

9: Paradise on Earth

1 See Koen Ottenheym, '"Possessed by such a passion for building": Frederik Hendrik and Architecture', in Keblusek and Zijlmans, *Princely Display*, pp.105–25; pp.111–16.

2 See Sellers, *Courtly Gardens in Holland*, pp.15–59.

3 Ibid., p.29.

4 Evelyn, *Sylva* (1664).

5 J. Korthals-Altes, *Sir Cornelius Vermuyden* (The Hague: W.P. van Stockum & Son, 1925).

6 C. Roberts, 'The Earl of Bedford and the coming of the English Revolution', *Journal of*

Modern History 49 (1977), 600–16.

7 For an account of van Baerle's relationship with Constantijn Huygens see T. Verbeek, E.-J. Bos and J. van den Ven (eds), 'The Correspondence of René Descartes 1643', *Questiones Infinitae: Publications of the Department of Philosophy Utrecht University*, 45 (2003), 246–7.

8 C.D. Van Strien, *British Travellers in Holland during the Stuart Period: Edward Browne and John Locke as Tourists in the United Provinces* (Leiden: E.J. Brill, 1993), p.149.

9 Cit. E. Den Hartog and C. Teune, 'Gaspar Fagel (1633–88): his garden and plant collection at Leeuwenhorst', *Garden History* 30 (2002), 191–205; 194.

10 See Andriesse, *Huygens*, pp.181–2.

11 22 April 1660, 'Aan de Hertogin van Lotharingen'. Worp, letter 5644.

12 Sellers, *Courtly Gardens in Holland*, p.175.

13 Christian Huygens, *Oeuvres Complètes* 8, pp.86–7.

14 See e.g. Philips Doublet to Christiaan Huygens, 9 March 1679. Worp, letter 2163.

15 See V.B. Sellers, *Courtly Gardens in Holland 1600–1650* (Amsterdam: Architectura & Natura Press, 2001).

16 On the precise family connections see M. Sikkens-De Zwann, 'Magdalena Poulle (1632–99): A Dutch lady in a circle of botanical collectors', *Garden History* 30 (2002), 206–20.

17 E. Den Hartog and C. Teune, 'Gaspar Fagel (1633–88): His garden and plant collection at Leeuwenhorst', *Garden History* 30 (2002), 191–205; 191.

18 Tachard, *Voyage to Siam*, p.51. For a fuller account of the VOC's nursery garden at the Cape see Jardine, *Ingenious Pursuits*, Chapter 6.

19 Den Hartog and Teune, 'Gaspar Fagel', p.194.

20 Ibid., p.197.

21 Cit. Den Hartog and Teune, 'Gaspar Fagel', p.201.

22 Cit. D. Chambers, '"Elysium Britannicum not printed neere ready &c": The "Elysium Britannicum" in the Correspondence of John Evelyn', in T. O'Malley and J. Wolschke-Bulmahn (eds), *John Evelyn's 'Elysium Britannicum' and European Gardening* (Washington DC: Dumbarton Oaks, 1998), pp.107–130; p.115.

23 Ibid., p.127.

24 Sikkens-De Zwann, 'Magdalena Poulle', p.216.

25 See M.A. da Silva and M.M. Alcides, 'Collecting and framing the wilderness: The

garden of Johan Maurits (1604–79) in North-East Brazil', *Garden History* 30 (2002), 153–76.

26 H.S. van der Straaten, *Maurits de Braziliaan: Het levensverhaal van Johan Maurits van Nassau-Siegen, stichter van het Mauritshuis, gouverneur-generaal van Nederlands-Brazilië, stadhouder van Kleef 1604–1679* (Amsterdam: van Soeren & Co., 1998)

27 Cit. da Silva and Alcides, 'Collecting and framing the wilderness', p.158.

28 Cit. ibid., p.166.

29 Cit. ibid., p.172.

30 Cit. ibid., p.150.

31 See W. Diedenhofen, '"Belvedere", or the principle of seeing and looking in the gardens of Johan Maurits van Nassau-Siegen at Cleves', in J. Dixon Hunt (ed.), *The Dutch Garden in the Seventeenth Century* (Washington DC: Dumbarton Oaks, 1988), pp.49–80.

32 For the definitive account of the 'tulipmania', see Anne Goldgar, *Tulipmania: Money, Honor, and Knowledge in the Dutch Golden Age* (Chicago and London: Chicago University Press, 2007).

33 Ibid., p.2.

34 See above, Chapter 5.

35 Goldgar and Montias have shown that paintings and tulip bulbs were both traded and bought by the same people. For the moral dilemma of disposable wealth in the United Provinces in the seventeenth century, see Schama, *Embarrassment of Riches*.

36 On Blathwayt's career see S. Saunders Webb, 'William Blathwayt, imperial fixer: From Popish Plot to Glorious Revolution', *William and Mary Quarterly* 25 (1968), 3–21; 'William Blathwayt, imperial fixer: muddling through to empire, 1689–1717', *William and Mary Quarterly* 26 (1969), 373–415.

10: Anglo–Dutch Exchange and the New Science

1 *Journaal van Constantijn Huygens, den Zoon*, p.103.

2 Ibid., p.114.

3 See L. Jardine, *Ingenious Pursuits: Building the Scientific Revolution* (London: Little, Brown, 1999), for a full bibliography.

4 Cit. Strien, *British Travellers in Holland*, p.264.

5 Ibid.

6 A coiled spring was a standard feature of a traditional clock, incorporated as a driver of the mechanism (wound up with a key to drive the clockwork as in any modern clockwork toy); Huygens's original idea was to move it to act as a regulator of the balance.

7 Oldenburg, *Correspondence* 11, 186 (translation from the French taken from the version published by Oldenburg in the *Philosophical Transactions of the Royal Society* in November 1676).

8 BL Sloane MS 1039, f.129.

9 Moray and Bruce were related by marriage, I believe (there are too many Morays/Murrays and Bruces to be able to prove this). They were both probably prominent Speculative Freemasons.

10 On the English community at Maastricht during the Commonwealth years see J.P. Vander Motten, 'Thomas Killigrew's "lost years", 1655–1660', *Neophilogus* 82 (1998), 311–34.

11 For the text of the correspondence between Sir Robert Moray and Alexander Bruce, Earl of Kincardine, see now D. Stevenson, *Letters of Sir Robert Moray to the Earl of Kincardine, 1657–73* (Aldershot: Ashgate, 2007). On Moray's laboratory see e.g. ibid., p.82.

12 Ibid., p.190. See J.H. Leopold, 'Christiaan Huygens, the Royal Society and Horology', *Antiquarian Horology* 21 (1993), 37–42; 37.

13 Stevenson, *Letters of Sir Robert Moray*, p.197.

14 Parts of the escapement mechanism in clocks.

15 Stevenson, *Letters of Sir Robert Moray*, pp.198–9.

16 The first surviving communication between Moray and Christiaan Huygens is a letter dated 22 March 1661 (o.s.), shortly before Huygens arrived in London for the first time from Paris. *Oeuvres Complètes* 3, pp.260–1. However, it is clear that the two already know one another well.

17 Huygens, *Oeuvres Complètes* 2, p.209.

18 Lodewijk Huygens writes to his brother Christiaan in this period saying that the van Aerssens' house is the most fashionable and most frequented house in The Hague.

19 Hume was chamberlain to Maria (Mary), Princess of Orange. See Oldenburg, *Correspondence* 2, p.477.

20 Stevenson, *Letters of Sir Robert Moray*, p.211.

21 Moray had played a prominent role in negotiations in Scotland during events preceding the arrest and execution of Charles I. Charles II recompensed handsomely those who had stood by his father right up to his end. See David Stevenson's introduction to his edition of the Kincardine correspondence.

22 E.L. Edwardes, *The Story of the Pendulum Clock* (1977), p.41, interprets this as a reference to a

type of 'crutch' (a fork-like device through which a clock pendulum runs) that Huygens had introduced.

23 A projection that engages on the teeth of a wheel, converting reciprocating into rotary motion (or vice-versa) in a clock.

24 Edwardes, *Story*, p.58, believed Moray wrote 'Chopes', which he identified as 'chops' or backcocks, parts of the suspension system for pendulums in clocks. But the first letter of the word is certainly 's'.

25 Stevenson, *Letters of Sir Robert Moray*, p.217.

26 On Culross, the Bruce family home, see *Royal Commission on Ancient and Historical Monuments and Constructions of Scotland: Fife, Kinross and Clackmannan* (Edinburgh: HMSO, 1933), pp.69–87. See also *Dutch-style water landscape of Culross (across the Forth of Firth)* by John Slezer (1693).

27 Culross, 15 September 1668. Worp, letter 6677.

28 Moray was delayed in Paris, negotiating the terms of Charles II's return with the French, until summer 1660.

29 See references in G.E. Scala, 'An index of proper names in Thomas Birch, "The History of the Royal Society" (London, 1756–1757)', *Notes and Records of the Royal Society of London* 28 (1974), 263–329. See also M. Hunter, *Establishing the New Science: The Experience of the Early Royal Society* (Woodbridge: Boydell Press, 1989), p.81.

30 See D.S. Landes, 'Hand and mind in time measurement: The contribution of art and science', *Notes and Records of the Royal Society of London* 43 (1989), 57–69; 61.

31 See L.D. Patterson, 'Pendulums of Wren and Hooke', *Osiris* 10 (1952), 277–321.

32 Huygens was given a commission in Paris 14 March 1661 to convey to Mme Bruce (Veronica van Aerssen van Sommelsdijck) – *Oeuvres Complètes* 22, p.561.

33 Ibid., pp.569–70.

34 Ibid., p.576.

35 Ibid., p.606.

36 *Diary of John Evelyn* 3, pp.285–6.

37 24 July 1661. See D. Stevenson, *Letters of Sir Robert Moray to the Earl of Kincardine, 1657–73* (Aldershot: Ashgate, 2007).

38 Huygens to Moray, 14/24 June 1661. *Oeuvres Complètes* 3, p.284.

39 Huygens to Moray, 22 July/1 August 1661. Ibid., p.307.

40 Huygens to Lodewijk Huygens, 31 October/9 November 1662. *Oeuvres Complètes* 4, p.256.

41 This version of events is confirmed in Hooke's 1674–75 Cutlerian lecture.

42 A description of this clock is to be found in Huygens's *Horologium Oscillatorium* (1673). See M. Mahoney, 'Christian Huygens: The measurement of time and of longitude at sea', in *Studies on Christiaan Huygens*, ed. H.J.M. Bos et al. (Lisse: Swets, 1980), pp.234–70. In an unpublished Cutlerian lecture of 1674–75, rewritten (I believe) around 1678, Hooke describes the various clocks used in these trials.

43 Huygens, *Oeuvres Complètes* 22, p.606.

44 See Leopold, 'Christiaan Huygens, the Royal Society and Horology', p.39.

45 Huygens, *Oeuvres Complètes* 4, p.278. See also Christiaan to Lodewijk, 18/28 December 1662, ibid., pp.284–5.

46 Bruce to Huygens, 2/12 January 1663. Ibid., pp.290–1.

47 Leopold, 'Clockmaking in Britain and the Netherlands', *Notes and Records of the Royal Society of London* 43 (1989), 159.

48 See Huygens to Moray, 1 December 1662 (n.s.), *Oeuvres Complètes* 4, pp.274–5, and Huygens to Moray, 10/20 December 1662, ibid., pp.280–1.

49 Moray to Huygens, 9/19 January 1663. Ibid., p.296.

50 Huygens to Moray, 2 February 1663 (n.s.). Ibid., p.304.

51 Bruce to Huygens, 16/26 January 1663. Ibid., pp.301–2.

52 Huygens to Bruce, 9/19 January 1663. *Oeuvres Complètes* 22, p.593 (this is a letter from the Kincardine papers, so is out of order in the *Oeuvres Complètes*).

53 See J.H. Leopold, 'Clockmaking in Britain and the Netherlands', *Notes and Records of the Royal Society of London* 43 (1989), 155–65; 159.

54 Moray to Huygens, 19 February/1 March 1663. *Oeuvres Complètes* 4, p.318.

55 Ibid.

56 This suspicion is confirmed by the fact that Hooke's evaluation of the Huygens longitude clocks, as recorded in the minutes of the Royal Society in 1665, repeats these criticisms in very similar words.

57 In *A Description of Helioscopes and some other Instruments* (London: T.R. for J. Martyn, 1676) (conveniently to be found cited at length in Huygens, *Oeuvres Complètes* 7, pp.517–26), Hooke gives the date of this trial as 1662. In BL Sloane MS 1039, fol. 129v, in his Cutlerian lecture on the subject he recalls the date as

March 1664. I am confident that the actual date is March 1663.

58 Conveniently to be found cited at length in *Oeuvres Complètes* 7, p.519.

59 On 22 December 1665 Pepys recorded in his diary: 'I to my Lord Brouncker's and there spent the evening by my desire in seeing his lordship open to pieces and make up again his watch, thereby being taught what I never knew before.' Cit. Leopold, 'Christiaan Huygens, the Royal Society and Horology', p.39.

60 In 1663 Christiaan Huygens was again in London with his father, and frequented the Royal Society, which made him a foreign Fellow.

61 See e.g. Pepys diary, cit. note 59 above, and Moray's exchanges with Huygens about the new-design clock he is trying to get William Davidson to collect from The Hague for him in early 1665.

62 See L.D. Patterson, 'Pendulums of Wren and Hooke', *Osiris* 10 (1952), 277–321; 283.

63 Having examined the Trinity College Cambridge Hooke papers myself, I am now confident that sheets A–L of the longitude papers are from the early 1660s, but that everything thereafter is from the 1670s, possibly as late as 1678–79. I am grateful to the Wren Library, Trinity College Cambridge, for giving me access to these papers.

64 Richard Waller, *Posthumous Works of Robert Hooke* (1705), p.v. On the Moray negotiations with Bruce and Huygens see the Kincardine papers (RS transcript), pp.406–7.

65 I base this account on the important article by Michael Wright, 'Robert Hooke's longitude timekeeper', in M. Hunter and S. Schaffer (eds), *Robert Hooke: New Studies* (Woodbridge: The Boydell Press, 1989), pp.63–118. Wright's compilation of key recorded moments in Hooke's spring-regulated timekeeper development is at pp.76–8.

66 Huygens, *Oeuvres Complètes* 5, pp.503–4 (letter 1481). This is one of the two letters Hooke considered to constitute a betrayal of his confidence to Huygens on Moray's part. The other is that of 22 July 1665. Huygens, *Oeuvres Complètes* 5, pp.426–8 (letter 1436).

67 'Mr. Hooke having made a proposition of giving the discovery of the longitude, as he conceived it, to the society, it was ordered, that he should choose such persons to

commit this business to, as he thought good, and make the experiment; that by such persons chosen, the council might be satisfied of the truth and practicableness of his invention, and proceed accordingly to take out a patent for him.'

68 Richard Waller, *Posthumous Works of Robert Hooke* (1705), p.v.

69 Ibid.

70 I am extremely grateful to Felix Pryor for assisting me in tracking down this document, and giving me sight of a legible photocopy.

71 See Waller, *Posthumous Works*, p.vi.

72 Holmes was already carrying out tests of deep-sea sounding devices for the Royal Society.

73 Holmes's account of this incident is recorded in the Journal Books of the Royal Society for 11 January 1665. See Birch 2, pp.4–5.

74 Huygens, *Oeuvres Complètes* 5, p.204 (letter 1315). See also ibid., pp.222–3 (letter 1324).

75 Ibid., p.224 (letter 1325).

76 *Philosophical Transactions* 1, 6 March 1665.

77 The grave outbreak of plague in July 1665, which necessitated the removal of the Court first to Hampton Court and then to Oxford, and the dispersal of the Royal Society members to the safety of the country, marked the end of this phase in Hooke's longitude timekeeper aspirations.

78 See below, Chapter 12.

79 It is via the Isle of Wight route that Holmes's path crossed that of Robert Hooke (born on that island). It has been plausibly argued that Grace, Robert's niece, was the mother of Holmes's illegitimate daughter Mary. See L. Jardine, *The Curious Life of Robert Hooke: The Man Who Measured London* (London: HarperCollins, 2003).

80 Huygens, *Oeuvres Complètes* 5, p.224 (letter 1325). Huygens's attitude to his first longitude clocks was entirely consistent: he doubted their suitability from the start (*Oeuvres Complètes* 4, p.285).

81 Huygens, *Oeuvres Complètes* 5, p.256 (letter 1345).

82 Birch 2, p.21.

83 For a clear sense of the concern caused by Holmes's conduct on that voyage, and Pepys's lack of trust of him, see Pepys, *Diary* 6, p.43.

84 Ibid., p.56.

85 Birch, *A History of the Royal Society* 2, p.23.

86 Moray also added two further experiments

Holmes claimed to have carried out with the clocks (ibid.).

87 Ibid., p.26.

88 I owe this discovery to C.H. Wilson, 'Who captured New Amsterdam?', *English Historical Review* 72 (1957), 469–74: 'Fortunately our answer [to the question of whether Holmes was involved in the capture of New Amsterdam in 1664] need not rest on surmise, for we have Holmes's own account of his movements during the months when he is supposed by some historians to have been on his way to America, and capturing New Amsterdam [*Captain Robert Holmes his Journalls of Two Voyages into Guynea in his M[ajesty']s Ships The Henrietta and the Jersey*, Pepys Library Sea MSS. No. 2698]' (pp. 472–3).

89 For Holmes's buccaneering style, see *Captain Robert Holmes his Journalls of Two Voyages...*, p.168.

90 See Patterson, 'Pendulums of Wren and Hooke', pp.302–5.

91 Huygens, *Oeuvres Complètes* 7, pp.323–4. Bruce's response to receiving his own complimentary copy of Huygens's *Horologium Oscillatorium* was similarly critical. See Leopold, 'Clockmaking in Britain and the Netherlands', p.41.

11: Science Under the Microscope

1 I am extremely grateful to Dr Jan Broadway for this reference.

2 On the history of discovery and development of the microscope in the Netherlands see E.C. Ruestow, *The Microscope in the Dutch Republic: The Shaping of Discovery* (Cambridge: Cambridge University Press, 1996), and S. Alpers, *The Art of Describing: Dutch Art in the Seventeenth Century* (Chicago: Chicago University Press, 1983).

3 It received the imprimatur of the Royal Society on 23 November 1664.

4 For a fuller version of this episode see L. Jardine, 'Robert Hooke: A reputation restored', in M. Cooper et al. (eds), *Robert Hooke: Tercentennial Studies* (Ashgate, 2006), pp.247–58.

5 13 February 1665. Huygens, *Oeuvres Complètes* 5, p.236.

6 Ibid., p.245.

7 On Huygens's annotations of his copy see M. Barth, 'Huygens at work: Annotations in his rediscovered personal copy of Hooke's "Micrographia"', *Annals of Science* 52 (1995), 601–13.

8 Huygens, *Oeuvres Complètes* 5, p.240.

9 See the letter of thanks sent by Auzout to Sir Constantijn Huygens. I accept McKeon's redating of this letter: R.K. McKeon, *Établissement de l'Astronome de Précision et Oeuvre d'Adrien Auzout* (2 fascicules), Thèse présentée pour le Doctorat du Troisième Cycle (Paris, 1965).

10 5 June 1665 (n.s.). Huygens archive, Leiden.

11 Auzout proposed setting up the Observatory in the dedicatory letter to Louis XIV which prefaced his *L'Ephéméride du comète de 1664* (1665).

12 Hooke, *Micrographia*, fol. e1v.

13 Such a printed report is equivalent, in the period, to a priority claim, preceding an application for patent.

14 A. Auzout, *Lettre à Monsieur l'Abbé Charles, sur la Ragguaglio di nuove Osservationi da Giuseppe Campani* (Paris, 1665). Campani's book was reviewed in the first issue of the *Philosophical Transactions* in London in March 1665.

15 Auzout and the Royal Society (i.e. Oldenburg) had been corresponding since early January 1665, following the publication of Auzout's *L'Ephéméride du comète*. See A.R. and M.B. Hall (eds and trans.), *The Correspondence of Henry Oldenburg*, 13 volumes: vols 1–9 (Madison: University of Wisconsin Press, 1965–73); vols 10–11 (London: Mansell, 1975–76); vols 12–13 (London: Taylor & Francis, 1986) 2, pp.341; pp.359–68. The *Journal des sçavans* began publication in January 1665, but ceased after three months. It began again in January 1666. Thus Auzout's published letters may well have been intended for publication in the *Journal*, where indeed a review of the Campani (probably by Auzout) was eventually published in January 1666.

16 See Oldenburg, *Correspondence* 2, pp.383–410.

17 Ibid., p.384. See also Preface fol. b1r.

18 Ibid., p.420.

19 Ibid., p.429.

20 M. Hunter, A. Clericuzio, and L.M. Principe, *The Correspondence of Robert Boyle*, 6 vols (London: Pickering & Chatto, 2001) 2, p.387.

21 Moray also explained to Huygens that Hooke was having to put a lot of effort into preparing the lectures he had undertaken under the sponsorship of Sir John Cutler. So Cutler (another who dogged Hooke's career, and caused him long-running difficulties) is already involved in this episode.

22 Huygens, *Oeuvres Complètes* 5, p.213.

23 Huygens had already made a note to himself to make the iron circle a modification in his

own machine six months earlier.

24 13 September 1664 (Huygens archive, Leiden). In October 1665 Moray (in Oxford) reported to Huygens that Oldenburg had informed him by letter that trials were revealing further problems (Huygens, *Oeuvres Complètes* 5, pp.503–6).

25 For the intimate (indeed, passionately affective) tone of these letters, at least in the early days of the correspondence, see the first letter sent by Moray, 31 May 1661 (Huygens archive, Leiden; also transcribed in Huygens, *Oeuvres Complètes*).

26 This is confirmed by the fact that on 2 November 1664 Hooke was admonished to 'endeavour to have his new instrument for grinding optic-glasses ready against the next meeting' (T. Birch, *A History of the Royal Society of London for Improving Natural Knowledge, from its first Rise*, 4 vols (London, 1756) 1, p.483).

27 McKeon, *Établissement de l'Astronome de Précision* 2, pp.209–10.

28 Huygens, *Oeuvres Complètes* 5, p.156. See McKeon 1965 2, pp.111–12.

29 This interest in Campani's techniques for making high-accuracy telescopes formed part of a larger debate about the Copernican theory of planetary motion, and the Inquisition's attitude towards it. See for instance the review of Auzout's *Lettre à Monsieur l'Abbé Charles* (Paris, 1665) in the *Journal des sçavans* of 11 January 1666.

30 See McKeon, *Établissement de l'Astronome de Précision* 2, p.211.

31 Huygens, *Oeuvres Complètes* 5, p.174, 25 December 1664. McKeon 1965 2, p.112.

32 Huygens, *Oeuvres Complètes* 5, p.198, minute of a letter dated 15 January 1665.

33 On 2 January 1665 Huygens wrote to Moray impatiently asking for more information about Hooke's working model of the lathe. He described how, in his own trials, he did better by keeping the circle fixed. Huygens, *Oeuvres Complètes* 5, p.186. See also ibid., p.346, and *Oeuvres Complètes* 22, pp.82–4.

34 This was not the only 'leak' of Hooke's lens-grinding machine. See Oldenburg, *Correspondence* 2, p.306.

35 Ibid., pp.441–2.

36 Hunter, Clericuzio and Principe, *The Correspondence of Robert Boyle* 2, p.493.

37 During the early months of the plague exchange of letters between London and the rest of England was hampered by anxieties over infection.

38 Oldenburg, *Correspondence* 2, p.529.

39 Ibid., p.538.

40 Hunter, Clericuzio and Principe, *The Correspondence of Robert Boyle* 2, pp.610–11.

41 Oldenburg, *Correspondence* 2, p.474. The original is bound in the back of a copy of A. Auzout, *Réponse de Monsieur Hook aux considerations de M. Auzout. Contenue dans vne lettre écrite à l'auteur des Philosophical Transactions, et quelques lettres écrites de part & d'autre sur le sujet des grandes lunetes. Traduite d'anglois* (Paris, 1665), in the BL.

42 Oldenburg, *Correspondence* 2, p.516 (author's translation).

43 Ibid., pp.447, 448, 452–3.

44 The Halls' annotations to the letters in the Oldenburg *Correspondence* treat Hooke's contribution consistently as if it were an ill-conceived and botched project, and as if Auzout were self-evidently correct in all his criticisms.

45 Oldenburg, *Correspondence* 2, p.83. Wren's position was presumably not helped by the fact that he had recently had to concede Huygens's superior talent as an observational and theoretical astronomer, when Huygens's model for the rings of Saturn was demonstrably more plausible than the one Wren had himself come up with.

46 See Hunter, Clericuzio and Principe, *The Correspondence of Robert Boyle* 2, p.544, Boyle to Oldenburg, 30 September 1665.

47 Christiaan Huygens's father is a key figure in the establishing of his official scientific position in Paris. Several letters show Huygens thanking the King for allowing his father's intercession on his behalf in the matter of the Académie des sciences appointment, and for lavish gifts for his father from the King, sent in appreciation of his efforts.

48 Auzout to Oldenburg, 1 July 1665. Oldenburg, *Correspondence* 2, p.428.

49 See Hunter, Clericuzio and Principe, *The Correspondence of Robert Boyle* 2, p.504; p.517.

50 This was yet another responsibility Hooke had taken over from someone else, this time from Wren, who had given up the job on the excuse that he was about to be sent to France by the King.

51 i.e. Cutler lectures.

52 1 August 1665. Huygens, *Oeuvres Complètes* 5, p.427.

53 Oldenburg, *Correspondence* 2, pp.294, 297.

54 My own view is that this review is by

Auzout, though it might be by Justel.
55 Cit. C.D. Andriesse, *Titan kan niet slapen: een biografie van Christiaan Huygens* (Amsterdam: Contact, 1993), French trans. D. Losman, *Christian Huygens* (Paris: Albin Michel, 1998), p.348.
56 Huygens to Constantijn Huygens, 30 December 1688, cit. R. Westfall, *Never at Rest: A Biography of Isaac Newton* (Cambridge: Cambridge University Press, 1980), p.473.
57 Cit. Andriesse, *Christian Huygens*, p.377.
58 From the diary of Constantijn Huygens, cit. ibid., p.378.
59 This account is based on Westfall, *Never at Rest*, Chapter 11. See also Westfall, *Never at Rest*, p.473.
60 It was during this period that Hooke and Newton met at Halley's house, and Hooke failed to get satisfaction once again over his being credited with some part in the inverse square law.
61 Ibid., pp.378–9.
62 From the diary of Christiaan Huygens, cit. Andriesse, *Christian Huygens*, p.380.
63 Westfall, *Never at Rest*, p.480.
64 Some scholars maintain that these discussions took place at Hampton Court. The two men were, however, both in London for several months, and had ample opportunity to seek out each other's company.
65 Westfall, *Never at Rest*, p.488.
66 Ibid., p.496.
67 Christiaan Huygens died at Hofwijk in 1695.
68 Wren also found himself largely out of favour, though his ongoing architectural projects, and his usefulness to Queen Mary in her many rebuilding projects, sustained his public position until her death.
69 Hooke was by now no longer being remunerated as Curator of Experiments, though he continued to appear at meetings, lecture and lead discussions of experiments. It was probably about this time that a letter – evidently orchestrated by Hooke – was sent to Halley as Clerk of the Royal Society, urging him to take Hooke on once more in a salaried position. This letter is reproduced in J.B. Nichols, *Illustrating the Literary History of the Eighteenth Century* (London: J.B. Nichols & Son, 1822) 4, pp.66–7.
70 Westfall, *Never at Rest*, pp.174–5.
71 See Newton to Oldenburg, 19 March 1672, cit. Westfall, *Never at Rest*, p.245.

72 Newton to Oldenburg, 21 December 1675, cit. ibid., p.273.
73 Cit. A.R. Hall, 'Two unpublished lectures of Robert Hooke', *Isis* 42 (1951), 220.
74 Ibid.
75 Ibid., p.222.
76 Ibid., p.224.
77 Ibid., p.220.
78 For Newton's detailed marginal annotations in his copy of *Micrographia*, see G. Keynes, *A Bibliography of Robert Hooke* (Oxford: The Clarendon Press, 1966), pp.97–108.
79 Jardine, *Curious Life of Robert Hooke*, Chapter 8.
80 See Andriesse, *Huygens*, pp.203–13.
81 Cit. ibid., p.210.
82 This account is based on R.S. Wilkinson, 'John Winthrop, Jr., and America's first telescopes', *New England Quarterly* 35 (1962), 520–3, and J.W. Streeter, 'John Winthrop, Junior, and the fifth satellite of Jupiter', *Isis* 39 (1948), 159–63.
83 See below, Chapter 12.
84 Cit. Streeter, 'John Winthrop', p.161.

12: Anglo–Dutch Influence Abroad
1 T. Sprat, *The history of the Royal-Society of London for the improving of natural knowledge* (London, 1667), pp.88–9.
2 On the early history of New Netherland see J. Jacobs, *New Netherland: A Dutch Colony in Seventeenth-Century America* (Leiden: Brill, 2005), and J. Venema, *Beverwijck: A Dutch Village on the American Frontier, 1652–1664* (Albany and Hilversum: State of New York University Press and Verloren, 2003). For a thoroughly readable general book see R. Shorto, *The Island at the Centre of the World: The Untold Story of Dutch Manhattan and the Founding of New York* (New York: Doubleday, 2004).
3 Jacobs, *New Netherland*, p.475.
4 Cit. Shorto, *The Island at the Centre of the World*, pp.63–4.
5 Jacobs, *New Netherland*, p.373.
6 Ibid., p.93.
7 Ibid., p.143.
8 For a full account see ibid., passim.
9 *Captain Robert Holmes his Journalls of Two Voyages into Guynea in his M[ajestie]'s Ships the Henrietta and the Jersey*, Pepys Library Sea MSS. No. 2698, p.168.
10 J.D. Davies, 'Holmes, Sir Robert (c.1622–1692)', *Oxford Dictionary of National Biography*, Oxford University Press, 2004 [http://www.oxforddnb.com.catalogue.ulrls.lon.ac.uk:80/view/article/13600, accessed 4

June 2007]. On the canard that it was Holmes who actually attacked and took New Amsterdam see C.H. Wilson, 'Who captured New Amsterdam?', *English Historical Review* 72 (1957), 469–74.

11 Cit. J. Scott, '"Good night Amsterdam"': Sir George Downing and Anglo–Dutch state-building', *English Historical Review* 118 (2003), 334–56; 346.

12 Ibid., pp.346–7.

13 Shorto, *Island at the Centre of the World*, p.330.

14 M. Kurlansky, *The Big Oyster: New York in the World, A Molluscular History* (London: Jonathan Cape, 2006), p.37.

15 Antonivaz, 9 May 1642. Worp, letter 2996.

16 See C. Lesger, *The Rise of the Amsterdam Market and Information Exchange: Merchants, Commercial Expansion and Change in the Spatial Economy of the Low Countries, c. 1550–1630* (Aldershot: Ashgate, 2006).

17 T. Sprat, *The history of the Royal-Society of London for the improving of natural knowledge* (London, 1667), p.401.

18 Cit. M. 'T Hart, 'Cities and statemaking in the Dutch Republic, 1580–1680', *Theory and Society* 18 (1989), 663–87; 663.

19 Cit. ibid., p.674.

20 Cit. ibid., p.679.

21 Lesger, *Rise of the Amsterdam Market*, p.224.

22 H.J. Cook, *Matters of Exchange: Commerce, Medicine, and Science in the Dutch Golden Age* (New Haven and London: Yale University Press, 2007). See also H. J. Cook, 'Time's bodies: crafting the preparation and preservation of naturalia', in P.H. Smith and P. Findlen (eds), *Merchants and Marvels: Commerce, Science and Art in Early Modern Europe* (London: Routledge, 2002), pp.223–47, and 'The cutting edge of a revolution? Medicine and natural history near the shores of the North Sea', in J.V. Field and F.A.J.L. James (eds), *Renaissance and Revolution: Humanists, Scholars, Craftsmen and Natural Philosophers in Early Modern Europe* (Cambridge: Cambridge University Press, 1993), pp.45–61.

23 L. Neal, 'Venture shares in the Dutch East India Company', draft paper, 'prepared for the Yale School of Management Conference of Interest and Enterprise: Essays in Financial Innovation March 6 & 7, 2003, Yale University' (consulted online).

24 This account of the VOC and its economic significance is based on J. de Vries and A. van der Woude, *The First Modern Economy: Success, Failure and Perseverance of the Dutch Economy,*

1500–1815 (Cambridge: Cambridge University Press, 1997), pp.382–96 and 457–64.

25 Ibid., p.385.

26 W. Temple, *Miscellanea…by a person of honour* (London: E. Gellibrand, 1680), pp.204–5.

27 Ibid., pp.214–15.

28 See H.J. Cook, *Matters of Exchange: Commerce, Medicine and Science in the Dutch Golden Age* (New Haven and London: Yale University Press, 2007), pp.349–77.

29 Cit. ibid., p.371.

30 Wilhelmi […] P.[…] J.[…] […] […] Transisalano Daventriensis Dissertatio de arthritide: Mantissa schematica: De acupunctura: et Orationes tres, I. De chymiæ ac botaniæ antiquitate & dignitate. II. De physiognomia: III. De monstris. Singula ipsius authoris notis illustrata (London, 1683). For more on this treatise see R.W. Carrubba and J.Z. Bowers, 'The western world's first detailed treatise on acupuncture: Willem Ten Rhijne's De Acupunctura', *Journal of the History of Medicine* 29 (1974), 371–98.

31 For the Anglo–Dutch context for this discussion of George Downing's attitude to Dutch Republican fiscal policies, see Jonathan Scott, *England's Troubles: Seventeenth Century English Political Instability in European Context* (Cambridge: Cambridge University Press, 2000), and Scott, 'What the Dutch Taught Us: The Late Emergence of the Modern British State', *Times Literary Supplement* (16 March 2001), pp.4–6.

32 See Jonathan Scott, 'Downing, Sir George, first baronet (1623–1684)', *Oxford Dictionary of National Biography*, Oxford University Press, 2004 [http://www.oxforddnb.com. catalogue. ulrls.lon.ac.uk:80/view/article/7981, accessed 10 June 2007]

33 Cit. Scott, '"Good night Amsterdam"', p.344.

34 The account that follows of Downing's important role in shaping English fiscal policy after the Restoration is based on ibid., pp.334–56.

35 Ibid., p.354.

Conclusion: Going Dutch

1 William returned to The Hague in late February 1671.

2 William was made Captain General (overall military commander) by the States General in 1671, and Stadholder in 1672, following the murder of the de Witt brothers and the fall of the Republic.

3 W. Troost, *William III, the Stadholder-King: A Political Biography*, trans. J.C. Grayson

(Aldershot: Ashgate, 2005), pp.63–4.

4 PRO, LC5/2, pp.29–31. I am extremely grateful to Dr Anna Keay of English Heritage for passing this reference to me.

5 Troost, *William III, the Stadholder-King*, pp.62–3.

6 Worp, letter 6778.

7 Worp, letter 7077.

8 De Gedichten van Constantijn Huygens online, University of Leiden website: http://www.let.leidenuniv.nl/Dutch/Huygens/index.html.

9 See Wren family, *Parentalia*, p.323.

10 CLRO, RCA 82, fol. 268v.

11 J.E. Moore, 'The Monument, or, Christopher Wren's Roman accent', *Art Bulletin* 80 (1998), 498–533.

12 An Act of Parliament of 1667 contained the instruction that: 'The better to preserve the memory of this dreadful visitation; Be it further enacted that a Columne or Pillar of Brase or Stone be erected on or as neare unto the place where the said Fire so unhappily began as Conveniently as may be, in perpetuall Remembrance thereof, with such Inscription thereon, as hereafter by the Mayor and Court of Aldermen in that behalfe be directed.' Work excavating the foundations was completed in November 1671, and construction must have commenced shortly thereafter.

13 Cit. van Strien, *British Travellers in Holland*, p.263.

14 KA 48 fol. 5. Constantijn Huygens to Christopher Wren, 'Surveyor of the Kings buildings'.

15 Offenberg expresses uncertainty as to whether the letter addressed to 'a courtier at the court of the Prince of Orange' was actually intended for Huygens (p.420). The letter to Wren (to which Offenberg does not refer) confirms that this was indeed the case.

16 See A. Offenberg, 'Dirk van Santen and the Keur Bible: New insights into Jacob Judah (Ayre) Leon Templo's model Temple', *Studia Rosenthaliana* 37 (2004), 401–22. Thanks to Moti Feingold for bringing this article to my attention.

17 Hooke, *Diary*, p.179.

Bibliography of Secondary Sources

Adamson, J. (ed.), *The Princely Courts of Europe 1500–1750* (London: Weidenfeld & Nicolson, 1999)

Akkerman, N.N.W., *The Letters of the Queen of Bohemia* (unpublished dissertation, Free University of Amsterdam, 2008)

Akkerman, N.N.W., and P.R. Sellin, 'A Stuart Masque in Holland, Ballet de la Carmesse de La Haye (1655)', Parts 1 and 2, *Ben Jonson Journal* 11 (2004), 207–58; 227 and 12 (2005), 141–64

Akkerman, N.N.W., and Marguérite Corporaal, 'Mad Science Beyond Flattery: The Correspondence of Margaret Cavendish and Constantijn Huygens', *Early Modern Literary Studies* Special Issue 14 (May 2004), 2.1–21 [http://purl.oclc.org/emls/si-14/akkecorp.html]

Alpers, S., *The Art of Describing: Dutch Art in the Seventeenth Century* (Chicago: Chicago University Press, 1983)

Andriesse, C.D., *Titan kan niet slapen: een biografie van Christiaan Huygens* (Amsterdam: Contact, 1993), French trans. D. Losman, *Christian Huygens* (Paris: Albin Michel, 1998)

Andriesse, C.D., trans. S. Miedema, *Huygens: The Man behind the Principle* (Cambridge: Cambridge University Press, 2005)

Asch, R.G., 'Elizabeth, Princess (1596–1662)', *Oxford Dictionary of National Biography*, Oxford University Press, Sept 2004; online edn, May 2006 [http://www.oxford dnb.com.catalogue.ulrls.lon.ac.uk:80/view/article/8638, accessed 27 March 2007]

Bachrach, A.G.H., *Sir Constantine Huygens and Britain*, 1 (Leiden and Oxford: Brill and Oxford University Press, 1962)

Bachrach, A.G.H., and R.G. Collmer (eds), *Lodewijk Huygens: The English Journal 1651–1652* (Leiden: Brill, 1982)

Barth, M., 'Huygens at work: Annotations in his rediscovered personal copy of Hooke's "Micrographia"', *Annals of Science* 52 (1995), 601–13

Baxter, S.B., *William III* (London: Longmans, 1966)

Beddard, R., 'The unexpected Whig revolution of 1688', in Beddard (ed.), *The Revolutions of 1688* (Oxford: Clarendon Press, 1991), pp.11–101

Beddard, R., *A Kingdom without a King: The Journal of the Provisional Government in the Revolution of 1688* (Oxford: Phaidon, 1988)

Beer, E.S. de (ed.), *The Diary of John Evelyn*, 6 vols (Oxford: Clarendon Press, 1955; reprinted 2000)

Beneden, B. van, and Nora de Poorter (eds), *Royalist Refugees: William and Margaret Cavendish in the Rubens House 1648–1660* (Antwerp: Rubenshuis & Rubenianum, 2006)

Beneden, B. van, 'Introduction', in B. van Beneden and Nora de Poorter (eds), *Royalist Refugees: William and Margaret Cavendish in the Rubens House 1648–1660* (Antwerp: Rubenshuis & Rubenianum, 2006)

Birch, T., *A History of the Royal Society of London for Improving Natural Knowledge, from its first Rise*, 4 vols (London, 1756)

Blom, F. (ed.), *Constantijn Huygens: Mijn Leven verteld aan mijn Kinderen*, 2 vols (Amsterdam: Prometheus/Bert Bakker, 2003)

Blom, F.R.E. (ed.), *Constantijn Huygens: Journaal van de Reis naar Venetië* (Amsterdam: Prometheus Publishers, 2003)

Bosher, J.F., 'Huguenot merchants and the Protestant International in the seventeenth-century', *William and Mary Quarterly* 52 (1995), 77–102

Brewer, J., *The Sinews of Power: War, Money and the English State, 1688–1783* (New York, 1989)

Brodsley, L., C. Frank and J.W. Steeds, 'Prince Rupert's drops', *Notes and Records of the Royal Society* 41 (1986), 1–26

Brotton, J., *The Sale of the Late King's Goods* (London: Macmillan, 2006)

Brown, B.C. (ed.), *The Letters and Diplomatic Instructions of Queen Anne* (London: Cassell and Company Ltd, 1935)

Brown, J., 'The Sale of the Century', in *Kings and Connoisseurs: Collecting Art in Seventeenth-Century Europe* (New Haven and London: Yale University Press, 1995), pp.59–94

Brown, J., and J. Elliott (eds), *The Sale of the Century: Artistic Relations Between Spain and Great Britain, 1604–1655* (New Haven and London: Yale University Press, 2002)

Bruijn, J.R., 'William III and his two navies', *Notes and Records of the Royal Society of London* 43 (1989), 117–32

Brusati, C., *Artifice and Illusion: The Art and Writing of Samuel van Hoogstraten* (Chicago and London: Chicago University Press, 1995)

Carlos, A.M., J. Jey and J.L. Dupree, 'Learning and the creation of stock-market institutions: Evidence from the Royal African and Hudson's Bay Companies, 1670–1700', *Journal of Economic History* 58 (1998), 318–44

Carrubba, R.W., and J.Z. Bowers, 'The western world's first detailed treatise on acupuncture: Willem Ten Rhijne's De Acupunctura', *Journal of the History of Medicine* 29 (1974), 371–98

Chambers, D., '"Elysium Britannicum not printed neere ready &c": The "Elysium Britannicum" in the Correspondence of John Evelyn', in T. O'Malley and J. Wolschke-Bulmahn (eds), *John Evelyn's 'Elysium Britannicum' and European Gardening* (Washington DC: Dumbarton Oaks, 1998), pp.107–30

Claydon, T., *William III and the Godly Revolution* (Cambridge: Cambridge University Press, 1996)

Colie, R.L., *'Some Thankfulnesse to Constantine,' A Study of English Influence upon the Early Works of Constantijn Huygens* (The Hague: Nijhoff, 1956)

Colvin, H., *A Biographical Dictionary of British Architects 1600–1840*, third edition (New Haven and London: Yale University Press, 1995)

Cook, H.J., *Matters of Exchange: Commerce, Medicine and Science in the Dutch Golden Age* (New Haven and London: Yale University Press, 2007)

Cook, H.J., 'The cutting edge of a revolution? Medicine and natural history near the shores of the North Sea', in J.V. Field and F.A.J.L. James (eds), *Renaissance and Revolution: Humanists, Scholars, Craftsmen and Natural Philosophers in Early Modern Europe* (Cambridge: Cambridge University Press, 1993), pp.45–61

Cook, H.J., 'Time's bodies: Crafting the preparation and preservation of naturalia', in P.H. Smith and P. Findlen (eds), *Merchants and Marvels: Commerce, Science and Art in Early Modern Europe* (London: Routledge, 2002), pp.223–47

Couch, S.M., 'The practice of avenue planting in the seventeenth and eighteenth centuries', *Garden History* 20 (1992), 173–200

Crawford, T., '"Allemande Mr. Zuilekom". Constantijn Huygens's sole surviving instrumental composition', *Tijdschrift van de Vereniging voor Neederlandse Muziekgeschiedenis* 37 (1987), 175–81

Damme, I. van, 'A city in transition: Antwerp after 1648', in B. van Beneden and Nora de Poorter (eds), *Royalist Refugees: William and Margaret Cavendish in the Rubens House 1648–1660* (Antwerp: Rubenshuis & Rubenianum, 2006), pp.55–62

Darley, G., *John Evelyn: Living for Ingenuity* (London: Yale University Press, 2006)

Davids, K., and J. Lucassen (eds), *A Miracle Mirrored: The Dutch Republic in European Perspective* (Cambridge: Cambridge University Press, 1996)

Davidson, P., and A. van der Weel (eds and trans.), *A Selection of the Poems of Sir Constantijn Huygens (1596–1687)* (Amsterdam: Amsterdam University Press, 1996)

Dethloff, D., 'Lely, Sir Peter (1618–1680)', *Oxford Dictionary of National Biography*, Oxford University Press, 2004 [http://www.oxforddnb.com.catalogue.ulrls.lon.ac.uk:80/view/article/16419, accessed 2 April 2007]

Dickson, P.G.M., *The Financial Revolution in England: A Study in the Development of Public Credit, 1688–1756* (London: Macmillan, 1967)

Diedenhofen, W., '"Belvedere", or the principle of seeing and looking in the gardens of Johan Maurits van Nassau-Siegen at Cleves', in J. Dixon Hunt (ed.), *The Dutch Garden in the Seventeenth Century* (Washington DC: Dumbarton Oaks, 1988), pp.49–80

Dogaer, G., 'De inventaris der schilderijen van Diego Duarte', *Jaarboek van het Koninklijk Museum voor schone Kunsten Antwerpen* (1971), 195–221

Edwardes, E.L., *The Story of the Pendulum Clock* (London: Sherratt Publishing, 1977)

Field, J.V., and F.A.J.L. James (eds), *Renaissance and Revolution: Humanists, Scholars, Craftsmen and Natural Philosophers in Early Modern Europe* (Cambridge: Cambridge University Press, 1993)

Furgol, E.M., 'Morgan, Sir Charles (1575/6–1643)', *Oxford Dictionary of National Biography*, Oxford University Press, 2004 [http://www.oxforddnb.com.catalogue.ulrls.lon.ac.uk:80/view/article/19217, accessed 7 April 2007]

Gelder, J.G. van, 'Rubens in Holland in de Zeventiende Eeuw', *Nederlands Kunsthistorisch Jaarboek* 3 (1950–51), 103–50

Gelder, J.G. van, 'Rubens Marginalia IV', *Burlington Magazine* 123 (1981)

Gelderblom, A.-J., 'The publisher of Hobbes's Dutch *Leviathan*', in S. Roach (ed.), *Across the Narrow Seas: Studies in the History and Bibliography of Britain and the Low Countries* (London: The British Library, 1991), 162–6

Geyl, P., 'Frederick Henry of Orange and King Charles I', *English Historical Review* 38 (1923), 355–83

Geyl, P., *Orange and Stuart 1641–1672* (London: Phoenix Press, 2001; first English edition 1969)

Golahny, A., M.M. Mochizuki and L. Vergara, *In His Milieu: Essays on Netherlandish Art in Memory of John Michael Montias* (Amsterdam: Amsterdam University Press, 2006)

Goldgar, A., 'Poelenburch's garden: Art, flowers, networks, and knowledge in seventeenth-century Holland', in A. Golahny, M.M. Mochizuki and L. Vergara, *In His Milieu: Essays on Netherlandish Art in Memory of John Michael Montias* (Amsterdam: Amsterdam University Press, 2006), pp.183–92

Goldgar, A., 'Nature as art: The case of the tulip', in P.H. Smith and P. Findlen (eds), *Merchants and Marvels: Commerce, Science and Art in Early Modern Europe* (London: Routledge, 2002), pp.324–46

Goldgar, A., *Tulipmania: Money, Honor, and Knowledge in the Dutch Golden Age* (Chicago and London: Chicago University Press, 2007)

Grew, M.E., *William Bentinck and William III (Prince of Orange): The Life of Bentinck Earl of Portland from the Welbeck Correspondence* (London: John Murray, 1924)

Grijp, L.P., '"Te voila donc, bel oeil": An autograph tablature by Constantijn Huygens', *Tijdschrift van de Vereniging voor Nederlandse Muziekgeschiedenis* 37 (1987), 170–4

Groenveld, S., '"J'equippe une flotte très considerable": The Dutch side of the Glorious Revolution', in R.Beddard (ed.), *The Revolutions of 1688* (Oxford: Clarendon Press, 1991), pp.213–45

Groenveld, S., 'Frederick Henry and his entourage: A brief political biography', in P. van der Ploeg and C. Vermeeren (eds), *Princely Patrons: The Collection of Frederick Henry of Orange and Amalia of Solms in The Hague* (Zwolle: Waanders Publishers, 1997), pp.18–33

Groenveld, S., 'The house of Orange and the house of Stuart, 1639–1650: A revision', *Historical Journal* 34 (1991), 955–72

Groot, C.H. de, *Die Urkunden uber Rembrandt* (The Hague: M. Nijhoff, 1906)

Hall, A.R. and M.B. (eds and trans.), *The Correspondence of Henry Oldenburg*, 13 volumes: vols 1–9 (Madison: University of Wisconsin Press, 1965–73); vols 10–11 (London: Mansell, 1975–76); vols 12–13 (London: Taylor & Francis, 1986)

Hart, Marjolein 'T., 'Cities and statemaking in the Dutch Republic, 1580–1680', *Theory and Society* 18 (1989), 663–87

Hartog, E. den, and C. Teune, 'Gaspar Fagel (1633–88): His garden and plant collection at Leeuwenhorst', *Garden History* 30 (2002), 191–205

Held, J.S., 'Constantijn Huygens and Susanna van Baerle: A hitherto unknown portrait', *Art Bulletin* 73 (1991), 653–68

Hill, R., 'Ambassadors and art collecting in early Stuart Britain: The parallel careers of William Trumbull and Sir Dudley Carleton, 1609–1625', *Journal of the History of Collections* 15 (2003), 211–28

Hill, R., 'Sir Dudley Carleton and his relations with Dutch artists 1616–1632', in E. Domela, M. van de Meij-Tolsma, J. Roding et al., *Dutch and Flemish Artists in Britain 1550–1700* (Leiden: Primavera Press/Leids Kunsthistorisch Jaarboek, 2003), pp.255–74

Hoak, D., 'The Anglo–Dutch revolution of 1688–89', in D. Hoak and M. Feingold (eds), *The World of William and Mary: Anglo–Dutch Perspectives on the Revolution of 1688–89* (Stanford: Stanford University Press, 1996), pp.1–26

Honig, E.A., 'The art of being "artistic": Dutch women's creative practices in the 17th century', *Woman's Art Journal* 22 (2001–02), 31–9

Honig, E.A., *Painting and the Market in Early Modern Antwerp* (New Haven and London: Yale University Press, 1998)

Howarth, D., *Images of Rule: Art and Politics in the English Renaissance, 1485–1649* (London, 1997)

Huisken, J., K. Ottenheym and G. Schwartz, *Jacob van Campen: Het klassieke ideal in de Gouden Eeuw* (Amsterdam: Architectura & Natura Pers, Stichting Koninklijk Paleis Amsterdam, 1995)

Hulse, L., 'Cavendish, William, first Duke of Newcastle upon Tyne (bap. 1593, d. 1676)', *Oxford Dictionary of National Biography*, Oxford University Press, Sept 2004; online edn, May 2006 [http://www.oxforddnb.com.catalogue.ulrls.lon.ac.uk:80/view/article/4946, accessed 9 April 2007]

Hunt, J.D., 'Anglo–Dutch garden art', in D. Hoak and M. Feingold (eds), *The World of William and Mary: Anglo–Dutch Perspectives on the Revolution of 1688–89* (Stanford: Stanford University Press, 1996)

Hunt, J.D. (ed.), *The Dutch Garden in the Seventeenth Century* (Washington DC: Dumbarton Oaks, 1988)

Hunter, M., *Establishing the New Science: The Experience of the Early Royal Society* (Woodbridge: Boydell Press, 1989)

Hunter, M., A. Clericuzio and L.M. Principe, *The Correspondence of Robert Boyle*, 6 vols (London: Pickering & Chatto, 2001)

Israel, J.I., 'General Introduction', in Israel (ed.), *The Anglo–Dutch Moment: Essays on the Glorious Revolution and its World Impact* (Cambridge: Cambridge University Press, 1991), p.1

Israel, J.I., 'Propaganda in the making of the Glorious Revolution', in S. Roach (ed.), *Across the Narrow Seas: Studies in the History and Bibliography of Britain and the Low Countries* (London: The British Library, 1991), pp.167–77

Israel, J.I., 'The Dutch role in the Glorious Revolution', in J.I. Israel (ed.), *The Anglo–Dutch Moment: Essays on the Glorious Revolution and its World Impact* (Cambridge: Cambridge University Press, 1991), pp.105–62

Israel, J. I., 'The United Provinces of the Netherlands: The Courts of the House of

Orange', in J. Adamson (ed.), *The Princely Courts of Europe: Ritual, Politics and Culture under the Ancien Régime 1500–1700* (London: Weidenfeld & Nicolson, 1999), pp.119–40

Israel, J.I., *Empires and Entrepots: The Dutch, the Spanish Monarchy and the Jews, 1585–1713* (London & Ronceverte: The Hambledon Press, 1990), Chapter 15, 'The economic contribution of Dutch Sephardi Jewry to Holland's Golden Age, 1595–1713', pp.417–48

Israel, J.I. *The Dutch Republic: Its Rise, Greatness, and Fall, 1477–1806* (Oxford: Oxford University Press, 1995)

Israel, J.I., *Dutch Primacy in World Trade, 1585–1740* (Oxford: Oxford University Press, 1989)

Israel, J.I., and G. Parker, 'Of Providence and Protestant winds', in J.I. Israel (ed.), *The Anglo–Dutch Moment: Essays on the Glorious Revolution and its World Impact* (Cambridge: Cambridge University Press, 1991), pp.335–6

Jacobs, J., *New Netherland: A Dutch Colony in Seventeenth-Century America* (Leiden: Brill, 2005)

Jacobsen, G.A., *William Blathwayt: A Late Seventeenth Century English Administrator* (New Haven: Yale University Press, 1932)

Jardine, L., 'Robert Hooke: A reputation restored', in M. Cooper et al. (eds), *Robert Hooke: Tercentennial Studies* (Ashgate, 2006), pp.247–58

Jardine, L., *Ingenious Pursuits: Building the Scientific Revolution* (London: Little, Brown, 1999)

Jardine, L., *The Awful End of Prince William the Silent: The First Assassination of a Head of State with a Handgun* (London: HarperCollins, 2005)

Jardine, L., *The Curious Life of Robert Hooke: The Man Who Measured London* (London: HarperCollins, 2003)

Jones, J.R., 'James II's Revolution: Royal politics, 1686–92', in J.I. Israel (ed.), *The Anglo–Dutch Moment: Essays on the Glorious Revolution and its World Impact* (Cambridge: Cambridge University Press, 1991), pp.47–72

Jong, E. de, *Nature and Art: Dutch Garden and Landscape Architecture 1650–1740* (Penn Studies in Landscape Architecture) (Philadelphia: University of Pennsylvania Press, 2001)

Jongste, J. de, J. Roding and B. Thijs (eds), *Vermaak van de elite in de vroegmoderne tijd* (Hilversum: Verloren, 1999)

Kalkman, W., 'Constantijn Huygens en de Haagse orgelstrijd', *Tijdschrift van de Vereniging voor Nederlandse Muziekgeschiedenis* 31 (1981), 167–77

Kan, A.H. (ed.), *De Jeugd van Constantijn Huygens door hemzelf beschreven* (Rotterdam: Donker, 1946)

Keblusek, M., '"A divertissiment of little plays": Theater aan de Haagse hoven van Elizabeth van Bohemen en Mary Stuart', in J. de Jongste, J. Roding and B. Thijs (eds), *Vermaak van de elite in de vroegmoderne tijd* (Hilversum: Verloren, 1999), pp.190–202

Keblusek, M., 'Cultural and political brokerage in seventeenth-century England:

The Case of Balthazar Gerbier', in E. Domela, M. van de Meij-Tolsma, J. Roding et al., *Dutch and Flemish Artists in Britain 1550–1700* (Leiden: Primavera Press/Leids Kunsthistorisch Jaarboek, 2003), 73–82

Keblusek, M., 'Mary, Princess Royal (1631–1660)', *Oxford Dictionary of National Biography*, Oxford University Press, 2004 [http://www.oxforddnb.com.catalogue.ulrls.lon.ac. uk:80/view/article/18252, accessed 9 April 2007]

Keblusek, M., and J. Zijlmans, *Princely Display: The Court of Frederik Hendrik of Orange and Amalia van Solms* (Zwolle: Historical Museum, The Hague, 1997)

Keesing, E., 'Wanneer was wie de heer van Zeelhem?', *De zeventiende eeuw* 9 (1993), 63–5

Keynes, G., *A Bibliography of Robert Hooke* (Oxford, The Clarendon Press, 1966)

Knowles, J., ' "We've lost, should we lose too our harmless mirth?" Cavendish's Antwerp Entertainments', in Beneden and de Poorter, *Royalist Refugees*, pp.70–7

Korthals-Altes, J., *Sir Cornelius Vermuyden* (The Hague: W.P. van Stockum & Son, 1925)

Landes, D.S., 'Hand and mind in time measurement: The contribution of art and science', *Notes and Records of the Royal Society of London* 43 (1989), 57–69

Laslett, P. (ed.), *Locke's Two Treatises on Government* (Cambridge: Cambridge University Press, 1960)

Latham, R., and W. Matthews (eds), *The Diary of Samuel Pepys*, 11 vols (London: HarperCollins, 1972, reissued 1995)

Leeuwen, R. van (ed.), *Paintings from England: William III and the Royal Collections* (The Hague: Mauritshuis & SDU Publishers, 1988)

Leopold, J.H. 'Christiaan Huygens, the Royal Society and Horology', *Antiquarian Horology* 21 (1993), 37–42

Leopold, J.H., 'Clockmaking in Britain and the Netherlands', *Notes and Records of the Royal Society of London* 43 (1989), 155–65

Lesger, C., *The Rise of the Amsterdam Market and Information Exchange: Merchants, Commercial Expansion and Change in the Spatial Economy of the Low Countries, c.1550–1630* (Aldershot: Ashgate, 2006)

Louw, H.J., 'Anglo-Netherlandish architectural interchange c.1600–c.1660', *Architectural History* 24 (1981), 1–23

Macandrew, H., and K. Andrews, 'A Saenredam and a Seurat for Edinburgh', *Burlington Magazine* 124 (1982), 752–5

McEvansoneya, P., 'The sequestration and dispersal of the Buckingham collection', *Journal of the History of Collections* 8 (1996), 133–54

McKeon, R.K., *Établissement de l'Astronome de Précision et Oeuvre d'Adrien Auzout* (2 fascicules), Thèse présentée pour le Doctorat du Troisième Cycle (Paris, 1965)

Mahon, D., 'Notes on the "Dutch Gift" to Charles II: 1', *Burlington Magazine* 91 (1949), 12–18, 303–5, 349–50

Mahoney, M., 'Christian Huygens: The measurement of time and of longitude at sea', in H.J.M. Bos et al. (eds), *Studies on Christiaan Huygens* (Lisse: Swets, 1980), p.234

Margry, P.J., and H. Rodenburg (eds), *Reframing Dutch Culture: Between Otherness and Authenticity* (Aldershot: Ashgate, 2007)

Montias, J.M., 'Art dealers in the seventeenth-century Netherlands', *Simiolus: Netherlands Quarterly for the History of Art* 18 (1988), 244–56

Montias, J.M., *Art at Auction in Seventeenth Century Amsterdam* (Amsterdam: Amsterdam University Press, 2002)

Montias, J.M., *Vermeer and His Milieu: A Web of Social History* (Princeton: Princeton University Press, 1989)

Motten, J.P. Vander, 'Killigrew, Thomas (1612–1683)', *Oxford Dictionary of National Biography*, Oxford University Press, 2004 [http://www.oxforddnb.com.catalogue. ulrls.lon.ac.uk:80/view/article/15538, accessed 8 April 2007]

Motten, J.P. Vander, 'Thomas Killigrew's "lost years", 1655–1660', *Neophilologus* 82 (1998)

Motten, J.P. Vander, *Sir William Killigrew (1606–1695): His Life and Dramatic Works* (Gent: Universa, 1980), pp.22–7

Mowl, T., *Architecture without Kings: The Rise of Puritan Classicism under Cromwell* (Manchester: Manchester University Press, 1995)

Muller, F. and J., 'Completing the picture: The importance of reconstructing early opera', *Early Music* 33 (2005), 667–81

Muller, J.M., 'Rubens's Museum of Antique Sculpture: An Introduction', *The Art Bulletin* 59 (1977), 571–82

Neal, L., *The Rise of Financial Capitalism: International Capital Markets in the Age of Reason* (Cambridge: Cambridge University Press, 1990)

Noske, F., 'Two unpaired hands holding a music sheet: a recently discovered portrait of Constantijn Huygens and Susanna van Baerle', *Tijdschrift van de Vereniging voor Nederlandse Muziekgeschiedenis* 42 (1992), 131–40

Offenberg, A., 'Dirk van Santen and the Keur Bible: New insights into Jacob Judah (Ayre) Leon Templo's model Temple', *Studia Rosenthaliana* 37 (2004), 401–22

O'Malley, T., and J. Wolschke-Bulmahn (eds), *John Evelyn's 'Elysium Britannicum' and European Gardening* (Washington DC: Dumbarton Oaks, 1998)

Onnekink, D.M.L., *The Anglo–Dutch Favourite. The Career of Hans Willem Bentinck, 1st Earl of Portland (1649–1709)* (PhD dissertation, University of Utrecht)

Oresko, R., 'The Glorious Revolution of 1688–9 and the House of Savoy', in Israel, *The Anglo–Dutch Moment*, pp.365–88

Ottenheym, K., *Philips Vingboons (1607–1678), Architect* (Zutphen: Walburg Pers, 1989)

Ottenheym, K., '"Possessed by such a passion for building": Frederik Hendrik and Architecture', in M. Keblusek and J. Zijlmans, *Princely Display: The Court of Frederik Hendrik of Orange and Amalia van Solms* (Zwolle: Waanders Publishers, 1997), pp.105–25

Ottenheym, K., 'Architectuur', in J. Huisken, K. Ottenheym and G. Schwartz (eds), *Jacob van Campen: Het klassieke ideaal in de Gouden Eeuw* (Amsterdam: Architectura & Natura Pers, Stichting Koninklijk Paleis Amsterdam, 1995), p.155

Pattacini, L., 'André Mollet, Royal gardener in St James's Park, London', *Garden History* 26 (1998), 3–18

Patterson, L.D., 'Pendulums of Wren and Hooke', *Osiris* 10 (1952), 277–321

Pieters, J., 'Among ancient men: Petrarch, Machiavelli, Sidney and Huygens', in *Speaking with the Dead: Explorations in Literature and History* (Edinburgh: Edinburgh University Press, 2005), pp.12–53

Ploeg, P. van der, and C. Vermeeren, '"From the 'Sea Prince's' Monies": The Stadholder's Art Collection', in P. van der Ploeg and C. Vermeeren (eds), *Princely Patrons: The Collection of Frederick Henry of Orange and Amalia of Solms in The Hague* (Zwolle: Waanders Publishers, 1997), pp.34–60

Prak, M., *The Dutch Republic in the Seventeenth Century* (Cambridge: Cambridge University Press, 2005)

Rasch, R., *Driehonderd brieven over muziek van, aan en rond Constantijn Huygens*, 2 vols (Hilversum: Verloren, 2007)

Rasch, R., 'Constantijn Huygens in Brussel op bezoek bij Leopold Wilhelm van Oostenrijk 1648–1656'. *Revue belge de Musicologie/Belgisch Tijdschrift voor Muziekwetenschap* 55, 'Six siècles de vie musicale à Bruxelles/Zes eeuwen muziekleven te Brussel' (2001), 127–46

Rasch, R.A., 'Seventeenth-century Dutch editions of English instrumental music', *Music and Letters* 53 (1972), 270–3

Raylor, T., '"Pleasure reconciled to virtue": William Cavendish, Ben Jonson, and the decorative scheme at Bolsover Castle', *Renaissance Quarterly* 52 (1999), 402–39

Roach, S. (ed.), *Across the Narrow Seas: Studies in the History and Bibliography of Britain and the Low Countries* (London: The British Library, 1991)

Roth, L. (ed.), *Correspondence of Descartes and Constantyn Huygens 1635–1647* (Oxford: Clarendon Press, 1926)

Rowen, H.E., *John de Witt, Grand Pensionary of Holland, 1625–1672* (Princeton: Princeton University Press, 1978)

Ruestow, E.C., *The Microscope in the Dutch Republic: The Shaping of Discovery* (Cambridge: Cambridge University Press, 1996)

Sainsbury, W.N. (ed.), *Original Unpublished Papers illustrative of the Life of Sir Peter Paul Rubens, as an artist and diplomatist, preserved in H.M. State Paper Office* (London: Bradbury & Evans, 1859)

Samuel, E., 'Manuel Levy Duarte (1631–1714): An Amsterdam Merchant Jeweller and his Trade with London', *Transactions of the Jewish Historical Society of England* XXVII, 11–31

Samuel, E., 'The disposal of Diego Duarte's Stock of Paintings 1692–1697', *Jaarboek Koninklijk Museum voor Schone Kusten-Antwerpen* (1976)

Sayce, L., 'Continuo lutes in 17th- and 18th-century England', *Early Music* 23 (1995), 666–84

Scala, G.E., 'An index of proper names in Thomas Birch, "The History of the Royal Society" (London, 1756–1757)', *Notes and Records of the Royal Society of London* 28 (1974), 263–329

Schaffer, S., 'The Glorious Revolution and medicine in Britain and the Netherlands', *Notes and Records of the Royal Society of London* 43 (1989), 167–90

Schama, S., *Rembrandt's Eyes* (Harmondsworth: Allen Lane for Penguin Press, 1999)

Schama, S., *The Embarrassment of Riches: An Interpretation of Dutch Culture in the Golden Age* (London: Collins, 1987)

Scholten, F., 'François Dieussart, Constantijn Huygens, and the classical ideal in funerary sculpture', *Simiolus: Netherlands Quarterly for the History of Art* 25 (1997), 303–28

Schwartz, G., 'Saenredam, Huygens and the Utrecht Bull', *Simiolus: Netherlands Quarterly for the History of Art* 1 (1966–67), 69–93

Schwartz, G., and M.J. Bok, *Pieter Saenredam: The Painter and His Time* (London: Thames & Hudson, 1990)

Schwoerer, L.G., *The Declaration of Rights, 1689* (Baltimore and London: The Johns Hopkins University Press, 1981)

Scott, J., *England's Troubles: Seventeenth Century English Political Instability in European Context* (Cambridge: Cambridge University Press, 2000)

Scott, J., 'What the Dutch Taught Us: The Late Emergence of the Modern British State', *Times Literary Supplement* (16 March 2001), 4–6

Scott, J., '"Good night Amsterdam": Sir George Downing and Anglo–Dutch state-building', *English Historical Review* 118 (2003), 334–56

Sellers, V. Bezemer, *Courtly Gardens in Holland 1600–1650* (Amsterdam: Architectura & Natura Press, 2001)

Shorto, R., *The Island at the Centre of the World: The Untold Story of Dutch Manhattan and the Founding of New York* (New York: Doubleday, 2004)

Silva, M.A. da, and M.M. Alcides, 'Collecting and framing the wilderness: The garden of Johan Maurits (1604–79) in North-East Brazil', *Garden History* 30 (2002), 153–76

Slack, P., 'Government and information in seventeenth-century England', *Past & Present* 184 (2004), 33–68

Slive, S., 'Art historians and art critics – II: Huygens on Rembrandt', *Burlington Magazine* 94 (1952), 260–4

Smith, P.H., and P. Findlen (eds), *Merchants and Marvels: Commerce, Science and Art in Early Modern Europe* (London: Routledge, 2002)

Smuts, R.M., *Court Culture and the Origins of the Royalist Tradition in Early Stuart England* (Philadelphia, 1987)

Speck, W.A., *Reluctant Revolutionaries: Englishmen and the Revolution of 1688* (Oxford: Oxford University Press, 1988)

Spencer, R., 'Chitarrone, theorbo and archlute', *Early Music* 4 (1976), 407–23

Steele, I.K., 'Communicating an English Revolution to the Colonies, 1688–1689', *Journal of British Studies* 24 (1985), 333–57

Stevenson, D., *Letters of Sir Robert Moray to the Earl of Kincardine, 1657–73* (Aldershot: Ashgate, 2007)

Straaten, H.S. van der, *Maurits de Braziliaan: Het levensverhaal van Johan Maurits van Nassau-Siegen, stichter van het Mauritshuis, gouverneur-generaal van Nederlands-Brazilië, stadhouder van Kleef 1604–1679* (Amsterdam: van Soeren & Co., 1998)

Streeter, J.W., 'John Winthrop, Junior, and the fifth satellite of Jupiter', *Isis* 39 (1948), 159–63

Strien, C.D. van, *British Travellers in Holland during the Stuart Period: Edward Browne and John Locke as Tourists in the United Provinces* (Leiden: Brill, 1993)

Strien, T. van, and K. van der Leer, *Hofwijk: Het gedicht en de buitenplaats van Constantijn Huygens* (Zutphen: Walborg Pers, 2002)

Strong, R., *The Artist and the Garden* (New Haven: Yale University Press, 2000)

Styles, J., and A. Vickery (eds), *Gender, Taste, and Material Culture in Britain and North America, 1700–1830* (New Haven and London: Yale University Press, 2006)

Sumner, A., 'Hanneman, Adriaen (c.1604–1671)', *Oxford Dictionary of National Biography*, Oxford University Press, 2004 [http://www.oxforddnb.com/view/article/12215, accessed 19 Feb 2007]

Swetschinski, D.M., and L. Schönduve, *De familie Lopes Suasso: Financiers van Willem III* (Zwolle: Waanders, 1988)

Taylor, S., 'Plus ça change …? New perspectives on the Revolution of 1688', *Historical Journal* 37 (1994), 457–70

Tiersot, J., 'Une famille de musiciens français au XVIIe siècle les de Barre. III. Les enfants de Pierre et Anne de la Barre chez Huygens', *Revue de musicologie* 9 (1928)

Toynbee, M.R., 'Adriaen Hanneman and the English court in exile', *Burlington Magazine* 92 (1950), 73–80

Toynbee, M.R., 'Some early portraits of Princess Mary, daughter of Charles I', *Burlington Magazine* 82 (1943), 100–3

Venema, J., *Beverwijck, A Dutch Village on the American Frontier, 1652–1664* (Albany and Hilversum: State of New York University Press and Verloren, 2003)

Verbeek, T., E-J. Bos and J. van den Ven (eds), 'The Correspondence of René Descartes 1643', *Questiones Infinitae: Publications of the Department of Philosophy Utrecht University* 45 (2003)

Vries, J. de, and A. van der Woude, *The First Modern Economy: Success, Failure and Perseverance of the Dutch Economy, 1500–1815* (Cambridge: Cambridge University Press, 1997)

Webb, S.S., 'William Blathwayt, imperial fixer: From Popish Plot to Glorious Revolution', *William and Mary Quarterly* 25 (1968), 3–21

Webb, S.S., 'William Blathwayt, imperial fixer: Muddling through to empire, 1689–1717', *William and Mary Quarterly* 26 (1969), 373–415

Wedgwood, C.V., *William the Silent* (London: Jonathan Cape, 1967)

Weil, R.J., 'The politics of legitimacy: Women and the warming-pan scandal', in L.G. Schwoerer (ed.), *The Revolution of 1688–9: Changing Perspectives* (Cambridge: Cambridge University Press, 1992), pp.65–82

Westermann, M., 'Vermeer and the interior imagination', in *Vermeer and the Dutch Interior* (Madrid, 2003)

Westfall, R., *Never at Rest: A Biography of Isaac Newton* (Cambridge: Cambridge University Press, 1980)

Westrup, J.A., 'Domestic music under the Stuarts', *Proceedings of the Musical Association* (1941–42), 19–53

Whitaker, K., *Mad Madge: Margaret Cavendish, Duchess of Newcastle, Royalist, Writer and Romantic* (London: Chatto & Windus, 2003)

Wilkinson, R.S., 'John Winthrop, Jr., and America's first telescopes', *New England Quarterly* 35 (1962), 520–3

Wilson, C.H., 'Who captured New Amsterdam?', *English Historical Review* 72 (1957), 469–74

Winner, D., *Brilliant Orange: The Neurotic Genius of Dutch Football* (London: Bloomsbury, 2000)

Witt, L. de, *Evolution and Ambition in the Career of Jan Lievens (1607–1674)* (unpublished PhD, University of Maryland, 2006)

Wolloch, N., 'Christiaan Huygens's attitude towards animals', *Journal of the History of Ideas* 61 (2000), 415–32

Worp, J.A. (ed.), *De briefwisseling van Constantijn Huygens (1608–1687)*, 6 vols ('s-Gravenhage: Martinus Nijhoff, 1911–17)

Worp, J.A. (ed.), *De gedichten van Constantijn Huygens, naar zijn handschrift uitgegeven*, 9 vols (Groningen, 1892–99)

Worp, J.A., 'Nog eens Utricia Ogle en de muzikale correspondentie van Huygens', *Tijdschrift der Vereeniging voor Noord-Nederlands Muziekgeschiedenis* 5 (1896)

Worsley, L., '"His magnificent buildings": William Cavendish's patronage of architecture', in B. van Beneden and Nora de Poorter (eds), *Royalist Refugees: William and Margaret Cavendish in the Rubens House 1648–1660* (Antwerp: Rubenshuis & Rubenianum, 2006), pp.101–4

Worsley, L., U. Härting and M. Keblusek, 'Horsemanship', in Beneden and de Poorter, *Royalist Refugees*, pp.37–54

Wright, M. 'Robert Hooke's longitude timekeeper', in M. Hunter and S. Schaffer (eds), *Robert Hooke: New Studies* (Woodbridge: The Boydell Press, 1989), p.63

Zijlmans, J., 'Life at the Hague Court', in M. Keblusek and J. Zijlmans (eds), *Princely Display: The Court of Frederik Hendrik of Orange and Amalia van Solms* (Zwolle: Waanders Publishers, 1997), pp.30–46

Zwann, M.S.-D., 'Magdalena Poulle (1632–99): A Dutch lady in a circle of botanical collectors', *Garden History* 30 (2002), 206–20

Index

Page numbers in *italic* indicate illustrations and captions.

A

Aachen, Treaty of (1678), 62
ABN Amro (bank), 358
Académie royale des sciences, Paris, 266, 297, 316
acupuncture, 344–5
Aerssen, François van *see* Sommelsdijck, Heer van
Aga, 327, 329
Albany, New York (*formerly* Fort Orange), 321, 323, 326, 331
Amalia, Princess *see* Solms, Princess Amalia von
America (North): Dutch settlement and activities in, 320–6; British take over Dutch territories, 327, 329–32, 346
Amsterdam: stock exchange crashes (1688), 41; art in, 120–1; international trade, 175, 320, 333–5; buildings, 205; Botanical Garden, 249; and New Netherland settlement, 324–6; wealth and culture in, 334–7, *334–5*, *336*; Bourse and financial system, 336–8, *337*, 340
Anamaboa, 327, 329
Anglo-Dutch wars, 47, 162, 264, 285, 290, 329, 352–3
Anne, Queen (*earlier* Princess), 56–7, 79
Antônio Vaz (island), 253
Antwerp: art and artists, 90, 120–1, 131, 193; affluence, 175–6; émigré English community, 175, 195, 197–8, 204; character, 176, 180, 193, 204; Duke and Duchess of Newcastle in, 195–8, 200, 203; Huygens visits, 208; Spanish pressure on, 333
Arenberg, Duke of: garden, 250
Arms of Amsterdam (ship), 321
art: collections acquired and sold, 100–10, 113–18, 120–31, 136–9, 184, 259–60; gifts from Dutch to Charles II, 139–40, 142–5; in English Royal Collection, 144–5, 147–8;

paintings retained by Dutch after William's death, 145; Duartes and, 182–4
Arundel, Althea, Countess of, 108–9
Arundel, Thomas Howard, 2nd Earl of, 101–2, 106–8, 110, 116, 130, 132, 184
Auzout, Adrien, 203, 296–9, 301–8
Avaux, Jean Antoine de Mesmes, comte d', 41
Axholme, Isle of, Lincolnshire, 237

B

Bacon, Sir Francis: Sir Constantijn Huygens meets, 167; 'New Atlantis', 81
Baerle, David van, 122–3
Baerle, Gaspar van, 150–1, 254–5
Baerle, Johan van II, 122, 238
Baerle, Petronella van (wife of Paulus Bisschop), 122
Baerle, Susanna van *see* Huygens, Susanna
Ballet de la Carmesse, 188–92
Bank of England: founded, 345, 347–8
Bedford, Francis Russell, 4th Earl of, 238
Bedford Level, Cambridgeshire, 238
Bentinck, Hans Willem (*later* 1st Earl of Portland): prepares Dutch invasion of England, 4, 37, 246; lands in England, 11; on lack of English support for invasion, 15–16; correspondence with William, 28; and William's *Declaration*, 29; gathers intelligence on English, 37, 50; negotiates with Brandenburg, 38; admires Wilton gardens, 50; garden designs at Hampton Court and Kensington Palace, 50; gardens and country estate, 225, 250, 252, 256; buys Sorgvliet from Jacob Cats, 239, 241; as adviser to William, 248; supplies plants to Fagel, 248; remarries, 256; earldom, 310
Bentinck, Martha Jane (*née* Temple), 256
Berckhout, Pieter Teding van, 144